The American Dream
pop to the present

Thames & Hudson The British Museum

The American Dream
pop to the present

Stephen Coppel
Catherine Daunt
Susan Tallman

With contributions from Isabel Seligman and Jennifer Ramkalawon

This publication accompanies the exhibition 'The American Dream: pop to the present' at the British Museum from 9 March to 18 June 2017

The exhibition is sponsored by Morgan Stanley

TERRA
FOUNDATION FOR AMERICAN ART

Supported by the Terra Foundation for American Art

This exhibition at the British Museum has been made possible by the provision of insurance through the Government Indemnity Scheme. The British Museum would like to thank the Department for Culture, Media and Sport and Arts Council England for providing and arranging this indemnity.

First published in the United Kingdom in 2017 by Thames & Hudson Ltd, 181A High Holborn, London WC1V 7QX, in collaboration with the British Museum

This paperback edition 2017

British Library Cataloguing-in-Publication Data

A catalogue record for this book is available from the British Library

ISBN 978-0-500-29282-2

Printed and bound in Slovenia by DZS Grafik

To find out about all our publications, please visit
www.thamesandhudson.com
There you can subscribe to our e-newsletter, browse or download our current catalogue, and buy any titles that are in print.

For more information about the Museum and its collection,
please visit **britishmuseum.org**

Frontispiece: James Rosenquist, *F-111* (detail), 1974, colour lithograph with screenprint on four sheets, British Museum, London 2009,7050.1.1-4. Presented by Dave and Reba Williams in honour of Antony Griffiths

Note: Dimensions of works are given in millimetres and inches, height by width by depth.

For intaglio prints, the plate size is given, for all other types of print, the size of the image is given. Where the image covers the whole sheet, only the sheet size is given. Only the paper size is given for drawings.

Initials at the end of each biography and catalogue entry denote the author:
SC Stephen Coppel
CD Catherine Daunt
ST Susan Tallman
IS Isabel Seligman
JR Jennifer Ramkalawon

Contents

Sponsor's foreword

Morgan Stanley is delighted to sponsor 'The American Dream: pop to the present', continuing our longstanding support of the British Museum, and giving visitors the opportunity to experience the art of a transformational time.

Charting the story of the modern western world as seen through the lens of the United States, this dramatic and vibrant exhibition illustrates the vital role played in the evolution of art by technological advance and innovation, enabling leading artists and thinkers to give voice to their ideas through creative new forms.

We live in a time of constant change, which throws up new challenges and opportunities every day. Helping our clients meet these challenges and opportunities is our mantra, with innovation at the forefront of everything we do. So this exhibition, which brings a dynamic period of American history to London, a leading financial and cultural centre, resonates strongly with us.

We hope you enjoy this opportunity to view some of the most iconic art of the past fifty years.

Robert Rooney
CEO of Morgan Stanley International

Morgan Stanley

Director's foreword

Exhibitions sometimes invite sequels. The present one takes up the story from Stephen Coppel's 'The American Scene: prints from Hopper to Pollock', first shown at the British Museum in 2008, before its tour to Nottingham, Brighton and Manchester. The next chapter in American printmaking had to await the opening of the Sainsbury Exhibitions Gallery in 2014 to accommodate the monumental scale and the serial nature of post-1960 American prints, as well as time to develop the collection to sufficient strength. 'How one wishes that the British Museum could improve its holdings in American printmaking from the 1960s and after,' Robert Hughes had pleaded at the end of his commendatory review in the *Guardian* newspaper of 'The American Scene'. To that end a dedicated campaign was mounted to build on the foundations laid by the previous generation of prints and drawings curators, Antony Griffiths and Frances Carey.

Stephen Coppel, the present show's curator, and Hugo Chapman, the Simon Sainsbury Keeper of Prints and Drawings, would like to acknowledge the crucial support given by the Vollard Group. Established in 2012 for the acquistion of modern works on paper, the Vollard Group has assisted in the purchase of some of the exhibition's most memorable works, such as Andy Warhol's bilious portrait of Richard Nixon in *Vote McGovern* and Robert Rauschenberg's celebration of Apollo 11's mission to the moon in *Sky Garden*. Vollard member Hamish Parker has been particularly supportive of the project from the outset: in addition to generously funding numerous acquisitions, he has just as importantly provided the means to enable Catherine Daunt to assist Stephen. We are also deeply grateful to the Monument Trust for continuing to support Catherine, who has played a crucial role in all aspects of the exhibition. We are also most thankful to Susan Tallman whose scholarly expertise on American printmaking informs her lively essay and contributions to the catalogue.

I would like to specially thank the National Gallery of Art, Washington, DC, and the Museum of Modern Art, New York, as well as the American Friends of the British Museum and American private collectors, who have so kindly and generously lent works essential to telling the story of their nation's unique contribution to modern printmaking. We are conscious of the great responsibility all our lenders, including Tate, Victoria and Albert Museum, Warwick University Art Collection and European private owners, have entrusted in us.

Above all we simply could not have contemplated charting such a vital, diverse and creative period of American art had it not been for the munificence of the exhibition's sponsor Morgan Stanley. We are also grateful for generous support from the Terra Foundation for American Art. To them and to all those who have helped us in this undertaking, I would like to express our most sincere thanks.

Hartwig Fischer
Director, British Museum

Acknowledgments

In keeping with the collaborative nature of the print workshop this publication, and the exhibition it accompanies, is the outcome of a collective enterprise in which many individuals and organizations have been involved. I wish to record here my deepest thanks to Susan Tallman for her scholarly essay and entries as well as her expertise and to my co-curator Catherine Daunt who not only contributed substantially to the catalogue by researching and writing so many of the entries but was closely involved in all aspects of the exhibition and publication which she carried out with extraordinary perception, efficiency and good nature. I wish also to thank Isabel Seligman, the Bridget Riley Art Foundation exhibition curator at the British Museum, who contributed section 6 on minimalism and conceptualism, and Jennifer Ramkalawon, the Museum's curator of Western graphic art, for contributing on Willem de Kooning. The authors are acknowledged with their initials in the publication.

Many individuals have helped in various ways, and in particular I wish to thank the following: In the United States: Brooke Alexander and Barbara Baruch; Eric Avery; Richard Axsom; Kathan Brown and Valerie Wade of Crown Point Press; Gregory Burnet of Burnet Editions and Catherine Gatto Harding; Scott and Cindy Burns; Barbara Bertozzi Castelli of the Castelli Gallery; Christophe Cherix, Starr Figura and Jodi Hauptman of the Museum of Modern Art, New York; Jeanne and Geoffrey Champion; Nicolas Collins; Gary Conklin; Margaret Conklin and David Sabel; Gifford Combs; Tom Cvikota; Mary Dean at Ed Ruscha Studio; Jim Dine; James and Laura Duncan; Sidney Felsen and Joni Moisant Weyl of Gemini G.E.L.; Richard S. Field; Ruth Fine; Francis Finlay; Larry Gagosian; Leslie and Johanna Garfield; Bill Goldston of ULAE; Elizabeth Glassman; Felix Harlan and Carol Weaver; Heather Hess; the Horace W. Goldsmith Foundation; Linda and Howard Karshan; David Kiehl of the Whitney Museum of American Art; Barbara Krakow and Andrew Witkin of the Barbara Krakow Gallery; David and Evelyn Day Lasry of Two Palms Press; David Zwirner, Angela Choon and Greg Lulay of the David Zwirner Gallery; Michael Marmor; David Nolan and Maureen Bray of the David Nolan Gallery; Maureen Pskowski at Jasper Johns Studio; the Robert Rauschenberg Foundation; Shaye Remba of Mixografia; Andrew Robison, Judith Brodie and Charles Ritchie of the National Gallery of Art, Washington, DC; Donna and Ben Rosen; the late John Rowe of the Joseph F. McCrindle Foundation; Mary Ryan and Jeff Lee of the Mary Ryan Gallery; Susan Sheehan of the Susan Sheehan Gallery; the late Tom Slaughter; Craig F. Starr; Ken Tyler; Dave and Reba Williams; Wendy Williams of the Easton Foundation; Deborah Wye.

In the UK and Europe: James Bartos; Charles Booth-Clibborn; Alan Cristea; Ian Christie; Thomas Dane; Diana Dethloff; Elizabeth Dooley of Warwick University; Jan Lowe and Briar Davies from Elbow Productions; Factory Settings Ltd.; Paola Ferrero; Georgie Gerrish; Jonathan Howard of DHA Design Services; Lyndsey Ingram; Bernard Jacobson; Elizabeth H. Llewellyn; Markus Michalke; Frances Morris of Tate Modern; Frederick Mulder and Anne-Françoise Gavanon; Pippa Nissen and James Pockson of Nissen Richards Studio; Midge and Simon Palley; Judith Pillsbury; Hamish Parker; Graham Rifkin; Frankie Rossi; Raphaelle Blanga and Greg Rubinstein of Sotheby's; Gill Saunders of the Victoria and Albert Museum; Karsten Schubert; Philip Simpson; Paul Stolper; Babs Thomson; Robin Vousden.

At the British Museum colleagues past and present have lent every encouragement and support to the publication and the exhibition: Hartwig Fischer, the Director and Neil MacGregor, former Director; Hugo Chapman, Simon Sainsbury Keeper of Prints and Drawings, and all my colleagues in the department of Prints and Drawings, especially Jordina Diaz Ferrando, Angela Roche, Christopher Coles, Enrico Zanoni and departmental volunteer Monica Sidhu, the former keeper Antony Griffiths and my predecessor in charge of the modern collection Frances Carey. I would like to thank Charlie Collinson for framing; Dudley Hubbard and John Williams for photography; Alice Rugheimer, Julianne Phippard and Tomasina Munden for conservation and David Giles for mounting; in Exhibitions Carolyn Marsden-Smith, Caroline Ingham, Matt Weaver, Elizabeth Bray, Curt Riegelnegg, Mark Finch and Paul Teigh; in the Registrar's Office Jill Maggs, Chris Stewart and Sarah Choy; Rebecca Penrose, Freddie Matthews and his team in Learning and National Partnerships; Emma Poulter and Patricia Wheatley in Digital and Publishing; in Marketing Kate Carter and Ann Lumley; in Press Hannah Boulton, Nicola Elvin and Benjamin Ward; in the Development office Caroline Usher, Jennifer Suggitt, Sarah Cook, Mira Hudson and Tadas Khazanavicius and the American Friends of the British Museum; with special thanks to Claudia Bloch, senior editorial manager at the British Museum for overseeing the publication with Louise Ramsay and Julia MacKenzie at Thames & Hudson.

Stephen Coppel

List of lenders

The British Museum would like to thank all the lenders to the exhibition
'The American Dream: pop to the present' for their generosity.

American Friends of the British Museum

James M. Bartos Collection

Thomas Dane, London

Collection of Larry Gagosian

Johanna and Leslie Garfield

Collection Michalke, Munich, Germany

Museum of Modern Art, New York

National Gallery of Art, Washington

Private collection, UK

Private collection, UK (promised gift to the British Museum)

Private European Collection

Tate, London

The University of Warwick Art Collection

Victoria and Albert Museum, London

Piecing together the American Dream
Stephen Coppel

'Everybody has their own America, and then they have the pieces of a fantasy America that they think is out there but they can't see…the fantasy corners of America seem so atmospheric because you've pieced them together from scenes in movies and music and lines from books. And you live in your dream America that you've custom-made from art and schmaltz and emotions just as much as you live in your real one.'[1] So Andy Warhol speculated in his picture-book *America*, first published in 1985, two years before his death at the age of 58. Perhaps no artist better encapsulated the ethos of the American Dream than this son of Czech immigrants who was born and studied in Pittsburgh before moving to New York in 1949 where he changed his name from Warhola to Warhol, a shift that indicated his desire for closer assimilation into the greater American society. Warhol understood perfectly the aspirations of working America towards achieving the outward symbols of material success – the college education, stable employment, suburban home, marriage, family – all of which were bound up with a sense of self-worth, drive and ambition to live the dream that the years of growing affluence and relative peace (with the exception of the Korean War) seemed to offer following the Second World War. The extraordinary expansion of American manufacturing during the post-war years – the assembly lines churning out automobiles, television sets, refrigerators, washing machines and other household goods, rolling out to consumers across the country – gave the impression of plenitude and prosperity within reach of those who worked hard and strove for success. Yet cracks within the American Dream had appeared as early as 1949, when Arthur Miller's excoriating tragedy *Death of a Salesman* pricked the nation's conscience on its first staging in New York, where it was received to great critical acclaim. Warhol's exposure of the illusionary nature of the American Dream, almost as if he were projecting it onto the billboard of American consciousness, was to be his unique achievement.

In 1962 Warhol astounded the New York art world with his serial images of America as constructed and relayed in mass advertising, the news media and the movies. Emulating the method of a mass-production line, Warhol created a stream of paintings of Campbell's Soup cans (fig. 1), horrific car crashes, Coca Colas, Elvis Presleys and Marilyn Monroes. By exploiting the technique of screenprinting from the commercial world Warhol found a highly efficient means of transferring his imagery in different repetitions and permutations onto canvas and paper. Deadpan and emotionally detached, Warhol offered no comment on his choice of subject. It was banal, everywhere and immediately recognizable. As Warhol later recalled, 'In August '62 I started doing silkscreens…I wanted something…that gave…an assembly-line effect…when Marilyn Monroe happened to die that month, I got the idea to make screens of her beautiful face – the first Marilyns.'[2] Behind the glamour of celebrity and fame lay the tragedy; Marilyn, recently divorced from Arthur Miller, her second husband, had taken her own life with a drug overdose. Based on a publicity photo from the height of her fame during the 1950s, Warhol's depiction of the alluring screen goddess with her famous blonde hair became a memorial to a fallen idol, a puncturing of the dream of Hollywood stardom. Underpinning the potency of Warhol's imagery was a kind of religious sensibility that appeared to come from his Eastern Catholic background: Marilyn Monroe as the siren Madonna worshipped on a pedestal of publicity; the widow Jackie Kennedy as the weeping Madonna after the assassination of President John F. Kennedy in 1963; and the electric chair as a site of state-sanctioned crucifixion.

The explosion of pop art in the early 1960s was to elevate subject matter drawn from popular culture to the level of high art. A number of artists – most famously Warhol, but also James Rosenquist who had worked as a billboard painter high above Times Square – had come out of the commercial art world during the 1950s and understood its strategies for gaining attention through punchy, primary colour; big, often disjunctive scale; and arresting imagery. Roy Lichtenstein found his visual language in popular comic books where the dream of romance and the perpetual fight against evil malefactors seemed to promulgate and reinforce prevailing stereotypes of American society. For Lichtenstein, the crude Ben-day dots of commercial printing with its use of the primaries (red, yellow and blue) and black outline offered a visual grammar for organizing and structuring his carefully composed works. While Lichtenstein translated the comic-book dots on to his canvases by painstakingly rubbing paint with a toothbrush through a perforated stencil, he discovered that the screenprint gave him the ideal medium for realizing the impersonal commercial effect he was seeking.

By its flat, unmodulated blocks of colour and the ease with which photo-stencils could also be deployed, the screenprint became the medium par excellence among pop artists for translating their visions into print. Coming as it did from the screen shops dotted around Manhattan

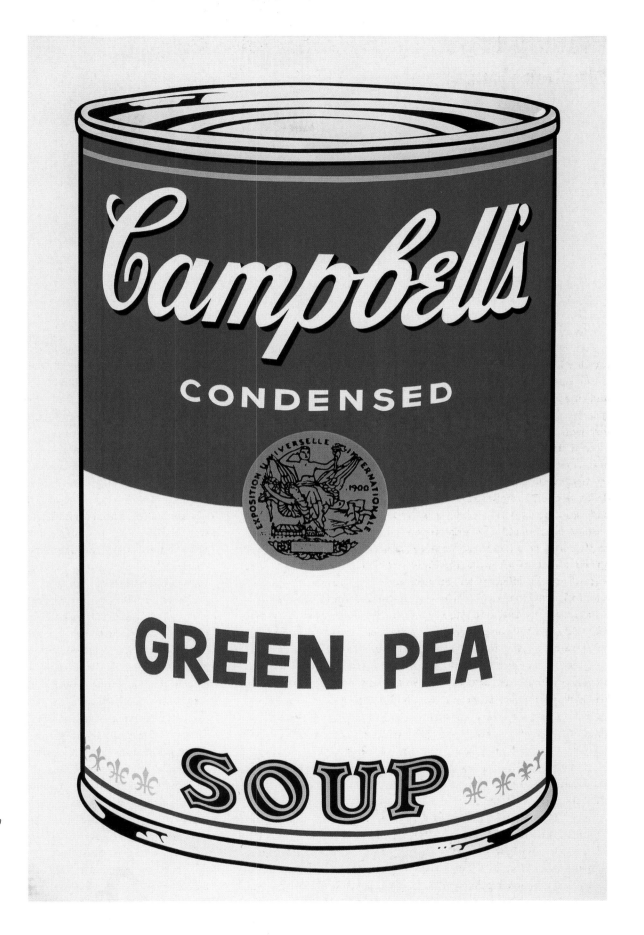

Fig. 1 Andy Warhol, *Campbell's green pea soup* from *Campbell's Soup I*, 1968, colour screenprint, 889 x 584 (35 x 23). British Museum, London 1981,0620.37. Donated by Brooke Alexander

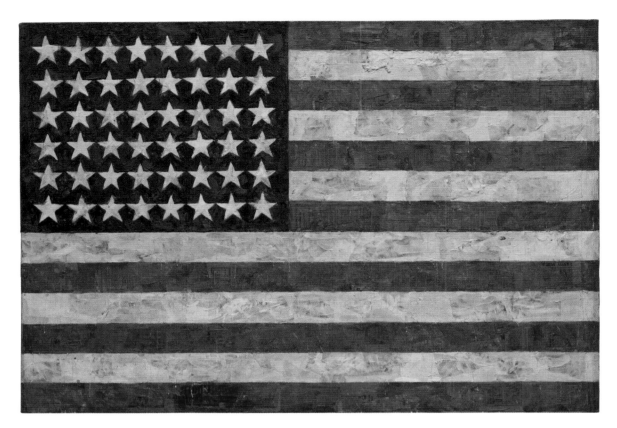

LEFT: Fig. 2 Jasper Johns, *Flag*, 1954–55, encaustic, oil and collage on fabric, 1073 x 1538 (42¼ x 60½). Museum of Modern Art, New York 106.1973. Gift of Philip Johnson in honor of Alfred H. Barr, Jr.

OPPOSITE: Fig. 3 Jasper Johns, *Map*, 1961, oil on canvas, 1982 x 3147 (78 x 123⅞). Museum of Modern Art, New York 277.1963. Gift of Mr and Mrs Robert C. Scull

producing cheap posters and advertising material, the screenprint suited the imagery of pop art. Moreover, its cool, impersonal, uninflected surfaces naturally appealed to pop artists reacting against the abstract expressionists whose spontaneous and highly personal painterly gestures had dominated the American avant-garde during the 1950s. In the eyes of this rising generation, the abstract expressionists, with their emphasis on expressing the creative forces of the subconscious mind, appeared to shut out the everyday consumer-driven world they inhabited.

Portfolios of prints became the ideal container for disseminating the new pop art style. Among the earliest and most influential were the three volumes of *11 Pop Artists* published by Rosa Esman in 1966, which included prints by leading figures such as Warhol, Lichtenstein, Rosenquist, Tom Wesselmann and Mel Ramos. Nearly all the portfolio prints were produced at the commercial screen shop Knickerbocker Machine and Foundry, Inc., in New York City in large editions of 200. They effectively served as albums of the new movement. Warhol contributed three iterations of Jackie Kennedy (cat. 138), appearing essentially alone in the full glare of the media at President Kennedy's state funeral, while Lichtenstein's comic-based *Sweet Dreams Baby!* (cat. 10) socked the public in the face with the new style and became one of its most famous images. The thirty-three prints that comprise the *11 Pop Artists* portfolios were widely distributed: complete sets were sent as touring exhibitions around America and Europe over the two years following their publication, and largely contributed to broadening the appeal of pop art beyond the United States. The highly original artist's book *1¢ Life*, published in 1964, performed a similar function. Twenty-eight artists, many of whom were the newly rising pop artists, provided images in the form of colour lithographs to accompany the often erotic, highly charged poetry of the Chinese American artist

Walasse Ting. It was the perfect forum for Wesselmann to present his preoccupation with the Great American Nude (cat. 12) – blonde, naked and female – reclining in voluptuous abandon against a patriotic backdrop of the American flag. Wesselmann's irony was always lightly veiled and his pneumatic nudes were never that far away from the centrefold spreads of *Playboy*, the American men's magazine that first launched with a front cover and nude centrefold of Marilyn Monroe in December 1953, but became almost as well known for its stories and interviews with leading political and cultural figures during the 1960s.

Jasper Johns and Robert Rauschenberg explored – a decade earlier – ideas that were later taken up by pop. From the early 1960s they developed their own visions in printmaking, as did Jim Dine. All three artists distanced themselves from the pop label as one imposed upon them by the art world. Johns took ordinary, recognizable objects, such as the American flag (fig. 2), found in every classroom and public building in the United States, which, like his targets, he had first painted in the mid-1950s. Johns exploited the fact that these well-known objects, which also included the map of the continental United States, first painted in 1961 (fig. 3), were so commonplace that they were not noticed. He subjected these motifs to a constant examination and re-examination through different processes in a painterly manner that became his signature. The screenprint *Flags I* (cat. 16), for instance, was printed as a double, downward-hanging flag in matt colour inks from thirty screens but the flag on the right was given an additional layer of screenprinted varnish that immediately sets up a subtle shift in our visual perception of the opposing flat and glossy renditions. Its sister, *Flags II* (cat. 17), was subjected to a monochrome treatment, printed from the same screens minus the gloss varnish but all using the one grey colour. As opposed to the hard, impersonal surfaces of pop screenprints, Johns

achieved painterly effects by layering dozens of screens and retaining some of the gestural traces of the abstract expressionist painters, such as red and black drips. As Johns revealed in an early interview, 'I prefer work that appears to come out of a changing focus – not just one relationship or even a number of them but constantly changing and shifting relationships to things in terms of focus.'[3] Johns first took up lithography in 1960 at Universal Limited Art Editions (ULAE), the print workshop on Long Island outside New York City established three years earlier by the enterprising émigré Tatyana Grosman. There he began to investigate the possibilities implicit in printmaking: its doublings, reversals, positive/negative, colour/ monochrome and so on. Johns' preoccupation with formal strategies of repetition, alteration and opposition posit an enclosed hermetic world, yet the subject matter, including his deployment of the alphabet and the numerals 0 to 9, is so familiar that reference to an external reality always breaks through. At the same time, Johns has preserved a sphinx-like silence with regard to any political or social reading that his repeated depictions of the American flag or the map of the United States might imply.

Rauschenberg took a more free-wheeling, intuitive approach to his image making. In 1962, two years after Johns, he also began to make prints at ULAE that combined photo-derived imagery from newspapers and magazines with hand-drawn marks on the lithographic stone. Rauschenberg was initially reluctant to take up lithography, famously

declaring 'that the second half of the twentieth century was no time to start writing on rocks'.[4] The incorporation of everyday imagery – baseball players, army helicopters, the Statue of Liberty – gave his work a kaleidoscopic vitality expressive of the restless, dynamic world that was contemporary America. Uniting the diverse imagery is the artist's vigorous gestural mark-making that, as in the case of Johns, recalls the legacy of abstract expressionism. A year later Rauschenberg would make headlines when he became the first American artist to win the coveted grand prix at the Fifth International Exhibition of Prints in Ljubljana in 1963 for his aptly titled *Accident* (cat. 44) – the celebrated lithograph in which the artist chose to exploit the complete breakage of the stone that he was working on by drawing attention to the wide-open crack and even adding some faux broken chips of his own at the bottom of the image. This acceptance of accident and the spontaneity of invention characterized Rauschenberg's approach to printmaking. In 1967 he began to work at Gemini G.E.L. in Los Angeles at the invitation of the master printer Ken Tyler. The initial project culminated with *Booster* (cat. 45), a 1.8-metre high print in lithography and screenprint that presented a composite X-ray of the artist's body standing naked except for his boots and overlaid by a sky-measuring chart of the heavens. Then billed as the biggest lithograph ever made, it required two stones laid end to end as none could be found large enough to accommodate the image. Technical ingenuity and overarching

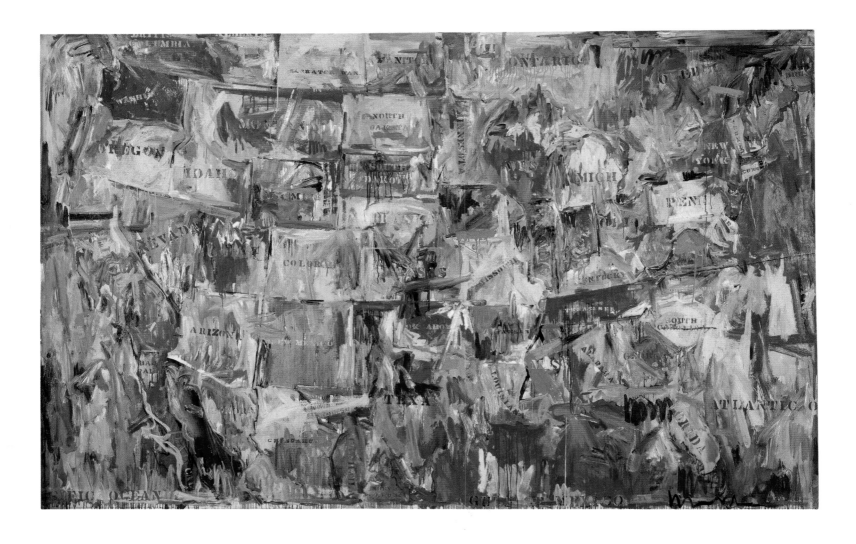

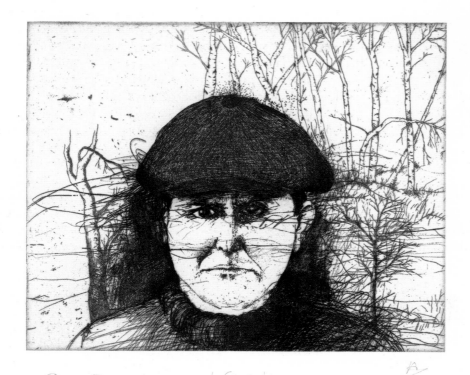

Fig. 4 Jim Dine, *Self Portrait in a Flat Cap (the green cap) second state*, 1974, etching, 655 x 500 (25¼ x 19⅝). British Museum, London 2014,7067.35. Presented by the artist in honour of Alan Cristea

ambition, qualities that typified the 'can-do' attitude of Ken Tyler's Gemini workshop, were pressed into service for a triumphant outcome. Rauschenberg's body, a secular Ecce Homo, stands as the measure of all things human.

The human dimension is also at the heart of Dine's work. The appearance of bathrobes, tools and paintbrushes from early in his career was viewed by some critics as signalling allegiance to a pop art sensibility. Dine, however, intended the standing empty bathrobe, its sleeves positioned on hips in a male stance, as a surrogate portrait of the artist himself. Similarly, the erect wrenches, pliers and bolt cutters – tools deriving from his family hardware store in Cincinnati, Ohio, where he grew up – became symbols of masculinity, while the paintbrush, pendulous and hirsute, stood as a metaphor for the artist's creative activity and presence. As Dine once declared: 'I am not a Pop Artist…I am too subjective for it. Pop is concerned with external things. I deal with inner things. When I use objects, I see them as a vocabulary of emotions.'[5] From the early 1970s, when minimalism and conceptualism were upheld as the true tenets of the avant-garde, Dine began to draw directly from the human figure, including self-portraits (fig. 4) and the nude (fig. 5), a development that was perceived by some viewers as retrograde at the time, although the figure, whether overtly or in various guises, has always been present in his work.

It is perhaps not surprising that the great technological feat of launching men to the moon with the Apollo 11 mission on 16 July 1969 should inspire Rauschenberg to break new boundaries in printmaking with his *Stoned Moon* (cats 26–31) series of lithographs. The artist had been invited by the National Aeronautics and Space Administration (NASA) to observe the blast off from Cape Kennedy (now called Cape Canaveral) in Florida. Four days later, on 20 July 1969, Neil Armstrong became the first person to step on the lunar surface, followed by fellow astronaut Buzz Aldrin. Apollo 11 marked the culmination of the 'space race' with the Soviets, which had gripped the public imagination from the early 1960s: the first manned orbit of earth by the Russian cosmonaut Yuri Gagarin on 12 April 1961 had provoked President Kennedy a month later to declare that putting man on the moon by the end of the decade would be a priority for the American nation. Congress committed immense financial and technical resources to realizing this objective. To commemorate the progressive achievements of the American space project, NASA initiated in 1962 an art programme under the direction of James Dean, an administrator who had trained as an artist. For the Apollo 11 mission, Rauschenberg was one of seven artists selected to witness the launch, although Dean had to explain to NASA officials who he was. Rauschenberg was given free rein to interpret the event at first hand. Armed with a mass of photographs, documents and diagrams he had selected from the NASA archives, he returned to the Gemini workshop where he worked around the clock over the next two months with Ken Tyler and his printers to create his astonishing series of thirty-three lithographs inspired by the moon-shot.[6]

Encompassing in its title a triple reference to the rocks brought back by the astronauts from the moon, the lithographic stones upon which Rauschenberg created his space-age rock art and the heady euphoria of the druggy counter-culture of the late 1960s, the *Stoned Moon* series evokes the excitement and jubilation that greeted this event, witnessed

on television sets around the world. Rauschenberg later gave this poetic description of what he saw from the viewing platform:

> The bird's nest bloomed with fire and clouds. Softly largely slowly silently Apollo 11 started to move up. Then it rose being lifted on light. Standing mid-air, it began to sing happily loud. In its own joy wanting the earth to know it was going. Saturated, super-saturated, and solidified air with a sound that became your body. For that while everything was the same material. Power over power joy pain ecstasy. There was no inside, no out. Then bodily transcending a state of energy, Apollo 11 was airborne. Lifting pulling everyone's spirits with it.[7]

While acknowledging the first landing on the moon as an achievement of American ingenuity and endeavour, Rauschenberg in the print series also celebrates it more idealistically as a triumph of mankind; nature and technology could work in harmony to create a better understanding of our common humanity and of the world in which we live. In many of the prints the birds and palm trees of the Florida marshes coexist with the mighty Saturn V rocket. As if to emulate the rocket's titanic proportions, *Sky Garden* (cat. 26) rises to almost 2.2 metres, breaking the record for the largest hand-printed lithograph, which had been set by *Booster* two years earlier; positioned in a visual rhyme with the rocket is a long-beaked, spindle-legged wading bird in a pool of blue. The ferocious blast of the rocket takes up two-thirds of the print in explosive red swirls, through which can be glimpsed an official from Mission Control looking up. The twin acts of walking on the moon and the earth are brought together by Buzz Aldrin's lunar footprint imposed on the wading bird, while the command module at upper left circles the moon before the returning astronauts make their splashdown in the sea by the three parachutes at lower left.[8] A summation of its themes, *Sky Garden* represents the great climax of the *Stoned Moon* series, in which Rauschenberg invoked the role of the history painter to record a contemporary event of monumental significance.

Fig. 5 Jim Dine, *The Cellist* from the series *Eight Sheets from an Undefined Novel*, 1976, soft-ground, etching and drypoint, with hand-colouring, 602 x 503 (23⅝ x 19¾). British Museum, London 1999,0131.39. Presented by the artist

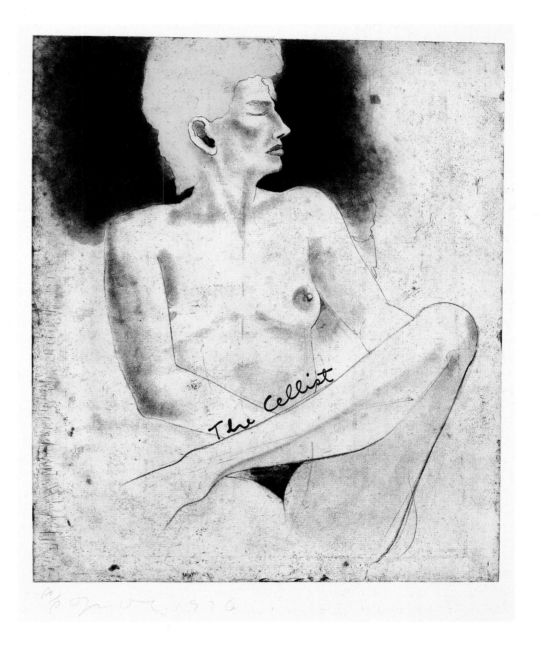

In 1970 Rauschenberg went a step further, offering a visual summary of the 1960s in his screenprint *Signs* (cat. 137). In this kaleidoscopic retrospective portrait of a turbulent decade, the national elation of the moon landing lies alongside a shattered American ideal: three assassinations (John F. Kennedy, his brother Robert F. Kennedy and the civil rights leader Dr Martin Luther King Jr.), the Vietnam War, the race riots and the student-led peace movement, while the rock singer Janis Joplin, who shared with Rauschenberg the backwater hometown of Port Arthur, Texas, howled the emotional angst of a generation (Joplin would die of a drug overdose later that year). The times were indeed a-changin', as Bob Dylan had declared back in 1964.

Signs of a different kind had greeted Warhol as he drove across America in a station wagon from New York to Los Angeles for the opening of his second exhibition at the Ferus Gallery in 1963. 'The farther west we drove,' he recalled, 'the more Pop everything looked on the highways. Suddenly we all felt like insiders because even though Pop was everywhere – that was the thing about it, most people still took it for granted, whereas we were dazzled by it – to us, it was the new Art. Once you "got" Pop, you could never see a sign the same way again. And once you thought Pop, you could never see America the same way again.'[9] The previous year a dynamic young curator, Walter Hopps, had organized the first survey of pop art; held at the Pasadena Art Museum in Los Angeles County, it was entitled 'New Painting of Common Objects' (25 September–19 October 1962) and brought together East Coast artists Warhol, Lichtenstein and Dine and five West Coasts artists, including Ed Ruscha and Wayne Thiebaud. The Ferus Gallery in Los Angeles, first established by Hopps in 1957 and then largely run under the direction of Irving Blum, created a vital venue for the new art style. Warhol was given his first exhibition at Ferus in 1962 and Ruscha followed in 1963.

The visual impact of words and signage viewed from the car on the open highway became a prevailing theme in Ruscha's work. In 1956, at the age of 18, he left his hometown of Oklahoma City with his friends Joe Goode, Mason Williams and Jerry McMillan and drove west along Route 66 to begin college in Los Angeles. He made the 1,400-mile trip back and forth several times a year, the monotony of the highway interrupted by the filling stations, landmarks that Ruscha later described as 'like a musical rhythm to me – cultural belches in the landscape'.[10] They inspired his seminal book *Twentysix Gasoline Stations* (cat. 55), first published in 1963, documenting the road journey in a series of seemingly banal snapshots of the gas stations that punctuated the route. Ruscha likened himself to a reporter: 'I felt there was so much wasteland between L.A. and Oklahoma City that somebody had to bring in the news to the city. It was just a simple, straightforward way of getting the news and bringing it back.'[11] In this modest, pocket-sized book Ruscha signalled the visual importance of the highway in the collective consciousness of Americans who were constantly criss-crossing the country, so memorably evoked in Jack Kerouac's famous novel, *On the Road*, first published in 1957.

The vernacular streetscape of Los Angeles – the famous Hollywood sign, the billboards, advertising signs, apartment blocks, parking lots, the tinsel-town Sunset Strip – provided fertile ground for Ruscha's words-as-image and books. It is a landscape viewed through the windshield of a moving car; billboards coming into view and then retreating like the sign *Made in California* (cat. 65), with its perspiring letters evoking heat, sunshine

and oranges. Although the stretched horizontal-landscape format of many of his prints and drawings points to the open spaces of California, Ruscha has also acknowledged another source: 'I've been influenced by the movies, particularly the panoramic-ness of the wide screen. The wide screen says something about my work.'[12] The saturated colour of the Technicolor screen was wittily expressed in his *Standard Station* (cat. 56) (based on one of the nondescript snapshots in *Twentysix Gasoline Stations*) and in his *Hollywood* sign (cat. 58) sinking into the sunset behind the Hollywood Hills. His training in commercial graphic design at Chouinard Art Institute (now called Cal Arts) in Los Angeles and his experience in the mid-1960s as a freelance layout designer under the pseudonym Eddie Russia for *Artforum* magazine, whose offices were above the Ferus Gallery, specially equipped Ruscha for his engagement with printmaking and the making of artist's books. Acutely aware of the visual strategies of advertising and graphic design, he deployed this language in a deadpan ironic way that seems to epitomize the West Coast experience. In 1981, in a short film on his work and Los Angeles, Ruscha made this revealing comment on how he conceptualized his work: '"Hollywood" is like a verb to me. It's something that you can do to any subject or any thing. You can take something in Grand Rapids, Michigan and "Hollywoodize" it. They do it with automobiles, they do it with everything we manufacture.'[13] The New York-based artist Alex Katz was to do this with his own ironic self-portrait (cat. 117), made in 1978, inspired by a Mexican-born Hollywood actor styled as a wholesome all-American regular guy in slick car advertisements. For David Hockney, arriving in Los Angeles in the early 1960s, the lifestyle of ease, sunshine and swimming pools fulfilled the Hollywood dream to which he had been exposed through films while growing up in gloomy, austerity-riven Britain.

Through their uncompromising rigour and detachment, minimalism and conceptual art in the late 1960s and 1970s might seem to be a deliberate withdrawal from the relentless visual assault of American life that so inspired Warhol and Ruscha. Yet one cannot look at the repetitions and standardized units of Donald Judd's stacks (p. 177), the permutations of Brice Marden's grids (cats 101–3), or the monumentality and weight of Richard Serra's works (cats 108 and 109) without thinking of America's industrial efficiency and might during this period or its grid-structured cities. Judd, for one, deliberately sought a neutral, industrial aesthetic; one stripped of emotion yet, paradoxically, moving in its reductive purity, whether expressed in woodcut or sculpture. 'If Minimalism formally expressed "less is more," Conceptual art was about saying more with less,' the critic Lucy Lippard later observed.[14] In 1967 Sol LeWitt, conceptualism's high priest, formulated his 'Paragraphs on Conceptual Art', which was first published in the pages of *Artforum*, declaring: 'The idea becomes a machine that makes the art.'[15] Paramount was the idea rather than its execution. If Warhol thought of the making of his art in terms of an assembly line, LeWitt was little different in entrusting his ideas to assistants and fabricators for their realization. For the minimalists and conceptual artists printmaking was an obvious and natural endeavour as it allowed their ideas to be expressed serially, in which the combined effect was greater than the sum of its parts. LeWitt's propositions, such as *Three Kinds of Lines and All Their Combinations* (cat. 106), found a resolution in printmaking that was both cerebral and poetic. The emergence of photorealism in the late 1960s, a style characterized by the illusion

of scrupulous veracity to the photographic depiction of external reality, would seem to be the very antithesis of conceptualism and minimalism. Chuck Close and Richard Estes, the foremost exponents of photorealism, although both artists bristled at the label, worked from imagery derived from photographs in their painting and printmaking. Yet Close's tightly framed, frontal portraits (cats 114–16) and Estes' urban diners, shop and office façades (cats 118–21) are essentially constructed realities composed within an intractable minimalist grid.

Printmaking's long history as a medium of political and social criticism appealed to American artists during this period. Central to this was the voice given to feminism by a generation of women artists who agitated for greater exposure and representation in the art world. Drawing upon some of the strategies of the conceptual artists of the 1970s such as Sol LeWitt, who attempted to circumvent the commercial gallery system by producing artists' books and non-object based work, feminists organized themselves in consciousness-raising forums and collectives such as the Art Workers Coalition, led by Lucy Lippard. The latter pressure group campaigned for greater inclusion of women, non-white and openly gay artists in art museums, particularly the Museum of Modern Art, New York. Artists such as May Stevens and Nancy Spero became actively engaged with feminist causes alongside their involvement with the civil rights movement and protests against the Vietnam War. Patriarchal authority and small-minded male chauvinism were highlighted through the figure of Big Daddy in Stevens' series of screenprints, drawings and paintings (cats 159 and 160) in the late 1960s and early 1970s. Ida Applebroog drew attention to issues of male/female power relations by sending her small, cheaply produced artist's books (cat. 162) as unsolicited mail to individuals and organizations in the New York art world in the late 1970s. Manifestos, flyers, posters, artists' books and artists' magazines were the unpretentious print mediums by which women artists sought to reach a much wider, untapped audience outside the exclusive, moneyed gallery structure. As Lippard expounded in 1976, these publications 'open up a way for women artists to get their work out without depending on the undependable museum and gallery system (still especially undependable for women). They also serve as an inexpensive vehicle for feminist ideas… The next step is to get the books out into supermarkets…I have this visual [*sic*] of feminist artists' books in school libraries (or being passed around under desks), in hair dressers, in gynecologists' waiting rooms, in Girl Scout Cookies.'[16]

Language-based works disseminated through the print became a potent vehicle for getting across the message. Jenny Holzer's *Inflammatory Essays* (cat. 148) from the late 1970s were cheaply printed by off-set on different colour sheets of paper for flyposting on public areas around New York City. Adopting the rigorous structuring devices she admired of Sol LeWitt and the minimalist Donald Judd, Holzer conceived each of her texts within a strict limit of 100 words arranged on twenty left-hand justified lines, all expressed in bold, italicized capitals for maximum impact and attention. But if the form owed a debt to these male artists the content certainly did not. Holzer's explosive tracts presented a babble of voices of America, from the psychotic language of the street – *DON'T TALK DOWN TO ME* – to the rantings of the American gun lobby: *YOU GET AMAZING SENSATIONS FROM GUNS…GUNS MAKE WRONG RIGHT FAST*. In recent years Holzer has used heavily redacted documents requested under the Freedom of Information Act (FOIA) to highlight the level of state paranoia after the terrorist atrocities of 9/11 in 2001. Even a requested FBI file on the polemical English novelist George Orwell (who died in 1950) was farcically reduced to dense blocks of abstract black (cat. 149) by the US government's Office of Personnel Management (OPM) invoking a frequently used exemption clause (Exemption 7C under FOI legislation) protecting information from disclosure where it 'could reasonably be expected to constitute an unwarranted invasion of personal privacy'.[17] Under this rubric, it would seem, the Freedom of Information Act, originally established as a piece of enlightened legislation, releases just enough information to satisfy a legal requirement but not enough to provide meaningful content or context.

The AIDS epidemic that swept America from the mid-1980s galvanized artists into making campaigning prints, posters, stickers and other readily distributable printed matter. The gay artists' collective General Idea (cat. 154), which formed in Toronto in the late 1960s before moving to New York in 1986, pointedly appropriated one of the most recognizable symbols of the 1960s peace and love generation, Robert Indiana's *LOVE*. They created their own *AIDS* device of similarly arranged letters for proliferation in various formats – prints, posters, wallpapers, postage stamps, etc. – with the aim of spreading the message like a virus through the body-politic of America. ACT UP, the direct-action group of the AIDS Coalition to Unleash Power, which was set up in 1987, engaged gay activist artists such as Keith Haring and David Wojnarowicz to produce a variety of printed matter attacking the Reagan administration for its silence over the AIDS crisis and for its failure to intervene in the big-business interests of the pharmaceutical giants whose high charges for the new AIDS drugs seemed to put profits before lives (cats 152 and 153).

African American artists have also turned to language and the print to explore questions of race and identity. An avid reader from childhood, Bronx-born Glenn Ligon took classics of American literature and investigated different perceptions of race, from the stereotype of laughing black people ('negro sunshine') in an early Gertrude Stein story to Ralph Ellison's groundbreaking 1952 novel *Invisible Man* where the quoted text literally becomes invisible through its dense black printing (cat. 184). Literature also provided the starting point of Fred Wilson's *Arise!* (fig. 6) and the related series of aquatint etchings in which black, growth-like blobs are accompanied by a litany of voices from famous black characters in literary works ranging from Shakespeare's *Othello* to Melville's *Moby-Dick* and Arthur Miller's *The Crucible*, all penned by white authors, often reinforcing stereotypes. Other artists, such as Kara Walker and Willie Cole, have turned to America's history of slavery to point to its legacy of enduring social and economic deprivation. Walker, who spent her teenage years growing up outside Atlanta in Stone Mountain, Georgia, where the Ku Klux Klan was re-founded during the First World War, has explored the abuses of the slave trade, plantation life and the Civil War in her large-scale prints and paper-cut silhouettes. Willie Cole's monumental woodcut *Stowage* (cat. 183) addresses slavery's legacy by taking the famous 18th-century diagram of a slave ship he first encountered in a school textbook and re-interpreting it as a giant ironing board, symbolic of generations of black domestic servitude.

Much has been made of an eclipse of the American Dream at the start of the new millennium, as the nation's great manufacturing might has

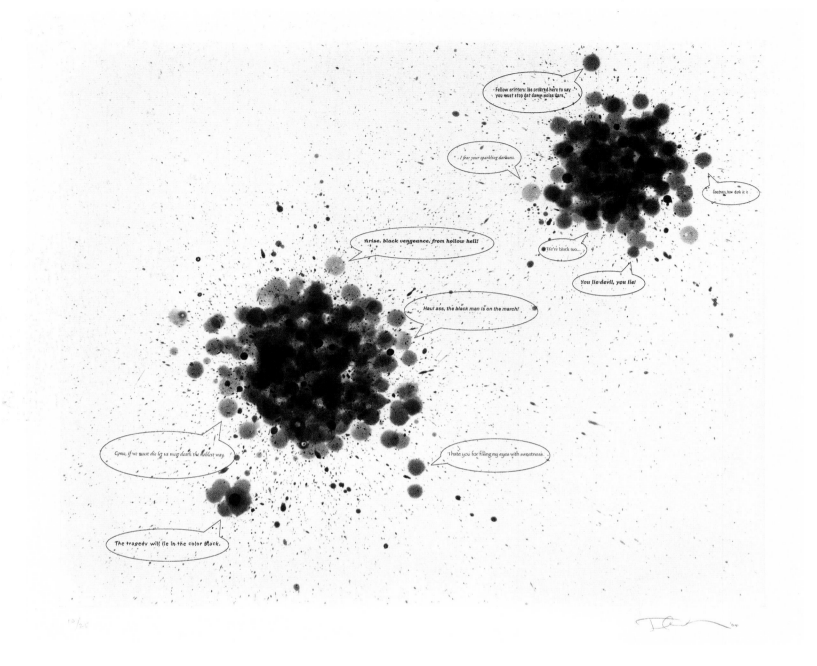

come into severe competition from the fast-growing economies of Asia, particularly of China and India. Middle-American incomes have stagnated, education has become unaffordable and class mobility (the essence of the Dream) has hardened. Ed Ruscha's ghostly gasoline station and his bullet-riddled rusty signs would seem to point to a dream that has faded or been shot through (cats 192, 193 and 194). Racial violence, gun crime, the terrorist attacks of 9/11, the 2003 war in Iraq, the financial collapse of 2008 have all contributed to an undermining of national pride and optimism. Yet despite the uncertainties of the contemporary world America remains a vital, creative place. The technological revolution centred in Silicon Valley has given rise to new empires – Google, Apple, Microsoft and Facebook – that have helped create an interconnected global world in which information and data are accessed, collected, shared, transmitted and

disseminated; whether this is all to the good, the dominance of American technology is a credit to the country's ingenuity, enterprise and chaotic energy. The Ethiopian-born American artist Julie Mehretu (cat. 195), in her compositions of swirling forces, eddying, changing direction and gathering new pace, articulates something of the extraordinary restless power and capacity for renewal that still epitomizes America.

OPPOSITE: Fig. 6 Fred Wilson, *Arise!*, 2004, spit-bite aquatint with direct gravure, 500 x 600 (19⅝ x 23⅝) plate, 775 x 864 (30½ x 34) sheet. Published by Crown Point Press. British Museum, London 2012,7078.4. Purchased with funds given by Hamish Parker

RIGHT: Fig. 7 Julie Mehretu working on her series of etchings *Algorithms/Apparitions/Translations* at the workshop of Burnet Editions, New York City, 2013

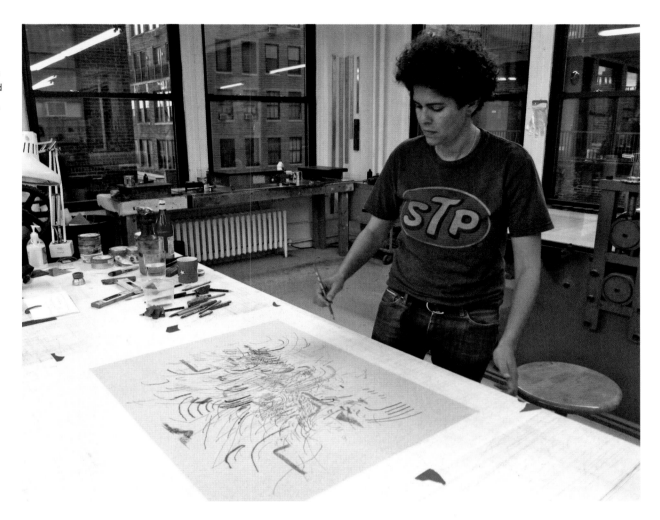

1. Andy Warhol, *America*, 1985; London: Penguin Books, 2011, p. 8.

2. Andy Warhol and Pat Hackett, *POPism: The Warhol Sixties*, 1980; London: Penguin Books, 2007, p. 28.

3. Jasper Johns, quoted in G. R. Swenson, 'What is Pop Art? Part II. Jasper Johns', *ARTnews*, 62:10 (February 1964), pp. 43, 66–67 (p. 43).

4. Robert Rauschenberg, 'Work Notes – 1962', quoted in Edward A. Foster, *Robert Rauschenberg: Prints 1948–1970*, exh. cat., Minneapolis: Minneapolis Institute of Arts, 1970, n.p.

5. Jim Dine, quoted by Klaus Albrecht Schröder, 'Jim Dine Self-Portraits', in Schröder and Antonia Hoerschelmann, *I Never Look Away. Jim Dine Self-Portraits*, Vienna: Albertina and Kehrer, 2016, p. 19.

6. For a full discussion of Rauschenberg's engagement with America's space exploration and the *Stoned Moon* project, see Robert S. Mattison, *Robert Rauschenberg: Breaking Boundaries*, New Haven and London: Yale University Press, 2003, pp. 105–65.

7. His collage of image and text is reproduced in Robert Rauschenberg, 'Notes on Stoned Moon', *Studio International*, 178:917 (December 1969), pp. 246–47 (p. 247).

8. Mattison, op. cit. [note 6], p. 154.

9. Warhol and Hackett, op. cit. [note 2], p. 50.

10. Ed Ruscha, cited in Calvin Tomkins, 'Ed Ruscha's L.A. An artist in the right place', *New Yorker*, 1 July 2013, pp. 48–57 (p. 53).

11. Ed Ruscha, in David Bourdon, 'Ruscha as Publisher (Or All Booked Up)', *ARTnews*, 71:2 (April 1972), pp. 32–36, 68–69; cited in Ed Ruscha, *Leave Any Information at the Signal: Writings, Interviews, Bits, Pages*, ed. Alexandra Schwartz, Cambridge, MA, and London: MIT Press, 2002, p. 41.

12. Ed Ruscha, in Bonnie Clearwater, 'An Interview with Ed Ruscha' (1989), in Ruscha, op. cit. [note 11], p. 291.

13. *L.A. Suggested by the Art of Edward Ruscha*, film, 28 min., produced and directed by Gary Conklin, Mystic Fire Video, 1981, transcribed in Ruscha, op. cit. [note 11], p. 221.

14. Lucy Lippard, in her 1996 essay, 'Escape Attempts', in the reissue of her sourcebook, *Six Years: The Dematerialization of the Art Object from 1966 to 1972*, 1973; Berkeley: University of California Press, 1997, p. xiii.

15. Sol LeWitt, 'Paragraphs on Conceptual Art', *Artforum*, 5:10 (Summer 1967), pp. 79–84, cited in Lippard, op. cit. [note 14], p. 28.

16. Lucy Lippard, untitled statement in artists' books issue of *Art-Rite*, 14 (Winter 1976–77), p. 10, cited in Gwen Allen, *Artists' Magazines: An Alternative Space for Art*, Cambridge, MA, and London: MIT Press, 2011, p. 139.

17. US Department of Justice, Freedom of Information ACT Guide, May 2004; www.justice.gov./oip/foia-guide-2004-edition-exemption-7

Irresistible: the rise of
the American print workshop
Susan Tallman

One of the most striking transformations in the history of American art is summed up in a painter's quip from 1972: it used to be, he said, that 'when you saw a friend on the Long Island Railroad on an early Wednesday morning, you knew he was going to town to see his shrink. Nowadays you know he's on his way to work with his lithographer.'[1] There are two striking implications here: first, that Freudian angst and the metaphysical mysteries of the subconscious had somehow been supplanted by a mechanical technology; and second, that the artist on the train did not intend to become a lithographer any more than he intended to become a psychoanalyst. The lithographer, like the shrink, was a consulting expert, there to identify and enable the artist's own desires and intentions.

The making of art had become a team event.[2]

Artists have not looked back. Whether eminent or emerging, artists today routinely work with printers, programmers, engineers, stonecutters, glass-blowers and dressmakers. Our notions of authorship have expanded to accommodate the idea that the artist's vision may be broader and more eclectic than the things her hand can shape. This shift is the product of a number of forces, but key among them is the triumph of a set of systems and values that arose in American print workshops fifty years ago.

In 1958 a young artist who had fallen in love with lithography wrote hopefully: 'A handful of creative people is all that is needed for a renaissance in an art to take place, if that handful comes together at the right time, in the right place.'[3] Mid-century America, however, showed few signs of being either.

New York was the centre of the art world because of painting – the vast canvasses of Jackson Pollock, Mark Rothko and others, with their visible struggle to wrest private truths from intransigent matter. American artists also made prints, but they were different artists. Both the printmakers and the painters had been profoundly affected by the British engraver Stanley William Hayter and his automatist method: moving the plate beneath the burin without explicit intent and responding to the unanticipated outcome (fig. 1). His Parisian workshop, Atelier 17, had been a gathering place for surrealists before the Second World War, and his New York atelier-in-exile drew both European refugees and the young Americans who revered them. Hayter taught these artists to experiment with their materials rather than dictate to them, and to wed themselves to one medium rather

than play the field. This close engagement with materials led to a new and expressive formal vocabulary – Pollock made engravings with Hayter in the mid-1940s that presage the tangled skeins of his drip paintings – but it could also lead to arcane technical elaboration. In America, some chose to follow Hayter's own methods and spread the gospel of expressive etching and engraving through the nation's rapidly expanding universities where printmaking was taught and practised. Others, like Pollock, took Hayter's lessons to heart, but gave up printmaking to apply them to paint and canvas. The paths of these two groups ran parallel, and thus never met.

In Europe it was different. School of Paris *peintres-graveurs* such as Marc Chagall and Joan Miró moved fluidly between the painting studio and the great lithographic ateliers of Mourlot or Desjobert, where gifted technicians would bring their images to completion. Some painters, notably Pablo Picasso and Jean Dubuffet, embraced printmaking as an experimental, hands-on activity and as a dialogue between artist and printer,[4] but others were content to let the workshop's *chromistes* work out the colours, the tonalities, even the lines. The American print world regarded such practices as craven, if not fraudulent. 'One of the distinguishing features of prints in the United States', the curator Una Johnson wrote in 1956, 'is that the majority of them are printed by the artist himself, and not by a professional craftsman-printer as is so often the case in France.'[5]

In truth, American *painters* didn't have the option. Etching, with its steep learning curve, was the province of specialists, and lithography – the most painter-friendly of traditional print media – was the province of almost no one. Lithography's great advantage for artists is that it uses familiar tools: brushes for broad gestures, pencils for shading, pen-and-ink for clean lines. But it is finicky. The chemical processing of the stone can easily go awry; an artist may work for days on a fine image only to see the first proof emerge as an unsalvageable black morass or a vacant ghost. And while there were a few places in the US where a determined artist might find a press and some assistance,[6] no American workshop could match the French for crumbles of charcoal, splatters of ink, or limpid washes. Nor were there American print publishers coaxing painters to leave their studios, nor any broader, compelling culture of the print. But there were 'a handful of creative people' who believed that American artists might make great prints if given the chance.

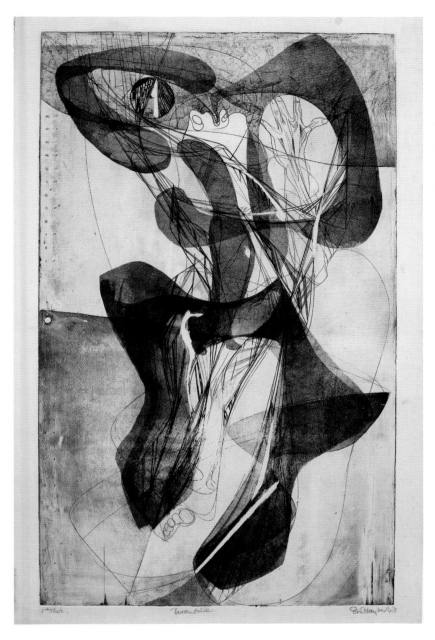

Universal Limited Art Editions

'Until 1955', Tatyana Grosman recalled, 'I just poured tea and I never spoke. I was a *femme d'artiste*…Great belief, great faith, great destiny. Everything would be glorious and fine.'[7] Grosman was a diminutive Siberian émigré married to an ailing painter, Maurice Grosman, and in sudden need of a livelihood. For Maurice's health they had moved to a cottage on Long Island, where, as luck would have it, she found two lithography stones being used as paving stones in the garden path.[8] She knew little about printing, but had a deep love of *livres d'artistes* that brought together the words of great poets and the prints of great artists. An old hand lithography press was bought from a neighbour for $15 and the printmaker Robert Blackburn was engaged to come out from the city and print in the Grosmans' living room.[9] In 1957 she began gently harassing young painters to make lithographs at the newly established Universal Limited Art Editions (ULAE) (fig. 2).

ABOVE, LEFT: Fig. 1 Stanley William Hayter, *Tarantelle*, 1943, engraving, scorper tool and soft-ground etching, 550 x 330 (21⅝ x 13). British Museum, London 1988,0409.92

ABOVE, RIGHT: Fig. 2 Jasper Johns working on page 8 from his print portfolio *0–9 (Black)*, 1963

It was not an easy sell. One of the first artists approached, Larry Rivers, spoke for many when he gave his view of printmaking as the 'dull occupation of pipe-smoking corduroy deep-type artisans'.[10] But if printmaking as a lifestyle had little cachet, certain attributes of print were intriguing to young painters. Jasper Johns had never made a lithograph, but his paintings of targets, flags, and other 'things the mind already knows' played with the conundrum of repetitive uniqueness that is at the heart of printmaking. On his first stone, Johns drew an array of ten numerals above a single, large zero. After the edition was printed,

he reworked the stone, transforming the zero into a one, around which traces of the earlier numeral hover like a nimbus.[11] The stone was editioned again, and again reworked as the one became a two, then a three, and on through all ten numerals. The resulting portfolio, *0–9* (1960–63), is visually intimate, epistemologically complex, and emotionally elusive. It is a masterpiece that took three years to complete (fig. 3).

Such languorous time frames were not unusual at ULAE. Grosman's reverence for the lithographic process bordered on mysticism: she preferred the entire stone to be printed, including its quarried edge, to show its integrity,[12] and she believed that the printer needed to 'be with' the stone spiritually as well as physically, and not only while developing the image, but also while printing the edition (early ULAE editions were often tiny as a result). As the curator William S. Lieberman observed, 'the commercial side of the operation, if indeed there is one, is incidental'.[13]

These indulgences were possible because ULAE was both printer and publisher. Most printers work for hire, with budgets and deadlines dictated by the client. By assuming all the financial risk, Grosman preserved control: she could pick her artists and give them free rein. At Mourlot, Picasso had scribbled away in a corner of the busy workshop; at ULAE, the entire studio (which moved from the Grosmans' living room to their garage) was given over to one artist at a time. The printer's job was to facilitate the artist's ideas, to recommend known techniques and to invent new ones as necessary. The artist's job was to make things that had never

been made before. The equipment was primitive and everyone was learning on the hoof, but Grosman's conviction was contagious – everything would be glorious and fine.

Tamarind Lithography Workshop

While Tatyana Grosman was pursuing painters, stones and paper in New York, June Wayne was making her case to the Ford Foundation that a handful of creative people could indeed resuscitate a moribund medium in Los Angeles. Wayne had recently returned from making lithographs in Paris with the master printer Marcel Durassier, and she had a compelling vision. The dearth of American ateliers, she saw, was only part of the problem. A self-sustaining culture of artists' prints required an infrastructure that stretched from trained printers to involved artists, educated curators, informed consumers, and a body of 'extraordinary prints'.[14] Wayne decried the 'dismal practice' of technicians making prints without the artist's direct hand;[15] like Grosman, she believed that great prints were the result of the creative interaction of artist, printer and process. But where ULAE was a small and private affair, Tamarind Lithography Workshop opened its doors in 1960 with the ambitions of a public institution.

Aspiring printers came on renewable fellowships, and artists were invited to generate editions and ensure that the printer-fellows learned to adapt to a variety of styles, personalities and demands (fig. 4). Historically, printers had guarded their tricks as professional arcana,[16] but at Tamarind every

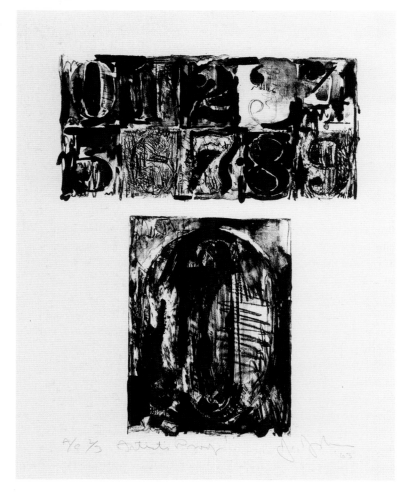

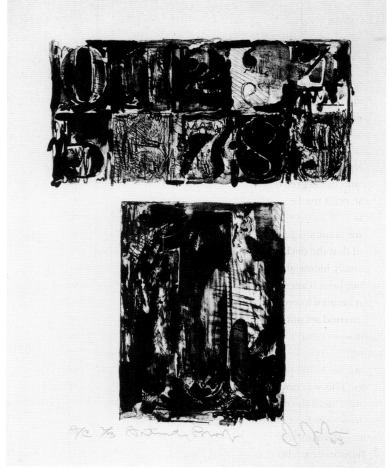

aspect of production, from chemical recipes to business plans, was considered, evaluated and published, culminating in the 1971 *Tamarind Book of Lithography: Art & Techniques*. Though ULAE was a business and Tamarind a not-for-profit institution, it was Wayne who understood the crucial role of consumer confidence in ensuring a market for (and consequently the further making of) artists' prints. Confusion over edition sizes and the degree of artist involvement had been a persistent problem for the print market. The limited edition and its fractional notation (edition size as the denominator, unique serial number as the numerator) had become standard practice in the 20th century, but it was not uncommon to find that the declared edition had been supplemented by a large number of visually identical proofs, also signed and numbered. Plates or stones that had not been 'cancelled' (purposely defaced) after an edition was printed might be used to create still more impressions.

Tamarind set out to right the ship through rules and transparency: all artists were required to draw their own stones, and protocols were set up to record the materials used and persons involved, the printing sequences, the disposition of the printing templates, and the number and allocation of proofs. This was novel: even at ULAE, 'there were no systematic curatorial records…until the mid 1960s'.[17] While most of the dictates on working methods were later abandoned as too rigid, Tamarind's guidelines for documentation remain the standard worldwide.

The workshop also adopted the practice, initiated in the 19th century by the Printsellers' Association in Britain, of marking each print with embossed blind stamps ('chops') in the corner. Tamarind prints bear both the workshop logo and the chop of the individual printer who aided the artist in developing the image.[18] The collaborative nature of the print was not a secret – it was celebrated on the print's surface.

Crown Point Press

Grosman and Wayne were smitten with stone lithography, but for Kathan Brown, the revelatory medium was etching – not the densely emotive intaglio of American academic printmakers such as Gabor Peterdi and Mauricio Lasansky, but the dry, clean discipline she learned as an exchange student in London at the Central School of Arts and Crafts in the late 1950s.[19] On a last holiday before returning to the US, Brown happened upon an abandoned press in an Edinburgh back garden; she cashed in her plane ticket and booked passage for herself and the press on a cargo ship bound for San Francisco.[20]

Crown Point Press was initially run by Brown and Jeryl Parker on the model of Birgit Skiöld's London workshop, where artists paid a small fee and worked together in a shared space.[21] Among the artists to take advantage of this local facility was Richard Diebenkorn, one of the great American painters of his generation. After making a few lithographs at Tamarind, he had taken up drypoint because the technique's physical resistance thwarted his painterly hand and forced him to seek out the bones

of the thing. Diebenkorn's images always danced a quiet tango between abstraction and representation: the balance might shift this way or that, but any given work would reveal both locked in a close embrace, mutually seductive and mutually resistant. He saw that the indirections and reversals of printmaking constituted a way of thinking. 'We should be doing something, not making something', he told Brown.[22] She recognized the value of the advice, but also saw that many of the plates he carried around in his pockets were great images; she began to print and publish his editions (fig. 5).

For Grosman, Wayne and Brown, printing was not a trade but a calling. Inexperienced in the printshop business, they benefited from what Wayne called 'the advantage of a short tradition'.[23] They aimed to replicate what they admired about European exemplars (mainly technical mastery of surfaces), but were largely free of the orthodoxies, the strict divisions of labour and the machismo that characterized daily operations in many European shops. (As late as the 1980s an aspiring female art lithographer in Paris was told, 'In my kitchen perhaps; in my bed anytime; in my workshop never.')[24] Their goal was to build milieus that fostered creative exchanges between artist and printer. The Tamarind-trained lithographer Irwin Hollander (fig. 6), who almost single-handedly turned Robert Motherwell into a dedicated printmaker, described collaboration as 'a kind of cat's cradle. One thing leads to another.'[25] Brown dislikes the word 'collaboration', but has written movingly about the reciprocity of inspiration, technique, innovation and learning that create magic in the printshop.[26] From the outside, the critic John Russell observed, 'What the master printer had to offer was not printmaking in the old sense: it was printmaking as metamorphosis, and it was irresistible.'[27]

It was a working method whose time had come. As reflected by new forms such as Happenings and the indeterminate compositions of John Cage, artists were now drawn to strategies for *relinquishing* personal control. For Robert Rauschenberg lithography offered a surface for fusing found images and personal gestures, as well as a working situation in which control was distributed between multiple people, objects and circumstances. His print *Accident* (cat. 44) offers dramatic evidence of this reality. Working on a large stone in 1963, Rauschenberg created a complicated melange of action photographs (clipped from magazines and newspapers), overtaken by splashes, erasures and scribbles, but as the stone passed through the press, it broke. He remade the composition on a new stone, but when this one also broke, he chose to print from the wreckage, casting the fatal fissure as a bright rivulet through churning darkness. Using a further stone, he added a pile of stone chips to the bottom of the image. *Accident* is, literally, an exercise in picking up the pieces.

It is possible that in a more experienced atelier those two stones would not have broken; it is all but certain that more traditional printers would have refused to print from them if they had. *Accident* took the Grand Prize at the Fifth International Exhibition of Prints in Ljubljana – the first time an American had won the event – prompting a special press release from the Museum of Modern Art.[28] *Accident* made ULAE famous and announced the arrival of a new entity – the adventurous American print.

Gemini G.E.L.

'By 1964,' printer Ken Tyler wrote, 'it had become clear to me that most traditional methods, as well as some recent practices of the hand-printing crafts, were not compatible with the images of major

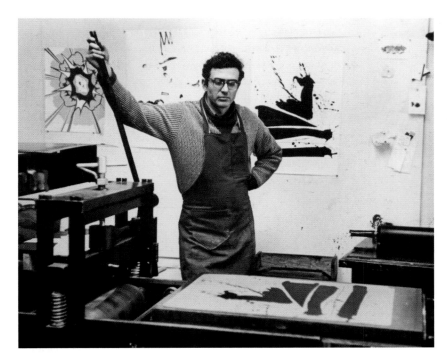

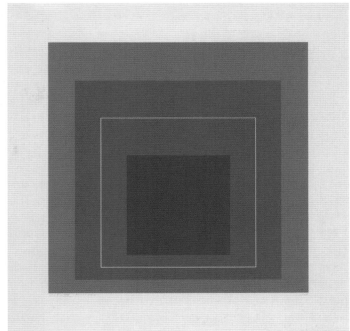

contemporary artists.'[29] Tyler had trained at Tamarind, where he rose to become technical director, and had witnessed numerous conflicts between artists and Tamarind's sometimes rigid rules for the 'original print'. Bruce Conner had set off a furore at Tamarind with his desire to print from a cancelled stone (he had cancelled it in order to print from it) and to 'sign' his editions with a thumbprint.

Tamarind was not alone in feeling the need to monitor the parameters of the 'original print'. In 1961 the Print Council of America, an organization of the nation's most eminent scholars and curators in the field, published a widely read definition that limited the term to works for which 'the artist alone has made the image in or upon the plate, stone, wood block or other material',[30] and also instituted a Dealer Certification Program for print vendors who pledged to abide by these standards.[31] These strictures, while well meaning, were out of step with the interests and working methods of an increasing number of important artists. Drawing on the stone by hand, for example, was an irrelevant requirement for the Bauhaus veteran Josef Albers, whose compositions of chromatically specific nested squares required the perfect consistency of a machine, along with the patience and precision of a master craftsman. For Albers, Tyler was the man, and for Tyler, Albers was 'the catalyst of my career'.[32]

When Tyler co-founded Gemini G.E.L. in Los Angeles in 1966 with two aspiring print publishers, Sidney Felsen and Stanley Grinstein, Albers' *White Line Squares* (1966–67) was their first major project (fig. 7). A printerly *tour de force*, the series secured Tyler's reputation as a technical wizard while provocatively defying the prime directive of the original print – the artist's physical involvement. The templates were fabricated by Tyler to Albers' specifications; instructions were exchanged by post and decisions were made over the phone. In one sense, Tyler was acting much like the French *chromistes*, but with the critical difference that Albers' prints did not *pretend* to manifest the artist's hand, and Gemini's detailed documentation made these facts known to all. The ethical quandaries surrounding the word

'original' were thus resolved through transparency, leaving artist and printer free to flirt with any production process they liked.

Tyler's approach aligned with the attitudes of many younger artists. As the tormented angst of expressionism gave way to the deceptive insouciance of pop, the look and function of commerce had become an active subject of art. Roy Lichtenstein and Andy Warhol were less concerned with how print might echo paint than how paint and canvas could imitate print. This would later come full circle when the painted artefacts of print were translated back into lithography and screenprint, as in Warhol's *Electric Chair* (cat. 2) print portfolio from 1971, which elaborates – in ten jarringly decorative colour variants – an image he first used in a series of screenprinted paintings in 1963, itself a grainy derivative of a press photo of the death chamber at Sing Sing Prison in Ossining, New York. Meanwhile, one of the most influential works of the decade was Ed Ruscha's *Twentysix Gasoline Stations* (cat. 55) – a small paperback printed by cheap, commercial photo-offset lithography. These were artists who wanted to make art that, in the words of Claes Oldenburg, did 'something other than sit on its ass in a museum'.[33]

Defenders of the 'original print' struggled to maintain a clear division between commercial and artistic processes, but it was a losing battle. In 1962, Andy Warhol and Robert Rauschenberg began using commercially prepared screens to transfer photographic images to their paintings. Soon after, young print publishers such as Rosa Esman (Original Editions, Tanglewood Press) and Marian Goodman (Multiples, Inc.) began commissioning print portfolios and 'multiples'[34] from commercial fabricators and screenprinters.[35] In New Haven, Albers protégés Norman Ives and Sewell Sillman fastidiously oversaw the production of publications at a commercial shop, Sirocco Screenprints. The *Ten Works by Ten Painters* portfolio (1964) made there included Warhol's *Birmingham Race Riot* (cat. 177), appropriated from a news photo in *Life* magazine.

Though screenprint had been promoted as an artistic medium in the 1930s and 1940s, its primary use was industrial, and in the hierarchy of

artistic print media, it occupied the bottom rung. (Intaglio was always the artiest, while lithography, being more difficult to get right, had bragging rights for printers.) In Britain, Christopher Prater's workshop, Kelpra Studio, developed a dynamic, collaborative practice that made screenprint the critical medium of British pop art, but in the US, with rare exceptions, printing screens were created entirely by technicians from designs supplied by the artists.[36] There was no Tamarind of screenprint – printers learned on the job or taught themselves. Adolph Rischner, who printed for Gemini before founding Styria Studio, perfected his skills in the aerospace industry; Steve Poleskie of Chiron Press says he learned from a booklet published by the Sherwin-Williams paint-store chain. Pop screenprints were successful because they relied on the qualities that commercial printers provided as a matter of course.

Tyler was a sublimely gifted lithographer, but he recognized that artists were not beholden to any one process. To accommodate his artists he designed and built hydraulic presses,[37] worked with manufacturers to improve the range and performance of papers,[38] and established a network of outside expertise that stretched from screenprinters (he tried unsuccessfully to lure Prater to Los Angeles),[39] to industrial moulding and embossing firms, to the dentist who made gold teeth for Jasper Johns' lead relief *The Critic Smiles* (1969). While most European print studios remained entrenched in the arts and crafts tradition, with its emphasis on antiquated hand labour, American workshops were willing to harness commercial innovations and marketing strategies to further the purposes of art. This was particularly true in Los Angeles, which Oldenburg described as 'a sort of paradise of technology'.[40] At Gemini, Rauschenberg expanded the physical scale of lithography still further in his *Stoned Moon* series (1969–70) (cats 26–31),

whose title connected America's psychedelic moment to its most impressive technological achievement, the momentous Apollo 11 space mission, whose launch he had observed at the invitation of NASA (fig. 8). More radically, he expanded the physical identity of the print with the refabricated cardboard constructions of his 1970–71 series *Cardbirds* (one of which was a working door) (cats 46 and 47), and his *Hoarfrost Editions* (1974) (cat. 48), whose diaphanous silks and satins were amended with offset lithography, screenprinting, collage and solvent transfers. To make *Profile Airflow* (1969) (cat. 49), Oldenburg spent a year carving a relief mould of the streamlined 1936 Chrysler Airflow sedan, while Tyler researched polyurethanes that met Oldenburg's desire for a material that 'would be firm but appear soft, be solid but appear fluid, be rigid but flexible enough to give when pressed'.[41] Translucent, green and weirdly organic to the touch, the 1.7-metre long relief was backed with an equally huge lithographic grid, and both were joined in a welded aluminium frame (fig. 9).

The collaborating printer was now a creative systems engineer.

As Tamarind-trained printers dispersed across the country, most emulated Gemini's gleeful bravado, if not its grandiose scale. In Los Angeles, Jean Milant's Cirrus Editions (founded 1970) produced smart, sleek editions, including two *Hollywood* images that Ruscha had screenprinted with Pepto-Bismol, caviar, jam and the weight-loss drink Metrecal in place of traditional printing ink. (Ruscha also used a supermarket trolley of ingredients to print *News, Mews, Pews, Brews, Stews & Dues* (cat. 64) in London in 1970.) In Chicago, Jack Lemon's Landfall Press, founded 1970, was equally unflinching in its approach to the medium. Graphicstudio was established at the University of South Florida in 1968 as a professional

Fig. 8 Robert Rauschenberg and printers producing *Stoned Moon* series at Gemini G.E.L., Los Angeles, 1969

print facility set within an academic research institution, a model that later spread across the country.[42] Beginning as a lithography workshop, it quickly developed expertise in three-dimensional fabrication and other novel technologies. And while Tamarind stuck to lithography, ULAE added an etching shop and relief printing options.

Cirrus, Landfall and Graphicstudio all published their productions, but many printers depended on the custom of print publishers, whose ranks swelled in tandem with the booming art market. Print publisher Brooke Alexander encouraged artists such as Sol LeWitt and Edda Renouf to work with Kathan Brown at Crown Point; Multiples, Inc. organized influential thematic portfolios, such as *Artists & Photographs* (1970), and later played matchmaker between the New York intaglio workshop Aeropress and artists such as Claes Oldenburg, Jennifer Bartlett and Richard Artschwager. Pace Gallery established its own print division in 1968 and recruited talented printers such as Joe Wilfer and, briefly, Picasso's etcher, Aldo Crommelynck to make prints with the gallery's artists. The British print publishers Editions Alecto and Petersburg Press worked with a transatlantic roster of artists and printers: David Hockney and Jim Dine; British etcher Maurice Payne (immortalized by Hockney) and American lithographers Bud Shark, Judith Solodkin and Maurice Sánchez, the last of whom spent four years working with the artist James Rosenquist on adaptations of his gargantuan paintings, such as *F-111* (cat. 4).[43]

In perhaps the clearest indication of American print ascendancy, the eminent French lithography workshop Mourlot opened a New York outpost in 1968. It lasted barely five years – the French printers were unhappy and American artists now had a wealth of alternatives. But Mourlot's great 19th-century presses stayed on, acquired by Styria Studio.

The print boom

By 1970 the print and its collaborative workshop were such pre-eminently American forms that the US Pavilion at the Venice Biennale was conceived as a print exhibition with participatory workshops in lithography and screenprint.[44] A *Life* magazine article that year cheered the 'skyrocketing' print market and the excitement that had touched 'every traditional printmaking process'.[45] Virtually every major American artist was making graphic work and some, including Ed Ruscha and Jim Dine, had temporarily stopped doing anything else.

When, in 1971, the Museum of Modern Art, New York, mounted a major exhibition, 'Technics and Creativity: Gemini G.E.L.', it was clear that the artist's print – and the artist's printer – had arrived at centre stage. In *Time* magazine, the critic Robert Hughes singled out Tyler as having 'driven the craft of printmaking beyond all its assumed limits'.[46] But other reactions to the MoMA show were muted, even hostile. The *New York Times* critic David L. Shirey detected a 'thick ether of staleness' and waxed romantic about artists who 'don't possess the spirit to collaborate' and 'must have their own work at their fingertips all the time'.[47]

Some of the animus probably reflected prejudice against art made in multiple and/or on the West Coast. (Hilton Kramer did not wait to see the show before pronouncing, 'this is an enterprise strictly circumscribed by an interest in highly saleable commodities'.)[48] It also, however, signalled a changing *Zeitgeist*. The sunny 'can-do' attitude of post-war America was a cliché, but it was indicative of economic and social realities that helped nurture those early sanguine print ventures. This mood unravelled with the decade's violent end – the escalation of the war in Vietnam, mass student protests, urban riots and police crackdowns – which politicized many

Fig. 9 Stack of moulded polyurethane reliefs for Claes Oldenburg's *Profile Airflow*, Gemini G.E.L., Los Angeles, 1968

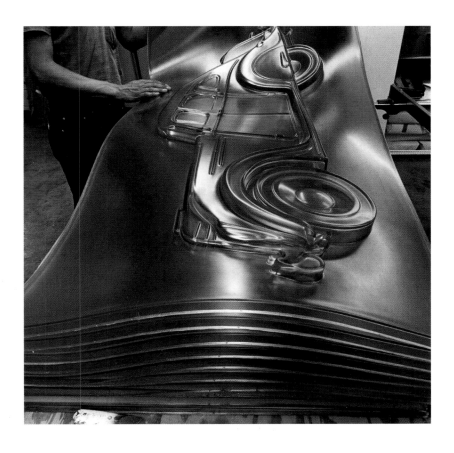

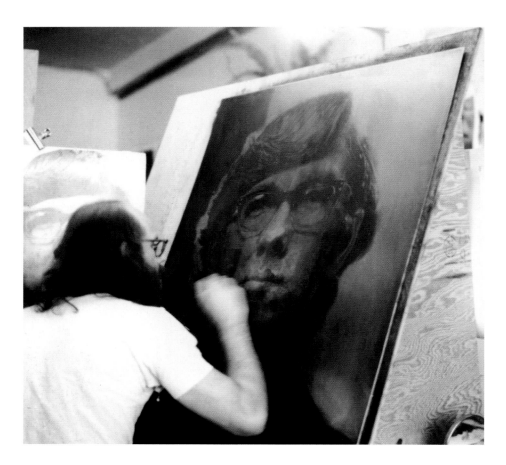

artists. Those cool industrial surfaces, which once signified positive engagement with the real world, were now perceived as by-products of a military-industrial complex trafficking in death. In a 1971 conversation with curator Richard S. Field, Andy Warhol acknowledged that even he felt he had exhausted the machine-made look.[49]

Had American workshops developed as strict domains of lithography, they might have fallen into irrelevance, but the resilient cat's cradle of collaboration simply tugged them in new directions. While pop artists had gravitated towards surfaces that mimicked mass-market production, the minimalist, conceptualist and photorealist artists who took to printmaking in the 1970s were far more concerned with physical presence – the tangible evidence that links image to object, and process to outcome. At the same time, feminist critique had begun to question the hierarchy that placed 'art' above 'craft', sparking interest in previously disdained subjects, methods and identities. The spectrum of materials and approaches to making was stretched at both ends: artworks became bigger *and* smaller; they utilized photocopiers *and* pre-industrial technologies; they were ordered over the phone *and* coloured in by hand.

Etching, unexpectedly, emerged as an important vehicle for conceptual and minimalist concerns, largely through the partnership of Crown Point Press in Oakland, California, and publisher Robert Feldman of Parasol Press in New York. The lure was not the medium's vaunted expressive immediacy, but its specific material rigour. Intaglio prints are more dimensional than lithographs or screenprints: the pressure of the press embosses a plate mark around the edge of the image and smooths the paper within, leaving the matt ink slightly raised and telling the tale of the print's making. These qualities appealed to artists concerned with close looking and analytic thinking, though what they chose to do with them was frequently technically unprecedented.[50] Chuck Close arrived at Crown Point with the intention of making a mezzotint – a tonal intaglio method popular in the 18th century for portrait prints. He thought, correctly, that mezzotint could capture the photographic gradient of his enormous photorealist portrait paintings, but neither he nor Kathan Brown had ever made one, and nobody had ever made one 1.2 metres high. Mezzotint is particularly labour-intensive: the entire plate is roughened to print black at the start, and the artist 'draws' by burnishing the metal to different grades of smoothness, pulling light from the darkness. Working from a gridded photograph of his friend Keith Hollingworth, Close spent two months burnishing the plate, one small square at a time, pore-by-pore and hair-by-hair (fig. 10). Since neither he nor the printers were familiar with the process, it was necessary to print the plate periodically to check progress, and under those repeated passes through the press at 1,000 pounds of pressure per square inch, the earliest-worked sections of the image wore down so they printed lighter than subsequent sections. In his paintings, Close had always been at pains to conceal his working grid; now it stood revealed. For Close, *Keith* (1972) (cat. 114) was a transformative disaster – the trenchant tension between the part and the whole changed the direction of his work: 'I started doing dot drawings and other pieces in which the incremental unit was visible and ultimately celebrated in a million different ways. That all came from making this print.'[51]

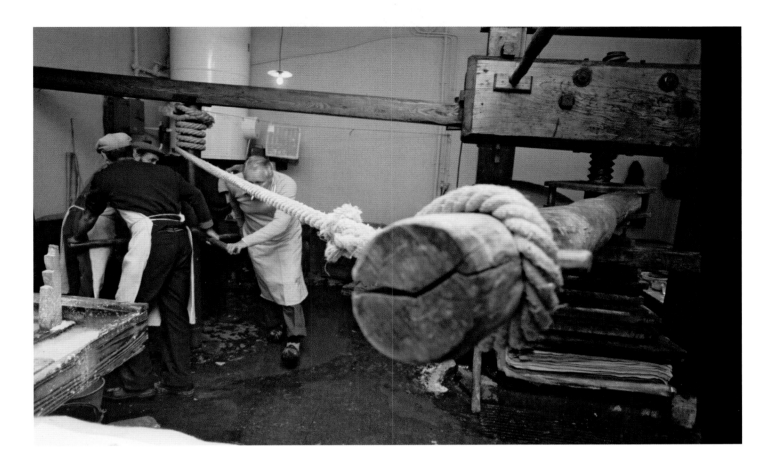

Woodcut, the most venerable of print techniques, also enjoyed a surprising revival in this period, though again not as an expressive, hands-on instrument of specialist printmakers. The prints Helen Frankenthaler started making at ULAE in 1972 ignored the linear black-and-white of Western woodcut, and drew instead on the shaped colour blocks of Asian print traditions. For *Savage Breeze* (1974) (cat. 91), she cut plywood sheets with a jigsaw, articulating fields of colour through which wood grain shivers like wind. Revealing the simple truth that relief prints could be pulled from all kinds of surfaces that can be divided or manipulated in all kinds of ways, Frankenthaler's prints opened up new vistas of print production. In 1982 Crown Point began a twelve-year-long publishing programme that paired contemporary artists with Japanese woodblock masters; this again sparked concerns over the distance between artist and printer, but also extended the perceived possibilities of woodcut in lasting ways.[52]

Even screenprint unfolded with new complexity. The arrival of the Japanese Simca Print Artists in New York in 1973 provided American artists with a new group of master craftsmen and a novel opportunity to be directly involved in screenprint production. For his exquisite 'crosshatch' works, Jasper Johns painted directly on multiple screens, roughly repeating the same marks, which were printed atop one another with translucent inks. This doubling transformed the familiar, snappy edge of screenprint into little cascades of doubt and reconsideration – a quality that Johns mused, 'might properly be considered an abuse of the medium'.[53]

Meanwhile, lithography – the medium that kicked off the whole game – struggled to loosen up. Tamarind's drive to codify best practices had guaranteed the efficient dissemination of knowledge, but it was out of step with the spontaneity many artists and printers now craved. In Parisian shops, American master printer Erika Schneider recalls, printers tasted 'the lithographic etch on the tip of our tongues…We used our senses and intuition while in the US they were using litmus paper.'[54] More problematically, some felt that the pressure to do things right could hamper a printer's willingness to do things unknown. 'Accidents,' Maurice Sánchez noted, 'were *not* the Tamarind way.'[55] Sánchez at his Derrière L'Etoile Studios and Judith Solodkin at SOLO Impression (both in New York) were among those who broke away from their strict training with purposeful playfulness and irreverence. Robert Kushner recalls Solodkin mixing lithographic tusche (the greasy ink used to mark the stone) with Fresca soda to produce starburst effects;[56] Sánchez developed new techniques of monotype – prints made by free drawing on a template, where artists could improvise without restriction.

Paperworks

The oldest medium to be revived was paper itself. In 1973 Ken Tyler and Robert Rauschenberg spent several days at the 15th-century Richard de Bas paper mill at Ambert in the Auvergne, France, making prototypes for shaped-paper editions (fig. 11). Rauschenberg's *Cardbird* constructions made with Tyler at Gemini in 1971 had drawn his attention to the substrate – the surface that gets printed on – normally considered a tabula rasa, but potentially a world of meaning unto itself. His Richard de Bas shaped-paper pieces, *Pages* and *Fuses* (1973) (cats 51 and 52), were funky and organic in character, and might seem the epitome of the craft-romanticism that Tyler so despised. But their radical unity of image and

object was compelling, and for many artists and printers they were a revelation. Few Americans at the time had any experience of artistic papermaking, but once again a handful of creative people emerged at a critical juncture to transform an obscure craft into a vital contemporary medium.[57] At the International Institute of Experimental Printmaking in California, Garner Tullis guided artists as they played with pulp; and at Dieu Donné paper mill in New York, Joe Wilfer and Chuck Close pressed dozens of shades of grey pulp through a plastic grid to make faces that were palpable and cerebral in equal measure. One of the most talented printers of his generation, Wilfer died prematurely and his loss was deeply felt by many artists, including Close, whose encomium focused not on perfection, but on resilience: 'There was never a mistake so big or an accident so great that he couldn't use it somehow.'[58]

Handmade did not mean homespun. When Tyler moved to the East Coast to found Tyler Graphics in Westchester County, north of New York City, in 1974, he brought together lithography, screenprint, etching, woodcut, papermaking and more on an extraordinary scale. Ellsworth Kelly's twenty-three *Colored Paper Images* (1976) were experiments in colour as material – paper pulp, powdered pigments, vinyl paints, dyes, mordants, moulds and presses (cat. 97). The monumental *Paper Pools* that David Hockney made in 1978 exploited the chromatic saturation and compelling physical substance of paper pulp, viscerally capturing the mutability and the weight of water (fig. 12). But it was Frank Stella whose relentless curiosity and technical ambition most closely mirrored Tyler's. Together they pursued 1.8-metre rafts of custom paper, laser-cut woodblocks and magnesium templates. *The Fountain* (1992) may be the most extravagant print ever made: 3 metres long, it is built from 67 colours, 7 screens, 3 woodblocks, and an unbelievable 105 intaglio plates. Predictably, Tyler was denounced for distorting the print's traditionally modest, democratic character. But his position had been clear from the start: he wasn't concerned with prints; he was concerned with art, and, as he had told *Life* magazine in 1970, 'art is autocratic, not democratic'.[59]

In truth, of course, art can be both. Tyler's ebullience represented one end of the spectrum, but by the 1980s and 1990s, collaborative print production in America had grown to comprise hundreds of workshops of every size and type. The 'big box' workshops like Gemini were balanced by small operations like that of the hugely influential solo printer Chip Elwell (1940–1986), whose short career largely defined the sophisticated-savage look of New York neo-expressionism. Jenny Holzer was mass-producing her *Truisms* by cheap photo-offset and flyposting them around New York at the same time that Aeropress, run by Patricia Branstead, brought the virtuosic, large-scale intaglio of Crown Point to New York with projects such as Claes Oldenburg's monumental *Screwarch Bridge* (1980) (cat. 7).[60] Beginning in 1979, Leslie Miller's Grenfell Press on West 29th Street has produced a steady stream of distinguished books and prints, including Vija Celmins's quietly spectacular woodcuts of night skies and ocean expanses. On the Lower East Side, Harlan & Weaver have worked exclusively in etching, forging close, long-term relationships with a small number of artists, including Kiki Smith and Louise Bourgeois. Meanwhile, Two Palms Press, a few blocks away, has incorporated screenprint, etching, lithography and a Tylerish industrial panache in the form of a massive rubber-moulding press. The emphatic physical relief it creates has been

used to dramatic effect in the word pieces of Mel Bochner, who once observed, 'there is no art that does not bear some burden of physicality'.[61] In Los Angeles, the Mixografia Workshop employs a proprietary method of casting and printing paper to produce editions that are as much sculptural artefacts as printed images, including Ed Ruscha's series of battered elegies to the American dream, *Rusty Signs* (cats 192 and 193).

There are private ventures, and public ones. The Lower East Side Printshop, for example, offers classes and studio time in addition to a professional printing and publishing programme.[62] Several universities now sport professional shops on the Graphicstudio model, including the LeRoy Neiman Center at Columbia.[63]

Given their pedagogic purview, public and academic shops usually accommodate a broad range of technologies – at a minimum, etching, lithography, screenprint and relief – and most consider free-wheeling experimentalism an essential part of their mission. These days the majority of workshops, however, are modest, technically specialized operations. Tamarind's first technical director, Garo Antreasian, notes that in the 1960s the small, 'personal service' printshop 'was considered both inefficient and uneconomical'.[64] Now it is the norm. This may reflect socio-economic shifts (real-estate costs and a booming high-end art market), the ease of outsourcing in a networked age, or simply the temperamental preferences of artists now broadly experienced in print media. Jasper Johns, Jim Dine and Ed Ruscha are among the eminent artists who maintain private arrangements with their favourite printers.[65]

Digital printmaking

The past few decades have seen some new technical developments: the notoriously difficult and seductive intaglio technique of photogravure was successfully revived, and a number of other 19th-century photomechanical techniques have followed suit.[66] Digital technologies of image manipulation and pigment printing have been broadly incorporated into more ancient forms but, despite the usual fearmongering, have in no way supplanted them. Software is used to clean up and manipulate photographic imagery and to proof 'virtually' colour and composition options. Many shops have large-scale pigment printers, which are frequently employed to supply elements for larger, more complex works. CAD systems for cutting wood and engraving metal templates have been in use for decades. All this differs, of course, from a straight digital reproduction of a pre-existing image, just as a photo-offset reproduction of a painting differs from Jasper Johns' creative use of offset in *Decoy* (1971).

The American print workshop today

The American collaborative printshop remains vital to contemporary art production. Gemini just celebrated its fiftieth anniversary under the directorship of co-founder Sidney Felsen,[67] and Crown Point still prints and publishes under the guidance of Kathan Brown. Since Tatyana Grosman's death in 1982, ULAE has been run by Bill Goldston, who joined the organization in 1969 as an apprentice printer. Tamarind, now under the aegis of the University of New Mexico, continues to print, publish, and train lithographers.[68]

But the 'American collaborative printshop' is no longer so notably American. Similarly structured shops can be found from Canada to Korea and from South Africa to Australia. American artists work with Niels Borch Jensen in

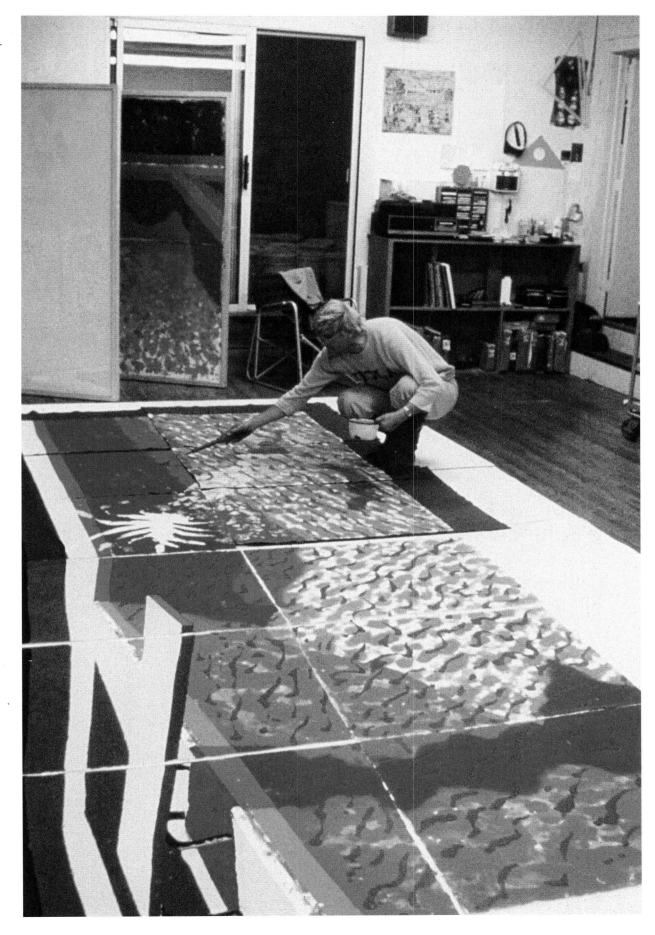

Fig. 12 David Hockney applying colour pulp with a turkey baster to *Le plongeur* while looking at *A Diver*, from his *Paper Pools* series, Tyler Graphics Ltd, Bedford Village, New York, 1978

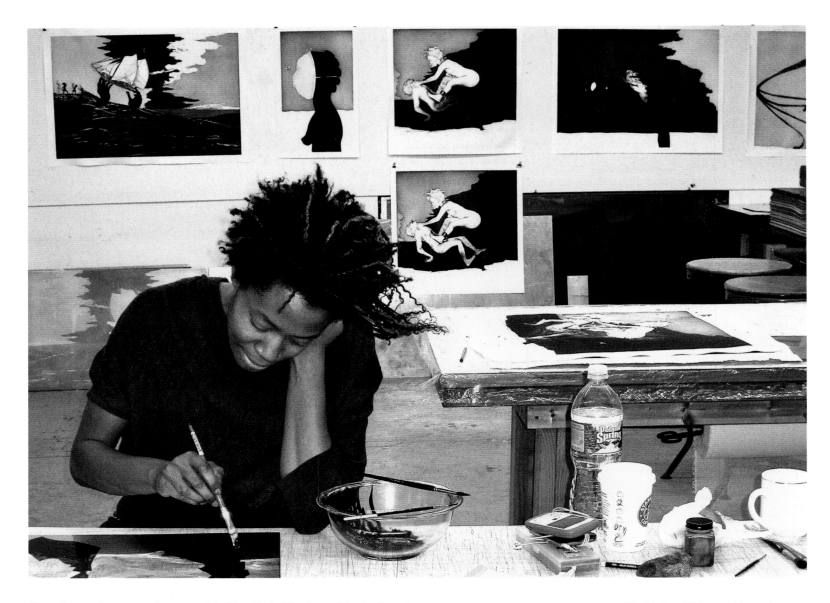

Fig. 13 Kara Walker working on her etchings *An Unpeopled Land in Uncharted Waters* at the workshop of Burnet Editions, New York City, 2010

Copenhagen, Japanese printers work in New York. The Santa Monica-based printer Jacob Samuel devised a portable etching workshop that fits into two carry-on suitcases with which he flew to artists' studios around the world. The Australian Greg Burnet has made some of the new century's most gripping etchings in New York with Julie Mehretu, Glenn Ligon and Kara Walker (fig. 13). When Ken Tyler retired in 2000, his equipment and operations relocated to the Tyler Print Institute in Singapore.

Robert Rauschenberg believed that 'two people having good ideas can produce more together than two people with good ideas can produce working separately'.[69] Art historian Leo Steinberg dubbed Rauschenberg's great contribution to postmodern art the 'flatbed picture plane' – a press bed 'on which objects are scattered, on which data is entered, on which information may be received, printed, impressed – whether coherently or in confusion'.[70] The flatbed was a pictorial solution to a new reality – a world perceived not as a coherent realm of things, but as an omnium-gatherum of information. But the flatbed is also, importantly, a shared space where multiple hands and eyes intervene, where multiple ideas play tag and propel things forward. It is a place where stones break and things go wrong and sometimes someone is able to reach into the abyss and rescue something.

1. Thomas B. Hess, 'Prints: Where History, Style and Money Meet', *ARTnews*, 70:9 (January 1972), pp. 29, 66–67 (p. 29).

2. Or, more accurately, art had *returned* to the team-based workshop model that had characterized Western art production from the time of Raphael to the 19th century.

3. June Wayne, 'Proposal for the Planning and Development for the Tamarind Workshop, Inc.', July 1959, p. 25. Ford Foundation Archives, Report No. 60-119.

4. The printers who worked most experimentally with Picasso and Dubuffet – Aldo Crommelynck and Serge Lozingot, respectively – also had great success with American artists in subsequent decades. Examples include Crommelynck's collaborations with Jasper Johns (cats 23 and 24) and Jim Dine, and Lozingot's projects with Philip Guston (cats 134 and 135) and Bruce Nauman (cats 71 and 72).

5. Una Johnson, *Ten Years of American Prints 1947–1956*, Brooklyn: The Brooklyn Museum, 1956. Quoted in Barry Walker, 'The Brooklyn Museum's National Print Exhibitions', Tamarind Papers, 13 (1990), p. 43.

6. Most notably Pratt Graphics Center (originally the Contemporary Graphics Art Center) founded in 1955 by Margaret Lowengrund (1902–1957).

7. Grosman, in Amei Wallach, 'Tatyana Grosman: A Memoir', in Esther Sparks, ed., *Universal Limited Art Editions: A History and Catalogue: The First Twenty-Five Years*, Chicago: The Art Institute of Chicago, 1989, pp. 9–15 (p. 9).

8. Lithography, invented at the end of the 18th century, originally used slabs of Bavarian limestone as printing surfaces; when commercial printers switched to metal plates the discarded stones were used for all sorts of purposes.

9. Blackburn (1920–2003) had learned lithography at the Harlem Community Arts Center sponsored by the Works Progress Administration (WPA) set up as part of the New Deal during the Great Depression. In 1948 he founded the open-access Printmaking Workshop where, in addition to his own work, he did occasional collaborative projects with artists, including Will Barnet and Philip Pearlstein. Blackburn printed for ULAE from 1957 to 1963, when Zigmunds Priede took over.

10. Larry Rivers, 'Life Among the Stones', *Location*, 1 (Spring 1963), p. 93. Quoted in Elizabeth Armstrong, *First Impressions*, Minneapolis: Walker Art Center, 1989, p. 11.

11. There are actually three editions of each state of the stone: one inked in black, one in grey, and one in a different colour for each numeral.

12. This practice is frowned upon by most professional printers because it puts damaging pressure on the edge of the stone when it is run through the press and may destroy the press's scraper bar. I am indebted to Thomas Cvikota for his insights into lithographic processes.

13. Lieberman in Calvin Tomkins, *The Scene: Reports on Post-Modern Art*, New York: Viking Press, 1970, p. 59.

14. June Wayne, 'To Restore the Art of the Lithograph in the United States', a proposal presented to the Program in Humanities and the Arts of the Ford Foundation, 1959. Reprinted in Marjorie Devon, ed., *Tamarind: Forty Years*, Albuquerque: University of New Mexico Press, 2000, p. 4.

15. Ibid., p. 2.

16. When Robert Blackburn went to Paris in 1953 to hone his lithography skills at Desjobert, he was not allowed to watch the printers grind the stones. See Elizabeth Jones, 'Robert Blackburn: An Investment in an Idea', Tamarind Papers, 6:1 (Winter 1982–83), pp. 10–14.

17. Sparks, op. cit. [note 7], p. 24.

18. Many other workshops adopted this practice subsequently.

19. Bruce Nauman recalls that when David Hockney's witty and concise etchings for *A Rake's Progress* (1963) were published, the American print establishment thought they had 'nothing to do with printmaking'. See Bruce Nauman, interview with Chris Cordes, in *Bruce Nauman Prints 1970–89*, New York: Castelli Graphics and Lorence-Monk Gallery; Chicago: Donald Young Gallery, 1989, p. 25.

20. Kathan Brown, *Know That You Are Lucky*, San Francisco: Crown Point Press, 2012, p. 35.

21. Brown and Parker were married at the time. Parker was also an accomplished printer and later worked for both Parasol Press and Pace Editions.

22. Brown, op. cit. [note 20], p. 39.

23. Wayne, op. cit. [note 14], p. 3.

24. The printer, Erika Schneider, persevered nonetheless. She became a master printer in intaglio and lithography at Atelier Franck Bordas and director of the Maeght print studios in France. She now runs Bleu Acier, Inc. in Tampa, Florida.

25. Hollander Workshop press release, 1965. Hollander founded his printshop in New York in 1964, later changing the name to Hollanders Workshop to acknowledge the involvement of Dutch master printer Fred Genis. It closed in 1972.

26. Crown Point 'printers are trained to think of themselves as teachers and facilitators, not collaborators'. Brown, op. cit. [note 20], p. 60.

27. John Russell, 'A Connoisseur's Guide to the Fine Art of Print Collecting', *New York Times*, 22 June 1979, ii, p. i.

28. MoMA curator William S. Lieberman was one of eight jurors for the award (the others were all European). See MoMA press release No. 81, 20 June 1963. www.moma.org/momaorg/shared//pdfs/docs/press_archives/3173/releases/MOMA_1963_0085_81.pdf?2010

29. Kenneth Tyler in Michael Knigin and Murray Zimiles, *The Contemporary Lithographic Workshop Around the World*, New York: Van Nostrand Reinhold Company, 1974, p. 75. Tyler also sided with Bruce Conner when the artist ran afoul of Tamarind rules.

30. Joshua Binion Cahn, ed., *What is an Original Print?*, New York: Print Council of America, 1961, p. 9.

31. Trudy V. Hanson, 'The Early Years of the Print Council of America: 1956–1972', in *Print Council of America: 50th Anniversary Celebration*, Print Council of America, 2007, p. 7.

32. See Pat Gilmour, *Ken Tyler, Master Printer, and the American Print Renaissance*, Canberra: Australian National Gallery, 1986. Albers was also a catalyst for the screenprint operation Maurel Studios (founded in 1955 by Black Mountain College alumna Sheila Marbain), and for the print publisher Ives-Sillman in New Haven, Connecticut. The first prints launched by Tyler Graphics Ltd. were also by Albers.

33. Claes Oldenburg, 'I am for…', in *Environments, Situations, Spaces*, New York: Martha Jackson Gallery, 1961, reprinted in Claes Oldenburg, *Store Days*, New York: Something Else Press, 1967, n.p.

34. 'Multiples' is an umbrella term for editioned objects that somehow do not fit the definition of 'print' – small sculptures, large felt banners, jewelry, toys, even food have been published as art multiples.

35. The firms most frequently employed were Aetna Silkscreen Products and Knickerbocker Machine and Foundry, Inc.

36. Maurel Studios and Chiron Press were among the few screenprint shops to work collaboratively with artists in the 1960s.

37. Like virtuoso violinists, printers become wedded to particular instruments. Tyler was among those who designed or adapted their own equipment. Aldo Crommelynck constructed presses from 19th-century parts to achieve his inimitably delicate effects. Irwin Hollander credited the presses made by Charles Brand with making 'the revolution in lithography possible'. See Dorothy C. Belknap and Stephanie Terenzio, *The Prints of Robert Motherwell with a Catalogue Raisonné 1943–1990*, New York: Hudson Hills Press, 1991, p. 24.

38. Tyler later patented the rigid archival honeycomb paper product, Tycore.

39. 'I felt we shared a common love of perfection and technological achievements', Tyler said. See Gilmour, op. cit. [note 32], p. 36.

40. Barbara Isenberg, 'Princes of Prints', *Los Angeles Times*, 14 May 2006. http://articles.latimes.com/2006/may/14/entertainment/ca-gemini14/2

41. Barbara Rose, 'The Airflow Multiple of Claes Oldenburg', *Studio International*, 179:923 (June 1970), pp. 254–55. In the end, the polyurethane that was used aged badly and the edition had to be recalled and remade.

42. Its founder, Donald Saff, was not trained at Tamarind, but most of the lithographers at Graphicstudio were.

43. Solodkin was Tamarind's first female master printer. Though both Tamarind and ULAE were founded by women, the demographics of lithographic printers skewed strongly male until recently. And of course women artists were radically underrepresented in galleries and museum exhibitions as well.

44. Twenty-five artists refused to allow their work to be shown, protesting US government policies of 'racism, sexism, repression and war', but twenty-two did participate. Artist William Weege, who was in charge of the screenprint component, turned out 'Impeach Nixon' posters, while Ed Ruscha lined one gallery with 360 sheets screenprinted by Weege with chocolate. See Grace Glueck, 'Off With the Show', *New York Times*, 4 October 1970, D24.

45. 'Original Art, Hot Off the Presses', *Life*, 68:2 (23 January 1970), pp. 57–61 (p. 57).

46. Robert Hughes, 'The Revival of Prints', *Time*, 18 January 1971.

47. David L. Shirey, 'Modern Museum Offers Works of "Multiple" Art', *New York Times*, 6 May 1971, p. 52.

48. Hilton Kramer, 'Technics of Fashion', *New York Times*, 2 May 1971, D21.

49. Richard S. Field, *Jasper Johns: Prints 1970–1977*, exh. cat., Middletown, CT: Wesleyan University Press, 1978, p. 58.

50. The uncrossed, unbroken lines of Sol LeWitt's prints and the white ink of Robert Ryman's aquatints are traditionally considered 'impossible' to produce consistently in intaglio. See Lizbeth Marano, *Parasol and Simca: Two Presses/Two Processes*, exh. cat., Lewisburg, PA: Bucknell University, 1984, n.p.

51. Chuck Close, in interview with Kathan Brown and Terrie Sultan, 'Mezzotint', in Terrie Sultan, *Chuck Close Prints: Process and Collaboration*, Princeton, NJ: Princeton University Press in association with Blaffer Gallery, the Art Museum of the University of Houston, exh. cat., 2003, p. 51.

52. In the traditional Japanese system, master craftsmen cut blocks from a drawing submitted by the artist, visually taking apart and physically rebuilding the image. In the Crown Point programme, the artist and publisher would travel to Kyoto for final proofing and tweaking, a process that might take a few days or several weeks. Many of these are now considered to be among the artists' finest work, and their visibility helped foment a worldwide movement of contemporary artists working with Japanese techniques (*Mokuhanga*).

53. Jasper Johns in the film *Hanafuda/Jasper Johns* by Katy Martin, 1978–81.

54. Email correspondence, 18 February 2016.

55. Sánchez in Deborah C. Phillips, 'Artist and Printer: "A Coincidence of Sympathies"', *ARTnews*, 80:3 (March 1981), pp. 100–106 (p. 105).

56. Ibid., p. 103.

57. Artistic papermaking in America descends from Douglass Morse Howell, who learned to make paper in France at the war's end, and later supplied paper for ULAE. Following a one-person workshop with Howell in 1962, Laurence Barker set up the first academic papermaking programme at Cranbrook Academy of Art in Bloomfield Hills, Michigan; his student Walter Hamady established a programme at the University of Wisconsin-Madison, which trained Gosin, Wilfer and Paul Wong (Dieu Donné's current director). Cranbrook alumnus John Koller founded HMP Papers, which worked closely with Tyler Graphics.

58. Close in Sultan, op. cit. [note 51], p. 15.

59. 'Original Art, Hot Off the Presses', op. cit. [note 45], p. 57.

60. Branstead had been Kathan Brown's assistant and the first designated Crown Point Master Printer. Other important shops founded by Crown Point alumni include Paulson Bott Press in Berkeley, California, and Simmelink/Sukimoto, now in Ventura, California.

61. Mel Bochner, 'Excerpts from Speculation (1967–1970)', *Artforum*, 8 (May 1970), pp. 70–73 (p. 70).

62. Highpoint Editions in Minneapolis also follows this model.

63. Tandem Press (University of Wisconsin-Madison) and the Brodsky Center for Innovative Editions (Rutgers University) are other examples.

64. Garo Z. Antreasian, 'Some Thoughts about Printmaking and Print Collaborations', *Art Journal*, 39:3 (Spring 1980), pp. 180–88 (p. 186).

65. Jasper Johns has been working with John Lund since 1996; Jim Dine brings Julia d'Amario to his studio in Walla Walla, Washington, every year to work on etching; and Ed Ruscha established Hamilton Press with printer Ed Hamilton in 1990 (though Hamilton Press also works with other artists).

66. Photographer Jon Goodman is largely responsible for the techniques revival in America, both through his own work and training others. Unlike photo-etching, photogravure uses a gelatin that translates into continuous tone rather than a dot-screen.

67. Stanley Grinstein died in 2014.

68. It is now called the Tamarind Institute.

69. Robert Rauschenberg, in Joseph E. Young, 'Pages and Fuses: An Extended View of Robert Rauschenberg', *Print Collector's Newsletter*, 5:2 (May–June 1974), pp. 25–30 (p. 25).

70. Leo Steinberg, 'Other Criteria', in *Other Criteria: Confrontations with Contemporary Art*, London, Oxford, New York: Oxford University Press, 1972, p. 84.

1 Pop art

In 1960 the United States was enjoying a post-war economic boom. As disposable income increased and luxury goods became cheaper, Americans were bombarded with a torrent of advertising. Car manufacturers, cosmetic companies and tobacco giants competed for their attention, all promising a share of the good life. Andy Warhol, Roy Lichtenstein, James Rosenquist and Claes Oldenburg shared a fascination with American consumerism. Broadly grouped as 'pop artists', they took the New York art world by storm in the early 1960s with their re-presentations of everyday imagery as high art. On the West Coast, the label was applied to Ed Ruscha and Wayne Thiebaud, who were included in the 'New Painting of Common Objects' exhibition at the Pasadena Art Museum, California, in 1962, alongside Warhol and Lichtenstein. In both aesthetic and approach, pop art was a radical departure from abstract expressionism, which had reigned as the prevailing avant-garde style in America since the late 1940s.

The pop artists took inspiration from newspapers, comic books, advertising and the movies to create work that blurred the line between fine and commercial art. Rosenquist, a former sign painter, appropriated the style and scale of billboard advertisements for his breakthrough *F-111* composition, which he produced first as a multi-panel painting (1964–65) and later as a four-sheet colour lithograph (1974, cat. 4). Warhol emulated a factory production line to create screenprinted images of celebrities, canned food brands and news photographs in a dazzling array of changing colours. Lichtenstein also made screenprints, meticulously replicating the Ben-day dots of commercial printing in his comic book-inspired images. In contrast, Oldenburg was interested in creating monumental sculptures, paintings and prints of workaday objects such as plugs and screws. With wit and deadpan detachment, the pop artists held a mirror to contemporary America, reflecting a world in which bigger was better and everything was a commodity.

Andy Warhol

1928–1987

Born Andrew Warhola in Pittsburgh, Pennsylvania, of working-class Czech émigré parents, he changed his name to Warhol about the time he graduated in pictorial design from Carnegie Institute of Technology, Pittsburgh, in 1949. That year he moved to New York where he made a successful career as a commercial graphic designer for fashion magazines, Manhattan department stores and for I. Miller, a women's shoe company, during the 1950s. From 1950 his Eastern Catholic mother came to live with him in New York until 1971, the year before she died. Fascinated by the world of advertising, glamour, the media and popular culture, in 1960 Warhol began to paint canvases inspired by these subjects that would make him the most famous pop artist of the 1960s and 1970s. From 1962 he produced his paintings by screenprinting his imagery on to canvas, exploiting the technique's commercial, mechanical character to create repetitions and multiple variations that he likened to the output of a factory assembly-line. His initial screenprinted series – Campbell's Soup cans (see fig. 1, p. 11), Disasters and Marilyns – were followed in 1963 by the equally groundbreaking Electric Chairs, Race Riots and Jackies, the year Gerard Malanga joined him as his principal assistant at the Factory, as Warhol's studio was henceforth dubbed. Decorated in aluminium foil and silver paint, the Factory became the crazy hangout for alternative 1960s counter-culture, where rock musicians Lou Reed and the Velvet Underground, gays, transvestites, filmmakers, including Paul Morrissey, and every kind of social misfit mixed. In 1968 Warhol narrowly escaped death when he was shot in the Factory by Valerie Solanis, a deranged hanger-on and sole member of S.C.U.M. (Society for Cutting Up Men). He famously announced in 1965 his intention to 'retire' from painting to concentrate on making off-beat films, although two years later he founded Factory Additions for publishing his screenprint portfolios, including the ten Marilyns and the Campbell's Soup cans. By the time he died, aged 58, following gall-bladder surgery, Warhol had made more than 400 print editions, almost all screenprints, with various publishers. SC

Andy Warhol

1 *Marilyn* **1967**

10 colour screenprints
Verso: signed and numbered '224/250'.
910 x 910 (35¾ x 35¾) each sheet
Feldman and Schellmann II.22–31
Tate: Purchased 1971

Glamour and death are addressed in Warhol's depiction of the celebrity icon Marilyn Monroe. Shortly after the famous movie star committed suicide in August 1962, Warhol began to memorialize her by making screenprinted canvases in different sizes and repetitions. In what would become his usual practice during this period, he used existing news or press-agency photos as his source image – in this case, a cropped and enlarged publicity still by the photographer Gene Kornman for Monroe's 1953 film *Niagara*, where she had been billed as 'the tantalizing temptress'. For these ten prints produced in 1967 Warhol exploited different combinations of intense flat colour, off-register dislocations and overprinting offered by the screenprint technique to produce radically different presentations of Marilyn's face as a mask of doomed stardom. Maintaining a passive indifference to its production, Warhol left the choice of colours to his assistant David Whitney, with the exception of the black and silver-grey version. They were printed in an edition of 250 by the New York commercial firm Aetna Silkscreen Products for Warhol's short-lived print publishing arm, Factory Additions (1967–70). The serial reiteration of Marilyn's face was a deliberate strategy; as Warhol once declared, 'repetition adds up to reputation'.[1] **SC**

1 Cited by Donna de Salvo, 'God is in the Details: The Prints of Andy Warhol', in Feldman and Schellmann 1997, p. 17.

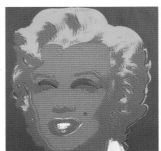
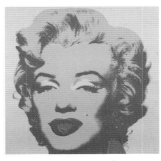
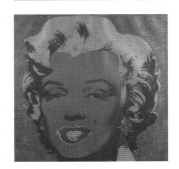
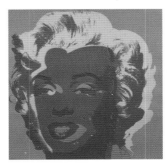
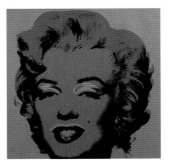
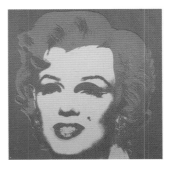
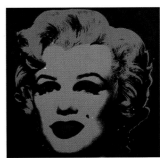

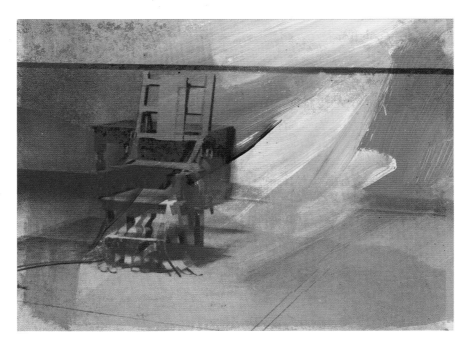

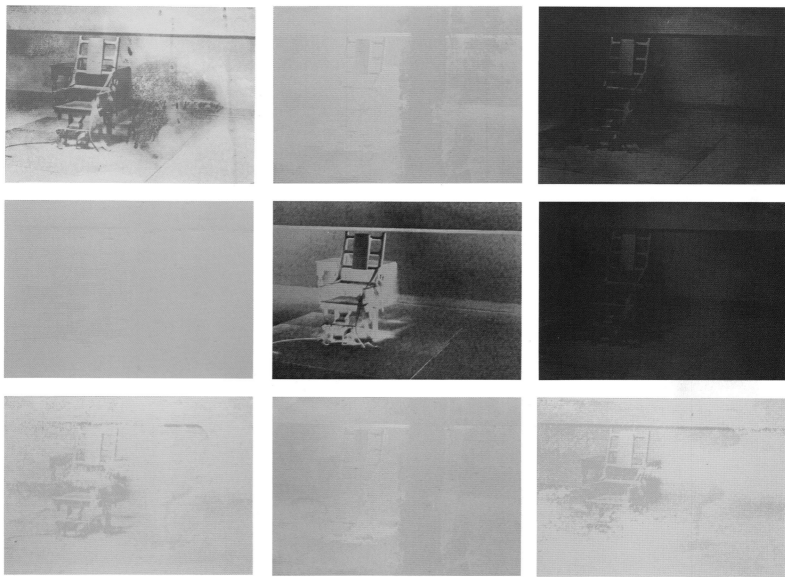

Andy Warhol
2 *Electric Chair* 1971
10 colour screenprints
Verso: each signed and dated in ballpoint pen, copyright stamp 'Copyright Factory Additions/Edition Bischofberger Zürich', numbered with rubber stamp 'A.p. X/L' (artist's proof outside ed. 250) except for Feldman and Schellmann II.81, which is numbered 'A.p. X/X'. 900 x 1219 (35½ x 48) each sheet
Feldman and Schellmann II.74–83
Private collection, UK (promised gift to the British Museum)

For this set of prints Warhol repeated the source image he had used for his earlier screenprinted canvases (cat. 3). In these prints, however, the electric chair is positioned more prominently by cropping the source image; this has the effect of enlarging the chair, reducing the sense of being in an enclosed room and eliminating the 'Silence' sign. In this respect the prints are closer to his so-called *Big Electric Chair* paintings of 1967. Unlike the set of ten *Marilyn* prints, the *Electric Chair* screenprints were printed outside the United States in Zurich for the Swiss art dealer and publisher Bruno Bischofberger, who commissioned them from Warhol in an edition of 250. The serial presentation of ten identical images in both positive and negative iterations and in different colour combinations has a hallucinatory, hypnotic effect on the viewer. As Warhol told an interviewer in 1963, 'when you see a gruesome picture over and over again, it doesn't really have any effect'.[1] An extra gestural screen-stencil was overlaid one of the prints to suggest a bloody smear across the chair. **SC**

1 G. R. Swenson, 'What is Pop Art? Answers from 8 Painters, Part I', *ARTnews*, 62:7 (November 1963), pp. 26, 60–61 (p. 61); reprinted in *I'll Be Your Mirror. The Selected Andy Warhol Interviews*, ed. Kenneth Goldsmith, with an introduction by Reva Wolf, New York: Carroll & Graf Publishers, 2004, p. 19.

Andy Warhol
3 *Little Electric Chair* 1964–65
Screenprint ink and acrylic paint on canvas
Signed and dated '64' on the canvas overlap. 557 x 710 (21⅞ x 28)
Frei and Printz 1433
Private European Collection

The empty chair sits in the chilling stillness of the chamber of death. At the upper right an official sign reads 'Silence', an ironic reminder of death as well as a reference to the presence of authorized witnesses at state-administered executions. By implication we too, as viewers, are made witnesses. In 1963, the year of the State of New York's last execution by electric chair, Warhol began to produce his screenprinted Electric Chair paintings that pictured the dark side of the American Dream. He used a press-service photo (published 13 January 1953) of the electric chair at the infamous Sing Sing Prison, Ossining, New York, as his source image. Public disquiet at state-sanctioned execution by electric chair had grown since the so-called atomic spies Julius and Ethel Rosenberg were put to death at this prison on 19 June 1953. **SC**

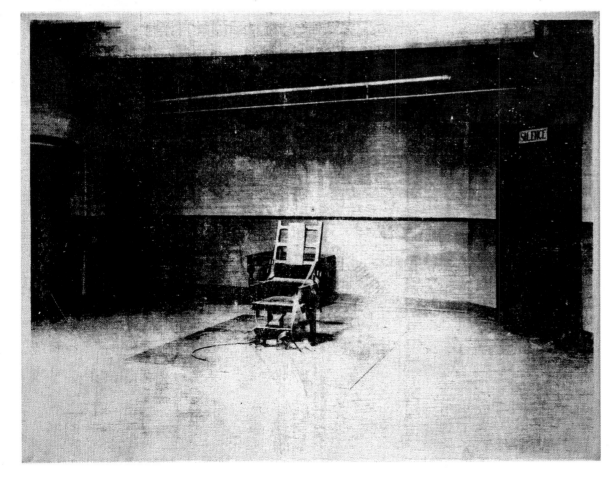

James Rosenquist

Born 1933

Born in Grand Forks, North Dakota, Rosenquist had an itinerant childhood before his family settled in Minneapolis, where he studied art at the University of Minnesota. He began painting Phillips 66 gasoline signs on highways for a contractor in the Midwest before a scholarship took him to the Art Students League, New York, in 1956. His experience painting billboards in New York, most famously above Times Square, in the late 1950s had a profound effect on developing the pop art style for which he became best known in the early 1960s – fractured and blown-up juxtapositions of commercial and everyday imagery presented on a giant billboard scale. From 1965 he began to make lithographs at ULAE, West Islip on Long Island, using airbrushes, paint rollers and stencils that gave his imagery an industrial, commercial look. Since then he has worked with many print workshops, including Gemini, Los Angeles, Styria Studio, New York, and Petersburg Press, London, while at Tyler Graphics, Mount Kisco, New York, in the late 1980s and early 1990s, he combined the processes of lithography and paper pulp to produce prints on a gigantic scale. **SC**

James Rosenquist

4 *F-111* 1974

Colour lithograph with screenprint
on four sheets
Each sheet signed, dated, numbered
'68/75' and titled respectively in pencil
'F 111 South', 'F 111 West', 'F 111 North',
'F 111 East'; printed at Styria Studio,
New York, and Petersburg Press, London,
and published by Petersburg Press.
South: 930 x 1780 (36⅝ x 70) sheet;
West: 920 x 1910 (36¼ x 75¼) sheet;
North: 930 x 1775 (36⅝ x 69⅞) sheet;
East: 920 x 1910 (36¼ x 75¼) sheet
Glenn 73
British Museum, London 2009,7050.1.1-4
Presented by Dave and Reba Williams in
honour of Antony Griffiths

Rosenquist's most famous composition,
F-111, 1964–65 (Museum of Modern
Art, New York), a multi-panel, 26.2-metre
long oil painting with aluminium (almost
four metres longer than the actual military
plane) was first shown in 1965 at the Leo
Castelli Gallery, New York, in an
immersive environment around the
gallery's four walls. Deployed in the
Vietnam War from the late 1960s, the
F-111 was the most advanced fighter-
bomber of the United States Air Force;
the mighty US industrial-military complex
invested many millions of dollars in its
development during the 1960s. In this
gigantic four-panel print Rosenquist
replicates the impact of his original
painting made ten years earlier. Cutting
through a series of fragmented images
denoting the American Dream of
domestic plenitude, steals the destructive
fighter-bomber in all its sleek technical
sophistication. Rosenquist rhymes the
blonde girl under the hairdryer with the
cone of a missile; the beach umbrella
shelters the rising atomic cloud; the
fragile household light bulb is broken like
an egg. The disjunctive close-up images,
dislocations of scale and the billboard
format are deployed to brilliant effect in
this print. **SC**

Claes Oldenburg

Born 1929

Born in Stockholm, the son of a Swedish diplomat posted to the United States, Oldenburg was brought up in Chicago from 1936. He studied English literature and art at Yale University (1946–50) and then enrolled at the Art Institute of Chicago. He obtained American citizenship in 1953. After moving to New York in 1956, Oldenburg became a leading figure in staging Happenings and other avant-garde performances in the Lower East Side of Manhattan. Making objects recreated from the detritus found on the streets of his neighbourhood, he constructed an environment that he called *The Street* (1960). For his environment *The Store* (1961) he rented a storefront where all the merchandise – food, clothing, etc. – were everyday objects of exaggerated form and scale that he had made from 'cloth, dipped in plaster dropped on chickenwire [and] painted with enamel'.[1] Oldenburg's environments and sculptures of the early 1960s, documented in his artist's book *Store Days* (New York: Something Else Press, 1967), signalled the emergence of pop art. In 1965 he began to produce proposals for monumental sculptures, including lipsticks and cigarette ends. In 1977, the year of his large retrospective at the Stedelijk Museum, Amsterdam, he married its curator, Coosje van Bruggen, and thereafter until her death in 2009 they collaborated on large-scale projects. Oldenburg has made prints and three-dimensional editions (multiples) at various workshops, including Gemini, Crown Point Press and Aeropress, and worked with various publishers including Multiples, Inc. and Petersburg Press. SC

1 Claes Oldenburg, *Store Days*, New York: Something Else Press, 1967, p. [56].

Claes Oldenburg

5 *Floating Three-Way Plug* 1976

Colour soft-ground etching and spit-bite aquatint

Signed, dated and inscribed 'A.P. XIV/XV' (artist's proof outside ed. 60) in pencil, inscribed on plate: 'ruin nun englouti/ Mondrian/cross x/section/mon/floating plug/floating plug in sunset/half buried plug', blindstamps of Crown Point Press, Oakland, California, and the printer (John Slivon). 1067 x 819 (42 x 32¼) plate, 1260 x 980 (49⅝ x 38¾) sheet

Platzker 154

British Museum, London 2011,7075.1 Purchased with the Presentation Fund in honour of Antony Griffiths

A gigantic three-way plug floats half-submerged in a tranquil bay or lake at sunset; in the distance a sailing boat goes by oblivious of this outlandish object. The idea of a colossal plug suspended in water, which Oldenburg associated with a sunken architectural ruin, began with a pencil drawing made in 1965 (Walker Art Center, Minneapolis). The transformation of an ordinary American plug into an architectural fantasy is achieved by gross magnification of scale – a device Oldenburg has consistently used in his sculptures, prints and drawings. The artist spent three periods in 1975 at Crown Point Press, Oakland, elaborating his visualization through subtle washes of aquatint. Viewed above and below the waterline the plug is located midway between the two states of air and water; the placid setting is subverted by the suggestion of mortal danger from the plug's prongs hanging in water. **SC**

Claes Oldenburg
6 *Giant Three-Way Plug*, **Scale B,**
2/3 1970
Mahogany wood sculpture
1473 x 991 x 749 (58 x 39 x 29½)
Tate: Purchased 1971

From the early 1960s Oldenburg has
taken a banal, everyday household object
like the three-way electrical plug, a basic
American design made of Bakelite, and
developed its sculptural possibilities, as
he put it, 'by running it through different
scales, materials and functions'.[1] Various
versions of this plug were made in 1970.
Scale A, the most monumental version,
was fabricated from Cor-Ten steel, with
bronze prongs, in three examples. Scale
B, the Tate's version, is half the size of
Scale A and one of three examples
constructed in hard wood, either in
mahogany or cherry, that Oldenburg has
said gave them the look of '1930s radio
sets'. By contrast, a 'soft' version in the
same scale was made in leather and
canvas, with wooden prongs. Unlike
Scale A, which was sited outdoors partly
buried in the ground (as at Allen Memorial
Art Museum, Oberlin College, Ohio, and
Philadelphia Museum of Art), Scale B
was conceived to be hung indoors from
the ceiling, its architectural character
suggesting to Oldenburg a floating
cathedral. He took the idea of the floating
monument further in the large aquatint
etching made six years later (cat. 5). **sc**

1 Claes Oldenburg, 'Log of the Three-Way Plug', in
 German Celant, Claes Oldenburg and Coosje van
 Bruggen, *A Bottle of Notes and Some Voyages*, exh.
 cat., Northern Centre for Contemporary Art,
 Sunderland, and the Henry Moore Centre for the Study
 of Sculpture, Leeds City Art Galleries, 1988, p. 112.

Claes Oldenburg

7 *Screwarch Bridge State II* **1980**
Etching with spit-bite and aquatint
Signed and numbered '9/35' in pencil,
blindstamps of print workshop Aeropress,
New York, and publisher Multiples,
New York. 597 x 1287 (23½ x 50⅝)
plate, 790 x 1460 (31⅛ x 57½) sheet
Platzker 173
Tate: Purchased 1985

In this magnificent aquatint etching a
suspension bridge is formed by two giant
screws bending over to meet with their
tips at midpoint over the river. Oldenburg's
architectural engineering fantasy derives
from an imaginary proposal for a bridge
across the Maas River in Rotterdam. In
1976 Oldenburg had begun working with
his Dutch partner, Coosje van Bruggen,
and spent part of that year and the next
living and travelling through the
Netherlands. On their return to America
Oldenburg created this etching with the
printer Patricia Branstead at Aeropress in
New York. The first state was a simple
line etching from one plate; this second
state was further elaborated with layers
of aquatint washes and fluid passages of
spit-bite from five plates in monochrome.
A third version was also produced in
colour with monoprinting. The etching
was prefigured by the series of 1.5-metre
high *Soft Screw* lithographs produced at
Gemini, Los Angeles, in 1976, where the
colossal screw tears like a tornado through
the landscape or bends over Times
Square. In 1984 a large-scale painted
aluminium version of the *Screwarch* was
installed as an outdoor sculpture between
two reflecting pools at the Boymans-van
Beuningen Museum, Rotterdam. **sc**

Roy Lichtenstein

1923–1997

Born in New York City, the son of a real-estate broker of German-Jewish descent, Lichtenstein served in the Second World War before returning to Ohio State University, Columbus, on the G.I. Bill to complete his BFA (1946) and MFA (1949). At Ohio the ideas of his teacher Hoyt L. Sherman on perception and visual unity became particularly important to him. In 1957 he began teaching at the State University of New York (SUNY) at Oswego where he adopted an abstract expressionist style in his paintings that he shortly after repudiated. Appointed to Rutgers University, New Jersey, in 1960, Lichtenstein met Allan Kaprow, a fellow teacher, and attended the latter's Happenings in New York, where he met Jim Dine and Claes Oldenburg. In 1961 he began his first pop paintings inspired by comic books (*Look Mickey*, 1961, National Gallery of Art, Washington, DC), war comics (*Whaam!*, 1963, Tate, London) and consumer-goods advertising (*Spray*, 1962, Staatsgalerie Stuttgart). Crude Ben-day dots used in commercial printing, bold black outlines and primary colours were hallmarks of his pop art style that became forever associated with his work. In 1962 he had his first solo show at Leo Castelli Gallery, New York, which thereafter represented him. In the same year he participated in 'New Painting of Common Objects', the first survey of American pop art, at Pasadena Art Museum, California, organized by the curator Walter Hopps.

Lichtenstein pursued printmaking in tandem with painting, contributing screenprints and offset lithographs to pop art print portfolios in the mid-1960s. From the late 1960s, when he first produced prints at Gemini, Los Angeles, he began to work consistently in series, often exploring art historical themes, including Monet's Haystacks and Cathedrals, Art Deco Modern Heads and Picasso's Bull Profiles. Threading through his career was his ironic preoccupation with the spontaneous abstract expressionist brushstroke, produced by the most labour-intensive methods. By the time of his death in 1997 Lichtenstein had produced over 300 editioned prints as well as numerous ancillary mailers and posters for his exhibitions and other projects. SC

Roy Lichtenstein
8 *Girl/Spray Can* from Walasse Ting, *1¢ Life* (Bern: E. W. Kornfeld, 1964, ed. 1133/2000) 1963
Colour lithograph printed on two sheets
337 x 560 (13¼ x 22) image, 411 x 582
(16⅛ x 22⅞) sheet (overall)
Corlett 33 and 34
British Museum, London 2014,7080.1.44
Purchased with funds given by the Vollard Group

These two lithographs are Lichtenstein's first prints in the new pop art style and they were produced as illustrations to Walasse Ting's poem 'Around the U.S.A.'. The cropped, close-up view of the girl with red lipstick and painted nails parodies the stereotype of the seductive blonde of American romantic comics. The dream of romance is juxtaposed with a parody of the American good life promoted by mass-advertising. In this case, a woman's hand pressing the top of a spray can with the tip of her manicured forefinger demonstrates the product's efficacy in household cleanliness. In both images Lichtenstein draws attention to the artifice of the devices used in advertising and popular culture – bold primary colours, defining black outlines and the dots of cheap mechanical printing. Lichtenstein often took clippings from comic books and from the advertisements of the Yellow Pages telephone directories as the starting point for his highly formalized pop art paintings. The lithograph *Spray Can* is related to his painting *Spray*, 1962 (Staatsgalerie Stuttgart).

1¢ Life was the project of the Chinese American poet and painter Walasse Ting (1929–2010) who asked many of the young emerging pop artists, including Andy Warhol, Jim Dine, Tom Wesselmann and Mel Ramos, as well as more-established European artists associated with the CoBrA group, such as Pierre Alechinsky and Karel Appel,

AROUND THE U.S.A.

IN 1959 A.D.
MILLIONS AND MILLIONS OF OLD LADIES
GO TO STOCK MARKET BUY FIRECRACKS
TO CASINO ENJOY MOONLIGHT
TO TOILET ROOM WATCH TELEVISION

TO HOTEL WATCH MAN'S BUTTOCKS
TO CEMETERY TO GIVE TIPS
TO NIGHT CLUB BUY ARTIFICIAL FLOWERS
TO MUSEUM BUY COPIES SECOND HAND
TO JUNK STORE BUY SOULS

LADIES HOLD YOUR OWN BREASTS
DON'T TOUCH MAN'S BUTTOCKS
YOUR STOMACHS CANNOT COMPARE WITH OCEAN
YOUR EYES CANNOT COMPARE WITH SUN
MY DEAR OLD LADIES
PLEASE MARRY PAPER HUSBANDS

PUT PERFUME IN YOUR BODIES
LET ALL BLOOD GO OUT
YOU WILL NEVER BE ANGRY CRYING MAD
IT IS GREAT TO LIVE
WITH ARTIFICIAL FLOWERS
KLEENEX
TOYS

to illustrate his free-wheeling, often erotically charged, poems. In all, twenty-eight artists contributed sixty-two lithographs, nearly all in vibrant colour, to the publication. The artists were either friends of Ting, who had first come to Paris in the early 1950s before settling in New York a few years later, or of his friend Sam Francis, the abstract expressionist painter, who edited the book and contributed six of its illustrations. Bringing together contemporary American and European artists, the publication was an ambitious, international collaboration. The lithographs were printed in Paris where Ting based himself for almost a year to supervise the printing; in 1964 the book was published in Bern in an edition of 2,000 by the Swiss publisher and art dealer E. W. Kornfeld.

Lichtenstein also designed the book's front cover, at Ting's request, of 'a rose open and lying down as a girl' (cited in Corlett, p. 291). A few years later Ting described the making of *1¢ Life*: 'Some artists come Paris to make lithographs. In New York I carry zinc plates to their studios, we drink and laugh… Lichtenstein: Spent two weeks, each hour one dot, looks like gentleman prefer the blond.'[1] **sc**

1 Walasse Ting, 'Near 1¢ Life', *ARTnews*, 65:3 (May 1966), pp. 38–39, 67–68 (p. 67).

Roy Lichtenstein

9 *Reverie* from *11 Pop Artists, vol. II*

1965, published 1966

Colour screenprint

Signed and numbered '96/200' in pencil.

689 x 583 (27⅛ x 23) image, 765 x 609

(30⅛ x 24) sheet

Corlett 38

Museum of Modern Art, New York.

Gift of Original Editions, 1966

Lichtenstein appropriated the visual language of the comic strip in his ironic presentations of melodramatic situations. With its matchless ability to achieve flat, saturated colour, bold black outlines and the Ben-day dots of comic-book illustrations, the screenprint, which had a long association with commercial printing, was ideally suited to Lichtenstein's pop art style. Lichtenstein's parody of a wistful blonde chanteuse from a romantic comic book draws attention to the emblematic treatment of emotion as sentimental kitsch in American popular culture. *11 Pop Artists*, from which this screenprint and *Sweet Dreams Baby!* (cat. 10) come, was issued simultaneously in three portfolio volumes in 1966. Commissioned by the tobacco company and arts sponsor Philip Morris, the portfolios were published by Rosa Esman of Original Editions who approached eleven leading pop artists from America and the United Kingdom to each produce a screenprint for each of the three volumes. The participating artists were Allan D'Arcangelo, Jim Dine, Allen Jones (UK), Gerald Laing (UK), Roy Lichtenstein, Peter Phillips (UK), Mel Ramos, James Rosenquist, Andy Warhol (cat. 138), John Wesley and Tom Wesselmann. *11 Pop Artists* toured widely in Europe as an exhibition of thirty-three prints from 1966 to 1968 and helped to define the aesthetic of pop art to a broader audience. **SC**

Roy Lichtenstein

10 *Sweet Dreams Baby!* **from** *11 Pop Artists, vol. III* **1965, published 1966**

Colour screenprint
Signed and numbered '96/200' in pencil.
905 x 649 (35⅞ x 25½) image,
957 x 702 (37⅝ x 27⅝) sheet
Corlett 39
Museum of Modern Art, New York.
Gift of Original Editions, 1966

The unseen assailant's knockout punch dispatches his victim to the sweet dreams of oblivion. Lichtenstein's screenprint for the third volume of *11 Pop Artists* is the antithesis of the ironic romantic schmaltz of *Reverie* (cat. 9) and the dreamy musings of its singer. Often called the 'Pow print', this is one of Lichtenstein's most defining images. It paraphrases the frankly expressed violence of war comics and the visualization of the sounds of physical force. Lichtenstein used a cutting of a fist punching a face from the comic book *Our Fighting Forces*, no. 95 (October 1965), published by National Periodical Publications, Sparta, Illinois, as the starting point for his screenprint (Archives of the Roy Lichtenstein Foundation). With deadpan detachment Lichtenstein makes no overt connection between the propagation of violence as deeds of derring-do in the comic strips and their real-life expression in the Vietnam War at this time. **SC**

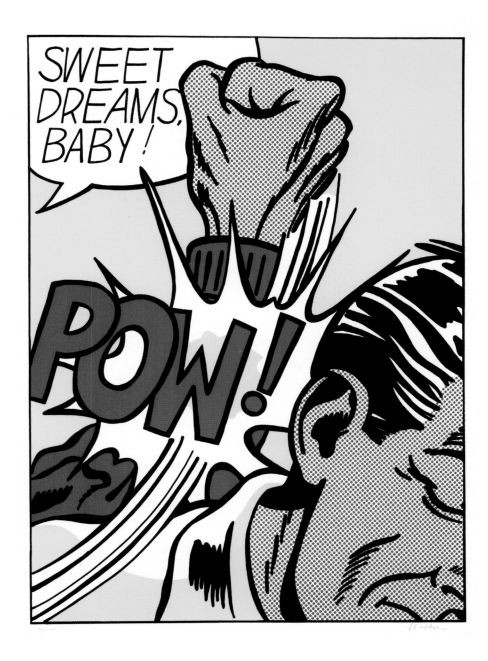

Tom Wesselmann

1931–2004

Born in Cincinnati, Ohio, Wesselmann began drawing cartoons while drafted in the US Army in the early 1950s, before completing a bachelor's degree in psychology at the University of Cincinnati. After moving to New York in 1956, he studied art at the Cooper Union where by 1959, his final year, he was making portrait and nude collages. Reacting against the gestural style of De Kooning and the abstract expressionists, Wesselmann became from the early 1960s a leading exponent of the new pop art style, although he disowned the association. 'I was a pop artist to the extent that I deliberately chose American imagery', he later explained.[1] During the 1960s he became best known for his Great American Nude series of paintings, often produced on a monumental scale, with their flattened forms and intense colour. In 1961 he held his first solo show at Tanager Gallery, New York; the following year he was included among the emerging generation of pop artists in 'The New Realists' exhibition at the Sidney Janis Gallery, who gave him a solo show in 1966 and thereafter represented him. Other series that continued into the 1980s include the Bedroom Paintings, Still Lifes and Smokers, often in the form of assemblages, shaped canvases or produced with moulded plastic. In 1980, under the pseudonym Slim Stealingworth, he wrote his autobiography in the third person, providing a detached account of his development as a figurative painter and appending an illustrated list of his prints to date.[2] From the early 1980s he created three-dimensional painted images from laser-cut metal. Wesselmann was initially a reluctant printmaker; his 1978 print retrospective at the Institute of Contemporary Art, Boston, comprised only thirty-eight prints. From the mid-1980s, inspired by the maquettes and colour studies made for the fabrication of his cut-metal works, he took up printmaking with renewed interest; by the time of his death in 2004 he had produced around 150 editions in all, with the screenprint as his preferred technique for its flat, bold colour and sharp outlines. **SC**

1 Thomas Buchsteiner and Otto Letze, et al., *Tom Wesselmann*, Ostfildern and New York: Cantz Verlag, 1996, p. 7.

2 Slim Stealingworth, *Tom Wesselmann*, New York: Abbeville Press, 1980.

Tom Wesselmann
11 *Untitled* from Walasse Ting, *1¢ Life*
(Bern: E. W. Kornfeld, 1964, ed.
1133/2000) 1964
Colour lithograph printed on two sheets
410 x 582 (16⅛ x 22⅞) sheet
British Museum, London 2014,7080.1.27
Purchased with funds given by the
Vollard Group

Wesselmann's image of a faceless reclining nude relates to the Great American Nude series of paintings begun in 1961. Identifiable by her distinctive blonde hair, the model in most of the series was the artist's wife, Claire Selley, whom he had first met as a fellow student at the Cooper Union and married in 1963. Wesselmann claimed that the archetype of the Great American Nude came to him after a dream of the colours red, white and blue. The series title resonated with contemporary discussions on the Great American Novel and, indeed, the Great American Dream. Wesselmann poses the model on striped covers suggestive of the American flag, while white stars decorate the wall behind her. Walasse Ting's blues-inspired poem provides the appropriate cadence to Wesselmann's illustration. In a statement at the time, Ting gave the following description of Wesselmann: 'He is cat, doesn't like to move. Beautiful wife great American nude all one.'[1] **SC**

1 Walasse Ting, 'Near 1¢ Life', *ARTnews*, 65:3 (May 1966), pp. 38–39, 67–68 (p. 68).

STOMACH SUNK IN WHISKY
PEE INSIDE PANTS

I SAW A LITTLE STAR
WHERE IS MY BABY TONIGHT

Tom Wesselmann

12 Study for *Great American Nude #75* 1965

Graphite and Liquitex acrylic paint on paper
Signed and dated in pencil. 325 x 307
(12¾ x 12)
Private collection, UK (promised gift
to the British Museum)

Wesselmann made numerous studies for
each work of his Great American Nude
series. This drawing is a monochrome
compositional study for *Great American
Nude #75*, a vacuum-formed plastic-
moulded work that was spray-painted in
primary colours (see opposite). In the final
work the effect of saturated colour was
heightened by the use of interior lighting.
By utilizing industrial processes such
as vacuum-forming, Wesselmann
transformed his Great American Nude
into a giant plastic doll, its tactile,
protruding forms and shiny surfaces
suggestive of a fetishist's blow-up
dummy. In the background of both the
study and the final work, although in
alternate positions, can be seen part of
an enlarged star that alludes to the
American flag. Wesselmann later
declared that his Great American Nude
series, which came to an end in 1973
with *#100*, had 'not a patriotic intention
or patriotic theme. It was an arbitrary way
for me to limit my palette.'[1] **SC**

1 Wesselmann in an interview with German TV
 in the 1990s; cited in John Wilmerding, *Tom
 Wesselmann: His Voice and Vision*, New York:
 Rizzoli, 2008, p. 48.

Great American Nude #75, 1965, spray-painted vacuum-formed Uvex with interior illumination, edition of 4, 1220 x 1372 (48 x 54)

Mel Ramos

Born 1935

A painter, printmaker and sculptor born in Sacramento, California, to Portuguese-American parents, Mel Ramos is best known for his depictions of comic-book heroes and pin-up nudes. As a student he was influenced by Wayne Thiebaud, one of his teachers at Sacramento Junior College (1954–55), who became a friend and with whom he made prints in the late 1950s and early 1960s.[1] In 1958 he obtained an MA from Sacramento State College, after which he taught at various institutions, most notably California State University, Hayward (1966–97). Often borrowing imagery from commercial advertising and magazines, Ramos was associated with the pop art movement. He had his first solo exhibition at the Bianchini Gallery, New York, in 1964 and has exhibited widely since. In 2012 the Crocker Art Museum, Sacramento, held a major retrospective of his work. Based for most of the year in Oakland, California, Ramos spends his summers in Horta de Sant Joan, Spain, where he has a home and studio. **CD**

1 Wendy Weitman, *Pop Impressions Europe/USA: Prints and Multiples from the Museum of Modern Art*, exh. cat., New York: MoMA, 1999, p. 98.

Cover of *Fight Comics*,
no. 39, 1 August 1945,
Fiction House

Mel Ramos
13 *Señorita Rio* **from Walasse Ting,**
1¢ Life **(Bern: E. W. Kornfeld, 1964,**
ed. 1133/2000) 1963
Colour lithograph
402 x 570 (15⅞ x 22½) image,
409 x 582 (16⅛ x 22⅞) sheet
British Museum, London 2014,7080.1.56
Purchased with funds given by the Vollard Group

In the early 1960s, much of Ramos's work was inspired by the comic-book imagery that he had been exposed to as a youth. Señorita Rio was a character that appeared in *Fight Comics* between 1942 and 1951. Drawn by the comic-book artist Lily Renée (b.1925), the heroine – a former Hollywood star of Puerto Rican descent turned American secret agent – fought fascists while posing as a Brazilian entertainer. This image is derived from the front cover of *Fight Comics*, no. 39 (1 August 1945), published by Fiction House (see left). In Ramos's version, which first appeared as a painting in 1963, Señorita Rio is spotlit in a roundel of a type often used in commercial branding. When Walasse Ting invited Ramos to participate in the *1¢ Life* project, Ting specifically requested an image of the character to illustrate his poem *America*, a comment on racial-stereotyping and division in American society.[1] A second lithograph produced by Ramos for the project features Tiger Girl, another *Fight Comics* heroine. Renowned for portraying buxom women in sexually provocative poses, Ramos was characterized by Ting in 1966 as: 'Football hero never eat hero sandwich, loves only glamour girls.'[2] **CD**

1 Wendy Weitman, *Pop Impressions Europe/USA: Prints and Multiples from the Museum of Modern Art*, exh. cat., New York: MoMA, 1999, p. 98.
2 Walasse Ting, 'Near 1¢ Life', *ARTnews*, 65:3 (May 1966), pp. 38–39, 67–68 (p. 68).

AMERICA

brain made by IBM & FBI
stomach supported by A&P
and Horn & Hardart
love supported by Time & Life
tongue supported by
American Telephone & Telegraph
soul made by 7up
skin start with Max Factor
heart red as U.S. Steel

three thousand miles
blue sky wallpaper
salt lake city kitchen
new england green garden
florida warm bed
new york city shining mirror
big mountain walk, big river sing
big tree fly in california
green banana hang
under new moon in montana
sun spit out sweet candy
in north dakota
star turn big diamond in iowa

red american as pumpkin
black american as horse
yellow american as sunflower
white american as fat woman
fat woman cut pumpkin
put sunflower in corner
push horse in dark
pumpkin dead
sunflower sad
horse angry
fat woman afraid horse make love
she stay alone
with
a
gun

153

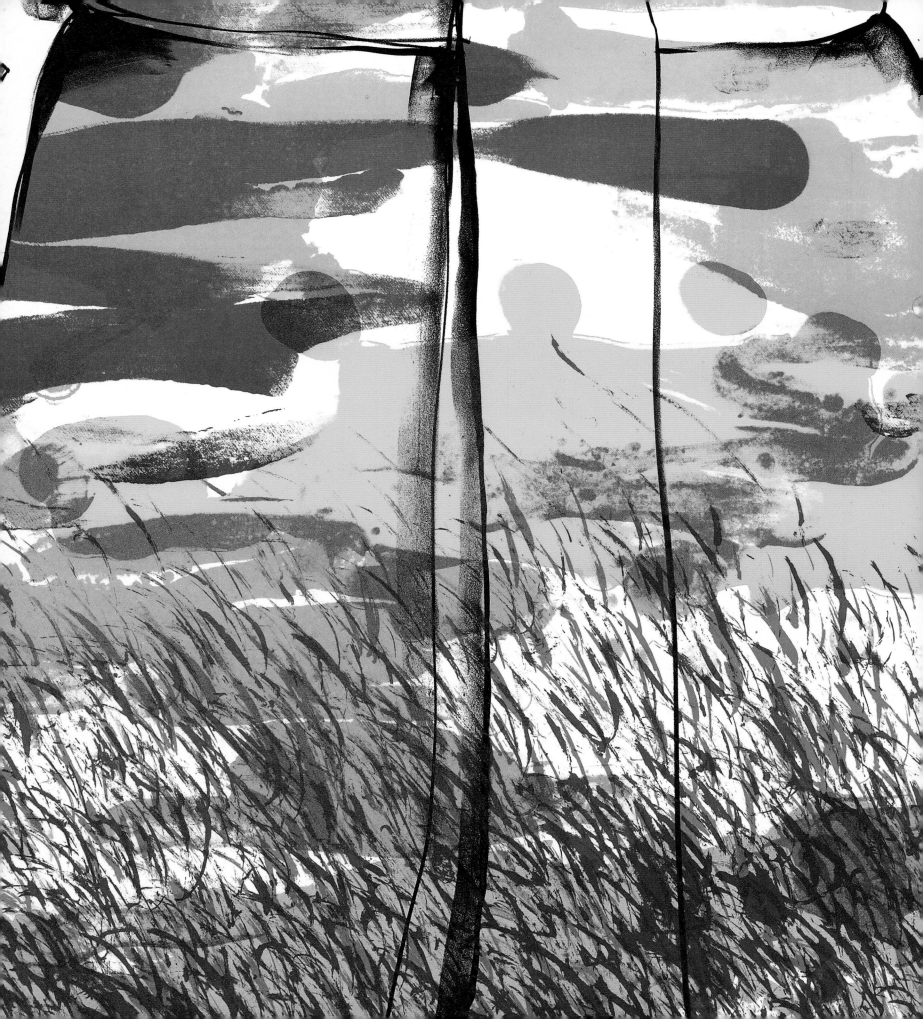

2 Three giants of printmaking
Johns, Rauschenberg, Dine

Jasper Johns, Robert Rauschenberg and Jim Dine all began to make prints in the early 1960s, having initially achieved success as painters. Finding the creative possibilities of printmaking to be exciting and rewarding, they each went on to produce a large body of technically complex and ambitious work that demonstrates their mastery of a variety of techniques. Working closely with printers at various workshops, they have repeatedly pushed the boundaries of printmaking to new levels and have proven themselves to be among the most innovative, creative and technically accomplished printmakers of the 20th century.

When Johns made his first lithographs at Universal Limited Art Editions (ULAE) on Long Island, New York, in 1960, he had already developed a repertoire of motifs in his paintings and sculptural reliefs that included the American flag, shooting targets, the map of the continental United States, the numerals 0 to 9 and the letters of the alphabet. In print, he has continued to interrogate and manipulate these instantly recognizable symbols, engaging the viewer's perception by presenting double images, reversals and optical illusions.

Rauschenberg was initially sceptical about printmaking but working at ULAE from 1962 convinced him of the creative possibilities of lithography. He subsequently produced some of the most important lithographs ever made, including the remarkable *Stoned Moon* series in 1969–70 (cats 26–31) at Gemini G.E.L. in Los Angeles. Echoing his earlier practice of combining painting and assemblage, his prints are typically composed of seemingly unrelated imagery taken from a variety of sources, juxtaposed with wide-sweeping gestural marks.

Dine also began to make prints at ULAE in 1962 after Johns introduced him to Tatyana Grosman, the workshop's founder. Like Johns, Dine used recurring objects in his work, which included bathrobes, paintbrushes and a variety of tools. In his case, the imagery is autobiographical. Initially associated with pop art, Dine disavowed the label arguing that his work was too subjective.

Jasper Johns

Born 1930

One of the most influential painters and printmakers of the 20th century, Jasper Johns was born in Augusta, Georgia, and raised mainly in South Carolina. He studied briefly at the University of South Carolina, then moved to New York before being deployed to Japan during the Korean War. Returning to New York in 1953, he met Robert Rauschenberg, the composer John Cage and choreographer Merce Cunningham; he began making objects that departed from the expressionist conception of the work of art as a revelation of biography. 'I didn't want my work to be an exposure of my feelings,' he once said.[1] Instead Johns turned to commonplace objects and images, remaking and restating their qualities in an ongoing investigation of vision, cognition and memory. The importance of his work was recognized immediately – the Museum of Modern Art in New York purchased four paintings from his first one-person exhibition at Leo Castelli Gallery, New York, in 1958 – and the power of his work has never abated; in 2011 he became the first artist since Alexander Calder to receive the Presidential Medal of Freedom. Concerned with repetition and variation, with, as he put it, 'a thing's not being what it was, with its becoming something other than what it is, with any moment in which one identifies a thing precisely and with the slipping away of that moment', Johns found in printmaking a natural instrument of inquiry.[2] Like Pablo Picasso and Richard Hamilton – the only two 20th-century artists who rival Johns' singular contribution to printmaking – he deploys it not simply as a way to make images, but as a means of examining the very nature of art and meaning. ST

1 Jasper Johns, quoted in Vivien Raynor, 'Jasper Johns: "I have attempted to develop my thinking"', *ARTnews*, 72:3 (March 1973), pp. 20–22.

2 Jasper Johns, quoted in G. R. Swenson, 'What is Pop Art? Part II. Jasper Johns', *ARTnews*, 62:10 (February 1964), pp. 43, 66–67 (p. 43); reprinted in 'Interview with G. R. Swenson', in *Theories and Documents of Contemporary Art: A Sourcebook of Artists' Writings*, ed. Kristine Stiles and Peter Selz, Berkeley, CA: University of California Press, 1996, p. 324.

Jasper Johns
14 *Coat Hanger I* 1960
Lithograph
Signed, dated and numbered '8/35' in pencil, blindstamp of ULAE, West Islip, New York. 650 x 530 (25⅝ x 20⅞) image, 913 x 683 (36 x 26⅞) sheet
Field 1970, 2; Sparks 2; ULAE 1994, 2
British Museum, London 1980,1011.31

Among the everyday objects that Johns adopted as subject matter in the late 1950s was a plain wire coat hanger. This lithograph, the second print he made at the very start of his career in printmaking at ULAE, West Islip, New York, closely resembles a drawing in which the title subject almost disappears in a field of dense gestural marks. (He later reworked the stone for a second edition in which the background is darkened and the hanger highlighted.) This image does two contradictory things: it affirms the work of art as a flat space for personal gesture – a tenet of abstract expressionism – and also as an object of perceptual confusion. Johns is an admirer of the 19th-century American *trompe l'œil* artist John F. Peto, whose painting *The Cup We All Race 4* (1905, de Young Museum, San Francisco) depicts a tin cup hanging on a hook in a similar formulation to the hanger. The intellectual exercise in *Coat Hanger* is so engaging – the hanger that keeps us hanging – that it is easy to overlook the pathos, the palpable absence embodied by the empty hanger, the implication that the real subject has already left the room. ST

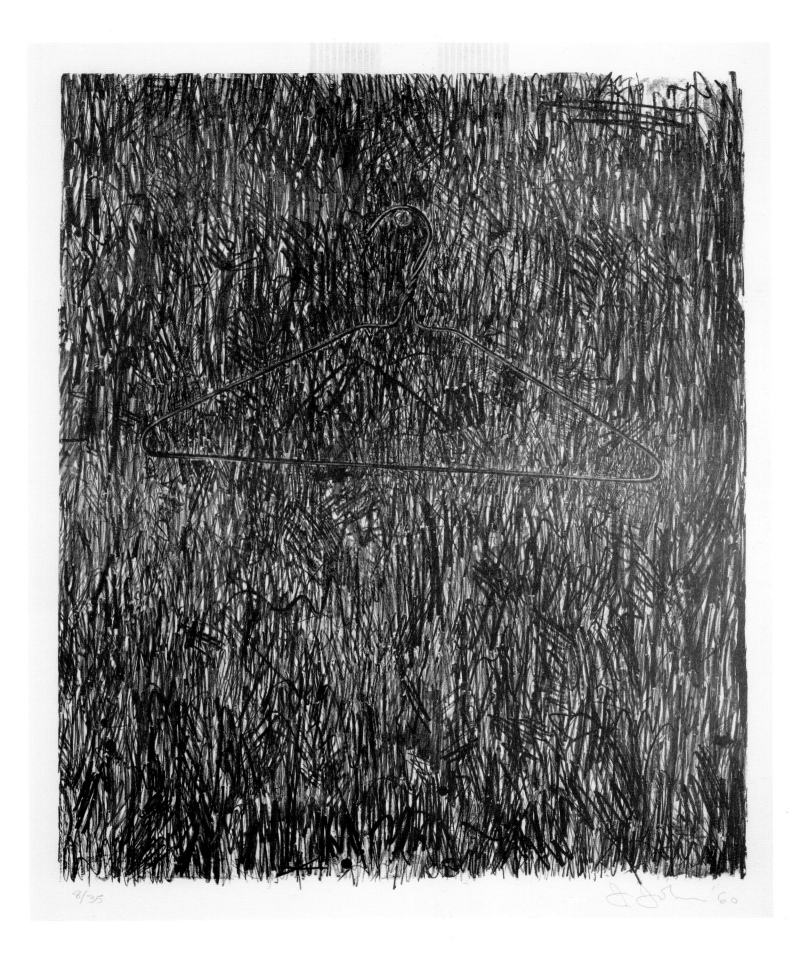

8/35 J. Johns '60

Jasper Johns
15 *Two Maps II* 1966

Lithograph printed in black on white
Japan paper laid on black paper
Signed, dated and numbered '15/30 II' in
white pencil, blindstamp of ULAE, West
Islip, New York. 643 x 515 (25⅜ x 20¼)
image, 838 x 673 (33 x 26½) sheet
Field 1970, 52; Sparks 61; ULAE 1994, 26
Gift of Barbara Bertozzi Castelli on loan
from the American Friends of the British
Museum

Johns has long exploited the doublings
and inversions built into the printing
process (positive/negative, left/right,
etc.), and nowhere more masterfully than
in *Two Maps II*. Like the flags and targets
he began painting in the 1950s, the map
of the continental United States appealed
as a found structure – a thing 'the mind
already knows'.[1] Repeating the composition
of an earlier painting, he drew the map
twice, filling in individual states so that
borders appear as irregular rivulets of
absence. Working with ULAE, he first
printed an edition in white ink on black
paper, creating a double negative in which
the empty borders appear black. In *Two
Maps II*, the situation is reversed yet again:
the stone was printed in black ink on a
thin white paper, which was then laid down
on black paper, making it almost impossible
to determine which is background and
which is drawing. As art historian and
curator Richard S. Field observed: 'For
Johns, as in printmaking itself, every
positive idea seemingly implies a negative
one, everything worth believing is also
worth doubting, and every truly significant
concept includes its opposite.'[2] ST

1 Jasper Johns, quoted in Leo Steinberg, 'Jasper
 Johns: The First Seven Years of his Art', in *Other
 Criteria: Confrontations with Twentieth-Century Art*,
 New York and Oxford: Oxford University Press,
 1972, pp. 17–54 (p. 31).
2 Richard S. Field, *The Prints of Jasper Johns
 1960–1993: A Catalogue Raisonné*, West Islip, NY:
 Universal Limited Art Editions, 1994, n.p.

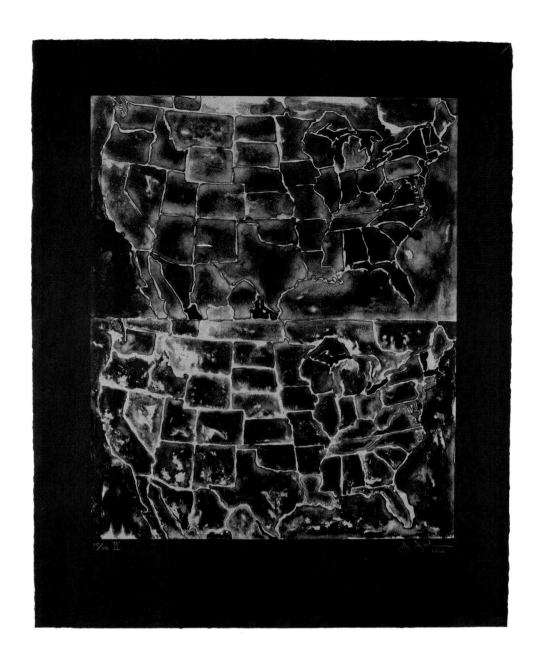

Jasper Johns

16 *Flags I* 1973

Colour screenprint
Signed, dated and numbered 'I 7/65' in
pencil. 675 x 850 (26⅝ x 33½) image,
699 x 889 (27½ x 35) sheet
Field 1978, 173; ULAE 1994, 128
Johanna and Leslie Garfield

No motif is more closely associated with
Johns than the American flag, which
he first painted in 1954. The baffling
literalism of that painting, *Flag* (Museum of
Modern Art, New York) (see fig. 2. p. 12)
– is it a thing or a picture of a thing?
– suggested both the knowing
mundaneness of Dada and the homespun
naïveté of folk art. Since then, Johns has
painted, drawn and cast the flag; rendered
it in eye-popping colour and in spectral

white; described its forty-eight-star
configuration and its fifty-star version.[1]
Though not oblivious to its symbolism,
Johns saw the flag as one of those
familiar things that is 'seen and not
looked at'.[2] Johns has described
screenprinting as 'simpleminded',[3]
and the bright colours, hard edges and
commercial associations that drew pop
artists to the medium in the 1960s held
little appeal for him. Working with the
Japanese printers at Simca Print Artists
in New York in the 1970s, however,
he discovered that multiple layers of
transparent inks could produce images of
a delicacy and sophistication that, Johns
quipped, 'might properly be considered an
abuse of the medium'.[4] From a distance,
Flags I is a large, brash rendition of the
stars and stripes; up close it dissolves

into a forest of individual marks printed
in fifteen colours from thirty different
screens. An additional screen of glossy
varnish distinguishes the flag on the right
from the matt flag on the left, echoing the
effect of a painting made the same year,
which paired a flag painted in oil paint
with one in encaustic. Made nearly twenty
years after Johns' first flag painting, *Flags I*
confronts the viewer with an almost perfect
symbiosis of the utterly straightforward
and the impossibly complex. **ST**

1 The stars in the American flag represent the states;
 the design of the flag was changed in 1959 after
 Alaska and Hawaii were granted statehood.
2 Jasper Johns in Max Kozloff, *Jasper Johns*,
 New York: Harry N. Abrams, 1967, p. 15.
3 Jasper Johns in the film *Hanafuda/Jasper Johns*
 by Katy Martin, 1978–81.
4 Ibid.

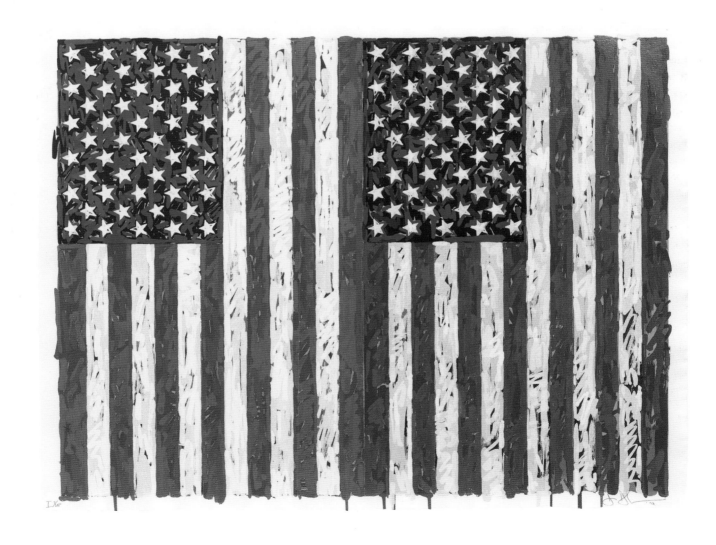

Jasper Johns
17 *Flags II* **1973**
Screenprint
Signed, dated and numbered 'II 52/60' in
pencil. 648 x 841 (25½ x 33⅛) image,
702 x 905 (27⅝ x 35⅝) sheet
Field 1978, 174; ULAE 1994, 129
Johanna and Leslie Garfield

The habit of rendering the colourful
universe in shades of grey is rooted in
technological expediency – until recently,
print media could only approach colour as
a cumbersome and expensive option. As
a result, people became fluent at reading
colour into pictures where it did not exist.
The American flag, whose colours are
known to all, is an obvious example of
this phenomenon. *Flags II*, however, is
not a simpler iteration of *Flags I*. It, too,
was printed from thirty screens at Simca
Print Artists (without the additional
varnish layer), but with just one ink –
a transparent graphite. Even before he
began making prints, Johns often
repeated the same subject in both colour
and black-and-white or grey, another
means of a thing 'becoming something
other than what it is'. **ST**

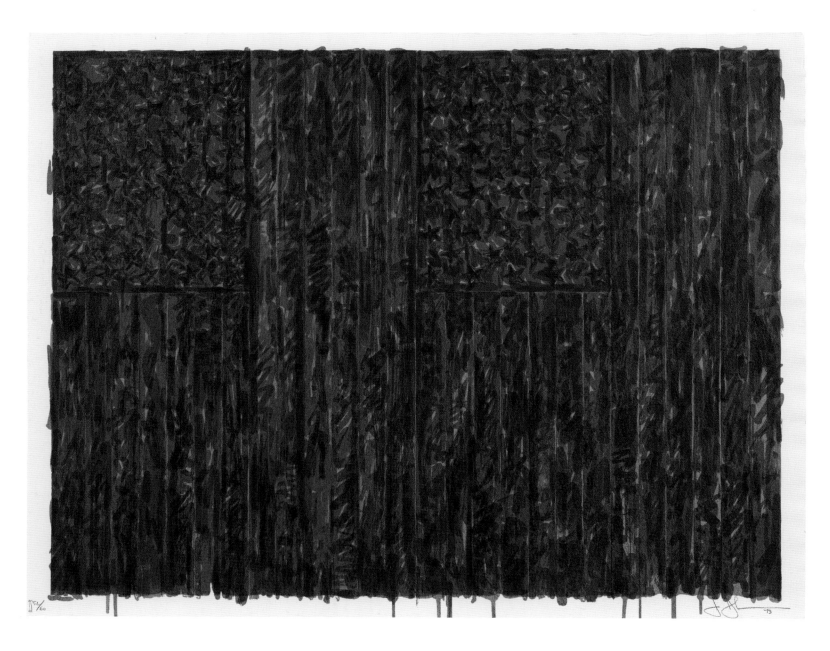

Jasper Johns

18 Two Flags 1980

Lithograph on cream Japanese paper
Signed, dated and numbered '38/56'
in pencil, blindstamp of Gemini G.E.L.,
Los Angeles. 1029 x 838
(40½ x 33) image, 1206 x 914
(47½ x 36) sheet
ULAE 1994, 209
Private collection, UK (promised gift
to the British Museum)

In this lithograph, as in *Two Maps II*
(cat. 15), the design is articulated
indirectly, through imperfectly abutting
areas of the same colour and character.
Every shape – whether white star or
blue canton – is both black and white.
Recognition is hampered, while simple
looking is rewarded. **ST**

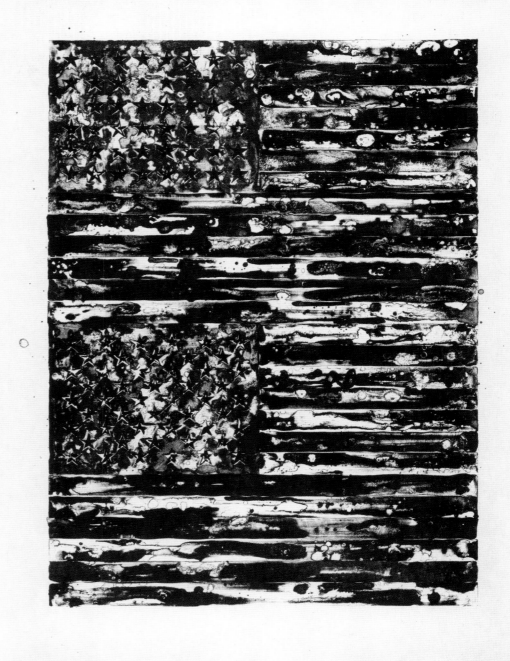

Jasper Johns

19 *Gray Alphabets* **1968**

Lithograph

Signed, dated and numbered '33/59' in pencil, blindstamp of Gemini G.E.L., Los Angeles. 1300 x 870 (51⅛ x 34¼) image, 1524 x 1066 (60 x 42) sheet

Field 1970, 114; ULAE 1994, 57

British Museum, London 1979,1006.20

The colour grey is for Johns a persistent motif in and of itself, applied in paint and print to virtually every motif in his repertoire. It first appeared in a title in the 1956 painting *Gray Alphabets* (The Menil Collection, Houston), whose composition and imposing scale are reiterated here: a 27 x 27 grid of rectangular boxes containing lowercase letters, a to z, in alphabetical order repeatedly. Because each row contains one more box than there are letters in the alphabet, things shift out of alignment: the rightmost letter of the top row is 'z', but the rightmost box of the second row is 'a' as the alphabet starts to wrap around on itself. If the letters were uniform in appearance, the pattern would be obvious – you would see a clear staircase of 'p's or 'w's marching upward and to the right – but the puddled ink and hollowed forms obfuscate and disrupt all simple readings. **ST**

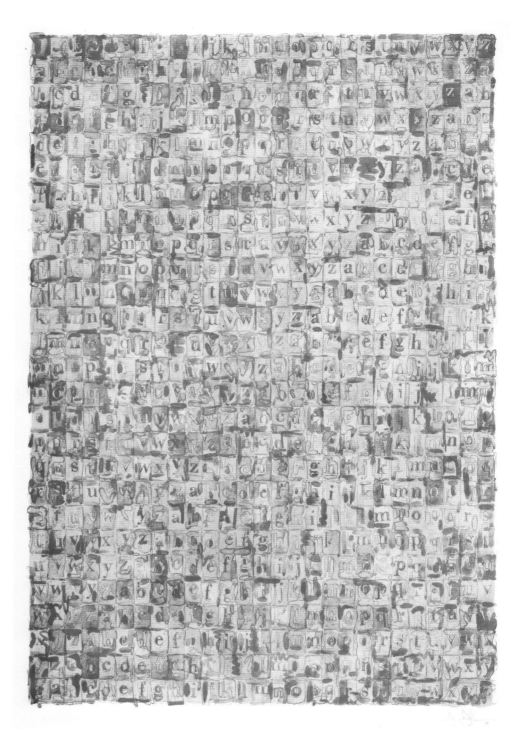

Jasper Johns

20 *Foirades/Fizzles* 1976

Artist's book with 5 texts by Samuel Beckett (1906–1989) and 33 intaglio prints (26 sugar-lift aquatints, 5 etchings, 1 soft-ground etching and 1 aquatint) housed in a case lined with a colour lithograph
Signed by the artist and author and numbered '78/250' in pencil.
330 x 254 (13 x 10) each sheet
Field 1978, 215–48; ULAE 1994, 173
Victoria and Albert Museum

This exquisite volume published by Petersburg Press follows in the tradition of the great early 20th-century *livres d'artistes*: bringing together the sympathetically minded work of a writer and an artist, without expecting one to illustrate the other. With thirty-three intaglio prints by Johns made at Atelier Crommelynck in Paris and five brief texts in two languages by Samuel Beckett, this is a book about translation: between French and English; between colour and shades of grey; between words and images. The title pairs a scatological French term for diarrhoea with its English cousin, defined by Beckett as 'wet fart' ('all damp, no squib')[1]; it neatly captures the sideslips of equivalence that concerned both its creators.

The subjects of Johns' etchings are almost all drawn from his four-panel painting *Untitled* (1972) (Museum Ludwig, Cologne): cast body fragments, a faux-flagstone pattern glimpsed on a wall in Spanish Harlem, and the short diagonal 'crosshatch' strokes that, Johns said, 'had all the qualities that interest me – literalness, repetitiveness, an obsessive quality, order with dumbness, and the possibility of complete lack of meaning'.[2] All these motifs are made and remade in a sequence of imprecise restatements – body parts, for example, go from flesh and blood to cast objects, to flat images, to stencilled words, forwards and backwards, beautiful to see and almost impossible to read. Though Beckett left the design entirely to Johns, he did express the hope that the crosshatching would appear at the front and flagstones at the back. When asked why, he explained: 'Here you try all these different directions but no matter which way you turn you always come up against a stone wall'.[3] **ST**

1 Samuel Beckett, in a letter to Ruby Cohn, 20 April 1974, quoted in Samuel Beckett, *Texts for Nothing and Other Shorter Prose, 1950–1976*, ed. Mark Nixon, London: Faber and Faber, 2010, note 27, p. xxiv.
2 Johns, quoted in Sarah Kent, 'Jasper Johns: Strokes of Genius', *Time Out London* (5–12 December 1990), pp. 14–15; reprinted in *Jasper Johns: Writings, Sketchbook Notes, Interviews*, ed. by Kirk Varnedoe and Christel Hollevoet, New York: MoMA, 1996, p. 292.
3 Johns, quoted in Edmund White, 'Jasper Johns and Samuel Beckett', *Christopher Street* (October 1977); reprinted in *Jasper Johns: Writings, Sketchbook Notes, Interviews*, op. cit., pp. 152–53.

Jasper Johns

21 *Targets* **1968**

Colour lithograph

Signed, dated and numbered '15/42' in pencil, blindstamp of ULAE, West Islip, New York. 879 x 660 (34⅝ x 25) sheet

Field 1970, 69; Sparks 75; ULAE 1994, 41

Johanna and Leslie Garfield

Johns' curiosity about the interdependence of looking and knowing has led him to cite optical illusions frequently in his work. This lithograph and its companion *Flags* (1968) plays with the perceptual phenomenon of afterimages: when the human eye is exposed to strong colour stimulus it shifts to a neutral ground and one will momentarily see the previous image in complementary colours.[1] Johns usually painted his colour targets with blue and yellow bands, but in this print they are orange and violet. If you stare at the off-centre black dot for a minute, and then at the dot in the white square below, a 'correct' blue and yellow target will appear before your eyes. The illusion works despite the fact that Johns has interfered with it: the bottom square slides off the page and already includes a ghostly impression of the target above; both are set within a larger composition of nuanced grey. Is it an illusion or a picture of an illusion? And is a picture of an illusion any less of an illusion? **ST**

1 Scientists are unsure of the exact physiological origin of afterimages, but it probably results from overcompensation by tired nerve cells, which may also extend to the brain.

Jasper Johns
22 *Untitled* **1980**
Colour lithograph
Signed and dated "77–80' in white pencil,
numbered '45/60' in pencil, blindstamp
of Gemini G.E.L., Los Angeles.
873 x 775 (34⅜ x 30½) sheet
ULAE 1994, 206
Johanna and Leslie Garfield

The two half-circles that dominate this
lithograph derive from the 'device' that
Johns began using in paintings in 1959
– a slat of wood, fixed at one end so it
can pivot to scrape an arc on the surface
of a painting, leaving behind a physical
trace of its actions. Such material records
are a frequent presence in Johns' work
– forensic evidence that points to a past
event. While the event in itself might be
meaningless, the act of pointing is at the
core of what it is to communicate and to
be human. It is what we do with language,
with pictorial representation, with memory.
In this print Johns pulls together a variety
of strategies from earlier paintings,
drawings and prints – primary colours;
the stencilled names of primary colours;
the overlaid numerals 0 through 9; the
device semi-circles; and within the arc on
the right the barely visible imprint of the
artist's arm and hand, the basis of all
pointing devices. **ST**

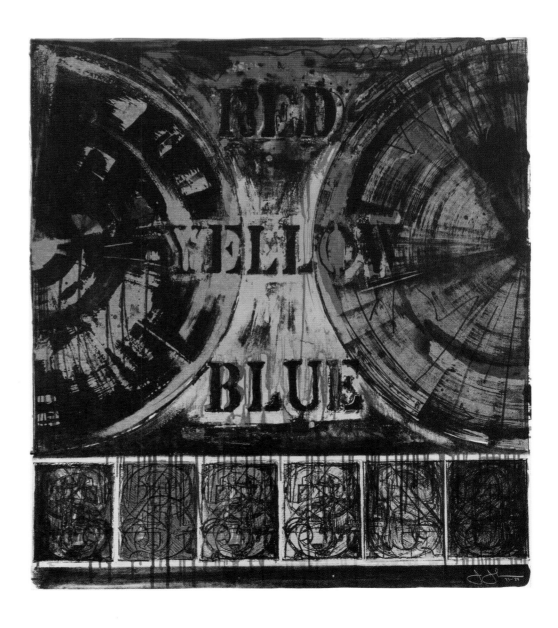

Jasper Johns

23 *Target with Four Faces* **1979**

Colour etching and aquatint

Signed, dated and numbered '49/88'

in pencil. 597 x 464 (23½ x 18¼) plate,

768 x 565 (30¼ x 22¼) sheet

ULAE 1994, 203

Johanna and Leslie Garfield

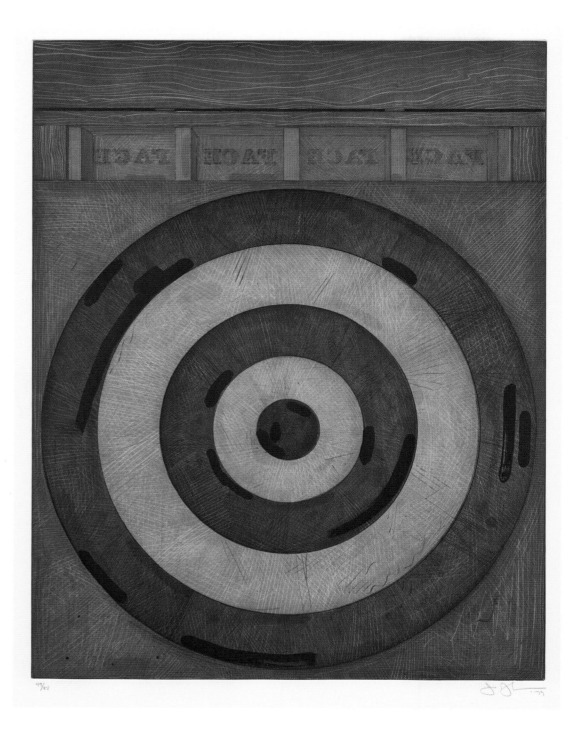

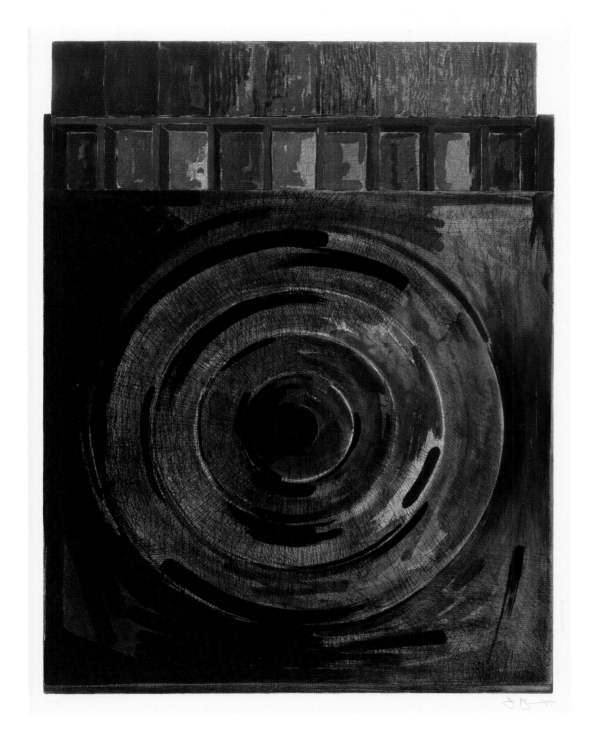

Jasper Johns
24 *Target with Plaster Casts* 1980
Colour etching and aquatint
Signed, dated and numbered '76/88'
in pencil. 599 x 452 (23⅝ x 17¾) plate,
755 x 567 (29¾ x 22⅜) sheet
ULAE 1994, 208
British Museum, London 2013,7080.2
Presented by Babs Thomson

These etchings refer to a pair of 1955
canvases, *Target with Four Faces*
(Museum of Modern Art, New York)
and *Target with Plaster Casts* (private
collection, USA) – works so influential
that, 'simply by existing,' the *New York
Times* critic Holland Cotter wrote, 'they
closed the door on one kind of art,
Abstract Expressionism, and opened
a door on many, many others'.[1]
In both works, painted targets are
surmounted by wooden pigeonholes with
hinged lids. One set contains painted,
cast anatomical fragments – part of a red
foot, an orange ear, a crimson hand, a
green penis, etc.; in the other, the raised
lid reveals four different casts of the
same face from nose to lower lip. The
confusion between abstraction, reality
and representation is continued in these
etchings from 1979–80, both printed at
Atelier Crommelynck in New York and
published by Petersburg Press, New York.
In *Target with Plaster Casts*, all nine
pigeonholes are empty but for the
luminous colours that match, in each
case, the colour of the painted cast. In
Target with Four Faces, each of the four
faces is simply replaced with the word
'FACE' stencilled backwards. The mute
opacity of the paintings is replaced with
gorgeous drawing and lucid jewel tones,
but nothing gets any clearer. **ST**

1 Holland Cotter, 'Bull's Eyes and Body Parts', *New
York Times*, 2 February 2007, www.nytimes.
com/2007/02/02/arts/design/02john.html?_r=0

Robert Rauschenberg

1925–2008

Born in Port Arthur, Texas, Milton Ernest Rauschenberg dropped out of
university after one term because of undiagnosed dyslexia. Later, his tendency to
'see everything in sight' would prove essential to his art.[1] After wartime service in
a Navy hospital, Rauschenberg – now called Bob – went to Kansas and Paris
before enrolling at Black Mountain College in North Carolina, where he studied
intermittently between 1948 and 1952. There he worked with Josef Albers, and
met Merce Cunningham and John Cage, whose belief that art's job was 'not to
suggest improvements in creation, but simply to wake up to the very life we're
living' was transformational.[2] With Jasper Johns in the 1950s, Rauschenberg
began producing a new kind of art – one not predicated on personal emotion,
but on an active investigation of the external world, a critical element in the shift
from modern to post-modern art. His Combines (1954–62) blurred the distinction
between painting and assemblage, and his Silkscreen Paintings (1962–64)
effectively transformed found images into paint. Rauschenberg's sweeping
curiosity, delight in risk-taking, and profound sociability made him the definitive
'interdisciplinary artist' – he worked with artisans and fabricators, performed with
dance companies, co-founded the Experiments in Art and Technology (EAT)
programme with engineers from Bell Labs and established the Rauschenberg
Overseas Cultural Interchange (ROCI). 'What he invented above all,' the critic
Leo Steinberg wrote, was 'a pictorial surface that let the world in again.'[3]
Rauschenberg himself argued, 'There is no reason not to consider the world
as one gigantic painting.'[4] **ST**

1 Robert Rauschenberg, quoted in Calvin Tomkins, 'Everything in Sight', *New Yorker* (23 May 2005), p. 70.

2 John Cage, 'Experimental Music', in *Silence*, Middletown, CT: Wesleyan University Press, 1961, p. 12.

3 Leo Steinberg, 'Reflections on the State of Criticism', *Artforum*, 10:7 (March 1972), pp. 37–49 (p. 49).

4 Robert Rauschenberg, quoted in Arnold Berleant, 'Aesthetics and the Contemporary Arts', *Journal of Aesthetics and Art Criticism*, 29:2
 (Winter 1970), p. 162.

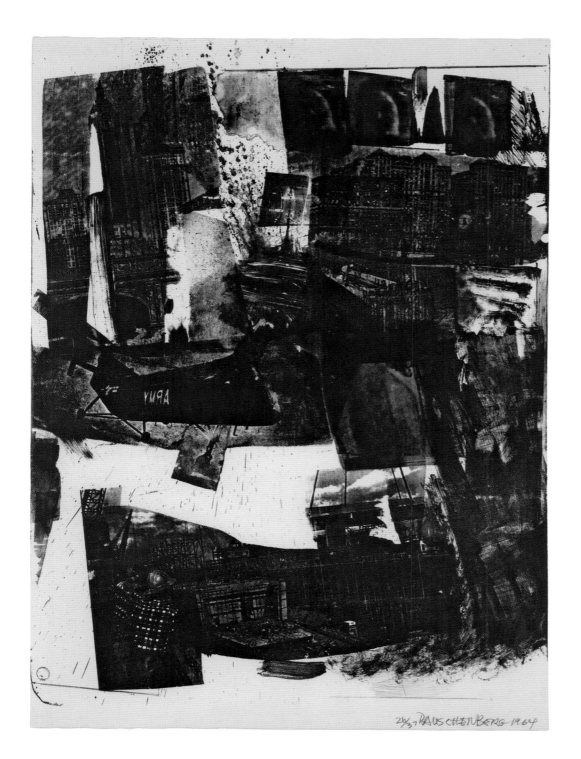

Robert Rauschenberg
25 *Spot* **1964**
Lithograph
Signed, dated and numbered '26/37' in
pencil, blindstamp of ULAE, West Islip,
New York. 1014 x 757 (39⅞ x 29¾)
image, 1047 x 757 (41¼ x 29¾) sheet
Foster 1970, 24; Sparks 20
British Museum, London 1979,1006.19

Rauschenberg spent years devising ways
to transfer images from one surface to
another without a press – he experimented
with photograms, solvent transfers, and
cars driven through paint puddles
and onto paper. Shortly after he began
making lithographs at ULAE in early
1962, Rauschenberg began using
commercially prepared printing screens
to transfer photographic imagery from
newspapers and magazines to his
paintings. The lithographic stone for *Spot*
was prepared using these same screens,
then overworked by the artist with
brushes and crayons, enveloping the
diverse photo-based images within an
open block of varying tones of black ink.
The ominous Army helicopter looming
here also appears in the painting *Archive*
(1963) (Collection of the Robert and
Jane Meyerhoff Modern Art Foundation),
where it is the colour of old blood, and in
the construction *Dry Cell* (1963) (Robert
Rauschenberg Foundation, New York)
where it hovers ethereally on Plexiglas.
Velázquez's *Rokeby Venus*, who reclines
voluptuously in many of Rauschenberg's
prints and paintings, appears here only
as the ghostly face caught in the mirror.
In and around these identifiable markers
buildings teeter and ink is flung in spots
and splashes. **ST**

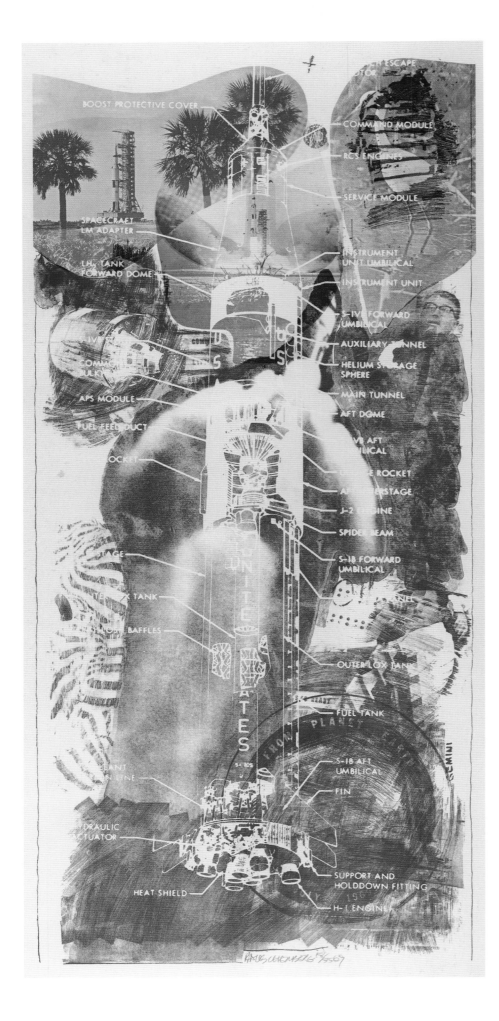

Robert Rauschenberg
26 *Sky Garden* from *Stoned Moon*
series 1969
Colour lithograph and screenprint
Signed, dated and numbered '18/35'
in pencil, blindstamp of Gemini G.E.L.,
Los Angeles. 2140 x 965 (84¼ x 38)
image, 2255 x 1067 (88¾ x 42) sheet
Foster 1970, 74; Fine 1984, 36
British Museum, London 2015,7027.1
Purchased with funds given by the
Vollard Group

'POWER OVER POWER JOY PAIN
ECSTASY. THERE WAS NO INSIDE, NO
OUT. THEN BODILY TRANSCENDING
A STATE OF ENERGY. APOLLO 11 WAS
AIRBORNE.'[1] Thus Robert Rauschenberg
described the 16 July 1969 lift-off of the
rocket that put men on the moon four
days later. Always fascinated by
technology, Rauschenberg had been
invited by NASA to Cape Kennedy
(now called Cape Canaveral), Florida, to
witness history in the making.[2] His *Stoned
Moon* series was the appropriately
ambitious, awestruck and cacophonous
result – thirty-three lithographs, including
the two largest hand-pulled lithographs
yet made, *Sky Garden* and *Waves*, whose
production had printers at Gemini working
around the clock. Given broad access
by NASA to facilities and personnel,
Rauschenberg met astronauts and
engineers, took in the vast Vertical
Assembly Building (now the Vehicle
Assembly Building), and observed the
wildlife that thrived in the surrounding area.

All these things enter into the prints, so, while the *Stoned Moon* series departs from his earlier work in being overtly about a specific event, it places that event within a kaleidoscopic, heterogeneous world. Pictures of birds meet pictures of astronauts, charts of precise scientific data coincide with clouds of scribbles and faint transfers. In *Sky Garden* a bright white diagram of the Saturn V rocket is screenprinted over an explosive red blast of human faces, machine parts and brushwork; in *White Walk* (cat. 30), blue and grey astronauts float amid control panels and puddles of ink enhanced by the embossing of the paper from a pock-marked lithographic stone; in *Sky Rite* (cat. 31), arcs of drawing give dynamic energy to the mission control room, while a pointing, spectacled figure assumes the heroic stature of Washington crossing the Delaware.

The violent late 1960s dented Rauschenberg's ebullient optimism, but in the collective – indeed collaborative – technological achievement of Apollo, he found redemptive beauty. (The title *Stoned Moon* is meant to evoke delirium.) Describing the night scene of the rocket being fuelled with liquid nitrogen, he wrote: 'the moon coming up, seeing the rocket turn into pure ice, its stripes and U.S.A. markings disappearing – and all you could hear were frogs and alligators… The whole project seemed one of the only things at that time that was not concerned with war and destruction'.[3] **ST**

1 Robert Rauschenberg, 'Notes on Stoned Moon', *Studio International*, 178:917 (December 1969), pp. 246–47 (p. 247).

2 Though most artists involved in the NASA Art Program were of a more realist bent, the organizers specifically sought 'the emotional impact, interpretation and hidden significance of these events' that artists could provide. See Hereward Lester Cooke and James D. Dean, *Eyewitness to Space*, New York: Harry N. Abrams, 1971, pp. 11–13.

3 Rauschenberg, in Calvin Tomkins, *Off the Wall: Robert Rauschenberg and the Art World of Our Time*, New York: Penguin Books, 1980, p. 288.

Robert Rauschenberg
27 Ar*ena I State I* from *Stoned Moon* series 1969
Lithograph in grey
Signed, dated and numbered '10/12' in pencil, blindstamp of Gemini G.E.L., Los Angeles. 1193 x 812 (47 x 32) sheet
Foster 1970, 92
British Museum, London 2012,7048.2
Purchased with funds given by the Joseph F. McCrindle Foundation to the American Friends of the British Museum

Robert Rauschenberg

28 *Tilt* from *Stoned Moon* series **1969**

Lithograph in blue and silver-grey

Signed, dated and numbered in pencil

'GIII' (outside ed. 60), blindstamp of

Gemini G.E.L., Los Angeles.

697 x 565 (27½ x 22¼) sheet

Foster 1970, 88

National Gallery of Art, Washington.

Gift of Gemini G.E.L. and the Artist, 1981

Robert Rauschenberg
29 *Medallion* **from** *Stoned Moon*
series 1969
Lithograph
Signed, dated and numbered in pencil
'GIII' (outside ed. 48), blindstamp of
Gemini G.E.L., Los Angeles.
813 x 647 (32 x 25½) sheet
Foster 1970, 90
National Gallery of Art, Washington.
Gift of Gemini G.E.L. and the Artist, 1991

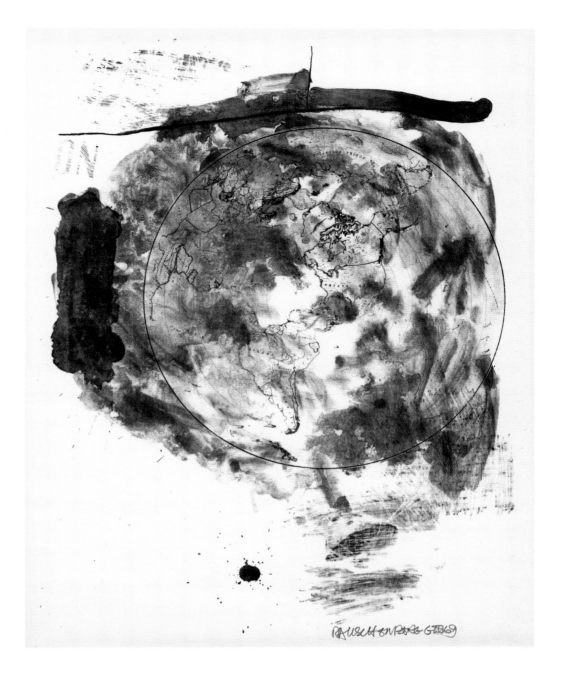

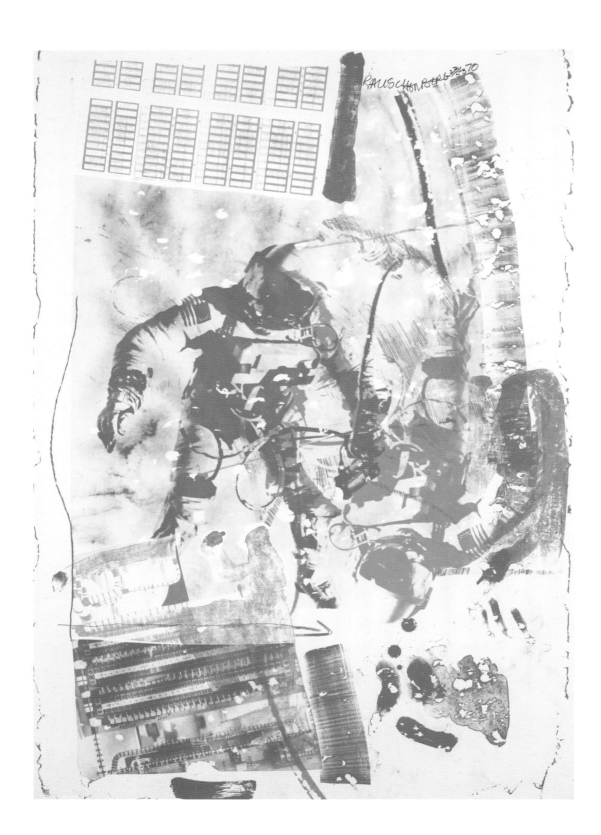

Robert Rauschenberg
**30 *White Walk* from *Stoned Moon*
series 1970**
Lithograph in green-grey, light and dark
blue
Signed, dated and numbered '22/53' in
pencil in image, blindstamp of Gemini
G.E.L., Los Angeles. 1073 x 749
(42¼ x 29½) sheet
Foster 1970, 95
British Museum, London 2014,7059.1
Purchased with funds given by the
Vollard Group

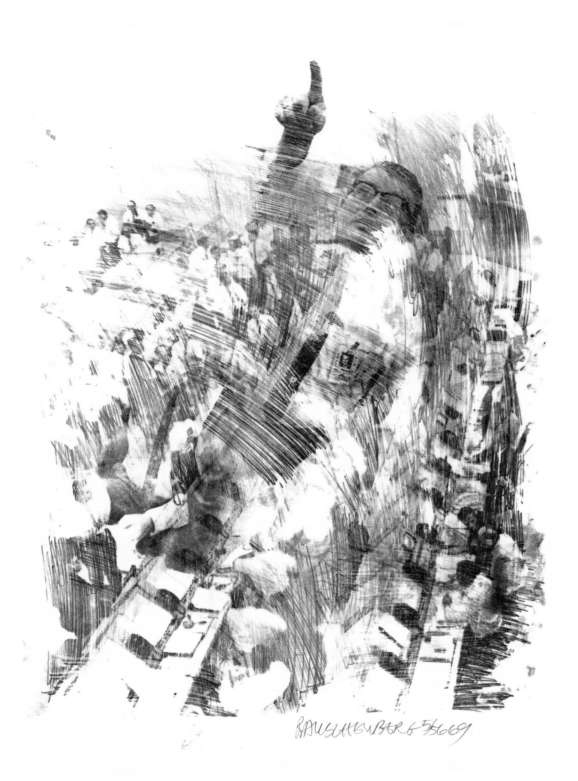

Robert Rauschenberg
31 *Sky Rite* **from** *Stoned Moon* **series**
1970
Lithograph
Signed, dated and numbered '5/56'
in crayon, blindstamp of Gemini G.E.L.,
Los Angeles. 838 x 583 (33 x 23) sheet
Foster 1970, 85
National Gallery of Art, Washington.
Gift of Benjamin B. Smith, 1985

Jim Dine

Born 1935

A prolific painter, printmaker, sculptor and photographer, Dine was born in Cincinnati, Ohio, where his father and grandfather ran a hardware store. After obtaining his BFA (1957) from Ohio University, Athens, he moved to New York City where he soon attained attention for his Happenings and for his paintings that included ordinary domestic objects, such as tools, which became associated as stand-ins for the artist. A founding member of the Judson Gallery, New York, he showed with Claes Oldenburg and Tom Wesselmann in 1959, although he bridled at being bracketed a pop artist by the critics. A passionate printmaker from his student years, in 1962 Dine was introduced by Jasper Johns to Tatyana Grosman of ULAE, West Islip, where he made his first tool lithographs. From 1967 to 1971 he lived in London where he engaged intensively in printmaking with the print publisher Paul Cornwall-Jones of Petersburg Press. On returning to the United States in 1971 to live in rural Vermont, his decision to draw from the figure marked a turning point in his career. In 1985 he left Vermont and established himself in studios in Connecticut and New York; in the early 1990s he set up a new studio for printmaking and sculpture in Walla Walla, Washington. A restless, roving artist, Dine has collaborated with master printers around the world, including Aldo Crommelynck, Paris, and Kurt Zein, Vienna, as well as in different workshops in America, such as Tamarind, New Mexico, and Graphicstudio, Florida. He has made over 1,000 prints; an archive of his prints is at the Museum of Fine Arts, Boston. In 2015 Dine presented to the British Museum over 200 prints in the form of single sheets, portfolios and illustrated books in honour of Alan Cristea, his London print dealer and publisher. **SC**

Jim Dine
32 *Self-Portrait in Zinc and Acid* **1964**
Etching
Signed, titled, dated '1964 December' and numbered '9/10', dedicated 'Merry Xmas Judith love Jimmy' in pencil, blindstamp 'ES' of the printer (Emiliano Sorini) lower right corner. 550 x 422 (21⅝ x 16⅝) plate, 754 x 562 (29⅝ x 22⅛) sheet
Mikro 25
British Museum, London 1979,1006.15

From the early 1960s the bathrobe has served as a surrogate of the artist's persona. 'I found this advertisement in the *New York Times*,' he later explained, 'and it looked like I was in it. It was an empty robe, and I thought, this is a good way to be a modern artist. I don't have to draw my face. So for a few years I used the bathrobe, and I kept calling them self-portraits.'[1] Beginning as a stand-in for the artist, the bathrobe has assumed an autonomous life in Dine's work, giving him the licence to make numerous iterations and improvisations. This etching is the first appearance of the bathrobe in his prints. The bathrobe is silhouetted as an outline against a dark tangle of expressive marks etched by the acid into the soft zinc plate. Produced in a small edition of ten in 1964, it was printed with the assistance of Emiliano Sorini who operated a press at the Pratt Graphic Workshop, New York. **SC**

1 Dine, in conversation with Clifford Ackley, 28–29 August 2010, in Clifford Ackley and Patrick Murphy, *Jim Dine Printmaker: Leaving My Tracks*, Boston: Museum of Fine Arts, 2012, p. 54.

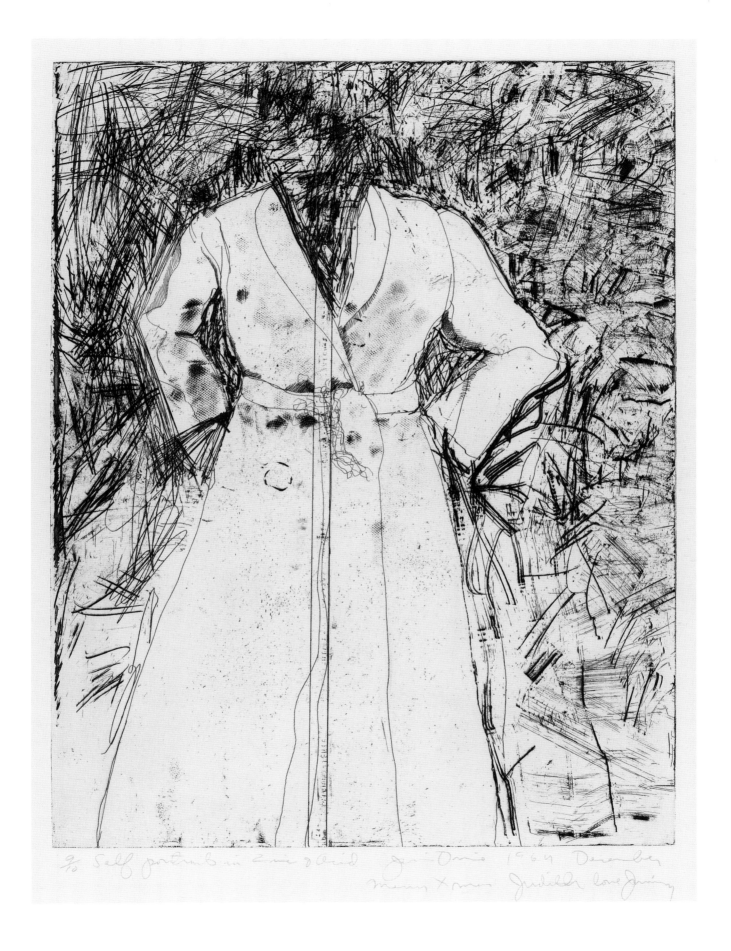

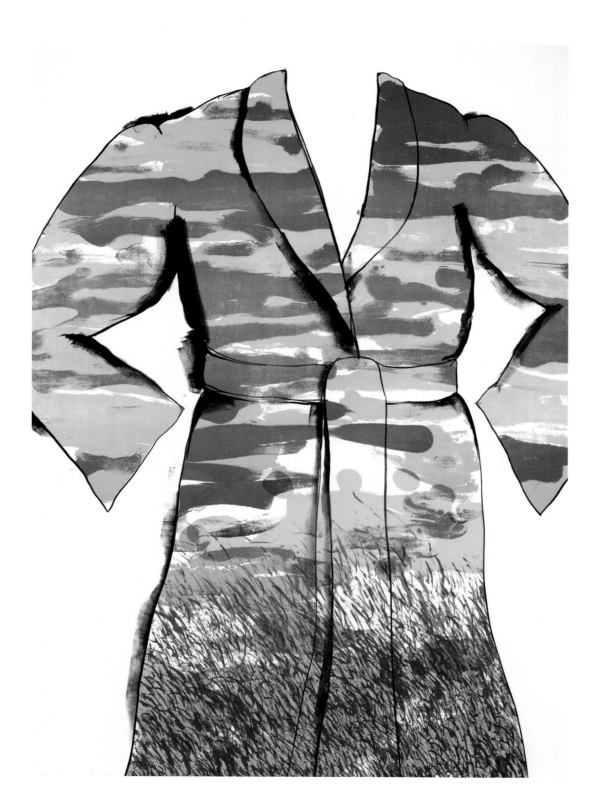

Jim Dine

33 *Self-Portrait: The Landscape* 1969

Colour lithograph
Signed, dated and inscribed 'A/P'
(artist's proof outside ed. 75) in pencil.
1350 x 960 (53⅛ x 37¾) sheet
Mikro 61
British Museum, London 2014,7067.6
Presented by the artist in honour of
Alan Cristea

This is the first of three monumental
bathrobes, almost life-size in scale, which
Dine made in 1969 using the same plate.
The other two are *Red Bathrobe* (Mikro
62) and *Night Portrait* (cat. 34). In this
version Dine has superimposed elements
of sky and grass on to the bathrobe to
evoke his identification with a sun-filled,
open-air landscape. The artist later recalled:
'The landscape was in the robe – sky,
a little sun, a little grass, a little dirt…[It]
was the first time I made a bathrobe in
printmaking that large. It had a big
presence as I wanted the *landscape* to be
in the robe and behind it but the robe was
to stand alone in space. The *landscape*
was not a decorative print on the fabric
of the dressing gown but an independent
element in the life of this object.'[1]

 In contrast to the sun-lit day portrait, a
night portrait (cat. 34) is evoked by Dine
by printing the same lithographic outline
in white ink on a black background. **SC**

1 Jim Dine, *A Printmaker's Document*, Göttingen:
 Steidl, 2013, p. 42.

Jim Dine

34 *Night Portrait* **1969**

Lithograph

Signed, dated and inscribed 'A/P'

(artist's proof outside ed. 21) in white

pencil. 1350 x 960 (53⅛ x 37¾) sheet

Mikro 63

British Museum, London 2014,7067.7

Presented by the artist in honour of

Alan Cristea

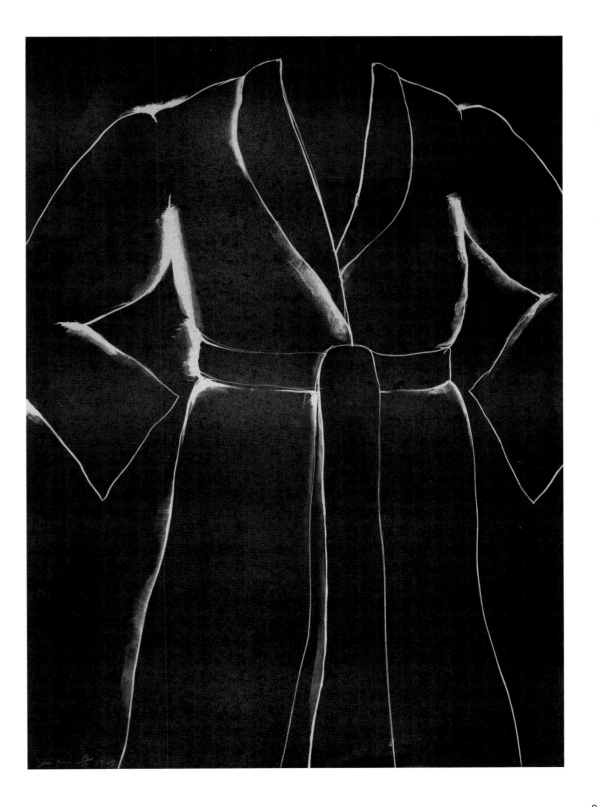

Jim Dine

35 *The Picture of Dorian Gray* **1968**

Illustrated book with 12 lithographs and 4 loose etchings

Signed on last page in green felt pen, inscribed 'Ed B' and 'A/P'. 440 x 310 (17⅜ x 12¼) each sheet

Mikro 47

British Museum, London 2014,7067.2.1-16

Presented by the artist in honour of Alan Cristea

Dine's script adaptation of Oscar Wilde's novel *The Picture of Dorian Gray* (1891) is the first of his many book projects. It was produced as a deluxe publication in collaboration with Paul Cornwall-Jones of Petersburg Press in London. Dine had been asked by Robert Kidd, a director working with the Royal Court Theatre, to prepare costume and set designs for a theatrical production of Wilde's masterpiece of the English decadence and the Aesthetic Movement. When this did not go ahead because the lead actor

absurdly complained the costumes were obscene, Dine used the drawings as the basis of lithographs to accompany a typewritten text of the script as a lavishly produced book. It was published in three sumptuous bindings: edition A in red velvet, edition B (this copy) in green velvet and edition C in red leather. Dine described the book as 'a book of costumes' and 'one of the most indulged things I ever made…that's how Dorian Gray was – completely indulged'.[1] The peacock costumes in which Dorian

parades through the book recall the extravagant fashions of the Swinging Sixties. The incorporation of words as integral to the image was a device that Dine adopted in his work from the early 1960s. **sc**

1 Jim Dine, 'Lithographs and Original Prints: Two Artists Discuss their Recent Work', supplement to *Studio International*, 175 (June 1968), p. 337, cited by Elizabeth Carpenter, 'Of Arts and Letters: Jim Dine's *Livres d'Artiste*', in *Jim Dine Prints 1985–2000: A Catalogue Raisonné*, Minneapolis: The Minneapolis Institute of Arts, 2002, p. 34.

HENRY Yes. Yes, you are. No renunciations. At present you are a perfect type.

DORIAN I wich that were true.

HENRY You know you are. Besides, Dorian, don't deceive yourself. Life is not governed by will or intention. Life is a question of nerves, and fibres, and slowly built-up cells in which thought hides itself and passion has its dreams. You may fancy yourself safe, and think yourself strong. But a chance tone of colour in a room or a morning sky, a particular perfume that you had once loved and that brings subtle memories with it, a line from a forgotten poem that you had come across again, a cadence from a piece of music that you had ceased to play - I tell you, Dorian, that it is on things like these that our lives depend. I wish I could change places with you. The world has cried against us both, but it has always worshipped you. It always will. You are the type of what the age is searching for, and what it is afraid it has found.

 DORIAN rises from the piano and passes his hand through his hair.

DORIAN Yes, life has been exquisite.

HENRY Why have you stopped playing? Give me the nocturne over again. ... that great honey-coloured moon that hangs in the dusky air. Whe is waiting for you to charm her, and if you play, she will come closer to the earth.

DORIAN You are very sweet, Harry, I can't play any more.

HENRY Let's go to the club, then. It has been a charming evening and we must end it charmingly.

DORIAN It's very late.

HENRY There is someone at White's who wants immensely to know you - young Lord Poole. He's already copied your neckties and has begged me to introduce him to you. He's quite delightful and rather reminds me of you.

DORIAN I hope not. (With a sad look in his eyes) I'm tired tonight, Harry. I shan't go to the club. It is nearly eleven, and I want to go to bed early.

HENRY What a pity. You have never played so well as tonight.

DORIAN (smiling) It is because I am going to be good. I'm a little changed already.

HENRY You can't change to me. You and I will always be friends.

DORIAN Yet you poisoned me with a book once. I should not forgive that.

HENRY My dear boy, you are really beginning to moralize.

DORIAN Harry, promise me that you will never lend that book to anyone. It does harm.

HENRY You and I are what we are, and will be what we will be. As for being poisoned by a book, there's no such thing as that. The books that the world calls immoral are books that show the world its own shame. That is all. Come round tomorrow. I'm going to ride at eleven. We might go together.

DORIAN Must I ?

HENRY Certainly ! The Park is quite lovely now. I don't think there have been such lilacs since the year I met you.

DORIAN Very well. I shall come round at eleven. Goodnight, Harry.

HENRY Goodnight, Dorian

 HENRY begins to go.

DORIAN Harry...

 DORIAN is about to say something but doesn't. Instead, he picks up the book with the yellow cover and hands it to HENRY. HENRY takes it with a smile. He goes. Slowly DORIAN picks up the mirror and looks at himself. He lets the mirror fall from his hands. He unlocks the painting. For a few moments he looks at it. He seizes the knife and lunges at the picture. As he stabs he lets out a great cry. He falls to the floor, motionless. The picture becomes as it was in the beginning. HENRY and VICTOR enter.

HENRY Dorian ! What's happened?

VICTOR I heard a great cry, monsieur.

HENRY Sasil's painting ! (He looks at it for a moment then sees the body)

VICTOR Look

 HENRY examines the body.

HENRY Who is this man, Victor? He is like a monster.

VICTOR I don't know, monsieur.

HENRY Find Mr. Gray !

VICTOR Monsieur Gray ! Monsieur Gray !

 HENRY has the ring in his hand.

HENRY Dorian !

Handwritten annotations: Dorian is never seen touching piano keys — big red — he just pretends. piano

final portrait is 10' x 5' enlarged head of Dorian Screaming

DORIAN GRAY

Jim Dine

36 *Five Paintbrushes (first state)* 1972
Etching
Signed, dated '1973' and inscribed 'A/P'
(1 of 15 artist's proofs outside ed. 75)
in pencil. 600 x 900 (23⅝ x 35½) plate,
760 x 900 (29⅞ x 35½) sheet
Krens 135
British Museum, London 2014,7067.22
Presented by the artist in honour of
Alan Cristea

The paintbrush, the artist's most obvious tool, became one of Dine's most persistent subjects. The various transformations of *Five Paintbrushes* from the same plate are among his most celebrated etchings. At each stage an edition was printed; these were published by Petersburg Press, initially in London and then in New York. The etching began with five regularly spaced paintbrushes, different in size and shape, hanging in a line. Six additional brushes were interposed in the spaces between the original five paintbrushes in the second state. For the third state (cat. 37), the bristles of the brushes were lengthened and made fuller by adding more etching and drypoint lines, the hairs appearing almost to twitch and sprout. The plate itself was cut in size at the top and from the right side, reducing the number of brushes to ten (although the original title of *Five Paintbrushes* was retained). Texture was added to the area around the handles with an electric sander. In the fourth state the plate was further reduced in size at top and bottom, a grey background tone was added with soft-ground, and an aquatint applied to give a darker mottled effect on the handles. In the fifth state etched and drypoint lines further darkened the background. The final sixth state (cat. 38) was the same in all respects as the previous one except that it was printed in a black-green ink. Exploring the metamorphosis of the image through printmaking, Dine called *Five Paintbrushes* 'my first example of a serial image, building on a plate, building and changing it in states, like Picasso'.[1] **SC**

1 Jim Dine, *A Printmaker's Document*, Göttingen: Steidl, 2013, p. 65.

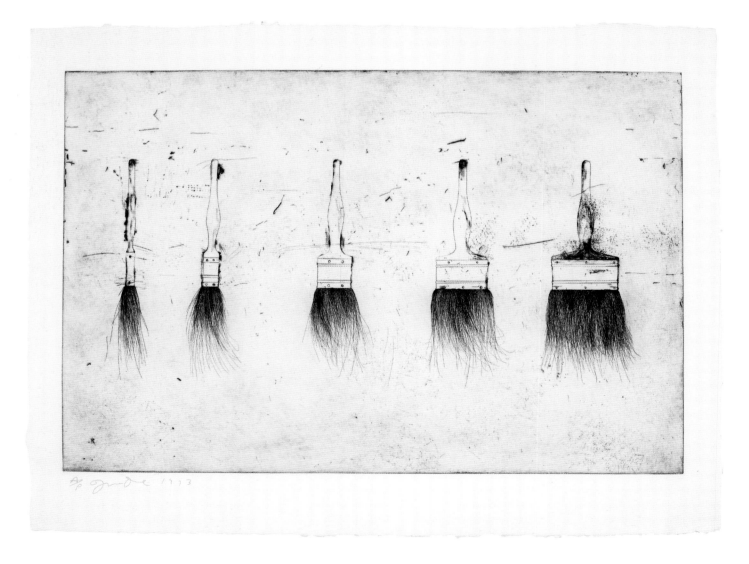

Jim Dine

37 *Five Paintbrushes (third state)*

1973

Etching and drypoint

Signed, dated and inscribed 'A/P'

(1 of 7 artist's proof outside ed. 28)

in pencil. 520 x 695 (20½ x 27⅜) plate,

750 x 900 (29½ x 35½) sheet

Krens 137

British Museum, London 2014,7067.23

Presented by the artist in honour of

Alan Cristea

Jim Dine

38 *Five Paintbrushes (sixth state)*

1973

Etching, drypoint, soft-ground and aquatint

Signed, dated and numbered '11/25' in

pencil. 356 x 692 (14 x 27¼) plate,

698 x 1003 (27½ x 39½) sheet

Krens 140

British Museum, London 2004,0602.43

Bequeathed by Alexander Walker

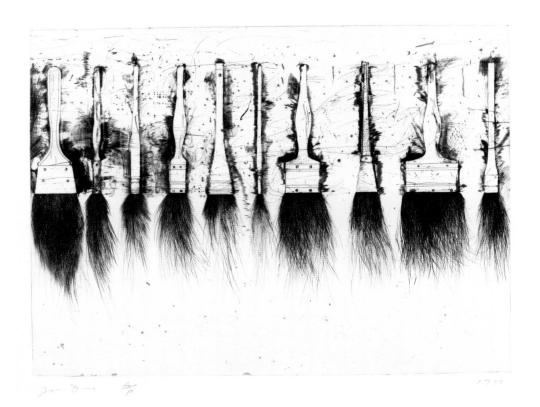

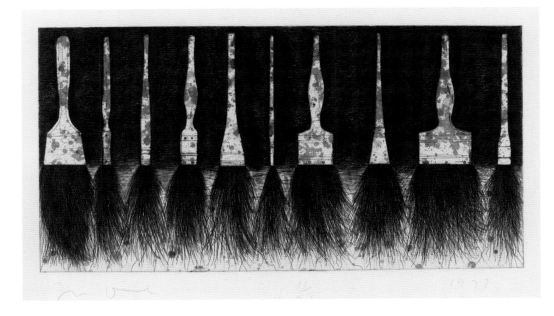

Jim Dine

39 *Big Red Wrench in a Landscape*
1973
Colour lithograph
Signed, dated and inscribed 'A/P 7/15'
(artist's proof outside ed. 120) in pencil,
printed by William Law, published by
Petersburg Press, New York, and Ulstein
Propyläen Verlag, Berlin (with their
blindstamp). 760 x 570 (29⅞ x 22½) sheet
Krens 146
British Museum, London 2014,7067.27
Presented by the artist in honour of
Alan Cristea

Jim Dine

40 *Bolt Cutters (second state)* **1973**
Etching and aquatint
Signed, dated and numbered '5/45'
in pencil. 615 x 605 (24¼ x 23⅞) plate,
1010 x 780 (39¾ x 30¾) sheet
Krens 144
British Museum, London 2014,7067.26
Presented by the artist in honour of
Alan Cristea

Often depicted life-size, Dine's tools –
wrenches, bolt cutters, paintbrushes,
saws – can be read as potent male
symbols, erect and upright. With its head
angled in the upper right corner and its
legs opened wide, this pair of bolt cutters
becomes a metaphor for the human form.
Dine has referred to Rembrandt as the
inspiration for the scribbled etched lines
and the chiaroscuro effects of light and
dark. A paintbrush can just be discerned in
each of the two lower corners. The etching
was printed and published by Petersburg
Press in New York. It was made from the
same plate as *Bolt Cutters (first state)*,
which was oriented to the upper left corner
and much sparer in outline. **SC**

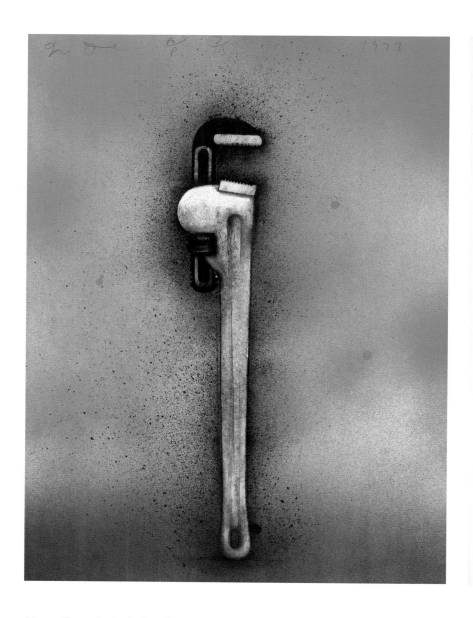

Jim Dine

41 *Saw* **1976**

Etching

Signed, dated and inscribed 'A/P' (1 of 4 artist's proofs outside ed. 30) in pencil.

820 x 575 (32¼ x 22⅝) plate,

1070 x 755 (42⅛ x 29¾) sheet

Krens 207

British Museum, London 2014,7067.48

Presented by the artist in honour of Alan Cristea

Through his mastery of the etched line, Dine's tools possess an extraordinary presence. In this etching the background is composed of back-and-forth horizontal strokes suggesting those made by a saw cutting through timber. At this time, in the mid-1970s, Dine began to use power tools, such as the die grinder, Dremel and even the chainsaw, to abrade and work the metal plates for his etchings, and later to carve the blocks for his woodcuts. This was printed at Tampa, Florida, with Mitchell Friedman, the young printer with whom he collaborated on many of his etchings. The grey tonal areas on the saw's blade were achieved by painting the acid directly on the plate and leaving it exposed to the Florida sun.[1] **SC**

1 Thomas Krens, *Jim Dine Prints: 1970–1977*, Williamstown, MA, and London: Williams College Museum of Art, 1977, p. 113.

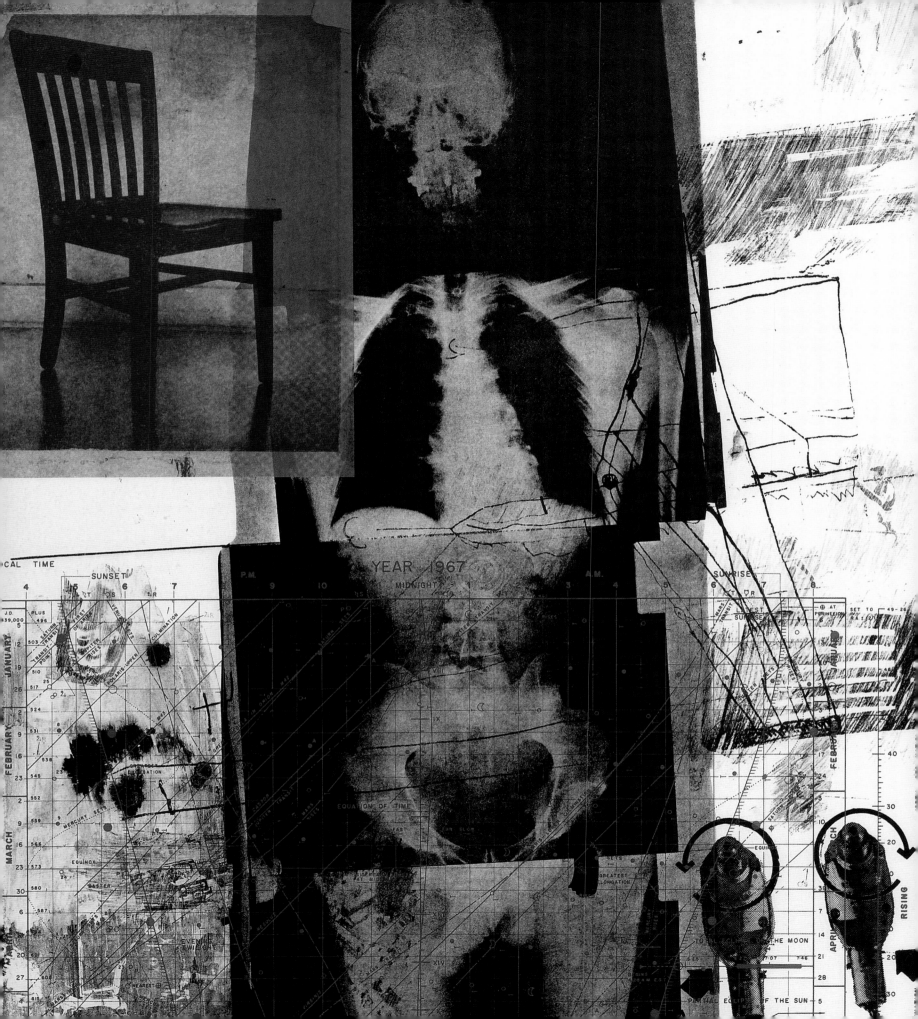

3 The print workshop
Laboratories of experimentation and collaboration

The achievements of printmakers such as Jasper Johns and Robert Rauschenberg would never have been possible without the infrastructure, expertise, flexibility and encouragement provided by print workshops such as Universal Limited Art Editions on Long Island, New York, and Gemini G.E.L. in Los Angeles. Since the 1960s, enterprising figures such as Tatyana Grosman (founder of ULAE, 1957) and Ken Tyler (co-founder of Gemini, 1966) have been instrumental in encouraging painters and sculptors first to take up printmaking and then to create work of unprecedented ambition. Without the collaborative nature of these workshops, pioneering prints such as Rauschenberg's prize-winning lithograph *Accident* (ULAE, 1963, cat. 44), Oldenburg's sculptural *Profile Airflow* (Gemini, 1969, cat. 49) and Chuck Close's *Keith/Mezzotint* (Crown Point Press, 1972, cat. 114) could never have been made.

The 1960s–70s was a period of great experimentation in American printmaking largely due to the willingness of printers to take risks. At Gemini, Tyler and his team facilitated some of Rauschenberg's most ambitious and off-beat prints, including *Booster*, 1967 (cat. 45), then the largest handmade lithograph ever made, and the *Cardbirds* series (1971, cats 46 and 47), which included printed facsimiles of cardboard boxes from the artist's studio. Less off-beat but just as technically challenging, Johns' *Color Numeral Series*, printed at Gemini in 1968–69 (cat. 50), prompted Tyler and his team to develop a new system of inking to achieve the complex sequence and delicate gradations of colour that the artist required. The creatively fertile relationships that developed between artists and printers at this time established a culture that has endured in the workshops ever since. It is a culture that has encouraged many artists to take up printmaking, who might otherwise have considered the medium too limiting, and which continues to yield new and exciting results.

Jasper Johns

For biography see page 58

42 *0 through 9* 1960

Lithograph

Signed, dated and numbered '22/35' in pencil, blindstamp of ULAE, West Islip, New York. 622 x 479 (24½ x 18⅞) image, 699 x 540 (27½ x 21¼) sheet
Field 1970, 4; Sparks 4; ULAE 1994, 3
National Gallery of Art, Washington. Rosenwald Collection, 1964

In this lithograph from 1960, one of his very first prints made at ULAE on Long Island, New York, Johns outlined ten typographic numerals one on top of the other, creating an accumulation of lines that either subsumes infinity (every possible combination of every number), or means nothing at all, depending on how you look at it. And looking at it is precisely what Johns asks us to do. Though from a technical point of view the lithograph is simple and straightforward, the drawing on the stone is graceful and inexplicably poignant. This image of overlaid numerals is also the subject of several paintings and drawings, and recurs in dozens of Johns' print editions. Visual symbols for abstract concepts (and more broadly, of the possibly arbitrary but internally consistent system of mathematics), the numerals presented an opportunity for intertwined formal and conceptual play. **ST**

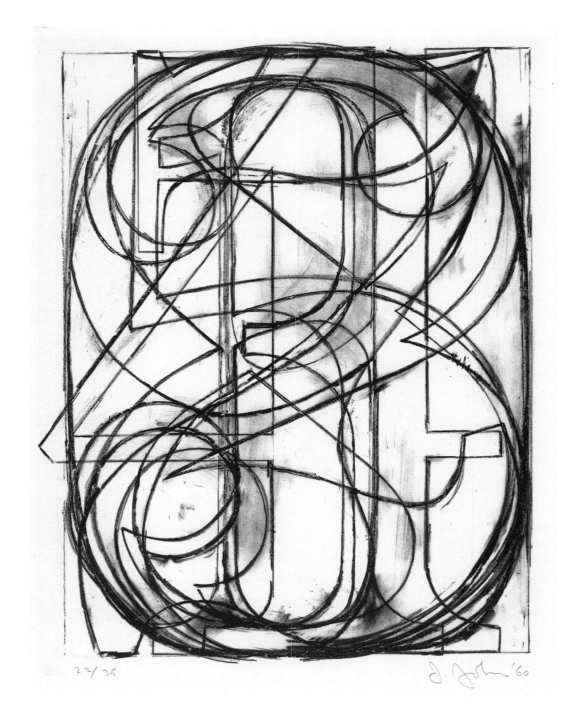

Jasper Johns

43 *Voice* **1966–67**

Lithograph and photo-lithograph
Signed and dated '66-67' in felt-tip pen
and numbered in pencil '4/5 Artist's Proof'
(outside ed. 30), blindstamp of ULAE,
West Islip, New York. 1150 x 783
(45¼ x 30⅞) image (irregular),
1231 x 813 (48½ x 32) sheet
Field 1970, 59; Sparks 67; ULAE 1994, 31
British Museum, London 1980,1011.18

Johns' work of the 1960s incorporated
an eclectic set of images, words, objects,
and traces of objects, reused in endless
re-combinations, as he prodded and
tested the strength of attachment
between a thing and the other thing it
claimed to represent. This enigmatic print
shares three elements with a concurrent
painting (The Menil Collection, Houston)
of the same name: the stencilled word
VOICE; a spoon and fork dangling on the
right-hand edge; and a rectangle that
presents itself as an artefact of a past
action. In the painting, a gawkily elongated
version of Johns' 'device' swipes an arc
through grey paint, stopping just before
the word VOICE. The print, however, is
dominated by an ambiguous, tonal smear
– the index of some unknown event. The
cutlery, reproduced photographically and
printed in silver, is simultaneously credible
and false. And the letters V-O-I-C-E, set
across the bottom edge like objects on
a shelf, suggest a silent kōan. **ST**

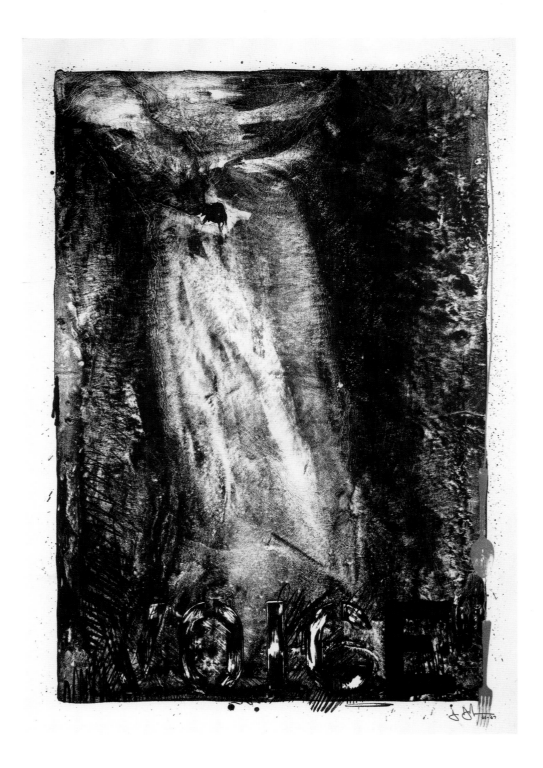

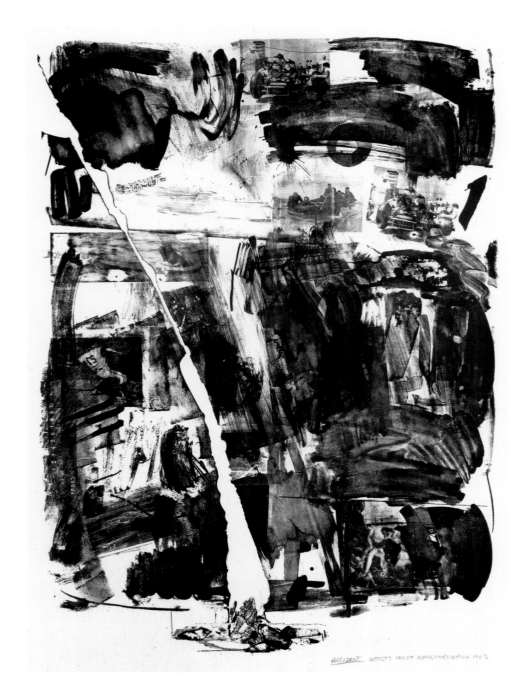

Robert Rauschenberg
For biography see page 70
44 *Accident* **1963**
Lithograph
Titled, signed, dated and numbered
'17/29' in pencil, blindstamp of ULAE,
West Islip, New York. 973 x 700
(38¼ x 27½) image, 1048 x 749
(41¼ x 29½) sheet
Foster 1970, 12; Sparks 9
British Museum, London 2016,7078.1
Purchased with funds given by the
Vollard Group, Gifford Combs, Margaret
Conklin and David Sabel and other
individual contributors

Rauschenberg said he began lithography
'reluctantly, thinking that the second half
of the twentieth century was no time to
start writing on rocks,'[1] but he was a
natural. Printmaking suited his persistent
fascination with repetition and erasure,
his voracious appetite for cultural jetsam,
his love of collaborative working situations
and his delight in the unexpected.
Nowhere is this clearer than in *Accident*,
the print that first called global attention
to the new American art when it won the
Grand Prize at the Fifth International
Exhibition of Prints in Ljubljana in 1963.
Its dynamic structure – a bolt of white
cutting through dark swathes of action
– was the gift of catastrophe. The
stone bearing Rauschenberg's dense
assemblage of borrowed photographs
and painterly gestures broke in the press.
He recreated it all on a new stone, but
when that broke also, he chose to print
from the pieces. He then made a sketch
of some broken pieces on another stone
to be printed at the bottom of the fissure
– a visual pun, and a means of sharing
the last word. **ST**

1 Robert Rauschenberg quoted in a press release from
the Museum of Modern Art, no. 81, 20 June 1963.

Robert Rauschenberg

45 *Booster* **from** *Booster and*
7 Studies **1967**

Colour lithograph and screenprint
Signed, dated and numbered '37/38' in
pencil, blindstamp of Gemini G.E.L., Los
Angeles. 1829 x 902 (72 x 35½) sheet
Foster 1970, 47
British Museum, London 2016,7071.1
Purchased with funds given by the
Vollard Group and Hamish Parker

Booster is a life-sized self-portrait, a
composition dominated by six lithographed
X-rays of the artist's body, extending 1.8
metres in height. Around the figure are
clouds of sketchy photo transfers; a pair
of jet engines hovers to the right of the
hip. Overtop all this, intense, discrete colour
is provided by a chair lithographed in blue
and the sharp red screenprinted lines and
coordinates of the artist's star chart. This
was Rauschenberg's first project with
master printer Ken Tyler's new Los
Angeles workshop, Gemini; a chance
for artist and printer to redefine what a
contemporary print might be in terms of
scale, materials and methods. Neither
saw any value in sticking to technologies
and aesthetic priorities that predated the
century. Compared to his work at ULAE,
Booster is bigger, sharper, cooler and
despite the subject matter, less personal
in character. Rauschenberg valued both
approaches and continued to work at
both workshops almost until his death. **ST**

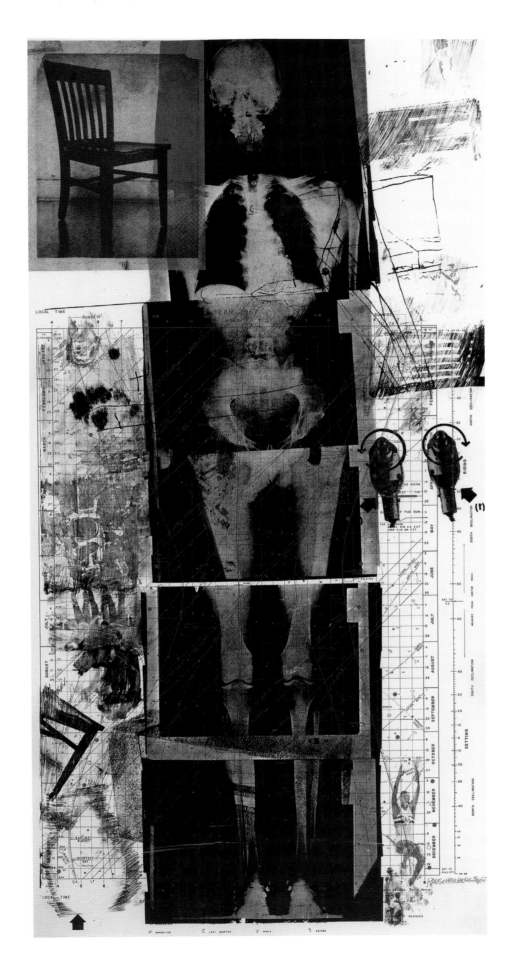

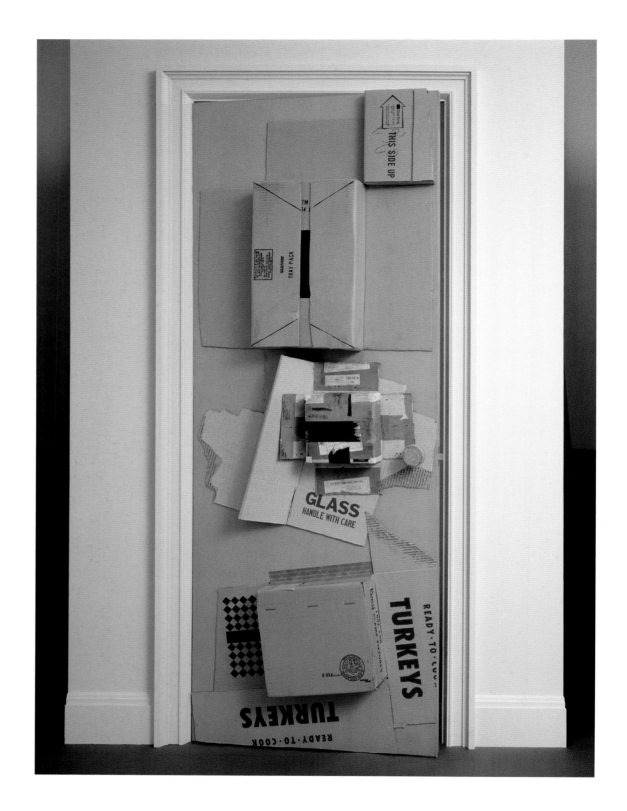

Robert Rauschenberg
46 *Cardbird Door* 1971
Cardboard, paper, tape, wood, metal,
offset lithography and screenprint
Signed and dated '6/25/71' in black
felt-tip pen, blindstamp of Gemini G.E.L.,
Los Angeles. 2032 x 762 x 279
(80 x 30 x 11) overall
Fine 1984, 37
National Gallery of Art, Washington.
Gift of Gemini G.E.L. and the Artist, 1981

Robert Rauschenberg

***47 Cardbird III* 1971**

Collage print comprising offset
lithography, screenprint, tape and
polythene on corrugated cardboard
Verso: signed and numbered '41/75' in
black ink, copyright stamp of Gemini
G.E.L, Los Angeles. 900 x 900
(35½ x 35½) (irregular)
British Museum, London 2011,7077.1
Purchased with the Presentation Fund
in honour of Antony Griffiths

In 1970 Rauschenberg moved to Captiva
Island off the coast of Florida and his
work took on a new tenor. The 1960s
had been a time of open, sometimes
frenetic experimentation for Rauschenberg
– exploded art forms, cutting-edge
technologies and political activism that
left him exhausted.[1] He began the new
decade with a series of works that carried
no overt social message and were made
from the lowliest of contemporary jetsam:
scavenged cardboard boxes, cut open
and arranged with minimal interventions.

The *Cardbirds* produced at Gemini are
painstaking facsimiles of found-material
constructions, down to the last torn edge
and smudge of dirt. Rauschenberg viewed
cardboard as 'a material of waste and
softness', a source of happy engagement.[2]
The *Cardbirds* ask to be considered as
integral things, rather than blank slates
for receiving images. *Cardbird Door*,
designed to fit a standard jamb and
function as a door, is perhaps the ultimate
statement of Rauschenberg's desire 'to
act in the gap'[3] between art and life: a
print/sculpture/installation you can walk
into, through, and out the other side. **ST**

1 To act on behalf of social justice, Rauschenberg
 wrote, 'I have had to concentrate almost exclusively
 on gloom and filter joy, investigate cruelty and
 suspect all changes. This is my responsibility,
 but it is exhausting.' Robert Rauschenberg, 'Note:
 Cardbirds', in *Rauschenberg: Cardbirds*, Los
 Angeles: Gemini G.E.L., 1971, n.p.
2 Ibid.
3 Robert Rauschenberg, 'Artist's Statement: Robert
 Rauschenberg', in Dorothy Miller, ed., *Sixteen
 Americans*, New York: MoMA, 1959, p. 58.

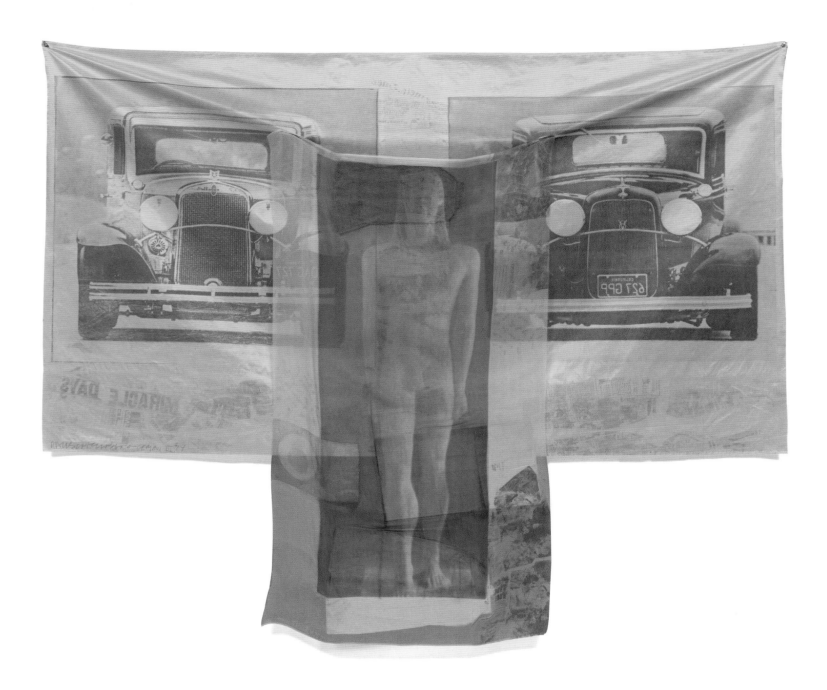

Robert Rauschenberg

48 *Preview* from *Hoarfrost Editions*
1974
Offset lithograph, newsprint, screenprint
transfers and collage on silk chiffon and
silk taffeta fabric
Signed, dated and numbered 'Gemini III'
in pencil, blindstamp of Gemini G.E.L.,
Los Angeles. 1753 x 2045 (69 x 80½)
overall
Fine 1984, 40
National Gallery of Art, Washington.
Gift of Gemini G.E.L and the Artist, 1981

The nine works collectively called the
Hoarfrost Editions are constructed from
sheer fabrics onto which images have
been put with lithography, screenprint, and
direct transfer (newspaper and magazine
pages were crumpled, doused with solvent,
and run through the press). In *Preview*, an
expanse of fabric carrying the image of
an archaic Greek *kouros* sculpture is
flanked by two classic American cars
from the 1930s – a Chevy and a Ford
– printed on the sheet behind. The formal
symmetry of these powerful images is

offset by the murmur of headlines,
advertising and other ephemera that runs
around and through them; the temptation
to read the material as fragile veils is
blocked by the paper bags that are affixed
to them here and there. Finally, the figure's
monumental solidity is undermined by
every passing breeze, as it causes the
diaphanous fabric to lift and sway. The
persistent human desire to fix things in
their proper place is clearly on view, as is
its inevitable failure, and the beauty that
failure can bring. **ST**

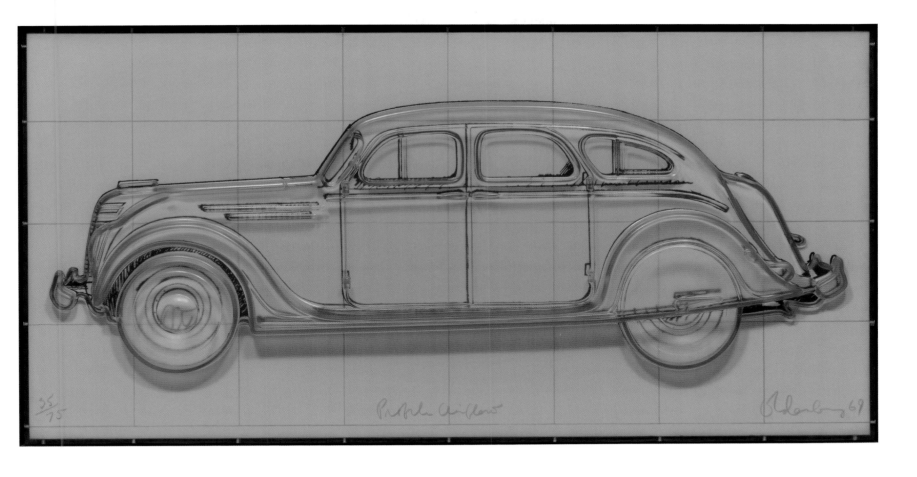

Claes Oldenburg

For biography see page 42

49 *Profile Airflow* **1969**

Moulded polyurethane relief over
lithograph in aluminium frame
Signed, dated, titled and numbered
'35/75' in pencil, blindstamp of Gemini
G.E.L., Los Angeles. 857 x 1665 x 93
(33¾ x 65½ x 3⅞) (irregular)
Platzker 59; Fine 1984, 14
Museum of Modern Art, New York.
Gift of John and Kimiko Powers, 1971

The Chrysler Airflow was the streamlined
automobile produced briefly in the
mid-1930s by the Chrysler Corporation
in Detroit; its revolutionary aerodynamic
body designed by Carl Breer proved too
advanced for its time, however, and
production ceased in 1937. Inspired since
childhood by the Chrysler Airflow that
he owned as a toy model, Oldenburg
fabricated this sculptural rendition as
a multiple at Gemini in 1969 using the
extraordinary technical ingenuity of the
master printer Ken Tyler and access to

the high-technology industries of the Los
Angeles area. Oldenburg spent a year
making the wooden reliefs from which
the moulds for the polyurethane cast
was made. His precise specifications for
the *Profile Airflow* relief were that it be
'clear in color, transparent like a swimming
pool but of a consistency like flesh, and
that these conditions be "permanent"'.[1]
The first batch of Profile Airflows
released on the market was found
to have turned from swimming pool
blue-green to yellow. Like defective cars,

the discoloured models were recalled and
replacements made with a different mix
of chemicals. **SC**

1 Claes Oldenburg's case history, in *Claes Oldenburg:
 The Multiples Store*, exh. cat., National Touring
 Exhibitions, Hayward Gallery, London, 1996, p. 32.

Jasper Johns
50 *Figures 0-9* from *Color Numeral Series* **1969**

A suite of 10 colour lithographs
Each signed, dated and numbered in a different coloured pencil, blindstamp of Gemini G.E.L., Los Angeles. 686 x 533 (27 x 21) each image, 965 x 790 (38 x 31⅛) each sheet
Field 1970, 104–113; ULAE 1994, 59–68
National Gallery of Art, Washington
0 Gift of Gemini G.E.L and the Artist, in Honor of the 50th Anniversary of the National Gallery of Art, 1990
1 Gift of Gemini G.E.L and the Artist, 1981
2 Gift of Woodward Foundation, Washington, DC, 1976
3 Gift of Gemini G.E.L and the Artist, 1991
4 Gift of Gemini G.E.L and the Artist, 1991
5 Gift of Woodward Foundation, Washington, DC, 1976
6 Gift of Gemini G.E.L and the Artist, 1991
7 Gift of Gemini G.E.L and the Artist, 1981
8 Gift of Gemini G.E.L and the Artist, 1991
9 Gift of Gemini G.E.L and the Artist, in Honor of the 50th Anniversary of the National Gallery of Art, 1990

One of Johns' first projects as a fledgling printmaker at ULAE in 1960 was a series of numerals (*0 through 9*, 1960–63) (see fig. 3, p. 22); for his first project at Gemini, seven years later, he again turned to the numeral sequence. But where the ULAE numerals were modest in size, handcrafted in feel, and suited to the slow perusal of the portfolio format, the Gemini numerals has the dramatic presence of installation art. Using deep and delicate washes,

Johns created heroic portraits of each symbol. Initially printed in sheer films of black and grey, the stones were reprinted for the *Color Numeral Series* using a sequential programme of three-colour rolls. In each successive print, two colours move down and a new one is added at the top (thus red-yellow-blue in *0* becomes purple-red-yellow in *1* and so on). The sequence uses the three primary colours (red, yellow and blue) and the three

secondary colours (orange, green and purple) in complex rotation. A colour enters at the top, then moves to the middle, then to the bottom, and is then absent for three prints before reappearing again at the top. The system is intricate enough that it is felt by the eye rather than recognized by the mind, a quality that would become central to Johns' work in the 1970s. The addition of white swathes of ink, handprints, borrowed images (such

as the Mona Lisa in *7*), and newsprint (Johns referred to these as 'another one of my impure ideas') further enriches and confuses the knitting together of whole and part.[1] To cap it off Johns signed each print in the colour corresponding to that appearing at the top of each print. The series was published in an edition of 40. **ST**

1 Jasper Johns, quoted in Joseph E. Young, 'Jasper Johns: An Appraisal', *Art International*, 13:7 (September 1969), pp. 50–56 (p. 53).

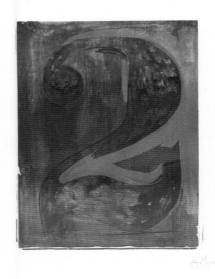

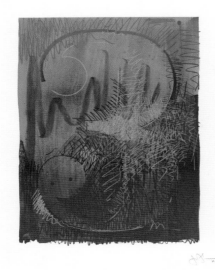

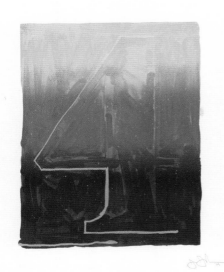

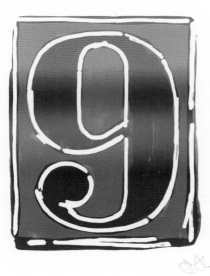

Robert Rauschenberg

51 *Link* from *Pages and Fuses* 1974

Handmade paper, pigment and
screenprinted tissue laminated to
paper pulp
Signed, dated and numbered 'GEMINI II'
in pencil (outside ed. 29). 606 x 495
(23⅞ x 19½) sheet (irregular)
Fine 1984, 39
National Gallery of Art, Washington. Gift
of Gemini G.E.L. and the Artist, 1981

Robert Rauschenberg

52 *Page 2* from *Pages and Fuses* 1974

Handmade paper
Embossed 'RAUSCHENBERG', dated
and numbered 'GEMINI II' in pencil
(outside ed. 11). 559 (22) diameter
Fine 1984, 38
National Gallery of Art, Washington. Gift
of Gemini G.E.L. and the Artist, 1981

In 1973 Rauschenberg's fascination with
the palpable stuffs of the world led him
and printer Ken Tyler to a 15th-century
French paper mill, where Rauschenberg
made eleven editions over the course
of a week. Using custom tin moulds,
Rauschenberg ladled uncoloured pulp to
create simple shaped-paper objects that
he dubbed Pages,[1] and a more complicated
group called Fuses, in which he added
dyed pulp and laminated tissue paper
screenprints to the unfinished, wet paper
sheets – a process he likened to 'trying
to flatten something in a bubble bath'.[2]
As usual, the screenprinted images were
culled from magazines (*Link* includes a
seagull, a telephone pole shot at such an
acute angle it is almost unrecognizable,
and an ambiguous ovoid). 'Fused' to the
organic irregularity of the paper, these
figures act as go-betweens – part of the
paper and part of another world. The
series was instrumental in establishing
papermaking as an independent medium
of contemporary art. **ST**

1 *Pages 5* and *4* also include twine.
2 Howardena Pindell, 'Robert Rauschenberg's "*Link*"',
 MoMA, 1 (Autumn 1974), p. 7.

Donald Sultan

Born 1951

A painter, sculptor, draughtsman and printmaker based in New York City, Donald Sultan was born in Asheville, North Carolina. He trained at the University of North Carolina, Chapel Hill (BFA, 1973), and the School of the Art Institute of Chicago (MFA, 1975), moving to New York in 1975. He first gained attention in the late 1970s with his large-scale paintings made from unusual materials including vinyl tiles and tar. Working across media, he established a repertoire of recurring motifs, notably lemons, tulips, chimneys and cigarettes. In deliberately seeking to find a line between figuration and abstraction, he developed a style that is both representational and abstract, frequently reducing everyday subjects to their most simple forms. In the 1980s he also painted urban landscapes and scenes of diverse catastrophes including industrial fires and railway accidents. Sultan made his first prints in 1979 in California at Crown Point Press, Oakland: a series of eight aquatints titled *Water Under the Bridge*. They were published by Parasol Press, New York, whose director, Robert Feldman, had initially persuaded Sultan to try printmaking. Sultan has since made prints using numerous techniques but is best known for his monochromatic aquatints, which relate closely to his charcoal still-life drawings. Since his first solo exhibition at Artists Space, New York, in 1977, his work has been exhibited widely both in the United States and internationally. **CD**

Donald Sultan
53 *Black Lemon, November 28 1984*
from the series *Black Lemons,*
1984–85 **1984**
Aquatint with open-bite
Signed, dated, titled and numbered
'7/10' in pencil. 1575 x 1219 (62 x 48)
plate, 1600 x 1230 (63 x 48⅜) sheet
Walker 25
British Museum, London 2009,7033.1

Sultan's first work featuring lemons was a painting in oil, spackle and tar on vinyl, titled *Four Lemons*, which he made in 1984. He became interested in the shape after seeing Manet's still-life painting *The Lemon* (1880–81, Musée d'Orsay) in an exhibition at the Metropolitan Museum of Art, New York, in 1983. Tulips were already a prominent subject in his work and he was attracted by the similarities between the two shapes. In 1984 he produced two sets of Black Lemon aquatints: a portfolio of four, from which this print comes, and another set of two. Earlier in the year, while working on his Black Tulip prints, he had developed a method of making aquatints that replicated the fuzzy lines of his charcoal drawings of the same subjects. After covering the plate with a powdery resin, Sultan created the negative spaces by gently brushing it away with a brush or blowing it through a glass tube. He did not melt the resin until the image was complete. As the prints from *Black Lemons, 1984–85* were so large (each printed from a single copper plate), the printer Jeryl Parker had to adapt his New York studio and construct a large aquatint box on rollers so that the dry resin was not disturbed during the process.[1] The portfolio was published in an edition of ten by Parasol Press, New York. **CD**

1 Barry Walker, *Donald Sultan: A Print Retrospective*, New York: The American Federation of Arts, in association with Rizzoli International Publications, 1992, p. 12.

Richard Diebenkorn

1922–1993

Born in Portland, Oregon, to parents he described as 'very upper bourgeois',[1] Richard Diebenkorn grew up in the San Francisco Bay Area and attended Stanford University before enlisting in the Marine Corps during the Second World War. He subsequently attended and taught at the California School of Fine Arts (now San Francisco Art Institute). Success came early – in 1948 the California Palace of the Legion of Honor mounted a solo show of his abstract expressionist paintings – but he returned to university to earn an MFA (1951) at the University of New Mexico, Albuquerque. Abandoning abstraction in the mid-1950s, Diebenkorn became a critical figure in Bay Area figurative painting. Notoriously self-critical, he was often frustrated by painting, and in 1963 started to call in at a neighbourhood etching workshop to play around with plates, 'glad that he couldn't see what he was doing'.[2] The workshop, Crown Point Press, based in Oakland, California, until 1986 when it moved to San Francisco, would eventually become the pre-eminent intaglio studio in the United States. Diebenkorn worked there, on and off, for the rest of his life. In 1966, after taking a teaching position at the University of California, Los Angeles, and setting up a studio in the Ocean Park neighbourhood of Santa Monica, Diebenkorn again changed tack, returning to abstraction, but imbuing it with a new grandeur, light and an architectonic structure. Though critics were often confused by his choices during his lifetime (he took up figuration at the height of abstract expressionism and abstraction at the height of pop art), two decades after his death, Diebenkorn is one of the most revered American artists of the 20th century. ST

1 Richard Diebenkorn, in Dan Hofstadter, 'Profiles: Almost Free of the Mirror', *New Yorker*, 63:29 (7 September 1987), pp. 54–73 (p. 61).

2 Kathan Brown, in Mark Stevens, *Richard Diebenkorn: Etchings and Drypoints 1949–1980*, Houston: Houston Fine Arts Press, 1981, p. 26.

Richard Diebenkorn

54 *High Green Version II* 1992

Colour aquatint, spit-bite aquatint, sugar-lift aquatint, hard- and soft-ground etching and drypoint with scraping and burnishing Signed with initials, dated, titled 'II' and numbered '35/65' in pencil, blindstamp of Crown Point Press, San Francisco.
1010 x 580 (39¾ x 22⅞) plate,
1357 x 858 (53⅜ x 33¾) sheet
British Museum, London 2004,0602.41
Bequeathed by Alexander Walker

Though Diebenkorn worked with many print techniques over the course of his career, his most compelling images were developed through the resistance and grace of intaglio. Beginning with drypoints, in which he scratched his marks into a metal plate, he gradually expanded his repertoire. In 1980 he began making vibrant colour aquatints with Kathan Brown at Crown Point Press; these were done by painting acid directly on to prepared plates, creating watery, luminous areas, such as the blue and green that dominate this print completed shortly before his death. As in many Diebenkorn compositions, a large colour field is edged with angular disruptions and inexplicable structures. There are intimations of landscape. Diebenkorn spoke about the impact of viewing the American West from a low-flying plane – the irregular grid, the abrupt divisions between desert and agriculture, the tracery of roads and 'ghosts of former tilled fields'.[1] The blue area here reveals subtle territorial divisions that seem to lie below the surface like artefacts of a past event. In the workshop, Diebenkorn developed his compositions by cutting and collaging bits and pieces from various proofs, drawing over them, eradicating and adding. Traces of these frequent changes of heart are always left visible in the final image, humanizing their perfect balance. ST

1 Richard Diebenkorn, in Dan Hofstadter, 'Profiles: Almost Free of the Mirror', *New Yorker*, 63:29 (7 September 1987), pp. 54–73 (p. 60).

35/65 II RD 92

4 Made in California
The West Coast experience

While the work of the New York-based pop artists was often infused with a frenetic anxiety, a cooler, more laid-back aesthetic was developing on the West Coast. The paintings and prints of Ed Ruscha chronicle the distinctive lifestyle and landscape of Los Angeles: freshly squeezed oranges, swimming pools, advertising billboards, road signs and palm trees. Drawing inspiration from vernacular architecture, signage and advertising, Ruscha wryly depicted a world of leisure and casual consumption in which the car reigned supreme. It was a lifestyle epitomized by his colour screenprint *Standard Station* (1966, cat. 56), which depicts a gas station prominently branded with the Standard oil company's sign and set against a vivid Hollywood sunset. David Hockney, who first lived in LA in 1964, also portrayed the city's easy living. His light-dancing swimming pools reflect his delight in the sunshine and sexual freedom that the city had to offer.

In northern California, Wayne Thiebaud began to make still lifes of confectionery and cosmetics in the early 1960s. Often laid out in seductive rows and lit by the sun, his sweets appear enticing, but their artificial colours and production-line perfection betray a lack of substance. Like Ruscha, Thiebaud romanticized his subjects, using the tools of advertising to create nostalgic images of childhood treats. He also drew on the world around him, seemingly referencing San Francisco's counter-culture in the trippy colours of his 1970 linocut *Gumball Machine* (cat. 78). This aspect of 1960s San Francisco is decidedly absent from the tree-lined avenues of Robert Bechtle's quiet, residential scenes, where status-symbol cars and tidy apartments offer a more conventional view of the American good life. On the surface at least, it is a life at odds with the anxious, aggressive America reflected in the work of the West Coast artist Bruce Nauman. Sharing Ruscha's interest in language, Nauman began to make unsettling word-image prints in the early 1970s, taking inspiration from the seedy neon signs of the urban landscape.

Ed Ruscha

Born 1937

Born in Omaha, Nebraska, Ruscha was brought up in Oklahoma City, Oklahoma, but left in 1956 at the age of 18 for Los Angeles to train in graphic design at the Chouinard Art Institute (now called Cal Arts). Thereafter based in Los Angeles, he also studied painting, photography and printmaking – all of which became central to his work. He was included in Walter Hopps's 1962 breakthrough exhibition 'New Painting of Common Objects' at the Pasadena Art Museum. In 1963 he held his first solo show at the Ferus Gallery, Los Angeles; in the same year he published his seminal artist's book *Twentysix Gasoline Stations*, the first of sixteen books self-published between 1963 and 1978. The visual power of words inspired by the language of billboards, signage, advertising, overheard phrases – the daily flux of life – has characterized his work, often juxtaposed in absurd or incongruous settings. **SC**

Ed Ruscha
55 *Twentysix Gasoline Stations* **1963**
(3rd edn, 1969)
Artist's book
179 x 140 x 5 (7 x 5½ x ¼) (closed)
Engberg B1
Private collection, UK

Produced by commercial photo-offset and sold originally for $3 a copy, Ruscha's self-published book was first printed in 1963 in an edition of 400 and then twice reprinted (in 1967 in 500 and in 1969 in 3,000 copies). It came to be seen as establishing the genre of the artist's book during the 1960s and 1970s – inexpensive publications created by artists for projecting and disseminating their ideas. This book presents exactly what is stated on the cover: twenty-six gasoline stations photographed on Route 66 from Los Angeles to Ruscha's hometown of Oklahoma City, a road trip of nearly 1,400-miles that he regularly made. No text accompanies the deadpan images apart from a caption identifying the service station and its location, starting with Bob's Service, Los Angeles, California, and ending with Fina, Groom, Texas, an indication that Ruscha is already on the return trip to LA. The repetition and sequencing of these images brings to mind a monotonous highway ribbon through a featureless American landscape that is broken only by the looming billboards of the gasoline stations. **SC**

TWENTYSIX

GASOLINE

STATIONS

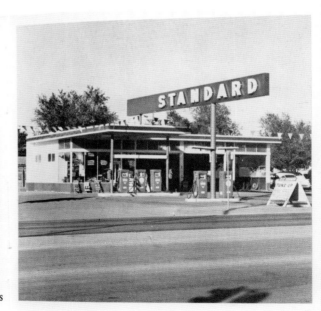

STANDARD, AMARILLO, TEXAS

Ed Ruscha

56 *Standard Station* 1966

Colour screenprint
Signed, dated and numbered '1/50'
in pencil. 495 x 932 (19½ x 36⅞) image,
651 x 1015 (25⅝ x 40) sheet
Engberg 5
Museum of Modern Art, New York.
John B. Turner Fund, 1968

Ruscha's first published print is strikingly close in composition to his earlier painting *Standard Station, Amarillo, Texas*, 1963 (Hood Museum of Art, Dartmouth College, Hanover, New Hampshire). The screenprint and the painting both derive from Ruscha's photograph *Standard – Amarillo, TX*, one of the filling stations in his artist's book *Twentysix Gasoline Stations* (cat. 55). Appropriating a device of commercial art, Ruscha's image exaggerates the sharp diagonal line to give dramatic emphasis to the Standard sign as a beacon on an anonymous American highway. The petroleum company's trade name also ironically stands out as a symbol of unchanging uniformity. Whereas in the painting the gas station was illuminated against a night sky raked by yellow searchlights, for the screenprint Ruscha blended the background colours to evoke a Hollywood sunset in lurid Technicolor. **SC**

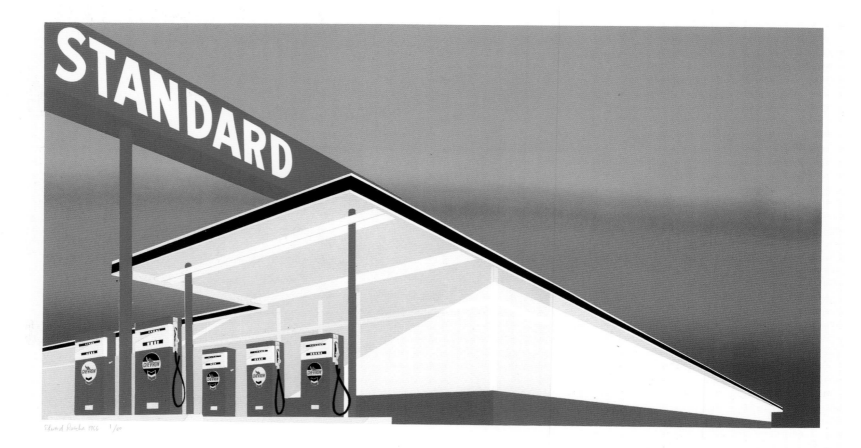

Ed Ruscha

57 *Every Building on the Sunset Strip*
1966
Artist's book
178 x 143 x 10 (7 x 5⅝ x ⅜) (closed);
7607 (300) (extended)
Engberg B4
Private collection, UK

First published in an edition of 1,000 in 1966, Ruscha's artist's book takes the unusual form of an accordion-folded strip of paper. When unfolded to its full length of 7.6 metres it reveals a street view of the Sunset Strip. Every building on this tawdry two-mile stretch of Sunset Boulevard in West Hollywood is located by its street address and by the cross streets. With a camera mounted on a moving vehicle, Ruscha photographed both sides of the Sunset Strip one Sunday morning when few people were about. Facing each other in two parallel strips, almost like automobile tracks, is a panorama of tinsel-town architecture and signage: motor inns, coffee houses, movie billboards ('The Russians Are Coming'), dance clubs ('Whiskey A-Go-Go'), car rentals ('Dollar a Day Rent a Car'), commercial notices ('Going Out of Business'), gasoline stations, apartment blocks, parking lots and real-estate offices – a portrait of LA forever fixed in time. **SC**

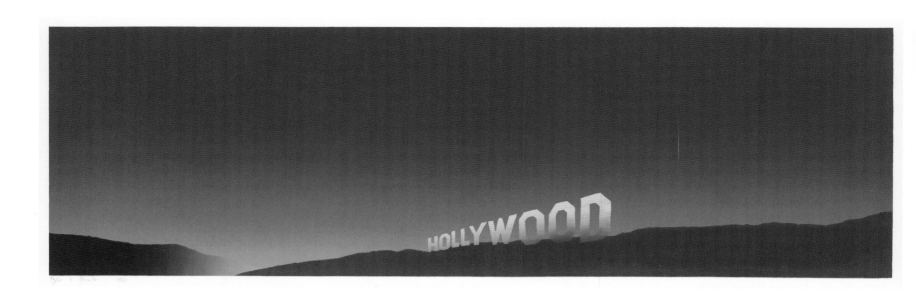

Ed Ruscha
58 *Hollywood* **1968**
Colour screenprint
Signed, dated and numbered '72/100'
in pencil. 318 x 1035 (12½ x 40¾)
image, 445 x 1124 (17½ x 44¼) sheet
Engberg 7
National Gallery of Art, Washington. Reba
and Dave Williams Collection, Florian Carr
Fund and Gift of the Print Research
Foundation, 2008

Instead of further down the slope as they
appear in reality, Ruscha sets out the
letters of the famous Hollywood sign in
a diminishing row along the ridge of the
Hollywood Hills. With the last glow of
the sinking sun, the blended colours of
the background evoke equally the closing
scene of a schmaltzy Hollywood movie in
widescreen Cinemascope and the orange
haze of a petrochemical Hollywood sunset.
Ruscha's studio in Western Avenue in
East Hollywood, where he worked for
many years, was in sight of the Hollywood
sign; as he observed, 'if I could see that
sign, I knew that the air was pretty clear;
otherwise too smoggy…it was a weather
indicator for me'.[1] **sc**

1 Ruscha in radio interview with Susan Stamberg,
 11 July 2000; cited in Ed Ruscha, *Leave Any
 Information at the Signal: Writings, Interviews, Bits,
 Pages*, ed. Alexandra Schwartz, Cambridge, MA,
 and London: MIT Press, 2002, p. 379.

Ed Ruscha

59 *Twentysix Gasoline Stations*
from the series *Book Covers* **1970**
Colour lithograph
Signed with initials, dated and inscribed
'U.S.F. VI' (1 of 10 University of South
Florida proofs outside ed. 30) in pencil,
blindstamps of Graphicstudio, Tampa,
Florida, and the printer (Charles
Ringness). 213 x 290 (8⅜ x 11⅜) image,
410 x 512 (16¼ x 20⅛) sheet
Engberg 45
British Museum, London 2010,7112.1
Purchased with funds given by the
Joseph F. McCrindle Foundation

By 1970 Ruscha had produced a small
collection of artist's books that shared the
deadpan aesthetic of his first publication
Twentysix Gasoline Stations (cat. 55).
A central spine of his work, Ruscha's
books provoked new departures and
developments in his painting and
printmaking. This print comes from
a series of six lithographs of his book
covers, including *Some Los Angeles
Apartments*, *Nine Swimming Pools* and
Real Estate Opportunities. Produced at
the Graphicstudio, University of South
Florida, Tampa, the books in these prints
appear to levitate or float within the

pictorial space. It would be a short step
from these works to Ruscha's visual
depiction of disembodied words. In this
print motor oil appears to be leaking from
beneath the pages of *Twentysix Gasoline
Stations*. **SC**

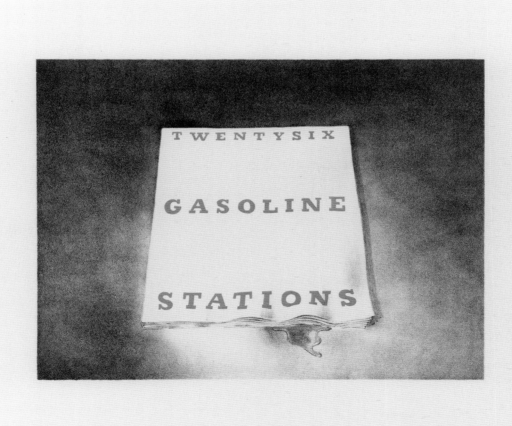

U.S.F. VI E.R. 1970

¹⁰/₂₀

E. Ruscha 1969

Ed Ruscha

60 *OOO* **1969**

Lithograph

Signed, dated and numbered '10/20' in pencil, blindstamps of Tamarind Lithography Workshop, Los Angeles, and the printer (Jean Milant). 126 x 176 (5 x 6⅞) image, 246 x 306 (9⅝ x 12) sheet

Engberg 24

British Museum, London 1980,1011.30

In 1969 Ruscha was invited to make prints on a two-month fellowship at the Tamarind Lithography Workshop in Los Angeles where he produced over twenty lithographs. Single words or letters took visual form; their impact heightened by *trompe l'œil* devices such as words giving the appearance of being created from spilled liquids or from ribbons of cut paper. In this print the three 'OOO's appear to stand upright from curls of paper while the crescent-shaped piece at lower right suggests a broken-off fragment. The shaded grey background emulates the effects of Ruscha's gunpowder drawings at this time (cat. 63). **sc**

Ed Ruscha

61 *OOO* **1970**

Colour lithograph
Signed, dated and inscribed 'Artist's Proof' (outside ed. 90) in pencil, blindstamp of Cirrus Editions, Los Angeles. 505 x 710 (19⅞ x 28) sheet
Engberg 44
British Museum, London 2015,7003.1
Purchased with a contribution from the Vollard Group

At Cirrus Editions, Los Angeles, which had been set up in 1970, Ruscha experimented in making liquid letters by dropping lithographic ink onto the stone to form letters or words that appeared to dissolve. The droplets and splashes are particularly appropriate in lithography, which depends on the antipathy between oil and water. In this print Ruscha creates a visualization of the non-lexical expression 'OOO', inviting the viewer to vocalize surprise or pleasure. The three rings appear to be on the point of breaking up into the enticing turquoise blue of a California swimming pool; in 1968 Ruscha had published his artist's book *Nine Swimming Pools* based on his colour photographs. **SC**

Ed Ruscha

62 *Sin* **1970**

Colour screenprint
Signed, dated and numbered '98/150'
in pencil, blindstamp of Cirrus Editions,
Los Angeles. 330 x 550 (13 x 21⅝)
image, 484 x 672 (19 x 26½) sheet
Engberg 41
British Museum, London 1981,0620.35

'Words have temperatures to me. When
they reach a certain point and become
hot words, then they appeal to me',
Ruscha told the artist Howardena Pindell
in 1973.[1] Ruscha's 'hot' word – 'sin' –
appears to be formed from folds of paper
that echo the accordion-folds of his book
Every Building on the Sunset Strip (cat. 57),
while beneath floats the temptation of a
red pimento-stuffed green olive depicted
actual size. The inclusion of life-size
objects in his compositions to 'nag' his
theme, as he once put it, goes back to
his 1962 pop art painting *Actual Size*
(Los Angeles County Museum of Art)
depicting a can of Spam. **SC**

1 Howardena Pindell, 'Words with Ruscha', *Print Collector's Newsletter*, 3:6 (January–February 1973), pp. 125–28 (p. 126); cited in Ed Ruscha, *Leave Any Information at the Signal: Writings, Interviews, Bits, Pages*, ed. Alexandra Schwartz, Cambridge, MA, and London: MIT Press, 2002, p. 57.

Ed Ruscha

63 *Whiskers* **1972**
Gunpowder and pastel on paper
Titled, signed and dated in pencil.
292 x 737 (11 ½ x 29)
Turvey D1972.38; Berry and Shear, p. 123
Private collection, UK (promised gift to
the British Museum)

In 1967 Ruscha made the unusual
discovery that gunpowder provided an
ideal medium for achieving a warm range
of grey tones when applied on paper in
layers. Obtaining regular supplies from
a gun store in downtown Los Angeles,
Ruscha used this material frequently in
his illusionistic ribbon drawings of single
words and objects in the late 1960s and
early 1970s. A stencil masked out the
design so that the word or object left blank
against the dark ground appears to float
in a fathomless space. In this witty drawing
actual-size trimmed whiskers collected
in the hollow of the curled paper give the
illusion of being blown away. **SC**

Ed Ruscha

64 *News, Mews, Pews, Brews, Stews & Dues* **1970**

Set of six organic screenprints, each signed, dated and numbered '71/125' in pencil, printed and published by Editions Alecto, London, and presented in a red velvet covered portfolio box. 584 x 787 (23 x 31) each sheet
News: 456 x 686 (18 x 27) image
Mews: 456 x 686 (18 x 27) image
Pews: 456 x 686 (18 x 27) image
Brews: 195 x 567 (7⅝ x 22⅜) image
Stews: 195 x 567 (7⅝ x 22⅜) image
Dues: 456 x 686 (18 x 27) image
Engberg 34–39; Sidey 2003, 982–87
British Museum, London 1979,0623.15.1-6

Ruscha's experiment in 'liquid words' culminated at Editions Alecto, London, where he produced six organic screenprints during a visit to England in 1970. Instead of conventional printing inks, he literally pressed into service food substances, syrups, pastes and flowers purchased from a London supermarket. While certain ingredients failed to print, by trial and error others were more successful – for instance, blackcurrant pie filling and salmon roe in *News*; axle grease and caviar in *Brews*. The associative rhyming of 'Old World' words and the Old Gothic typeface evoke Ruscha's response to being in England, a world away from the streamlined modernity and signage of the West Coast. **sc**

Ed Ruscha

65 *Made in California* **1971**
Colour lithograph
Signed with initials, dated and numbered
'83/100' in pencil on image, blindstamp
of Cirrus Editions, Los Angeles.
505 x 710 (19⅞ x 28) sheet
Engberg 52
British Museum, London 2013,7044.1
Purchased with funds given by Hamish
Parker

Language becomes landscape in
Ruscha's homage to California in this
lithograph made at Cirrus Editions, Los
Angeles. California sunshine and the
renowned sweetness of its oranges are
evoked by Ruscha's choice of the golden
ochre colour and the deployment of 'liquid
words' to suggest drops of freshly
squeezed juice. The format and large size
of this print recall billboards on a highway
proudly declaring the state's produce
and products. The print was made to
commemorate the group exhibition
'Made in California' involving Ruscha
at the Dickson Art Center, University
of California, Los Angeles, in 1971. **sc**

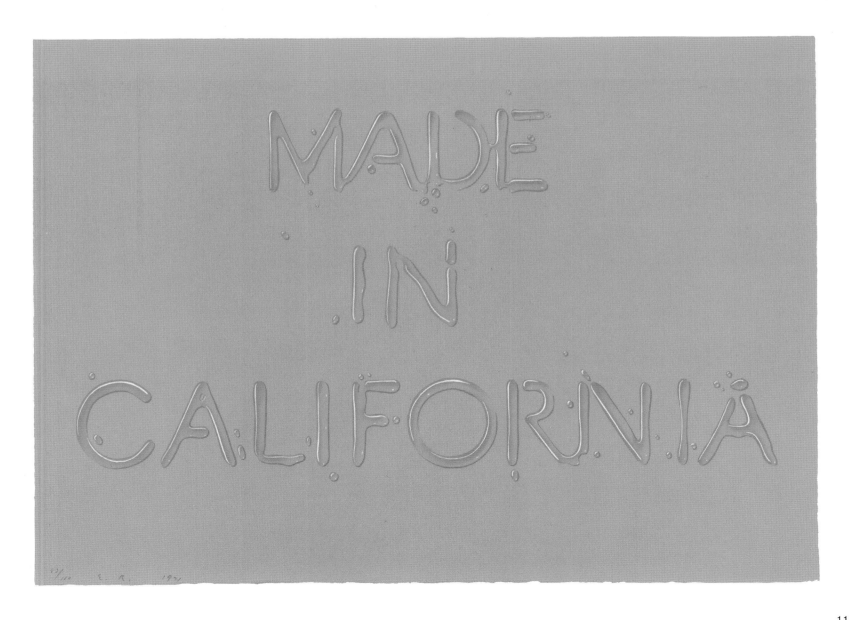

Ed Ruscha

66 *Big Dipper Over Desert* 1982

Colour aquatint
Signed and inscribed 'O.K.T.P' (trial proof
outside ed. 48) in pencil, blindstamp of
Crown Point Press, Oakland, California.
600 x 905 (23⅝ x 35⅝) plate,
762 x 1108 (30 x 43⅝) sheet
Engberg 131
National Gallery of Art, Washington.
Gift of Kathan Brown, 1998

From the mid-1970s Ruscha has
regularly spent periods of time living and
working in a remote house and studio in
the California High Desert, near Joshua
Tree National Monument, a three-hour
drive from Los Angeles. Before the
majesty of the wheeling night sky, Ruscha
remains wordless in this etching printed
in midnight blue. The tiny lone cactus tree
at lower left could be a stand-in for the
human figure, a reminder of one's earthly
insignificance. This etching was among
the first to be made by Ruscha with
Kathan Brown at Crown Point Press,
Oakland, in the early 1980s. **sc**

Ed Ruscha

67 *Intersecting Streets* **1999**

Lithograph
Signed, dated and annotated 'P.P.'
(printer's proof outside ed. 50) in pencil,
blindstamp of the printer (Ed Hamilton).
314 x 524 (12⅜ x 20⅝) image,
492 x 737 (19⅜ x 29) sheet
British Museum, London 2009,7087.1
Presented by Stephen Coppel in memory
of Maria Antonietta Coppel

In the late 1990s Ruscha produced a
series of dark-grey paintings of arterial
highways in the Los Angeles area viewed
obliquely from above. This lithograph
takes the idea further with human moral
conditions – 'Easy' and 'Lonely' – replacing
the named streets to form a cross that
contrasts the short and easy road with the
long and lonely one. The gritty spattered
background created by spraying black
acrylic on to a mylar sheet for transfer
to the printing plate suggests a haze
of petrochemical pollutants. Ruscha has
worked with the printer Ed Hamilton
since 1970 when they first collaborated
on the 'liquid words' at Cirrus Editions;
in 1990 they jointly set up the Hamilton
Press where this print was made. **SC**

Bruce Nauman

Born 1941

Born in Fort Wayne, Indiana, Nauman took his first degree in mathematics and art at the University of Wisconsin, Madison (1964), and then an MA in studio art at the University of California, Davis (1966), where Wayne Thiebaud was one of his teachers. Primarily a sculptor, Nauman has embraced video, photography, drawing, neon and installation as well as printmaking. His work is often concerned with the rigorous examination of language, whether through words, sounds or the repetitive actions of the body that are invested with an emotional charge and often present a bleak, uncompromising vision. In 1966 he had his first solo show at the Nicholas Wilder Gallery, Los Angeles, and two years later his first New York show at the Leo Castelli Gallery; both galleries also co-published his first prints produced at Cirrus Editions, Los Angeles, in 1971. An intermittent printmaker, Nauman also made his word-images at Gemini from 1973, where he continues to make prints. In 1979 he left California and moved to New Mexico where he lives and works in relative isolation on a property south of Santa Fe with the painter Susan Rothenberg. **SC**

Bruce Nauman
68 *Pay Attention* 1973
Lithograph
Signed and numbered 'AP 9' (artist's proof outside ed. 50) in pencil, blindstamp of Gemini G.E.L., Los Angeles.
952 x 704 (37½ x 27¾) image,
971 x 717 (38¼ x 28¼) sheet
Cordes 16
British Museum, London 2016,7075.1
Presented by Hamish Parker in honour of Catherine Daunt, Stephen Coppel and Hugo Chapman

An arresting command is followed by the shock of insult. In this work, as in *Clear Vision* (cat. 71), Nauman finds ways of turning the viewer into a performer – as we read we do what it says. The hand-drawn letters forming the words are arranged in rows on thick black lines; the word 'attention' is repeatedly drawn almost to the point of obscurity, ironically implying that the artist is not paying attention. Nauman's word-images are often presented in a shallow space as if they are monuments in sculptural relief. With this work Nauman has described how he was trying to achieve 'a real aggressive pushing at the edges and at the surface'.[1] **SC**

1 Bruce Nauman, interview with Christopher Cordes, *Bruce Nauman: Prints 1970–89*, New York: Castelli Graphics and Lorence Monk Gallery, and Chicago: Donald Young Gallery, 1989, p. 27.

Bruce Nauman

69 *Malice* **1980**

Neon tubing with clear glass tubing
Number 1 from the edition of 3.
178 x 737 x 76 (7 x 29 x 3)
Collection of Larry Gagosian

From 1967, when he produced his ironic sign *The True Artist Helps the World by Revealing Mystic Truths*, Nauman has taken the ubiquitous neon sign of commercial advertising to produce his own word messages that probe the underbelly of the American Dream. Neons such as the palindrome *Raw War* (1970), *American Violence* (1981–82) and *Malice* glow and flash with a malevolent intensity that underscore Nauman's political and social agenda. In *Malice* the very warm letters spelling the word in red are opposed by the backwards reiteration in the very cold colour of green. Several of Nauman's neons were reworked as word-images in printmaking (cats 70 and 145). **sc**

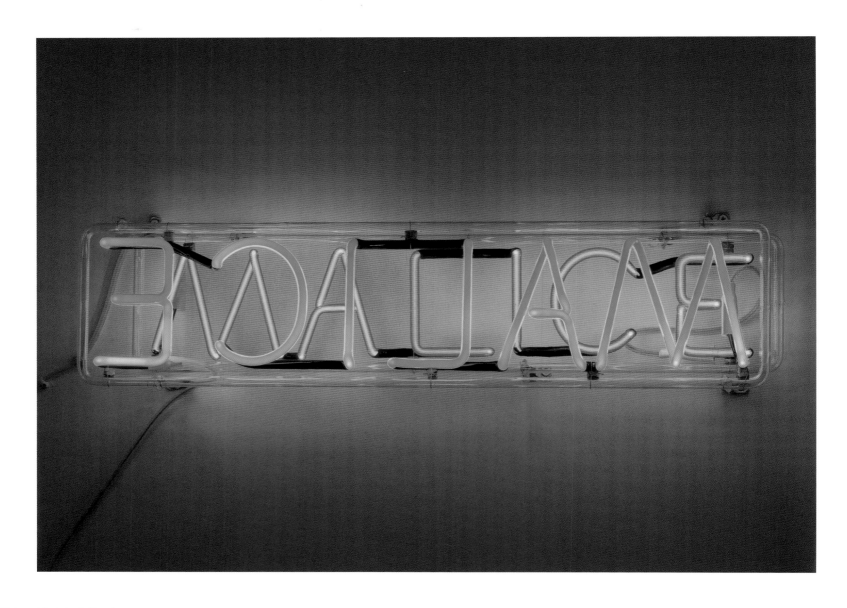

Bruce Nauman

70 *Malice* **1980**

Lithograph

Signed, dated and numbered '54/75' in pencil, blindstamp of the printer at the Trisolini Gallery of Ohio University, Athens, Ohio. 625 x 960 (24⅝ x 37¾) image, 750 x 1045 (29½ x 41⅛) sheet

Cordes 37

British Museum, London 2011,7077.2 Purchased with the Presentation Fund in honour of Antony Griffiths

By isolating the single word Nauman makes the viewer focus on its intrinsic particularity – malice – the harbouring of ill will. For the lithograph he thought of the word 'malice' differently from the neon sign (cat. 69), also made in 1980, with its alternating flashes of the superimposed noun in red (forward direction) and green (reverse direction). In the monochrome lithograph, which he produced using the printmaking facilities at Ohio University, Athens, Nauman drew the word front and back but on top of each other in precisely formed letters that have the appearance of being chiselled in stone – an effect he thought appropriate to the stone matrix he was working on. **SC**

Bruce Nauman

71 *Clear Vision* 1973

Lithograph and screenprint
Signed, dated and numbered '12/50'
in pencil, blindstamp of Gemini G.E.L.,
Los Angeles. 840 x 1165 (33 x 45⅞)
image, 915 x 1240 (36 x 48¾) sheet
Cordes 15
British Museum, London 2013,7044.2
Purchased with funds given by the Vollard
Group

Reversal is inherent to the process of printmaking. In this powerful image the words 'clear' and 'vision' are drawn directly on to the lithographic stone with crayon and wash so that they appear back to front and less clear when printed on a flat tint of screenprinted light grey. By this seemingly simple device Nauman challenges our perception of what constitutes 'clear vision' – how 'clear' is clear and is 'vision' necessarily clear? The reversal of printmaking also appealed to Nauman as a buffer between himself and his audience. As he once explained, 'I like the way front/back interplay confuses the information. Not knowing what you're supposed to look at keeps you at a distance from the art while the art keeps you at a distance from me; the combination produces a whole set of tensions.'[1] **sc**

1 Cordes, op. cit., p. 24.

Bruce Nauman

72 *Pearl Masque* **1981**

Lithograph

Signed, dated and numbered '11/50'
in pencil, blindstamp of Gemini G.E.L.,
Los Angeles. 655 x 880 (25¾ x 34⅝)
image, 720 x 950 (28⅜ x 37⅜) sheet

Cordes 42

British Museum, London 2015,7015.2
Purchased with funds given by Margaret
Conklin and David Sabel

The chisel-cut lettering of the enigmatic
phrase 'Pearl Masque' is subverted
by Nauman's gestural handling of the
lithographic washes, scraping, overdrawing
and wiping that animate and energize this
print and draw the viewer to consider their
beauty as intrinsic to its meaning. At the
same time the artist pushes the viewer
away. The word 'masque' (a 16th- and
17th-century English dramatic performance
whose players were masked) and its
homophone 'mask' both connote a form
of disguise, a distancing device that is very
much Nauman's intention: 'How does an
artist present himself? What is masked
and what is not – that tension between
what is given and what is held back.'[1]
He has said that in making this lithograph
he had in mind his earlier stone sculpture
installation, *The Consummate Mask of
Rock* (1975), made in Buffalo, New York,
accompanied by a text that began: 'This is
my mask of fidelity to truth and life./ This
is to cover the mask of pain and desire./
This is to mask the cover of need for
human companionship.' **SC**

1 Cordes, op. cit., p. 32.

Wayne Thiebaud

Born 1920

Born in Meza, Arizona, Thiebaud moved with his family to Los Angeles in 1921 and has remained based in California. He is best known for his deadpan depictions of cakes, confectionery and enticing consumer edibles, which he began to produce in bold colours and with thick creamy applications of paint from the early 1960s. In 1962 he was included in 'New Painting of Common Objects' organized by Walter Hopps at the Pasadena Art Museum, which featured five young California artists, including Ed Ruscha, alongside the New York artists Andy Warhol, Roy Lichtenstein and Jim Dine. That year he also had his first solo exhibition in New York with Allan Stone, who thereafter represented him. From 1964 he began to make etchings with Kathan Brown at Crown Point Press at Oakland, California. From the early 1970s, cityscapes of San Francisco, where he established his second home, began to appear. Alongside his own practice as a painter and printmaker, he lectured in fine art at the University of California, Davis, from 1960 until 1990, where he is emeritus professor. **SC**

Wayne Thiebaud
73 *Lunch* **1964**
Etching
Signed, dated, titled and numbered
'90/100' in pencil. 128 x 171 (5 x 6¾)
plate, 326 x 276 (12⅞ x 10⅞) sheet
Whitney 1971.10
British Museum, London 1997,1102.23
Presented by Mike Godbee

A simple lunch for two – two plates of garnished sandwiches, two plates of sliced avocado and two cans of beer – this is Thiebaud's first etching made at Crown Point Press with the printer Kathan Brown, who had prepared the meal. Seemingly mundane, these objects appealed to him as subjects where he could explore formal problems of representation in terms of line and volume. As he told Brown at their first meeting, he was trying to find out what was important in making a picture – a piece of pie on a plate might be 'a triangular shape on a round one'.[1] **SC**

1 Kathan Brown, *Know That You Are Lucky*, San Francisco: Crown Point Press, 2012, p. 45.

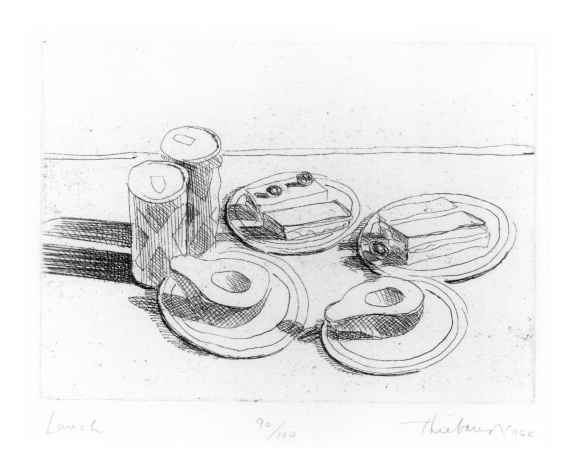

Wayne Thiebaud

74 *Bacon and Eggs* **1964**

Etching

Signed, dated, titled and annotated 'A/P'
(artist's proof outside ed. 100) in pencil.
130 x 151 (5⅛ x 6) plate, 327 x 275
(12⅞ x 10⅞) sheet
Whitney 1971.27
British Museum, London 1981,0620.40

Thiebaud's first project with Kathan
Brown at Crown Point Press produced a
set of seventeen small etchings, including
Lunch (cat. 73), published by the printer
under the collective title *Delights* in 1965.
Etching would become Thiebaud's
preferred medium, as the artist declared
to an interviewer: 'There's nothing…like
an etched line – its fidelity, the richness of
it, the density – you just don't get that any
other way.'[1] His painting dealer in New
York advised Brown to make an edition of
100, but this proved a daunting number
for her to print and for the market to absorb.
Half of the edition was issued in a bound
volume; the other half as loose sheets in
a portfolio box, plus several artist's proofs.
Some subjects from *Delights*, including
this setting for an appetizing breakfast,
were based with subtle modifications on
paintings made a few years earlier. He
returned to his compositions in later
paintings or by using different print
techniques such as lithography, woodcut
or linocut. Several of his etchings were
directly overworked with watercolour or
pastel and chalk, some years later. An
example of *Lunch* with watercolour
additions from 1967 is in the Achenbach
Foundation, San Francisco. **SC**

1 Constance Lewallen, 'Interview with Wayne
 Thiebaud, August 1989', *View, Crown Point Press*,
 6:6 (Winter 1990), pp. 1–23 (p. 17).

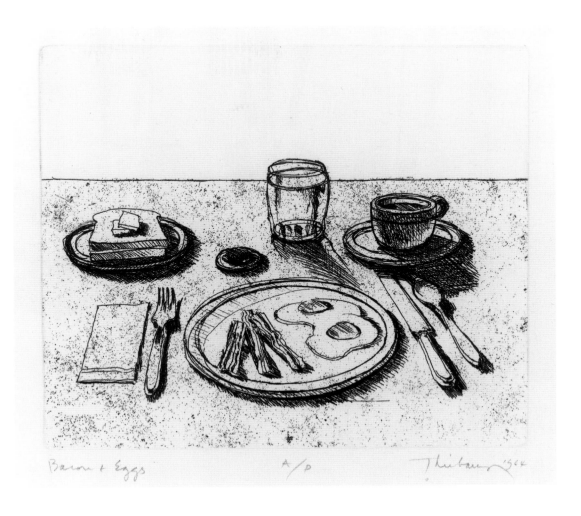

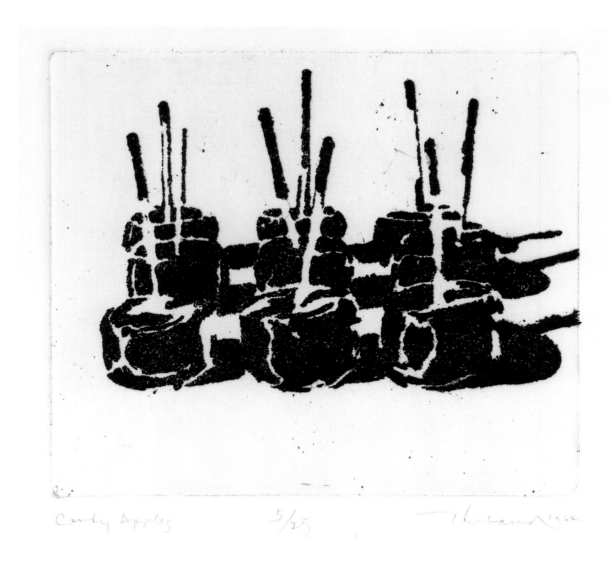

Candy Apples 5/25 Thiebaud 1964

Wayne Thiebaud

75 *Candy Apples* 1964

Sugar-lift aquatint

Signed, dated, titled and numbered
'5/25' in pencil. 127 x 145 (5 x 5¾) plate,
378 x 283 (14⅞ x 11⅛) sheet

Whitney 1971.19

British Museum, London 2015,7092.1
Purchased with funds given by the
Joseph F. McCrindle Foundation with a
contribution from the Vollard Group

The sticky, dark molasses of the toffee
apples are deftly rendered by Thiebaud
using sugar aquatint, a painterly tonal
technique in etching. The subject is
reduced to a study of simple round forms
of candied delights with projecting
verticals representing the sticks to hold
them. This was produced with Kathan
Brown at Crown Point Press but not
included in the *Delights* project (cats 73
and 74). **sc**

Wayne Thiebaud

76 *Suckers State I* **1968**

Lithograph
Signed, inscribed 'State I' and numbered
'114/150' in pencil, blindstamp of
Gemini G.E.L., Los Angeles.
204 x 363 (8 x 14¼) image (irregular),
408 x 558 (16 x 22) sheet
Whitney 1971.18
British Museum, London 2015,7092.2
Purchased with funds given by the
Joseph F. McCrindle Foundation with
a contribution from the Vollard Group

In this lithograph made in 1968 with
the master printer Ken Tyler at Gemini,
Los Angeles, Thiebaud returns to the
composition of the candied apples (cat. 75).
With strokes of the lithographic crayon
he builds up the round forms on a larger
scale while the delineation of the striped
patterns transforms the motif into
lollipops or 'suckers'. The objects are
isolated against a white ground, with
just the shadows and contiguous forms
suggesting spatial depth, a common
device in Thiebaud's works. A second

version of this lithograph was printed in
crimson red. Subtle shifts in technique,
size and colour are a key feature of
Thiebaud's practice. As he once remarked
to Kathan Brown, 'When you change
anything, you change everything.'[1] **SC**

1 Cited by Ruth E. Fine in *Thirty-Five Years at Crown Point Press: Making Prints, Doing Art*, exh. cat., with essays by Karin Breuer, Ruth E. Fine and Steven A. Nash, Fine Arts Museums of San Francisco, 1997, p. 8.

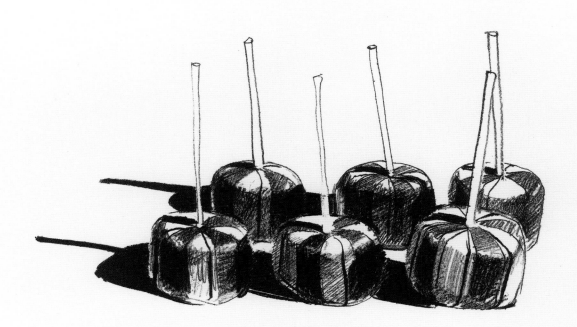

Wayne Thiebaud

77 Boston Cremes 1970

Colour linocut
Unsigned proof outside ed. 50.
345 x 516 (13⅝ x 20⅜) image,
568 x 765 (22⅜ x 30⅛) sheet
Whitney 1971.52
British Museum, London 2010,7007.4
Purchased with the Modern Fund and the
American Print Fund

This linocut is closely related to
Thiebaud's painting of the same title
(Crocker Art Museum, Sacramento) from
1962. Triangular wedges of the
crème-filled sponge cake, a confection
credited to a 19th-century chef from
Boston, are arranged in tempting rows on
a shelf counter. The creamy textures have
been achieved by the build-up of six
colours (black, blue, yellow, red, purple
and beige) through the linocut technique,
while the untouched white of the paper
provided the frosting. The glowing intensity
of the solid cakes is complemented by
the visual weight of their cast shadow in
bright blue. This and *Gumball Machine*
(cat. 78) were produced with Picasso's
colour linocut printer, Hidalgo Arnéra, in
Vallauris in the South of France in 1970. **SC**

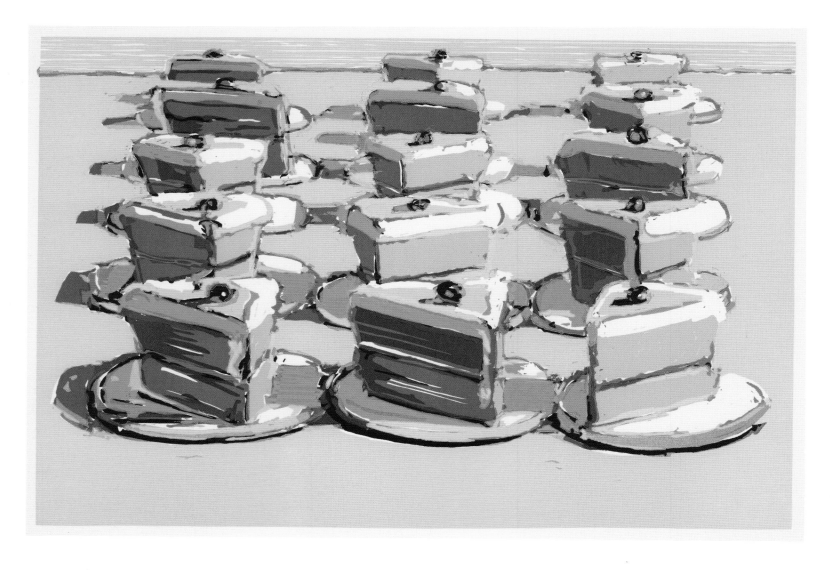

Wayne Thiebaud

78 Gumball Machine **1970**

Colour linocut

Unsigned proof outside ed. 50.

615 x 458 (24¼ x 18) image, 762 x 568
(30 x 22⅜) sheet

Whitney 1971.51

British Museum, London 2010,7007.5

Purchased with the Modern Fund and
the American Print Fund

The veneration of an everyday object of
consumerism – the bubble-gum vending
machine – and the eye-popping colours
are characteristic of pop art. Yet Thiebaud
is just as interested in the formal
juxtaposition of round objects (the huge
glass sphere bursting with gumballs) with
striped linear repetitions that suggest the
space in which the vending machine sits.
An American invention of the early 20th
century, the coin-operated gumball
machine that delivers its prized ball from
a chute below became a ubiquitous
feature of stores and shopping malls
across the United States of America.
The linocut is related to an earlier
painting, *Three Machines*, 1963 (Fine
Arts Museums of San Francisco). **SC**

Robert Bechtle

Born 1932

Born in San Francisco, where he trained as a painter at the California College of Arts and Crafts (BFA, 1954, and MFA, 1958), Bechtle, except after graduating, when he was drafted into US military service in Germany, has lived and worked in the San Francisco Bay Area all his life. Inspired by his immediate environment and working from his own photographs, from the mid-1960s he has worked as a photorealist painter producing meticulous depictions of automobiles, empty neighbourhoods and middle-class residential streets. In 1967 the San Francisco Museum of Modern Art gave him his first museum exhibition. As well as producing paintings, watercolours and drawings, Bechtle has also worked as a printmaker, firstly in lithography and then mostly in colour soft-ground etching at Crown Point Press from 1982. SC

Robert Bechtle
79 *Burbank Street, Alameda* **1967, editioned 2011**
Etching
Signed, dated and numbered '15/25' in pencil, verso: titled in pencil, blindstamp of Crown Point Press, San Francisco.
200 x 177 (7⅞ x 7) plate, 375 x 335 (14¾ x 13¼) sheet
British Museum, London 2012,7078.3
Purchased with funds given by Hamish Parker

Suburban streets are usually deserted in Bechtle's paintings and prints, yet here human presence is implied by the parked car outside residential homes. The artist is interested in the shapes and long shadows cast by the hard California light; in this case, by the tall slender trunks of the palm trees. Like Ruscha in Los Angeles, Bechtle investigates without comment the quintessential topography of California: its automobiles, apartment blocks and palm trees. The three etchings shown here come from an unfinished project begun with Kathan Brown at Crown Point Press in 1967. Bechtle had originally proposed making a set of etchings in the form of a bound volume called *The Alameda Book*, depicting scenes from the San Francisco Bay Area town of Alameda where he was brought up. SC

12/25 Bechtle 67

15/25 Bechtle 67

Robert Bechtle
80 *'60 T-Bird* 1967, editioned 2011
Etching
Signed, dated and numbered '15/25' in pencil, verso: titled in pencil, blindstamp of Crown Point Press, San Francisco.
190 x 227 (7½ x 8⅞) plate, 360 x 380 (14⅛ x 15) sheet
British Museum, London 2012,7078.1
Purchased with funds given by Hamish Parker

The classic 1960-model Thunderbird Ford automobile is the subject of this etching: a two-door personal luxury car, with white-wall tyres, prominent tail fins and its logo emblazoned on the side-door chrome. By the later 1960s, when this etching was made, the Thunderbird had acquired collector's item status, captured in this depiction of its proud owner nonchalantly stepping out of his automobile in open-neck shirt and sunglasses. **sc**

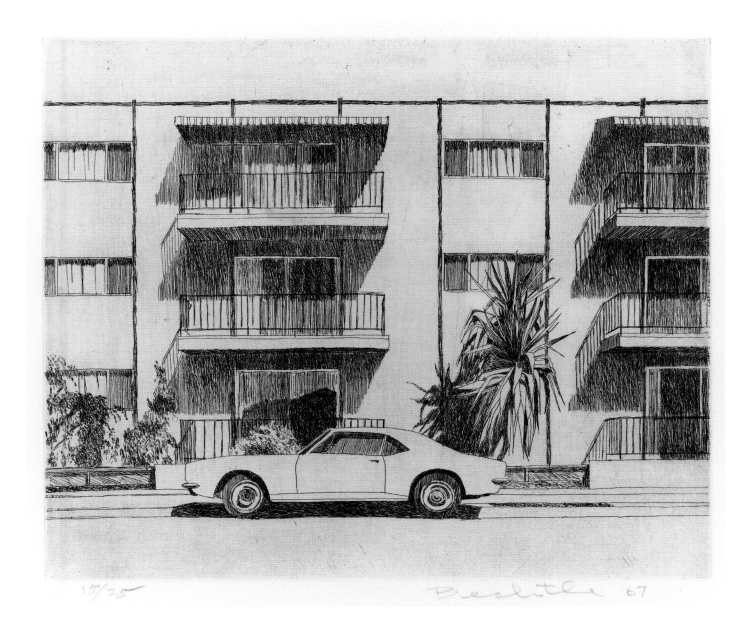

15/25 Bechtle 67

Robert Bechtle

81 *Alameda Camaro* 1967, editioned 2011

Etching

Signed, dated and numbered '15/25' in pencil, verso: titled in pencil, blindstamp of Crown Point Press, San Francisco.

190 x 227 (7½ x 8⅞) plate, 370 x 387 (14½ x 15¼) sheet

British Museum, London 2012,7078.2

Purchased with funds given by Hamish Parker

In 1967, when Bechtle made this etching, the Camaro was a brand-new car released on to the market that year by Chevrolet. Parked conspicuously outside an anonymous contemporary apartment block, it declares itself as a status symbol to the invisible middle-class inhabitants. The *Alameda Book* project was abandoned after just four etchings as the artist found conventional black-and-white etching too old-fashioned in the era of pop art. However, when the plates were rediscovered and printed more than forty years later, Bechtle was astonished to 'see a lot of connections to what I have done since'.[1] SC

1 Kathan Brown, 'Robert Bechtle', *Overview, Crown Point Press Newsletter* (May 2011), pp. 1–3 (p. 3).

David Hockney

Born 1937

Hockney has divided his working life between southern California and Britain with long stays in both countries. Born in Bradford, he proceeded from Bradford School of Art (1953–57) to the Royal College of Art, London, where he made his now-famous cycle of etchings *A Rake's Progress* (1961–63), which demonstrated his originality and wit. He made his first trip to the United States in 1961 where he met and sold two of his etchings to William S. Lieberman, curator at the Museum of Modern Art, New York. Two years later he returned to New York, meeting Andy Warhol and Henry Geldzahler, curator of 20th-century art at the Metropolitan Museum of Art, who became a lifelong friend, before arriving in Los Angeles for the first time in January 1964. During the 1960s the Los Angeles lifestyle of swimming pools, Beverly Hills collectors and glamorous modernist houses, as well as open gay culture and friendships, became the subject of his paintings. A consummate draughtsman, Hockney developed many of his themes in his prints; from 1965 he began an important collaboration with Ken Tyler at the Gemini workshop in Los Angeles and then on the East Coast at Bedford Village, New York. Constantly inventive, he has pushed the boundaries of printmaking by experimenting with paper pulp, added the photocopier, the fax machine and the digital paintbox to the printmaker's repertoire, and, most recently, embraced the iPad as a tool for creating original prints. **SC**

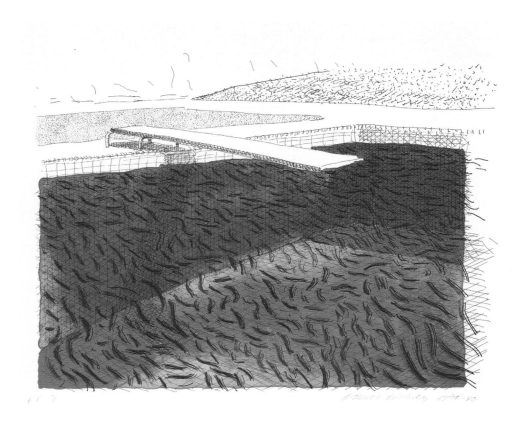

David Hockney
82 *Lithographic Water Made of Lines, Crayons and Two Blue Washes Without Green Wash* 1978–80
Colour lithograph
Signed, dated and inscribed 'AP X' (1 of 12 artist's proofs outside ed. 36) in pencil, blindstamp of Tyler Graphics Ltd, Bedford Village, New York. 546 x 750 (21½ x 29½) image, 750 x 867 (29½ x 34⅛) sheet
Tyler Graphics 252: DH39 (unrecorded variant)
Tate: Presented by Tyler Graphics Ltd in honour of Pat Gilmour, Tate Print Department 1974–7, 2004

On his first visit to Los Angeles in 1964 the young Hockney was spellbound by the California swimming pool as a feature of the suburban home. It represented a lifestyle of affluence, carefree leisure and perpetual sunshine. The swimming pool became a recurring subject in his paintings, drawings and prints. In 1978 Hockney was enroute to Los Angeles from London when he stopped to visit Ken Tyler in Bedford Village, New York, where the master printer had established himself after leaving Gemini in late 1973. The visit resulted in the massive Paper Pools project – a series of ninety-five works created from paper pulp – made in collaboration with Tyler over three months that was inspired by the printer's swimming pool at different times of day and under different weather conditions. In 1980 Hockney made a series of eleven lithographs with Tyler on the same theme, demonstrating his proficiency in lithography in his dexterous handling of line, crayon and wash. The diving board over the inviting blue water recalls the impact of Hockney's initial encounter with the California swimming pool as a symbol of the American Dream. **SC**

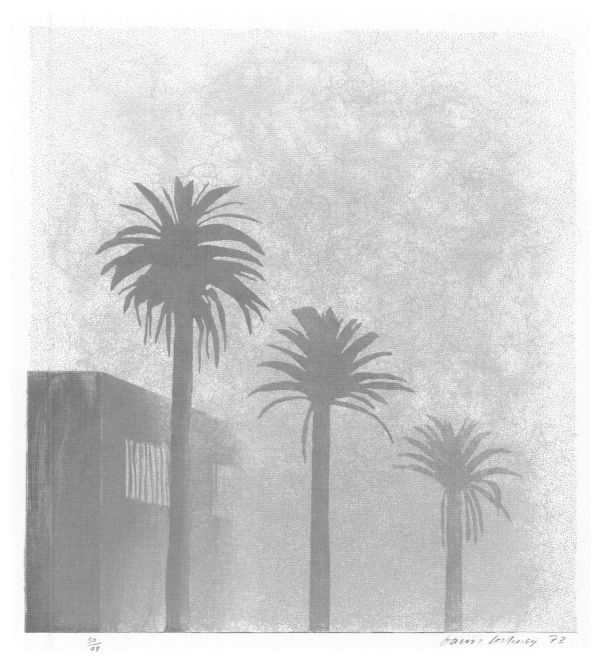

50/98

david hockney 73

David Hockney

83 *Mist* from *The Weather Series*

1973

Colour lithograph

Signed, dated, titled and numbered
'50/98' in blue pencil, blindstamp of
Gemini G.E.L., Los Angeles. 740 x 640
(29⅛ x 25¼) image, 1106 x 787
(43½ x 31) sheet

Brighton 138

Victoria and Albert Museum

An avenue of palm trees flanking an
anonymous light-industrial building is
veiled in the notorious petrochemical
smog of Los Angeles. Hockney's regular
stays in southern California each year
gave him access to the Gemini workshop
in Melrose Avenue close to where he was
then living in Los Angeles. This comes
from a set of six lithographs called *The
Weather Series*, which was his second
major project working with the master
printer Ken Tyler at Gemini. (In 1965
Hockney had made *A Hollywood
Collection*, a series of six lithographs
depicting artworks of stupefying banality
in elaborate frames intended as an
instant art collection to culturally aspiring
Hollywood actors.) By contrast to the
smog-filled *Mist*, the hard California
sunlight is celebrated in *Sun* while puddles
of rain, a snowy landscape and a streak
of lightning evoke weather conditions of
other places. *Wind* shows four prints from
the series being carried off by a sudden
gust down Melrose Avenue where they
had been printed. **SC**

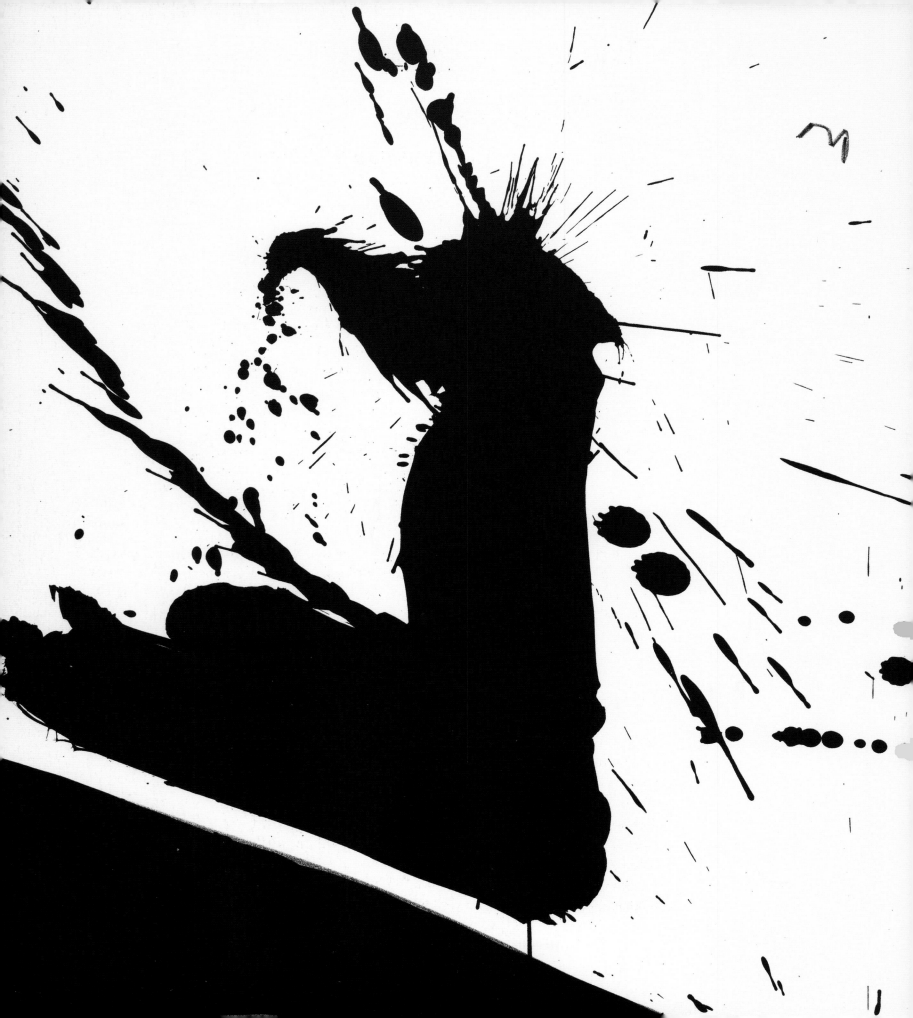

5 Persistence of abstraction
Gestural and hard-edge 1960s–1970s

Despite the arrival of pop art in the early 1960s, abstract expressionism continued to influence American artists into the 1970s. Willem de Kooning, a leading figure of the movement, began to engage seriously with printmaking in 1960, making his first abstract expressionist lithographs at the University of California, Berkeley. *Litho #1 (Waves #1)* and *Litho #2 (Waves #2)* echoed his paintings with their emphasis on the grand, spontaneous gesture and large-scale format. The influence of de Kooning's splashy lithographs can clearly be seen in the prints of Robert Motherwell who, like Cy Twombly, subscribed to the surrealist principle of automatism to create marks without prior deliberation to tap the subconscious mind. Impulsive and improvisatory mark-making was also central to the work of Sam Francis, who began to make prints in around 1960.

In contrast, Ellsworth Kelly and Frank Stella rejected gestural abstraction in favour of hard-edge geometric shapes and simplified forms. Both artists were influenced by the paintings of Josef Albers, primarily the *Homage to the Square* series that he began in around 1950 and which he extended into printmaking from 1962. Through his teaching at Black Mountain College, North Carolina, and Yale University, Albers introduced a generation of American artists to the principles of Bauhaus design, which included a focus on clean, minimal lines, symmetry and the absence of the personal gesture. His theories on colour were also influential, especially after the publication of his groundbreaking book *The Interaction of Color* in 1963. In that year Josef's wife, Anni, began to make prints, having previously gained recognition as a textile designer. Also a student of the Bauhaus, her colourful geometric designs translated particularly well into screenprints. Colour was central to the work of Helen Frankenthaler, whose colour-field abstraction seems to bridge the gap between gestural and hard-edge styles. From the late 1970s, her experiments with woodcuts ignited a renewed interest in the technique.

Roy Lichtenstein

For biography see page 46

84 *Brushstrokes* 1967

Colour screenprint

Signed and numbered '168/300' in pencil.

555 x 765 (21⅞ x 30⅛) image,

584 x 789 (23 x 31) sheet

Corlett 45

British Museum, London 1979,1215.1

The histrionic gestures of abstract expressionist painting are parodied in Lichtenstein's cartoon rendition. Like many of the pop artists, Lichtenstein reacted against the primacy of the personal gesture in abstract expressionism, the style that had dominated his formative years. In an ironic comment on the gestural painting of de Kooning and the abstract expressionist artists, Lichtenstein draws upon the comic-book's graphic language of the Ben-day dot and outlining to produce his curiously arrested brushstrokes. 'I want to hide the record of my hand', he explained to the art writer and curator John Coplans in 1967.[1] At the time he was working on his Brushstroke series of paintings and prints from 1965 to 1971. While espousing a desire for an impersonal mechanical look, Lichtenstein paradoxically achieved the dots in his paintings by painstakingly rubbing paint with a toothbrush through the holes of metal stencil screens placed on the canvas. In his prints, however, the dots were replicated by the mechanical means of screenprinting; their uniform, flat surface came closer to the look of the mechanized image that he was seeking to attain. This screenprint was produced for his first travelling retrospective exhibition organized by Coplans at the Pasadena Art Museum, California, in 1967. **sc**

1 John Coplans, 'Talking with Roy Lichtenstein', *Artforum*, 5:9 (May 1967), pp. 34–39 (p. 34); cited in James Rondeau and Sheena Wagstaff, *Roy Lichtenstein: A Retrospective*, exh. cat., London: Tate Publishing in association with The Art Institute of Chicago, 2012, p. 22.

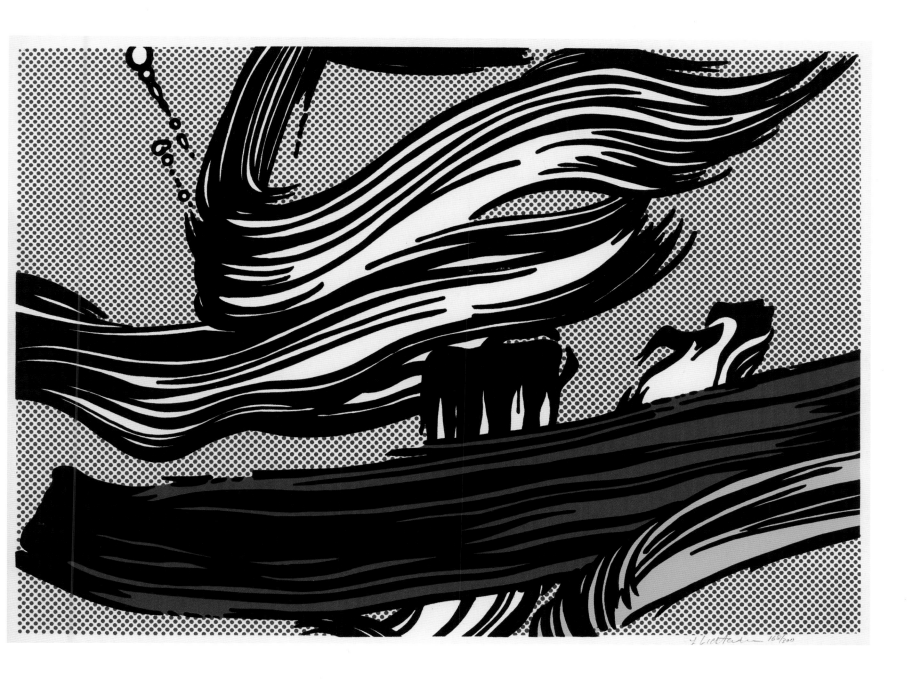

Willem de Kooning

1904–1997

One of the foremost abstract expressionist painters, de Kooning made relatively few prints in his long career. Born in Rotterdam, he worked as a house painter but also formally trained as a painter at the Rotterdam Academy. In 1926 he stowed away on a ship to America. In New York de Kooning quickly established a network of artist friends, including Arshile Gorky, Jackson Pollock and Franz Kline. He worked briefly at Stanely William Hayter's Atelier 17 in the early 1940s but no prints survive from this period. In 1950 he began the first of his gestural and highly charged canvases in the *Woman* series, for which he became best known. While concentrating on painting during this period, de Kooning contributed an etching for the various artists' portfolio *21 Etchings and Poems*, published by the Morris Gallery in 1960. That same year he made his first abstract expressionist lithographs at the University of California, Berkeley. Standing over large lithographic stones and drawing huge gestural marks with the aid of a mop, two enormous prints were the result. Another lithograph was made in 1966 as part of a portfolio. However, it was not until 1970, following a visit to Japan, where he was directly exposed to calligraphy and Sumi-ink brush painting, that de Kooning took up printmaking with new vigour and produced twenty-four monochrome lithographs at Irwin Hollander's workshop in New York. He also tried colour lithography but the results were largely a failure. After his retrospective at the Whitney Museum in 1984, de Kooning was diagnosed with Alzheimer's disease. He died at East Hampton in 1997. JR

Irwin Hollander had trained at Tamarind and persuaded de Kooning to re-engage with printmaking. Together with his Dutch business partner Fred Genis, Hollander worked on twenty lithographs printed from aluminium plates. De Kooning then made four further lithographs, but this time applying the lithographic ink (called tusche) directly on to the stone. *Minnie Mouse* and *The Preacher* are part of the four. It has been suggested that the popular Disney character 'Minnie Mouse' continues the theme of de Kooning's famous *Woman* paintings from the early 1950s. Minnie Mouse's oversized, high-heeled shoes are all that is clearly visible of the cartoon character through de Kooning's dynamic brushwork. The preacher's face (cat. 86), beneath his black wide-brimmed hat, gradually emerges from the frantic gestural marks. JR

32/60 de Kooning'71

A.P. XXII/XXII de Kooning'71

Cy Twombly

1928–2011

Born in Lexington, Virginia, Edwin Parker Twombly was nicknamed for the legendary baseball pitcher Cy Young. Twombly's art education included stints at the School of the Museum of Fine Arts, Boston; Washington and Lee University in Virginia; and the Art Students League in New York. Most importantly, at the suggestion of Robert Rauschenberg he spent the summers of 1951 and 1952 at Black Mountain College in North Carolina where he worked with Robert Motherwell, Franz Kline and John Cage. Twombly's distinctly personal visual language fused the acts of painting and writing into a single gestural and intermittently legible entity. Though rooted in the expressionist vision of art as an unpremeditated result of spontaneous action, Twombly's early work can also be seen as a precursor of pop art's interest in the material world of words and images. Fascinated by classical antiquity, Twombly moved in 1957 to Italy, where he remained for the rest of his life. He made prints only intermittently, and most often in portfolio formats that allude to the historical function of prints as artefacts of erudition. **ST**

Cy Twombly

87 *Sketches (a–f)* **1967, published 1975**

Portfolio of six etchings
Each signed, numbered '9/18' and lettered a–f in pencil, blindstamp of ULAE, West Islip, New York. 220 x 310 (8⅝ x 12¼) each sheet
a: 58 x 213 (2¼ x 8⅜) plate
b: 110 x 174 (4⅜ x 6⅞) plate
c: 120 x 174 (4¾ x 6⅞) plate
d: 129 x 176 (5 x 6⅞) plate
e: 173 x 124 (6¾ x 4⅞) plate
f: 174 x 109 (6⅞ x 4¼) plate
Bastian 12–17; Sparks 8–14
Private collection, UK (promised gift to the British Museum)

This portfolio, Twombly's first professional print project, was begun 'almost by accident' while visiting Robert Rauschenberg at ULAE in the summer of 1967.[1] Gathered together in a dossier-like folder tied with ribbon, the six *Sketches* etchings are small (plate *a* is barely 58 cm high), with the intimate immediacy of pages taken from a private notebook. Twombly's quick, repetitive gestures reveal the artist's hand as it comes to terms with the unexpected speed of the etching needle, gliding through wax ground with less friction than a pencil encounters on paper. The pronounced diagonal tilt of the marks is a reminder that the image on paper is reversed from the one he drew on the plate. Looking carefully, one can recognize among the freeform scribbles occasional backwards words – 'A RAIN OF KISSES' (plate *e*) accompanies a leaning tower of Xs and Os, while 'Olympia' (plate *d*) hovers above a collection of swift rectangles that might be windows or pages blown from a desk. **ST**

1 Esther Sparks, *Universal Limited Art Editions: A History and Catalogue: The First Twenty-five Years*, Chicago: The Art Institute of Chicago, 1989, p. 277.

⅕ a cy Twombly

⅕ b cy Twombly

⅕ c cy Twombly

⅕ d cy Twombly

⅕ e cy Twombly

⅕ f cy Twombly

Philip Guston

1913–1980

Born Philip Goldstein to immigrant parents in Montreal, Guston grew up mainly in Los Angeles. His early life was marked by tragedy: his father hanged himself and Guston, then a young boy, found the body. With Jackson Pollock he attended Los Angeles Manual Arts High School, from which both were expelled for printing lampoons of the school's English department. After a disappointing term at Otis Art Institute in Los Angeles, Guston abandoned formal education, and he threw himself into the world of modern art and left-wing politics. In 1935 he moved to New York where he painted modernist figurative murals for the Federal Art Project of the Works Progress Administration (FAP/WPA). Subsequently he took up teaching posts in the Midwest before receiving a fellowship to the American Academy in Rome. Back in New York in the 1950s, Guston turned towards abstraction, with paintings that featured central bursts of colour and densely worked surfaces. In the 1960s, however, drawing became more important to him and the diffuse shapes of his paintings gradually resolved into distinct objects and by 1968–69 into active, cartoon-like hooded figures, suggestive of the Ku Klux Klan, which appalled critics even as they inspired younger painters. Though not a prolific printmaker, Guston produced two major and influential print series: *A Suite of Ten Lithographs* (1966) with Irwin Hollander and twenty-five lithographs made with Gemini in the last months of his life. **ST**

Philip Guston
88 *Untitled* 1966
Lithograph
Signed, dated, inscribed 'Artist's Proof' and numbered 'IX/X' (outside ed. 20) in pencil, blindstamp of Hollanders Workshop, Inc., New York.
517 x 730 (20⅜ x 28¾) image,
568 x 765 (22⅜ x 30⅛) sheet
Semff 13
British Museum, London 2003,1231.18
Purchased with funds given by the American Friends of the British Museum

Guston's first lithographs, made at Tamarind Lithography Workshop in 1963, were powerfully composed black-and-white structures, stripped of the chromatic complexity of his painting. Three years later, Guston set aside painting altogether for a while, concentrating instead on drawing and a series of ten lithographs with Irwin Hollander, now running his own print workshop in New York. In this print he fills the space with an array of discrete elements, each rendered with a swift, fluid gesture of the brush and lithographic ink that may stretch out into a line or contour, or huddle up into a scribbled cloud. (Hollander was renowned for his ability to coax liquid greys from the lithographic stone.) Over the next few years these shapes would lose their abstract reticence and become hobnail boots, eyeballs, light bulbs and other accessories of psychological drama. **ST**

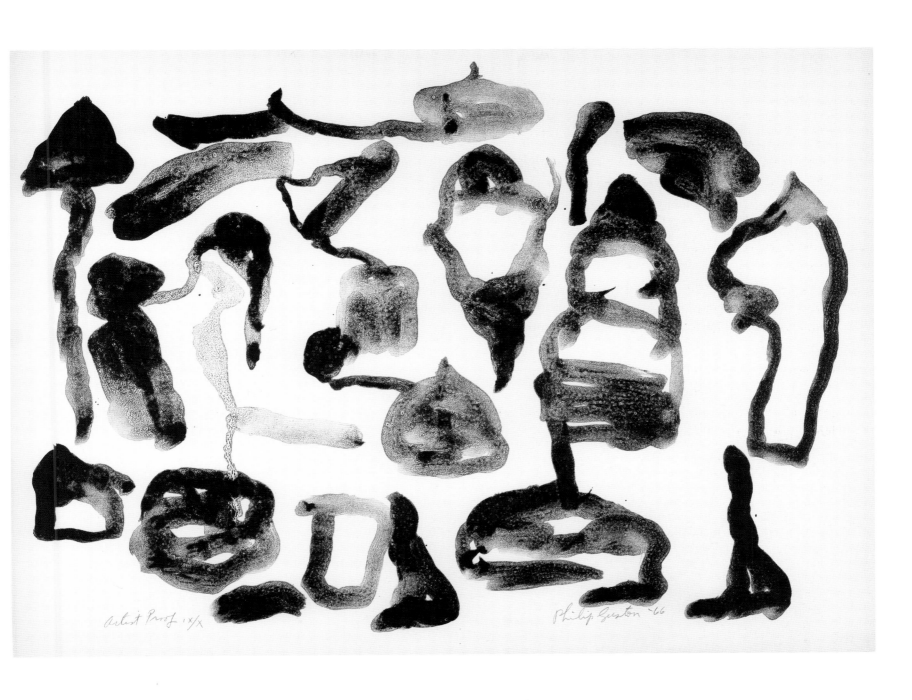

Artist Proof 1X/X Philip Guston '66

Robert Motherwell

1915–1991

The youngest and most erudite member of the first generation of the New York School of painters, Motherwell was born in Washington State but grew up mainly in California, where his father was a successful banker. After earning a BA in philosophy at Stanford University he went to Harvard at his father's insistence to pursue a doctorate. Switching to Columbia University in New York, he came into contact with a number of exiled European surrealists, and by 1941 he had determined to be a painter. Adopting surrealist automatist principles – freeing his hand to work without conscious intention and codifying the results as a personal vocabulary – Motherwell became an influential figure among younger American artists in the 1940s. He loved abstraction for its repudiation of 'the world of objects, the world of power and propaganda, the world of anecdotes, the world of fetishes and ancestor worship'.[1] His paintings were large and unequivocal, but his literary sensibility found expression in the drawings, collages and prints that became increasingly important during his last three decades. **ST**

1 Robert Motherwell, 'What Abstract Art Means To Me', lecture at the Museum of Modern Art, 5 February 1951. Reprinted in Robert Motherwell and Stephanie Terenzio, *The Collected Writings of Robert Motherwell*, New York and Oxford: Oxford University Press, 1992, p. 86.

Robert Motherwell

89 *Automatism A* **1965–66**

Lithograph on buff paper
Signed and inscribed 'artist's proof' (outside ed. 100) in brown pencil, initialled on the plate, blindstamp of Hollanders Workshop, Inc., New York.
714 x 540 (28⅛ x 21¼) sheet
Belknap 6
British Museum, London 2010,7107.1
Purchased with funds given by the Joseph F. McCrindle Foundation to the American Friends of the British Museum

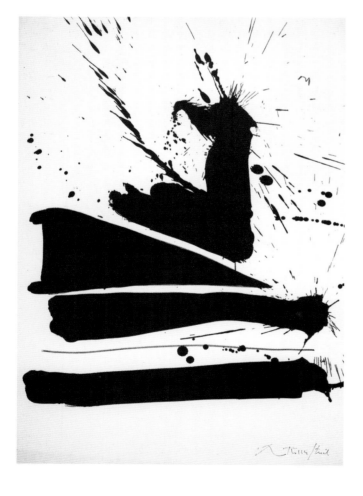

Robert Motherwell

90 *Automatism B* **1965–66**

Lithograph
Signed and inscribed 'Motherwell/trial' in ink (outside ed. 100), initialled on the plate. 765 x 540 (30⅛ x 21¼) sheet
Belknap 7
British Museum, London 2010,7107.2
Purchased with funds given by the Joseph F. McCrindle Foundation to the American Friends of the British Museum

Though Motherwell had made earlier lithographs, he did not really warm to the medium until the fall of 1965 when, finding himself in creative limbo after the opening that year of his retrospective exhibition at the Museum of Modern Art, New York, he sought refuge in the print workshop of Irwin Hollander. 'I had always loved working on paper, but it was the camaraderie of the artist-printer relationship that tilted the scale definitively,' he recalled.[1] The two *Automatism* compositions are formally related to the concurrent paintings, drawings and prints he called *Summertime in Italy* and *Beside the Sea*; all share a base of loose horizontal strokes surmounted by an open 'delta' shape or arcing splash, suggestive of waves breaking against the shore. In titling these two prints *Automatism*, however, Motherwell directed attention away from real-world allusions and towards the conceptual core of his art. For Motherwell, automatism was the strategic solution to the question of what art stripped of figuration might be and mean. Though he would make many larger and more sophisticated prints subsequently, these two monochrome lithographs are among the purest, most dynamic statements of Motherwell's aesthetic and philosophy. **ST**

1 Motherwell, quoted in Jack Flam, 'Robert Motherwell's Graphics', in Elizabeth Armstrong, *Tyler Graphics: The Extended Image*, Minneapolis: Walker Art Center, 1987, p. 52.

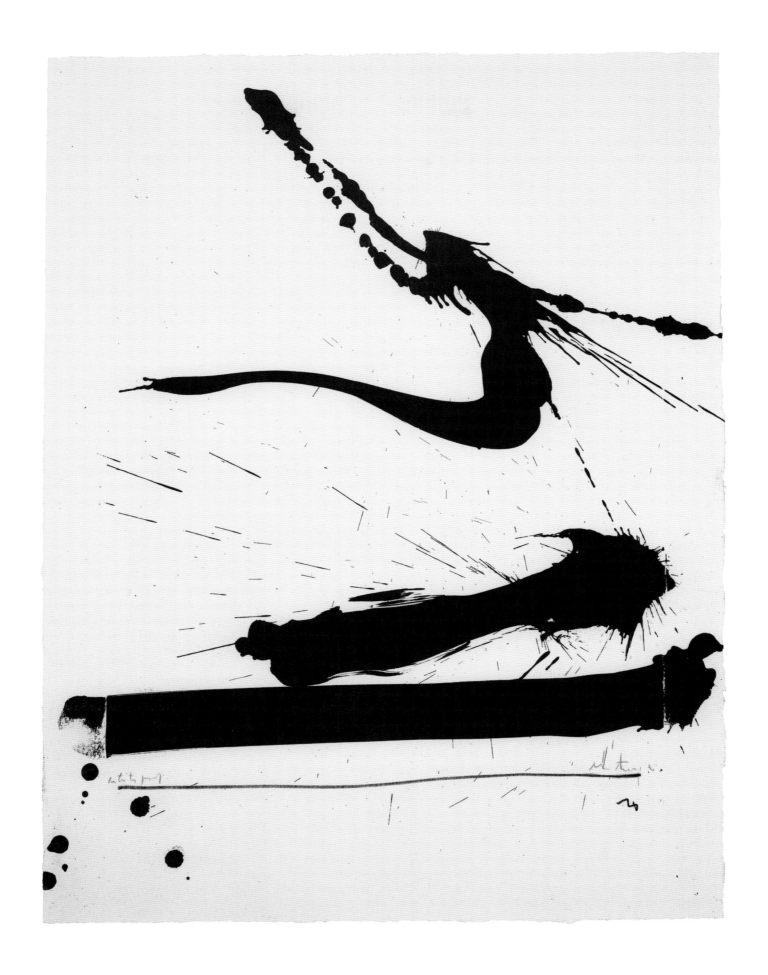

151

Helen Frankenthaler

1928–2011

The daughter of a State Supreme Court judge, Frankenthaler was born and raised in Manhattan. Upon graduating from Bennington College, Vermont, she returned to New York, and by the age of 23 had developed her signature painting technique of pouring thinned paint onto raw unprimed canvas so that the colour stained the fabric rather than sitting upon it. These fluid, lyrical works proved critical in the development of American 'color field' painting, which bridged the expressive abstraction of the New York school and the unity of parts that became central to minimalism. Initially frustrated by printmaking's progression by stages, Frankenthaler later came to rely on its flexibility, reusing elements in different orientations, different combinations and different colours. She always retained the practice of thinking by making, and the creation of some of her prints generated more working proofs than there were impressions in the final edition.[1] Her woodcuts and monumental prints are among her most critically acclaimed works. **ST**

1 Suzanne Boorsch, 'Conversations with Prints', in Pegram Harrison, *Frankenthaler: A Catalogue Raisonné, Prints 1961–1994*, New York: Harry N. Abrams, 1996, pp. 11–44 (p. 25).

Helen Frankenthaler
91 *Savage Breeze* **1974**
Colour woodcut on laminated Nepalese paper
Signed, dated and numbered '1/31' in pencil, blindstamp of ULAE, West Islip, New York. 753 x 633 (29⅝ x 24⅞) image, 800 x 692 (31½ x 27¼) sheet
Harrison 47; Sparks 29
Museum of Modern Art, New York. Gift of Celeste Bartos, 1975

In the early 1970s woodcut was an unfashionable technique associated mainly with the rough urgency of German expressionism. Frankenthaler, whose paintings so brilliantly exploited liquid effects, found that the act of gouging wood was indeed 'alien' to her wrist, but that a jigsaw provided a 'most freewheeling, fluid tool'.[1] Dividing the rectangle into component shapes and using translucent inks, the woodcuts she made in 1973–74 merged colour and woodgrain into a coherent entity, just as in her paintings colour and canvas became one. *Savage Breeze*, made with the printers Bill Goldston and Juda Rosenberg at ULAE, West Islip, New York, was the second of these works; it took an arduous forty-four days of press time to complete – a process that made the artist 'ecstatic, furious, frustrated', until finally she achieved the chromatic glow that resolves the image.[2] The formal grace and power of these works redefined woodcut for a new generation and set the stage for its global revival. **ST**

1 Helen Frankenthaler, 'The Romance of Learning a New Medium for an Artist', *Print Collector's Newsletter*, 8:3 (July–August 1977), pp. 66–67 (p. 67). Article based on lecture for the Drawing and Print Club Founders Society at the Detroit Institute of Arts, 3 May 1977.
2 Frankenthaler quoted in Judith Goldman, 'Painting in Another Language', *ARTnews*, 74:7 (September 1975), pp. 28–31 (p. 30).

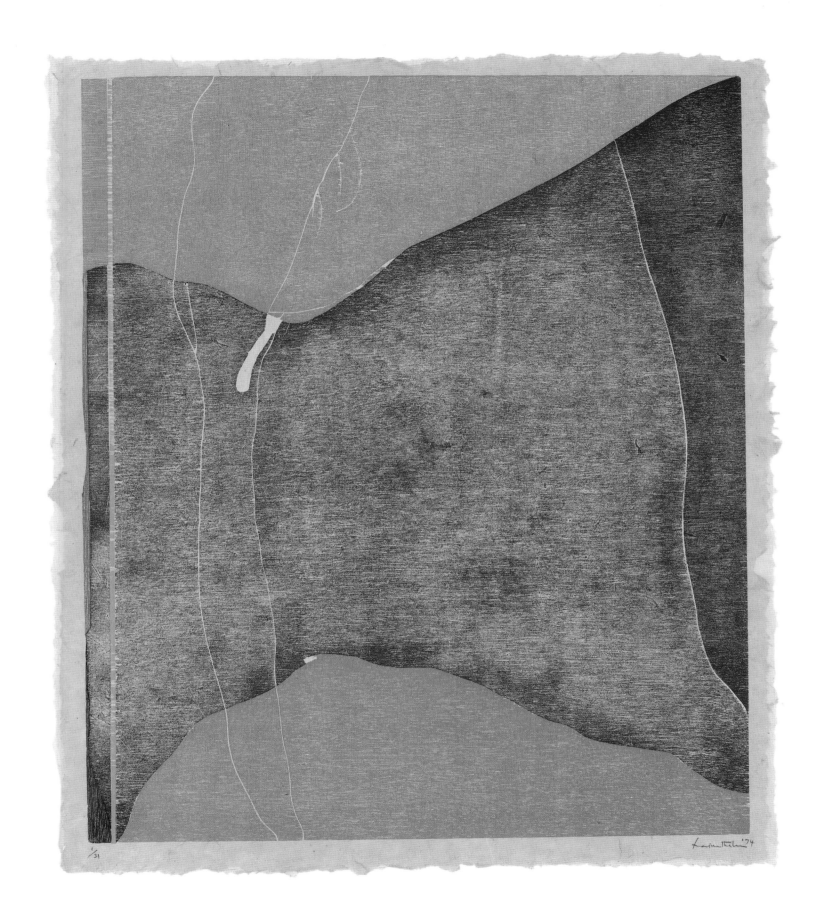

1/31 Kasuntlele '74

Sam Francis

1923–1994

A native of the San Francisco Bay Area, Francis was an abstract expressionist painter, but the openness of his work sets it apart from the solemnity of much of the New York school. Originally intending to be a doctor, Francis took up painting while in hospital with complications from injuries incurred as an airman during the Second World War. After earning a BA and MA from the University of California, Berkeley, he spent most of the 1950s in Paris. The light, colour and space that he considered essential to French painting would continue to inform his art, as would his study of Jungian psychology and Asian philosophical concepts about the balance of opposing forces.[1] Through his Swiss dealer, Eberhard Kornfeld, Francis learned about prints and printmaking, and he began working in lithography before returning to California in 1961. Observing the effect of gravity on drips and splatters as he worked on lithographic stones, Francis changed the way he painted, moving his canvases to the floor. Developing his images through improvisation, trial and error, Francis preferred to work in private, often using print studios at night when all the staff had gone home, and in 1970 he founded his own workshop, staffed with master printers for etching, screenprint and his greatest love, lithography. **ST**

1 Ruth E. Fine, 'Patterns Across the Membrane of the Mind', in Connie W. Lembark, *The Prints of Sam Francis: A Catalogue Raisonné 1960–1990*, New York: Hudson Hills Press, 1992, vol. 1, pp. 15–38 (p. 17).

Sam Francis
92 *Pink Venus Kiki* from Walasse Ting, *1¢ Life* (Bern: E. W. Kornfeld, 1964, ed. 1133/2000)
Colour lithograph
Signed and titled on the stone.
408 x 557 (16 x 21⅞) image (irregular), 410 x 582 (16⅛ x 22⅞) sheet
Lembark L.82
British Museum, London 2014,7080.1.39
Purchased with funds given by the Vollard Group

Francis read and wrote poetry throughout his life, and in 1964 he acted as editor of the ambitious publication *1¢ Life*, which brought the poetry of Walasse Ting together with lithographs by European and American artists. In the six prints Francis contributed, protozoa-like blobs meet, mate and bounce apart amid lively seas of splatter. *Pink Venus Kiki* spills across two pages in a riot of colour, with Ting's poem 'Black Stone for Sam Francis' running across the bottom. Larger shapes cluster at the edges or retreat off the page, leaving a relatively open centre that anticipate the 'Edge' images that would soon occupy the artist for several years. In Francis's art, as in Ting's text, individually meaningless forms come to life through their interactions with each other. Ting's 'black stone', initially described as 'so big so ugly', is transformed when it meets people, or rain or light:

> BLACK STONE IS NOT BLACK STONE
> BECOME
> BIG TWINKLING STAR SHINING
> NOT UGLY
> WHO SAY NO BEAUTY IN THIS WORLD
> WHO SAY NO TRUTH ON EARTH

ST

Sam Francis

93 *Always In and Out of Need* 1976

Lithograph printed in 15 greys and blacks
Signed and numbered '34/35' in pencil,
blindstamp of Gemini G.E.L., Los Angeles.
965 x 2057 (38 x 81) sheet
Lembark L.186
National Gallery of Art, Washington.
Gift of David Gensburg, 1983

For Francis, one of the great gifts of
printmaking was the ability it offered to
re-orient, recombine and re-ink stones
to produce new and unexpected results.
Always In and Out of Need is one of three
prints made with the lithographic printer
Serge Lozingot at Gemini, Los Angeles,
from different arrangements of a group of
nine lithographic stones that bore loose
renditions of spirals and Jungian mandala
shapes. In *Point*, five of these stones
were printed over one another in shades
of black, resulting in a dark, vibrant entity.
Straight Line of the Sun used six stones,
fifteen shades of black, and a frieze-like
composition. *Always In and Out of Need*
employs all nine stones, some printed
multiple times, to create a print over two
metres long and nearly a metre high to
evoke cosmic space. The repetition builds
depth and complexity, a seemingly
limitless universe in which nebulae, dark
and shining, swirl through traceries of
fine drops and splatters. **ST**

Josef Albers

1888–1976

Born and raised in the Ruhr Valley, Albers worked as a schoolteacher until his late twenties. After studying art in Berlin and Munich, at the age of 32 he enrolled at the Bauhaus, where he was appointed to the faculty in 1923, and where he met his wife, Anni, forming a lifelong creative partnership. Josef Albers embraced the Bauhaus emphasis on objective principles, efficiency in art and design, and geometric form. 'Abstracting', he wrote, 'is the essential function of the Human Spirit.'[1] When the school closed under Nazi pressure in 1933, the couple relocated to America to teach at the newly established Black Mountain College in North Carolina, where he became an influential instructor. Robert Rauschenberg recalled, 'Albers was a beautiful teacher and an impossible person…I'm still learning what he taught me, because what he taught me had to do with the entire visual world.'[2] By 1950, when he became head of the department of design at Yale University in New Haven, Connecticut, he had already begun *Homage to the Square* – the nested-square colour studies – that would occupy him for the rest of his life. His work and teaching on colour, as well as his 1963 publication *The Interaction of Color*, made Albers famous, and in 1971 his prints and paintings were the subject of the first retrospective at the Metropolitan Museum of Art, New York, devoted to a living artist. ST

1 Josef Albers, 'Why I Favor Abstract Art', *4 Painters: Albers, Dreier, Drewes, Kelpe*, New York: Société anonyme, 1936, quoted in Mary Emma Harris, *The Arts at Black Mountain College*, Cambridge, MA: MIT Press, 1987, p. 13.

2 Robert Rauschenberg in interview with Jonathan Stix, 8 May 1972, Black Mountain College project papers, North Carolina State Archives, Raleigh, quoted in Harris, op. cit., p. 122.

Josef Albers
94 *I-S LXXIIIb* from *Homage to the Square* 1973
Colour screenprint
Signed, dated, inscribed 'HC' (hors commerce) and numbered '19/35' in pencil, blindstamp of Ives-Sillman, New Haven. 444 x 444 (17½ x 17½) image, 712 x 712 (28 x 28) sheet
Danilowitz 2001, 219
British Museum, London 2000,0930.25
Presented by the Josef and Anni Albers Foundation through Nicholas Fox Weber

Among the Bauhaus ideals Josef Albers championed was that of efficiently produced, economically accessible fine art. At several points during his career he turned to printmaking to further this aim, most successfully in the many *Homage to the Square* editions made during his last two decades. These were experiments in perception – demonstrations of how colour appears to shift, retreat or expand, depending on its placement relative to other colours. There was no personal gesture in Albers' work, but it required tremendous chromatic precision – each colour block had to be perfectly calibrated and uniform. Working with his former students Sewell Sillman and Norman Ives in New Haven from 1962, Albers turned to screenprint, which provided consistent, flat blocks of colour. Together they produced nearly 100 screenprints before Josef's death in 1976. In addition, Albers extended the *Homage to the Square* series in lithography, exploiting the technique's thinner and more translucent films of ink; these prints were produced with Ken Tyler at Tamarind Lithography Workshop from 1963 and at Gemini from 1966. From 1974 he worked with Ken Tyler at Tyler Graphics producing screenprints on the *Homage to the Square* theme. ST

I–S LXXIII β #8 18/45 A '73

Anni Albers

1899–1994

Annelise Fleischmann was born in Berlin to a family of publishers and gravitated early to the visual arts. As a student at the Bauhaus, she was steered, like other women students, into the supposedly 'feminine' domain of textiles. Initially reluctant, she found herself unexpectedly fascinated by the formal and technical challenges of pattern, structure and image. She married Josef Albers in 1925, and with him migrated to the United States in 1933. Two years later they made the first of many visits to Mexico, where both artists fell in love with the intricate geometries of pre-Columbian art. (Josef called Mexico 'the promised land of abstract art'.[1]) In America, Anni Albers produced designs for mass production and also made framed 'pictorial weavings', which were meant to be viewed like paintings. Her solo show at the Museum of Modern Art, New York, in 1949 was the first given to a textile artist. Her involvement in printmaking began when she accompanied her husband to Tamarind Lithography Workshop in 1963, and by 1970 prints were her primary output. They allowed, she said, 'broader exhibition and ownership of work. As a result, recognition comes more easily and happily, the longed-for pat on the shoulder.'[2] **ST**

1 Josef Albers letter to Wassily Kandinsky, 22 August 1936, quoted in Brenda Danilowitz, *The Prints of Josef Albers: A Catalogue Raisonné, 1915–1976*, New York: Hudson Hills Press in association with the Josef and Anni Albers Foundation, 2001, p. 17.

2 Anni Albers in an interview with Richard Polsky, 11 January 1985, Orange, CT, 'American Craftspeople Project', Oral Research Office, Columbia University, New York, transcript in the Josef and Anni Albers Foundation archives, quoted in Nicholas Fox Weber and Pandora Tabatabai Asbaghi, *Anni Albers*, New York: Solomon R. Guggenheim Foundation, 1999, p. 176.

Anni Albers
95 *Camino Real* 1967–69
Colour screenprint
Signed, dated, titled and numbered
'42/90' in pencil. 408 x 383 (16 x 15)
image, 597 x 558 (23½ x 22) sheet
Danilowitz 2009, 12
British Museum, London 2000,0930.19
Presented by the Josef and Anni Albers
Foundation through Nicholas Fox Weber

Anni Albers used the sharp edges and strong flat colour inherent to screenprint to make fresh statements on ancient geometric motifs. *Camino Real* is based on a weaving that Albers designed for the Camino Real Hotel in Mexico City, a modernist landmark built for the 1968 Olympics. In weaving, triangles can only be approximated with stepped diagonals, but screenprint allowed for a sharpness that delighted Albers, who made interlocking triangles the basis of many subsequent prints. This self-published print was one of many she produced at Sirocco Screenprints in North Haven, close to her Connecticut home. **ST**

Camino Real 42/90 Anni Albers 1967/69

Ellsworth Kelly

1923–2015

Ellsworth Kelly was born in Newburgh, New York, and raised in northern New Jersey. Introduced to ornithology as a child, he developed the habit of paying close, analytic attention to the visual world. During the Second World War he served in the US Army's tactical deception unit, which sought to mislead the enemy with visual ruses such as fake airfields and tanks. Kelly then attended the School of the Museum of Fine Arts, Boston, before moving to Paris in 1948. There he honed his working method and aesthetic, distilling chance experiences into planar shapes of flat colour. He returned to New York in 1954 and over the subsequent decade emerged as a major figure in American abstraction. Though its simplicity might seem to align Kelly's work with minimalism, his images always arose from observations of the physical world rather than from investigations into how art objects function. In 1969, when he was included in the Metropolitan Museum of Art's first exhibition of contemporary American art, the works shown included not only his abstract painting and sculpture, but also his linear drawings of plants. After making early lithographs in France, Kelly began his sustained involvement with printmaking in the 1970s, eventually working in almost every form of traditional printmaking as well as with sculptural multiples and other hybrids. **ST**

Ellsworth Kelly
96 *Yellow* from *Twenty-Seven Color Lithographs* **1964–65**
Colour lithograph
Signed and inscribed 'A.P.' (1 of 9 artist's proofs outside ed. 75) in pencil, verso: numbered '2' in pencil. 594 x 394 (23⅜ x 15½) image (irregular), 890 x 601 (35 x 23⅝) sheet
Axsom 2012, 5
British Museum, London 2011,7004.1
Purchased with funds given by the Joseph F. McCrindle Foundation to the American Friends of the British Museum

While many of Kelly's peers approached art as a place of spontaneous invention, Kelly developed his distinctive colour-form identities through a careful process of observation, reconsideration and refinement. Drawing was, Richard Axsom has written, 'the mother lode of Kelly's art'.[1] This print comes from an early lithographic series printed by Marcel Durassier at Imprimerie Maeght in Paris. Throughout the series Kelly repeats a handful of flat bright colour forms, changing their colour, direction and proportions – there are stacks of imperfect ovoids; swollen, off-kilter rectangles with hollow or solid centres and the double parabola that appears in this lithograph. Kelly began exploring the curved parabola shape when he was living in Paris, and it would crop up repeatedly throughout his career – initially as shapes drawn or painted on another surface and later as freestanding or free-hanging objects. **ST**

1 Richard H. Axsom, *The Prints of Ellsworth Kelly: A Catalogue Raisonné*, Portland: Jordan Schnitzer Family Foundation, 2012, p. 16.

20/23

Kelly

Ellsworth Kelly
97 *Colored Paper Image XV (Dark Gray and Blue)* from *Colored Paper Images* **1976**
Coloured and pressed paper pulp
Signed and numbered '20/23' in pencil, blindstamp monograms of the artist and Tyler Graphics Ltd, Bedford Village, New York. 735 x 735 (29 x 29) image, 806 x 781 (31¾ x 30¾) sheet
Axsom 2012, 155
British Museum, London 2015,7102.1
Purchased with funds given by Hamish Parker

From the late 1960s onward, Kelly worked with shaped canvases, painted aluminium structures and other formats that were not simply images *on* things, but images *as* things. The printer Ken Tyler had become interested in the possibilities of handmade paper as a medium in itself, rather than simply a surface to print on. In 1976, working together at HMP paper mill in Woodstock, Connecticut, Kelly and Tyler produced twenty-three *Colored Paper Images* over a period of eight months, a project that inspired other artists such as David Hockney to experiment with paper pulp. To make this image, a mould was glued together from acrylic strips and placed on a freshly made white paper-pulp base. Then a mix of light and dark blue pulp was applied to one triangle of the mould, and a mix of grey and black pulp to the other. The mould was then removed and the sheet pressed to fuse the fibres, causing the colour to bleed into adjacent areas. Although the graceful compositions are familiar from Kelly's other work, the mottled texture and irregular edge mark a departure from his usual precision and control. **ST**

Frank Stella

Born 1936

One of America's most influential abstractionists, Frank Stella was born in Malden, Massachusetts, and educated at Phillips Academy, Andover, where his classmates included future sculptor Carl Andre and filmmaker Hollis Frampton. At Princeton University he majored in history for his BA, but grew increasingly interested in art. Soon after his graduation in 1958 he began work on the Black Paintings, which would form one of the clearest assertions of American minimalism – compositions of black stripes separated by thin lines of canvas, flat and symmetrical, they rebuffed the metaphysical rhetoric of abstract expressionism, proclaiming simply their status as things to be perceived. 'What you see is what you see', was Stella's famous formulation.[1] Fame was almost instantaneous: at 23 he was included in the Museum of Modern Art's 'Sixteen Americans' exhibition in 1959; at 33 he became the youngest artist to receive a one-man show there ten years later. Stella's work has grown ever more complex – even baroque – over the course of his career. While his early prints were restatements of painted compositions, a set of new techniques and materials in the 1980s (laser cutting, magnesium etching, paper making) prompted him to use prints as a primary vehicle of experimentation. Working with Ken Tyler over the course of three decades, Stella produced prints of unprecedented complexity and scale. After Tyler announced his retirement in 2000, Stella said he would cease making prints as well. ST

1 Frank Stella in 'Questions to Stella and Judd: Interview by Bruce Glaser, Edited by Lucy R. Lippard', in Gregory Battcock, *Minimal Art: A Critical Anthology*, New York: E. P. Dutton, 1968, p. 158. The original interview was aired on New York radio station WBAI in February 1964; it was later edited by Lippard and published in *ARTnews* in September 1966.

Frank Stella

98 *Purple Series* 1972

A suite of nine lithographs in metallic purple
Signed, dated and numbered '87/100'
in pencil, blindstamp of Gemini G.E.L.,
Los Angeles. 405 x 555 (15⅞ x 21⅞)
each sheet
Axsom 2016, 64–72
British Museum, London 2015,7101.1-9
Purchased with funds given by James A.
and Laura M. Duncan

In 1967 Stella began a project to record in lithography the compositions of all the stripe paintings he had made over the course of seven years. Beginning with the Black Paintings of 1958, he recast the paintings' designs at a different scale, in a different material, and with the express purpose of being collected as a group. (Initially the plan was to assemble the prints in special loose-leaf albums, exploiting the print's traditional historical role as a tool of comparison and analysis as well as of focused appreciation.) Produced in Los Angeles at Gemini, the *Purple Series* is the sixth of these publications. It derives from a group of shaped canvases made in 1963, each in the form of open polygons, articulated with concentric stripes of metallic paint. Because of their hollow centres, the paintings function as both things *on* the wall, and frames *for* the wall. In the prints, the wall is replaced with the page, but the ambiguity remains: what is irrelevant margin and what is active composition? As with the other 'Album' prints, Stella has placed the image oddly at the lower left of the page, further confusing expectation. The prints were printed in metallic purple ink from the stone and, like the paintings, named after his friends in the New York art world in the early 1960s. The gallery comprises: Kay Bearman, assistant to Henry Geldzahler, assistant curator of American painting and sculpture at the Metropolitan Museum of Art (dodecahedron); Henry Garden, pseudonym for Geldzahler, (octagon); Ileana Sonnabend, art dealer (trapezoid); D., the nickname of Emile de Antonio, documentary filmmaker and promoter of avant-garde art (decagon); Sidney Guberman, sculptor and Stella's contemporary at Princeton (hexagon); Charlotte Tokayer, friend of Richard Bellamy, director of the Green Gallery (pentagon); Carl Andre, sculptor and Stella's classmate at Phillips Academy Andover (parallelogram); Hollis Frampton, experimental filmmaker and another friend from Phillips Academy (square); Leo Castelli, the gallery owner who first represented Stella (triangle).[1] ST

1 Richard H. Axsom with Leah Kolb, *Frank Stella Prints: A Catalogue Raisonné*, New York: Jordan Schnitzer Family Foundation in association with the Madison Museum of Contemporary Art, 2016, p. 126.

Frank Stella

99 *Double Gray Scramble* 1973

150-colour screenprint
Signed, dated and numbered '59/100'
in pencil, blindstamp of Gemini G.E.L.,
Los Angeles. 594 x 1095 (23⅜ x 43⅛)
image, 730 x 1289 (28¾ x 50¾) sheet
Axsom 2016, 93
James M. Bartos Collection

A square built of concentric stripes, Stella
has noted, 'is about as neutral and as
simple as you can get'.[1] For that reason,
it constituted a handy vehicle for
experimenting with programmatic
sequences of colour. In *Double Gray
Scramble* Stella sets two such squares
side by side. Each uses the same
alternating bands of colour and shades
of grey, but the sequence is reversed: the
colours moving outward from the centre
on the left repeat those moving inward
from the periphery on the right. Explained
in words, the system is arbitrary and
implacable, but experienced visually it is
curiously compelling – space seems to
open up, the surface appears to glow and
satisfaction reigns. This vibrancy is also a
technical marvel: the printing at Gemini in
Los Angeles with Ken Tyler and his team
required 150 runs from fifty screens. **ST**

1 Frank Stella quoted in William Rubin, *Frank Stella
 1970–1987*, New York: MoMA, 1987, p. 43.

6 Minimalism and conceptualism from the 1970s

As a reaction against the personal gesture of abstract expressionism and the irony of pop art, minimalism and conceptualism emerged as two distinct yet intimately related strands of thought. While minimalism sought to restrict expressive means to their purest and simplest form, conceptualism valued the idea behind a work of art over the means of its execution. Artists such as the minimalist Donald Judd and the conceptualist Sol LeWitt paid close attention to the structure and properties of materials yet were happy to leave the making of their works to assistants. They purposely distanced themselves from abstract expressionism's obsession with the hand of the artist. Colour, form, texture and material were deliberately pared down to their essence. Lines simplified to horizontals and verticals gave rise to the expressive potential of the grid, one of minimalism's defining features in printmaking.

Many artists, such as Judd and Al Taylor, rejected the term 'sculpture', referring to their three-dimensional work as 'objects' or 'constructions'. They sought to make no reference to an external reality in their work. Their focus on simple, unitary form was balanced by an increasing interest in seriality. For LeWitt, Judd, Edda Renouf and Jennifer Bartlett printmaking provided the ideal medium to pursue their aesthetic within a self-imposed and disciplined order. Minimalist printmakers such as Fred Sandback, Renouf, LeWitt and Judd investigated absence and negative space, while others, including Richard Serra and Brice Marden, examined scale and proportion.

Edda Renouf

Born 1943

Born in Mexico City, Edda Renouf was educated in New York State where she gained her BA at Sarah Lawrence College and then MFA at Columbia University. In 1971, upon receiving her degree, Columbia gave her a fellowship to work abroad in Paris for a year. During this period, Renouf discovered her method of working that involved an exploration of what is normally designated the work of art's support – the stretched linen canvas. Her work is driven by close attention to materials, often removing an element in order to let another 'speak'. Holding the canvas up to the light allowed the artist to identify irregularities in the textile's weave and led her to remove certain threads within the canvas itself thereby revealing particular qualities inherent to its structure. In her drawings Renouf incises lines with an etching needle before applying pastel chalk, so that the burr of the incised paper collects a greater concentration of pigment, thus emphasizing the pastel's colour while bringing out the texture of the Arches paper. This is echoed in her painted work where the removal of threads from a linen canvas is coupled with numerous applications of acrylic glaze, which are often sanded, the uneven colour serving to highlight further the structure of the linen textile. Although approached by Stanley William Hayter to make prints at Atelier 17 in Paris, she was then too focused on her new discoveries in painting and drawing to undertake any experimentation with intaglio. However, in 1974, following her return to America, Renouf embarked upon a collaboration with Crown Point Press in Oakland, California, producing her first five portfolios of etchings: *Traces* (1974), *Clusters* (1976), *Marks* (1976), *Overtones* (1977) and *Resonances* (1979). The relationship was facilitated by Robert Feldman, print publisher at Parasol Press, New York, who had been fascinated by her work since attending her first solo show at Galerie Yvon Lambert in Paris in 1972. A retrospective exhibition of her paintings and drawings was given by the Staatliche Kunsthalle Karlsruhe in 1997. Her work is held in many museums, including the British Museum, the Centre Pompidou, Paris, and the Museum of Modern Art, New York. Renouf lives and works in Paris. IS

Edda Renouf
100 *Traces* 1974
Portfolio of six etchings and aquatints
Signed and dated in pencil and inscribed 'ap-[a to f]-6' (artist's proof set 6/10 outside ed. 25), blindstamps of Crown Point Press, Oakland, and the printer (John Slivon). 270 x 275 (10⅝ x 10⅞) each plate, 465 x 455 (18¼ x 17⅞) each sheet
Sollertis/Parasol Press 1–6
British Museum, London 1999,1128.9.1-6
Presented by the artist

This series, the artist's first venture in printmaking, explores many of the concerns that have continued to motivate her painted and drawn work. The threads that Renouf removes from her canvases in order to illuminate their internal structure, and which are in some cases reapplied, are represented by the delicately meandering lines, here transferred to the plate via soft-ground etching. The stack of short parallel lines in *b* recalls paintings such as *Trace I* (1973–74, private collection) where vertical threads have been removed in order to reveal a narrow column of horizontal strands. The prints exemplify the typically restrained palette of Renouf's early work: the backgrounds progress from stark white to a deepening mottled aquatint ground that echo the tonal ground of her canvases. The subtle formal variations in this series of etchings recall the significance of the cycle of the seasons and the four elements in her work and her abiding relationship to nature, which she has described as 'almost pantheistic'.[1] IS

1 Quoted in Ruth E. Fine, 'Marks and Memories: Drawings by Edda Renouf', in *Edda Renouf: Werke 1972–1997/Oeuvres/Works*, exh. cat., Staatliche Kunsthalle Karlsruhe, 1997, p. 58.

Brice Marden

Born 1938

Born in Bronxville, in Westchester County, New York, Marden was brought up
in Briarcliff Manor, also in Westchester. After Boston University School of Fine
and Applied Arts (BFA, 1961), he studied at the School of Art and Architecture,
Yale University (MFA, 1963), then under the direction of Josef Albers, where
Alex Katz was one of his visiting instructors and his fellow students included
Richard Serra and Chuck Close. After graduating, he worked as a security guard
at the Jewish Museum, New York, where he was exposed to Jasper Johns' first
retrospective (1964). Marden's first monochromatic single-panel painting from
that year showed his interest in a restricted palette and formal means. To make
ends meet, he worked at the Chiron screenprint workshop in New York before the
Bykert Gallery gave him his first solo show in 1966. He then worked as Robert
Rauschenberg's studio assistant for four years. During the 1960s and 1970s
Marden created minimalist works of formal rigour through the limited expressive
means of proportion, colour and surface texture. In the mid-1980s, following a
personal crisis, his work took a new direction that reflected his growing interest
in Chinese calligraphy and Zen Buddhism. An accomplished printmaker who
has worked extensively in screenprint, etching and lithography, Marden's
collaboration with Kathan Brown at Crown Point Press showed etching's
potential for subtlety in mark-making and became one of the highpoints of the
technique in the 1970s. Marden has produced over 150 prints within some sixty
portfolios and series. In 1992 the Tate held a retrospective of his prints. IS

Brice Marden

101 *Untitled* **from** *Ten Days* **1971,**

published 1972

Etching and aquatint

Signed, dated and numbered '4/30' in
pencil, blindstamp of the printer (Patricia
Branstead). 305 x 385 (12 x 15⅛) plate,
565 x 760 (22¼ x 29⅞) sheet

Lewison 1992, 20e

British Museum, London 1979,1006.8

Brice Marden

102 *Untitled* **from** *Ten Days* **1971, published 1972**

Etching

Signed, dated and numbered '17/30' in pencil, blindstamp of the printer (Patricia Branstead). 372 x 604 (14⅝ x 23¾) plate, 564 x 760 (22¼ x 29⅞) sheet

Lewison 1992, 20h

British Museum, London 2004,0602.109

Bequeathed by Alexander Walker

So titled because it was completed over a period of ten days, Marden's first portfolio of etchings was printed in collaboration with the printer Kathan Brown and her assistant Patricia Branstead at Crown Point Press in Oakland, California. It was produced at the instigation of the print publisher Robert Feldman of Parasol Press, New York, who had invited the artist to take up this project. This set of spare and reductive etchings reveals Marden's preference for the grid within a rectangular plate that is repeated by the format of the paper. In cat. 101, the black aquatint ground is overprinted in silver grey from a second etching plate composed of tiny cross-hatched marks within ruled grids. The illusion of surface texture echoes the highly worked surfaces of Marden's grid drawings, which he was making at this time, such as the graphite and beeswax drawing (cat. 103). By contrast, cat.102 appears almost starved of ink: the overall surface is activated by tiny accidental pitted marks, known as foul biting, created by an imperfectly laid ground that the artist had asked Kathan Brown to leave on the plate. Marden assigned no particular order to the etchings since he worked on them simultaneously. Each functions equally well as a stand-alone work. **IS**

Brice Marden

103 *Untitled* **1972**

Graphite and wax
Signed and dated in pencil. 559 x 762
(22 x 30)
Berry and Shear 2011, p. 236
Private collection, UK (promised gift
to the British Museum)

This drawing presents a rectangle divided
into 576 smaller rectangles in a 24 by 24
grid. The surface of each rectangle is
densely worked with beeswax to achieve
a great subtlety of texture. The use of
beeswax, which Marden had first
incorporated into his paintings in the
mid-1960s, had the effect of asserting
the primacy of the picture plane while
providing depth from the medium itself.[1]
Lacking the basic distinction of figure
and ground, each square is instead a
planar index of its making. Speaking of
his manner of working, Marden observed:
'The grids come out of the shape of the
paper or the shape they define. There was
always some sort of reference, very rarely
arbitrary. But with the grids, I always
thought drawing on the layers of graphite
was the labor of the drawing. It's possessing
it, making it yours. To start out with this
rectangle and make it yours by marking
it over and over.'[2] IS

1 Jeremy Lewison, *Brice Marden Prints 1961–1991.
A Catalogue Raisonné*, London: Tate Gallery, 1992,
pp. 20–21.
2 Quoted in 'Brice Marden interviewed by Saul
Ostrow', *BOMB*, 22 (Winter 1988), pp. 30–37
(p. 34), cited in Lewison, op. cit., p. 27.

Donald Judd

1928–1994

Best-known as a leading minimalist sculptor, Judd was born in Excelsior Springs, Missouri. After military service he studied at the College of William and Mary, Williamsburg, Virginia (1948–49), the Art Students League in New York City and at Columbia University (BA, 1953) where he majored in philosophy and undertook further studies in art history (1958–60). He began his career as a painter and as an uncompromising critic for *ARTnews*, *Arts Magazine* and *Art International*. In the early 1960s he turned to sculpture, stating that 'actual space is intrinsically more powerful and specific than paint on a flat surface'.[1] Judd defined his sculptural vocabulary based on boxes constructed from metal and wood, particularly in 'stacks' of wall-mounted elements of equal size, alternating solid and void. His grammar was one of repetition or progression, paying close attention to variations in the relationship between standard units, an emphasis on sequence rather than composition and stressing each unit's relation to the next. In 1964–65 Judd published his important essay 'Specific Objects' setting out the paradigm of a new minimalist art, which turned from the illusionism of painting to focus on a work of art's objective reality, in particular its colour, material and proportions. Although closely involved in all aspects of the work, Judd left the fabrication of his pieces by industrial processes to professional workshops. In the early 1970s, with support from the Chinati Foundation, Judd purchased a former US Army base in Marfa, western Texas, which became an open-air museum for his work and that of other artists, including Dan Flavin, Richard Long and Claes Oldenburg. While his first prints in the 1950s were figurative and traditional, from the early 1960s he developed a minimalist vocabulary, including the notion of seriality in his woodcuts. Judd created just over 300 prints, the majority of them woodcuts, in which rich and dense colour often played an expressive role. His sculptural work interplayed with his printmaking; after the woodblocks were printed he treated them as sculptural objects. As Judd himself stated, 'I think it is a little contradictory for me to do prints, but I like doing them.'[2] IS

1 Donald Judd, *Complete Writings 1959–1975*, Halifax: Press of the Nova Scotia College of Art and Design; New York: New York University Press, 1975, p. 184.

2 Jörg Schellmann and Mariette Josephus Jitta, *Donald Judd, Prints and Works in Editions: A Catalogue Raisonné*, Munich and New York: Edition Schellmann, 2nd rev. edn, 1996, p. 26.

Donald Judd
104 Untitled 1961–75
Woodcut on cream oriental paper
Signed, dated and numbered 'AP 3/6'
(artist's proof outside ed. 20) in pencil.
378 x 513 (14⅞ x 20¼) image,
628 x 860 (24¾ x 33⅞) sheet
Schellmann and Jitta 29
British Museum, London 2010,7103.1
Purchased with funds given by the James
A. and Laura M. Duncan Charitable Gift
Fund to the American Friends of the
British Museum

This is from a set of two woodcuts in black. In this print, horizontal and vertical lines form a rectangular grill in the centre, while in the second print only the horizontal lines are carved. The shapes recall Judd's sculptures (with six 'boxes' arranged in a vertical 'stack'). Yet the artist makes no attempt to reproduce his sculptures in two-dimensional form – a criticism that he levelled at his predecessors for being 'illusionistic'.[1] Though drawn by Judd, the woodblocks were cut in 1961 by the artist's father, Roy C. Judd, using electrical tools, but not printed until 1975. The grain of the woodblock on the fibrous paper gives the solid background a visually arresting texture. IS

1 'Specific Objects', *Arts Yearbook*, 8, 1965, pp. 74–82.

AP 3/6 Judd 75

Donald Judd

105 Untitled (Ivory Black) 1988

A series of 10 woodcuts
Verso: each signed and numbered '25/25'
in pencil. 600 x 800 (23⅝ x 31½)
each sheet
Schellmann and Jitta 177–186
Private collection, UK (promised gift
to the British Museum)

In 1988 Judd made three editions of this
woodcut series; this set is in ivory black, a
second was in cadmium red and a third in
ultramarine blue. The governing principle
of each set – the progressive division
of the rectangles – remains the same,
irrespective of colour. Judd begins here
with a solid and centrally positioned black
rectangle; this is then divided vertically by
a line down the middle and then by two
vertical lines; a single horizontal line and
then two horizontal lines. Running parallel
is a reversal of the same idea with the
borders printed in black and the central
rectangle left as an unprinted field,
followed by an identical division of the
borders. The symmetry of each sheet and
its proportions of 3:4 (while apprehended
with a deceptive immediacy) are integral
to the experience of the work. The ten
blocks were carved by Jim Cooper in
New York. The black, red and blue sets
were printed from the same blocks on
Japanese paper by Maurice Sánchez
and his team at Derrière L'Etoile Studios
and published by Brooke Alexander,
New York, in three editions of 25.
Displayed as a series, these woodcuts
echo Judd's sculptural stacks, which he
began to make in 1965 (see opposite). IS

Donald Judd, Untitled,
1980, black anodized
aluminium and clear acrylic
sheet. 229 x 1016 x 787
(9 x 40 x 31) each unit
(10 units)

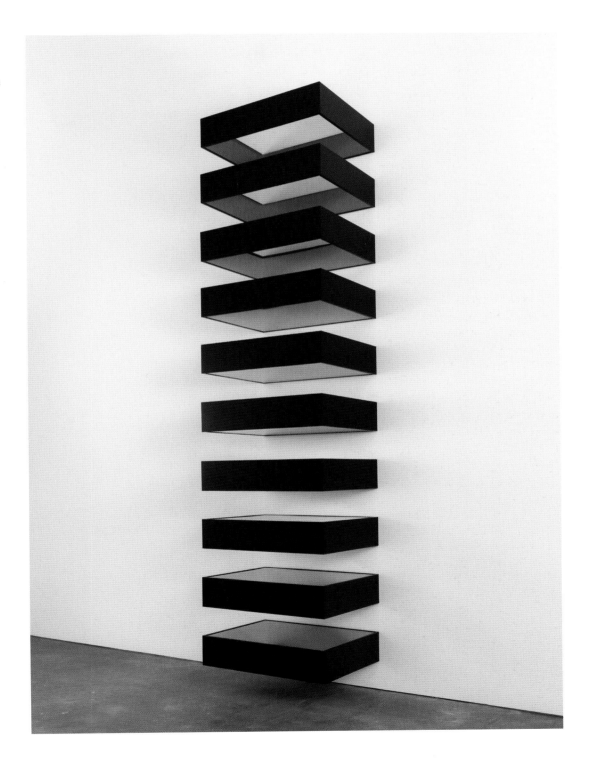

Sol LeWitt

1928–2007

Born in Hartford, Connecticut, to a Jewish family of Russian immigrants, LeWitt was brought up by his mother after his father died when he was young. He gained his BFA (1949) at Syracuse University before being drafted into the US Army to serve in Korea and Japan. Returning to America in 1953, he studied at the Cartoonists and Illustrators School, New York (now the School of Visual Arts), before working as a graphic designer for the architect I. M. Pei. In 1963 he abandoned painting to focus on making reliefs and constructions. Two years later he began work on his best-known modular sculptures (inspired by the serial photographs of Eadweard Muybridge depicting bodies in motion), which were based on variations in the arrangement of basic shapes, beginning with the cube. A pioneer of conceptualism, LeWitt's 'Paragraphs on Conceptual Art' (*Artforum*, 1967) set out a framework whereby the idea of a work of art was judged more important than its making, which could be carried out by assistants or draughtsmen: 'The idea becomes a machine that makes the art.'[1] This was a reaction to the highly subjective painting methods of the abstract expressionists. Henceforth, drawing, rather than painting, was LeWitt's preferred two-dimensional medium. In 1968 he created his first wall drawing at the Paula Cooper Gallery, New York, because, in his words: 'I wanted to do a work of art that was as two-dimensional as possible.'[2] At Syracuse University in the late 1940s LeWitt had taken up printmaking to produce lithographs in a social realist idiom, but it was not until 1970 that he fully engaged with printmaking (lithography, screenprinting, etching and later woodcut) to drive forward his programme of conceptual art. His first portfolio of etchings, *Squares with a Different Line Direction in Each Half Square*, produced as a set of ten prints with Crown Point Press in 1971, was printed from only two plates (rotated and overprinted) – the additive nature of printmaking perfectly complementing his systems-based way of working. Printmaking was to remain central to his practice and to his commitment to make art more widely available to 'unwealthy' people; he produced nearly 300 editioned prints and more than fifty artist's books during his lifetime. Based for periods in the medieval Italian town of Spoleto, he died in New York in 2007. IS

Sol LeWitt. Three kinds of lines & all their combinations. 1. Straight Lines, 2. Not-straight Lines, 3. Broken Lines, 4. Alternate Straight & Not-straight Lines, 5. Alternate Straight & Broken Lines, 6. Alternate Not-straight & Broken Lines, 7. Alternate Straight, Not-straight & Broken Lines. Seven black & white etchings in an edition of twenty-five copies. Printed by K. Brown, Crown Point Press, Oakland. Published by Parasol Press, Ltd. N Y C. 1973.

1 Sol LeWitt, 'Paragraphs on Conceptual Art', *Artforum*, 5:10 (Summer 1967), pp. 79–84.

2 Sol LeWitt, *Arts Magazine* (April 1970), cited in *Sol LeWitt: The Museum of Modern Art, New York*, edited and introduced by Alicia Legg, designed by Sol LeWitt, essays by Lucy R. Lippard, Bernice Rose and Robert Rosenblum, exh. cat., New York: MoMA, 1978, p. 169.

Sol LeWitt

106 *Three Kinds of Lines and All Their Combinations* **1973**

Portfolio of seven etchings (title-page, plates 1 and 2 illustrated here)
Verso: each signed and numbered '18/25' in pencil. 692 x 539 (27¼ x 21¼) each sheet approx.
Krakow 1973.01; Lewison 1986, E5
British Museum, London 1982,0123.16-22

This series illustrates LeWitt's continued fascination with the permutations of a basic, formal proposition – in this case, 'straight, not-straight and broken lines in all horizontal combinations'. The combinations are exhaustive, yet by no means predictable. They recall his statements that while elements should be restricted, and in themselves 'deliberately uninteresting', combined they may yield surprising results.[1] His pared-down grammar originally consisted solely of straight horizontal, vertical and diagonal lines, drawn in the three primary colours and black. In a series of related drawings in 1973, LeWitt expanded his linear vocabulary by two units – the 'not-straight' and the broken line – which increased the number of possible permutations. Unlike his silkscreen and woodcut prints, which were executed by assistants, LeWitt drew on the etching plates himself, considering them an extension of his drawing practice. All the printed sheets have been trimmed to eliminate the plate mark, thereby concealing the most obvious evidence of their making. This is perhaps an indication that, like his wall drawings, they should be considered 'ideas rather than objects'.[2] This portfolio was printed by the master printer Kathan Brown at Crown Point Press, Oakland, California, and published by Parasol Press, New York. It was among several important print projects made by LeWitt with Crown Point Press during the 1970s and 1980s. **IS**

1 Sol LeWitt, 'Paragraphs on Conceptual Art', op. cit., pp. 79–84.
2 Legg, *Sol LeWitt*, op. cit., p. 95.

Fred Sandback

1943–2003

A minimalist sculptor who created spare installations from elastic cord, steel rods and later yarn, Sandback was born in Bronxville, New York. After majoring in philosophy at Yale (BA, 1966), he entered the University's School of Art and Architecture where he studied sculpture (MFA, 1969) and met Robert Morris and Donald Judd, both visiting teachers. *Shadow Piece*, his contribution to the Yale Summer Group Show in 1967, was entirely environmental: the shadow cast by a low wall over a flight of steps in the art-school building was delineated with a fluorescent-orange elastic cord. Speaking of his work, Sandback later stated: 'I wanted to make something without an interior, at least in the sense of a conventional sculpture which has an interior, an invisible interior; I didn't want a volume enclosed by a surface.'[1] An early admirer was Judd, although Sandback chose to differentiate his work from the first generation of minimalists by referring to his three-dimensional works as sculptures rather than objects. In 1968 he had his first solo shows at Konrad Fischer Galerie, Dusseldorf, and at Heiner Friedrich, Munich. His later works created with yarn gave a softer line, with colour emphasizing the imaginary planes that these lines created. From 1970, when he made his first screenprint in two colours on yellow paper, he took up printmaking, exploring lithography, linocut, etching, and so-called 'reverse lithography'. He also experimented with photostat printing and monoprint. As the print historian Richard S. Field remarked, 'few artists have become so intimate with the materials of printmaking'.[2] In 1981 the Dia Art Foundation opened a museum of Sandback's work in Winchendon, Massachusetts, although the artist chose to close it in 1996, saying it was 'premature to start tending your own legacy'.[3] Sandback lived and worked in New York City but suffered from depression, taking his own life in 2003. His work is on permanent display at Dia:Beacon, New York. IS

1 'An Interview: Fred Sandback and Stephen Prokopoff', *The Art of Fred Sandback: A Survey*, Champaign-Urbana, Illinois: Krannert Art Museum, University of Illinois, 1985, n.p., www.fredsandbackarchive.org/ [accessed 13 July 2016].

2 Richard S. Field, 'Fred Sandback: Drawings and Prints', *Fred Sandback: Sculpture*, New Haven: Yale University Art Gallery and Houston: Contemporary Arts Museum, 1991, p. 32.

3 'Lines of Inquiry: Interview by Joan Simon', *Art in America*, 85:5 (May 1997), pp. 86–93, 143 (p. 92).

Fred Sandback, *Untitled (Vertical Corner Piece) [RLL]*, 1968, three elements fluorescent blue acrylic on 0.8 ($^1/_{32}$) diameter spring steel and elastic cord, overall 2845 x 76 x 51 (112 x 3 x 2)

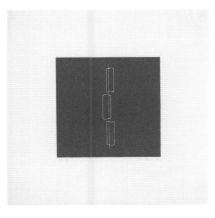 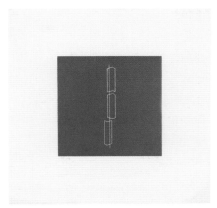 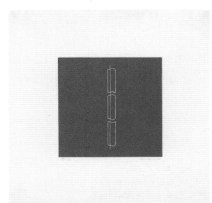 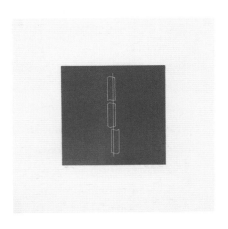

Fred Sandback

107 *Portfolio with 8 Linocuts* 1979

A suite of 8 linocuts in blue on Japanese
laid paper
Each signed, dated and numbered 'III/X'
in pencil. 178 x 178 (7 x 7) each image
approx., 348 x 348 (13¾ x 13¾) each
sheet approx.
Jahn 76–83
Private collection, UK (promised gift
to the British Museum)

This portfolio of linocuts relates to
Sandback's sculptural 'corner' pieces
(such as *Untitled (Vertical Corner Piece)
[RLL],* 1968, see opposite), where steel
rods project from wall to wall, connected
by elastic cord along the wall's surface.
In these prints, without the planes of the
walls, the emphasis is placed on the edges,
instead of the implied volume, constructing
a space in each print. Sandback began
making linocuts in 1975. Initially he
worked from a solid black field cutting
his few white lines. Some included the
boundaries of wall and floor, ceiling, or
corners, while others were simply fields.
The vibrant blue of these linocuts is the
outcome of these investigations, and acts
as a playful inversion of coloured yarn in
a white cube gallery. Sandback insisted,
however, that his prints stood independently
of his sculpture. 'The prints really are
prints,' he claimed, 'they always make use
of sculptural motifs, but beyond that they
are properly graphics. They are dealing
with themselves first as graphics and only
secondarily as a system of representation
or documentation.'[1] **IS**

1 'An Interview: Fred Sandback and Stephen
 Prokopoff', *The Art of Fred Sandback*, op. cit.

Richard Serra

Born 1939

Serra's most famous works are his site-specific sculptures made from massive plates of Cor-Ten steel, which are concerned with balance, weight and mass, and their relationship to the viewer. Born in San Francisco, he studied at the University of California, Berkeley and Santa Barbara (1957–61), and then at Yale University (1961–64) where he worked with Josef Albers on his seminal book *Interaction of Color* (1963) and met many of the visiting New York artists, including Philip Guston, Robert Rauschenberg and Frank Stella. A founding proponent of 'process art', Serra focused on the action of the work's making, including flinging molten lead in *Splashings* and *Castings* (1968–69) and producing the *Cuttings* and *Scatter Pieces* (1968–70). Serra began to use Cor-Ten steel for its durability (after a period of less than a decade it ceases to oxidize) while its materiality became the driving force behind his sculptural investigations. As early as 1972 Serra took up printmaking as an integral part of his practice – first in lithography and then from the mid-1980s in screenprinting with paintstick and in deeply bitten etching, his use of both mediums characterized by the achievement of dense surface texture. Serra has worked extensively with Gemini in Los Angeles, as well as with other printers, including Gregory Burnet at Burnet Editions, New York, where the *WM* series of aquatint etchings developed from Serra's *Weight and Measure* sculptural installation of two massive blocks of solid forged steel at the Tate Gallery in 1992. By 1999 Serra had made over 130 editioned prints. Serra has said of his prints: '[They] are not illustrations or depictions of the sculpture. The experience of building the sculpture acted as a catalyst that led to separate activities like etching and drawing. Work generates different kinds of work.'[1] **IS**

1 'Richard Serra: An Interview by Mark Rosenthal', in *Richard Serra. Drawings and Etchings from Iceland*, New York: Matthew Marks Gallery, 1992; cited in Silke von Berswordt-Wallrabe and Susanne Breidenbach, *Richard Serra Prints: Catalogue Raisonné 1972–1999*, Düsseldorf: Richter, 1999, p. 30.

Richard Serra, *My Curves are not Mad*, 1987, Cor-Ten steel, 4267 x 13700 x 3530 (168 x 539⅜ x 139) overall. Raymond and Patsy Nasher Collection, Nasher Sculpture Center, Dallas, Texas

Opposite, above: Richard Serra
108 *My Curves are not Mad* **1987**
Screenprint with paintstick
Signed, dated and numbered '13/19' in pencil, blindstamp of Gemini G.E.L., Los Angeles. 1283 x 1956 (50½ x 77) sheet
Berswordt-Wallrabe and Breidenbach CR44
Private collection, UK (promised gift to the British Museum)

The imposing effect of black dominates Serra's prints and drawings. 'Black is a property, not a quality', he has noted, 'In terms of weight, black is heavier, creates a larger volume, holds itself in a more compressed field. It is comparable to forging. Since black is the densest color material, it absorbs and dissipates light to a maximum and thereby changes the artificial as well as the natural light in a given room.'[1] Serra's print relates to a sculpture of the same name from 1987 (see left), made from two massive plates of Cor-Ten steel (each more than 13.7-metres long and weighing over 22,600 kg) that were twisted using incredible amounts of force to curve gently and yet allow enough space to walk in-between. The print echoes this imposition of weight as the dense mass of black seems to thrust outward towards the viewer. The title is a quotation from notes by Henri Matisse in his 1947 artist's book *Jazz*, in which the French artist claimed that he never drew a curve without being aware of its relation to the vertical.[2] This is particularly apt given the sculpture's emphasis on verticality, encouraging viewers to walk along its interior passage, while the massive weight is poised to bear down upon them. **IS**

1 Richard Serra, 'Notes on Drawing', in Richard Serra, *Writings – Interviews*, Chicago and London, 1994, pp. 177–81 (p. 179), cited in Berswordt-Wallrabe and Breidenbach, op. cit., p. 30.
2 Henri Matisse, *Jazz*, Paris: Tériade, 1947, cited in Jack Flam, ed., *Matisse on Art*, Berkeley and Los Angeles: University of California Press, rev. edn, 1995, pp. 172–73.

Right, below: Richard Serra
109 *Core* **1987**
Screenprint with paintstick on coated paper
Signed, dated and numbered '5/30' in
pencil, blindstamp of Gemini G.E.L., Los
Angeles. 1257 x 1448 (49½ x 57) sheet
Berswordt-Wallrabe and Breidenbach
CR42
Private collection, UK (promised gift
to the British Museum)

Although the screenprint is usually
typified by the application of flat colour
through a screen, Serra has chosen to
use paintstick (a special type of oil-crayon
block) to achieve a dense textured
surface. Layers of black were created by
first applying ink through a mesh screen
on to the paper below in the conventional
way. Paintstick was then pushed through
the screen in long downward strokes
several times to build up a deposit of
thick black texture. The result evokes the
mass and heft of Serra's monumental
sculptural works, with the unevenly
encrusted texture recalling the appearance
of corroded steel, the artist's favoured
material. Weight is also invoked by Serra's
placing on the paper, where the boundaries
of the dark mass extend beyond the sheet's
four edges. It suggests an uncontainable
colossal mass, only part of which can be
encompassed by our view. **IS**

Jennifer Bartlett

Born 1941

Bartlett was born in Long Beach, California. After obtaining a BA at Mills College, Oakland, California, she studied at the School of Art and Architecture, Yale University, where she received her BFA (1964) and MFA (1965). She was exposed to the vital New York art scene through her instructors, among them the artists Robert Rauschenberg, Claes Oldenburg and Jim Dine, while Brice Marden, Richard Serra and Chuck Close were among her near contemporaries. Bartlett has worked across media including painting, drawing, printmaking and sculpture, as well as architectural installation, continually experimenting both materially and conceptually. One of her most celebrated works, *Rhapsody* (1975–76, Museum of Modern Art, New York), consisted of nearly one thousand 30 cm square, steel plates, screenprinted and hand-painted in enamel. Measuring over 16 metres in length and 2.2 metres in height, it filled the entire gallery space when it was first exhibited at the Paula Cooper Gallery in New York. The monumentality and the particularity of the multi-part work – the units of which can be read both on their own terms and in relation to their various contexts – were to remain key themes throughout Bartlett's career. Another notable series, *In the Garden* (1980–81), is a sequence of 197 drawings in a diverse range of media including brush and ink, conté crayon and gouache. Embarking on her first portfolio of prints, *Day and Night* (1978), Bartlett entered a long-lasting collaboration with the print workshop Aeropress, New York. Her prints have been published by Paula Cooper Gallery, Brooke Alexander and Multiples, Inc. **IS**

Jennifer Bartlett, Drawing for *Graceland Mansion*, 1977, coloured pencil and graphite on graph paper, 432 x 559 (17 x 22) Metropolitan Museum of Art, New York, 1978.198.1 Purchase, Friends of the Department Gifts and matching funds from the National Endowment for the Arts, 1978

Jennifer Bartlett

110 *Untitled (Graceland Woodcut State II)* **1979–80**

Three-part colour woodcut printed in blue, grey, brown and black, on Japanese paper Signed, dated, titled and numbered '9/20' in pencil. 840 x 833 (33 x 32¾) each sheet approx.
Sheet 1: 635 x 576 (25 x 22⅝) image approx.
Sheet 2: 603 x 650 (23¾ x 25⅝) image approx.
Sheet 3: 637 x 650 (25 x 25⅝) image approx.
Field and Scott 5
British Museum, London
1981,0620.36.1-3

This woodcut triptych is related to *Graceland Mansions* (1978–79), a five-part print made using the five different techniques of drypoint, aquatint, screenprint, woodcut and lithography, each panel with its characteristic marks according to the technique. Seven blocks were used to create the woodcut panel in *Graceland Mansions*. For this state, the sixth and seventh original blocks were used. Although the title makes reference to Elvis Presley's home, Graceland Mansion, the house motif is connected to Bartlett's 1977 five-panel painting that she was working on when the singer died. The basic house – a simple geometric shape of a rectangle with

a triangle on top – suggests the ideal American home. A preparatory drawing on graph paper (see opposite), as well as the painting and the five-part print, shows different views of the house's structure, with the changing length and direction of shadow as the perspective rotates, indicating the passing of time from dawn to dusk. In this woodcut triptych, set in late afternoon, Bartlett oscillates between abstraction and representation as different changes are rung on the motif with the imposition of parallel vertical lines, parallel horizontal lines and their combination as a grid. Bartlett cut the blocks herself (with the guidance of Chip Elwell in New York), which was exhausting and labour-intensive

but suited her desire for the final work to reflect the process of its making. She observed that 'woodcut is very direct…It's quite close to drawing.'[1] One of Bartlett's most significant works, the Graceland print project was published by Brooke Alexander. **IS**

1 Quoted in Deborah C. Phillips, 'Looking for Relief? Woodcuts are back', *ARTnews*, 81 (April 1982), pp. 92–96 (p. 92), cited by Richard S. Field and Ruth E. Fine, 'Jennifer Bartlett' in *A Graphic Muse: Prints by Contemporary American Women*, New York: Hudson Hills Press, 1987, p. 49.

Al Taylor

1948–1999

Disavowing the label 'sculptor', Taylor referred to his three-dimensional works as constructions. He took a deliberately experimental approach to materials and their combinations, exploring the rich seam of possibilities at the intersection of drawing, printmaking and three-dimensional work. Wordplay and witty conjunctions underlay his work. As he noted in his only published interview: 'If you dissect a cliché sometimes you can find a pearl.'[1] Born in Springfield, Missouri, he grew up in Wichita, Kansas, and gained his BFA (1970) from the Kansas City Art Institute. After graduation he moved to New York City, which thereafter became his base. From 1975 to 1982 he worked as a studio assistant to Robert Rauschenberg where he met Brice Marden, Cy Twombly, James Rosenquist and other artists who became close friends. Initially he made paintings but after a trip to Africa in 1980, his first trip outside America, Taylor began to make three-dimensional constructions from found materials. 'Africa taught me about making do with what you have at hand', he later wrote.[2] In 1984 his first solo show at the Alfred Kren Gallery in New York included his drawings and three-dimensional assemblages. An exhibition at Kren's sister gallery in Cologne in 1989 introduced him to an important European network that included dealers (Fred Jahn in Munich), print publishers (Niels Borch Jensen in Copenhagen) and curators (Ulrich Loock in Bern and Michael Semff in Munich) who would support and promote his work. In 1992 he held his first solo museum exhibition at the Kunsthalle Bern in Switzerland. In 1998 he was diagnosed with lung cancer and died the following year aged 51. A retrospective of his drawings (2006) and another of his prints (2013) was organized posthumously by Michael Semff at the Staatliche Graphische Sammlung, Munich. **IS**

1 Ulrich Loock and Al Taylor, 'A conversation', in *Al Taylor*, Bern: Kunsthalle Bern, 1992, pp. 34–48 (p. 46).

2 Cited in Debbie Taylor, 'Chronology', in *Al Taylor, Prints: Catalogue Raisonné*, Michael Semff, ed., with the assistance of Debbie Taylor and interviews by Mimi Thompson, Ostfildern: Hatje Cantz, 2013, pp. 265–70 (p. 266).

Al Taylor
111 *Hanging Puddles II* **1991**
Drypoint, sugar-lift aquatint and
spit-bite aquatint
Signed, dated and numbered '15/20'
in pencil. 493 x 400 (19⅜ x 15¾) plate,
710 x 580 (28 x 22⅞) sheet
Semff 112
British Museum, London 2013,7046.1
Purchased with funds given by
Hamish Parker

An interrelated series of etchings, drawings and constructions on the theme of drying puddles was begun by Taylor in 1991. His fascination with the properties of liquids had earlier been explored in the *Puddles* and *Pet Stains* series begun in 1989, suggested by the occurrence of pets urinating on newspaper. This witty and irreverent meditation parodied the abstract expressionist techniques of pouring, dripping and spilling. Here, Taylor's application of aquatint creates the effect of a shadowy liquid seeping down the sheet before pooling at its lower edge. This echoes the use of toner and solvent in his drawn work (cat. 112). By contrast, the fine drypoint line suggests the wire of Taylor's constructions (cat. 113), with the puddles hung as if folded over a washing line. A three-dimensional space is thus created that is at odds with the behaviour of the liquid. This print was made in collaboration with the Danish printer Niels Borch Jensen, who had invited Taylor to Copenhagen during the artist's visit to Europe in 1991, resulting in seventeen print editions.[1] The fruitful partnership between Taylor and Jensen continued until the artist's untimely death. **IS**

1 Michael Semff, 'Serious Games: The Graphic Work of Al Taylor', in *Al Taylor, Prints: Catalogue Raisonné*, op. cit., pp. 27–31.

15/20

aTar. '91

Al Taylor
112 *Untitled (Hanging Puddles)*
c.1991–92
Pencil and xerographic toner fixed
with solvent
Verso: dated in pencil. 702 x 502
(27⅝ x 19¾)
Private collection, UK (promised gift
to the British Museum)

Taylor often used unusual media such
as xerographic toner in his drawings.
Here he has used a solvent to drag the
pigment downwards, creating a volatile
seeping effect, as if the puddles were
draining away towards the lower edge
of the sheet. IS

Al Taylor

113 *Untitled: (Hanging Puddles)* **1991**
Hot-rolled steel and wire
1257 x 533 x 533 (49½ x 21 x 21)
Collection Michalke, Munich, Germany

This construction illustrates the complex relationship between Taylor's drawn, printed and three-dimensional work. Although he claimed that working on paper or in three dimensions was ultimately one and the same thing, Taylor continued to play with the losses and gains in translation between these different aspects of his multi-faceted practice. Of the relationship between the two he has said, 'I get to a point in a drawing where I cannot make another move without making it three-dimensional. If you're curious at that moment about two lines that make an interesting situation for some reason, it just seems logical to me to take the next step – to use two pieces of wood in a similar situation.'[1] Whereas the puddles in the print and drawing (cats 111 and 112) may appear to be entangled, this relationship is fully articulated as the connection between two puddles passes through another, playing with the boundaries and surfaces suggested. The work almost appears like a drawing in space, which shifts with the viewer. **IS**

1 Ulrich Loock and Al Taylor, 'A Conversation', in *Al Taylor*, Bern: Kunsthalle Bern, 1992, pp. 34–48 (p. 34).

7 Photorealism
Portraits and landscapes

Photorealism developed in America towards the end of the 1960s in an apparent reaction to abstraction and minimalism. The style is characterized by highly detailed images of figures and landscapes presented with a detached objectivity and shallow depth of field that reflects the artists' photographic source material. The first major exhibition of photorealist painting was staged by the Whitney Museum of American Art, New York, in 1970 under the title '22 Realists', which included work by Chuck Close and Richard Estes, both of whom went on to make important photorealist prints.

Close began to make large-scale paintings of the human face in the mid-1960s, abandoning his earlier gestural style. The fact that portraiture was deeply unfashionable at the time added to its appeal. His 'heads' were based on photographs of his friends and family, which he enlarged with the use of a gridded maquette. Like Alex Katz, who began to focus on portraiture in the late 1950s, Close applied the monumental scale and two-dimensionality of abstract art to his figurative images on both canvas and paper. The large size of his first print, *Keith/Mezzotint* (1972, cat. 114), set a considerable challenge for both the artist and printers at Crown Point Press.

Focusing on places rather than people, Estes began his *Urban Landscapes* series of screenprints in 1972, having established himself as a painter. His uncanny images of quintessentially American locations are rendered in meticulous detail and vivid colours. Unpeopled and static, his scenes appear detached from reality, as if constructed in a studio. Also empty of the human presence are the vast, never-ending spaces of Vija Celmins' prints. Her detailed depictions of night skies and ocean surfaces appear photographic but as their repetitive marks draw the viewer in, they seem to dissolve into a dream-like abstraction.

Chuck Close

Born 1940

Born in Monroe, Washington, Chuck Close came to prominence as a leading photorealist artist in the late 1960s. Abandoning his early abstract expressionist style, he began to make the large-scale close-up painted portraits for which he is best known shortly after completing his MFA at Yale University in 1964. His work has consisted almost exclusively of images of the human face, captured initially through photography. In addition to himself, his subjects are primarily close friends, colleagues and family members, the same photographs of whom he has recycled multiple times. As a sufferer of prosopagnosia ('face blindness', or the inability to recognize faces), Close was drawn to portraiture partly because it helped him commit to memory the faces of those around him as flattened images.[1]

Printmaking has been an important part of his practice since 1972 when he produced *Keith/Mezzotint* (cat. 114); he has made prints in almost every technique since then. His focus on process has given rise to completely different pictorial solutions from the same image over many years. After a collapsed spinal artery left him paralysed in 1988, he has continued to work from a wheelchair using a brush in a brace strapped to his arm. **CD**

1 Christopher Finch, 'Close-Up: Christopher Finch interviews Chuck Close' (1 July 2010), www.guernicamag.com/interviews/close_7_1_10/ [accessed 23 December 2015].

Chuck Close

114 *Keith/Mezzotint* 1972

Mezzotint
Signed, dated, titled and numbered '8/10' in pencil. 1135 x 897 (44⅝ x 35⅜) plate, 1294 x 1062 (50⅞ x 41⅞) sheet
Pernotto 3; Sultan pl. 28
Museum of Modern Art, New York.
John B. Turner Fund, 1972

Although Close had studied printmaking as a student at Yale, this was the first print of his professional career and the only mezzotint he has made. It is based on a photograph of his friend the artist Keith Hollingworth (b.1937), whom he met while teaching at the University of Massachusetts, Amherst, in the mid-1960s. He first used the photograph in 1970 for a monumental portrait head painted in monochrome (Saint Louis Art Museum, St Louis). The print was made during a three-month residency at Crown Point Press in Oakland, California, that had been arranged by the print publisher Robert Feldman of Parasol Press. The project was extremely ambitious: Close not only wanted to print on a very large scale, which required the workshop to procure a new press, but he chose mezzotint, a technique traditionally used for making portrait prints in the 18th and 19th centuries but seldom employed subsequently. He also wanted to work in a technique of which neither he nor the master printer Kathan Brown had any experience so that it would be a process of mutual discovery. In mezzotint the plate is roughened up with a multi-toothed tool by hand so that it prints as a velvety black. But in this case the plate was so large that a dot screen was photo-etched on the plate to provide the necessary pitted 'tooth'. Adopting a method he had developed for his paintings, Close used a grid to transfer the source photograph from a maquette to the plate. Working from dark to light, Close created the image by scraping and burnishing the plate in varying degrees, square by square, so that it would print in a range of tones from black to white. Close first began to work on the part of the plate around the mouth and this is much lighter than the other areas of the face because it was worn down by extensive burnishing and over proofing. The artist did not mind as he saw it as a record of his process, and similarly he accepted the grid lines that could not be completely burnished away. The decision to retain the grid structure as integral to his process marked a turning point in his career. Since then, the exposed grid has become a defining feature of his work in different media. Widely acknowledged as a breakthrough work for its sheer size and technical audacity, the print was published by Parasol Press, New York, in an edition of ten. **CD**

Studio proof "Keith" Close 1972

Chuck Close

115 *Keith III* **1981**

Paperwork from dyed paper pulp
Signed, dated and numbered '5/20' in
white crayon. 889 x 681 (35 x 26⅞) sheet
Pernotto 19
British Museum, London 2012,7061.1
Purchased with funds given by the
Vollard Group

Initially thinking that the medium was not
suited to his style, Close was persuaded
to experiment with paper pulp by the
printer and papermaker Joe Wilfer,
known as the 'prince of pulp', in 1981.

This is one of five paper-pulp pieces
of *Keith* made by Close at Dieu Donné
paper mill, New York City, in collaboration
with Wilfer and his assistant Paul
Wong. Recycling a familiar image (the
photograph of Hollingworth) allowed
Close to focus on process and technique.
A base sheet of dyed handmade paper
was made first. Then, to enable him to
work in his usual way, Wilfer made a
grid-like metal grill, similar to those used
as covers for fluorescent lights, which
was placed over the base sheet. Wet
paper pulp made from heavily beaten
pieces of rag-trade cloth was variously

dyed and deposited into the separate
cells. In a time-consuming process, Close
used a Kodak grey scale and a maquette
to work out the tonal value of each cell,
with some twenty-four different greys
being used. The cellular grill prevented
one area of liquid grey pulp from bleeding
into its neighbour. The grill was then lifted
off and the paper-pulp squares fused
to the base sheet by pressing. Taking
around a year to complete, the five
versions of *Keith* were published by
Pace Editions, New York, each in an
edition of twenty. **CD**

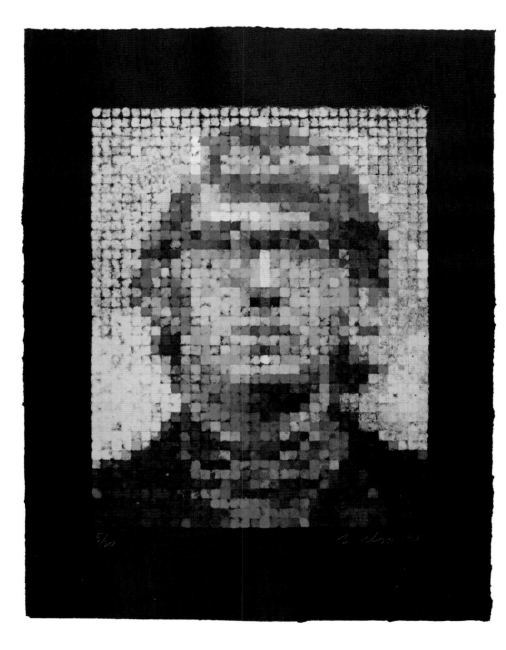

Chuck Close

116 *Phil Spitbite* **1995**

Spit-bite aquatint and etching
Signed, dated and numbered '58/60'
in pencil. 470 x 379 (18½ x 14⅞) plate,
710 x 502 (28 x 19¾) sheet
Sultan pl. 66
British Museum, London 2004,0602.29
Bequeathed by Alexander Walker

Starting with a large-scale painting, Close began to make portraits of the composer Philip Glass (b.1937), a contemporary at Yale, in 1969. He has since portrayed him in a variety of media including photography, drawing and tapestry, mostly using a single source photograph. This print was made at Spring Street Workshop, New York, and published by Pace Editions. It was printed from a single aquatinted plate divided into over 6,800 squares. The different shades of black, white and grey were achieved by leaving acid on the individual squares for differing lengths of time. With spit-bite aquatint, the acid is applied with a brush dipped in human saliva that helps to control the flow of acid and allows for more subtle variations in tone. Close and the printers worked out a numbering system to ensure each square was exactly the correct shade, a painstaking process. Although Close's photorealist style was in part a reaction against abstraction and minimalism, his use of the visible grid, particularly in the background of this print, recalls the working procedure of artists such as Brice Marden to quite different ends. **CD**

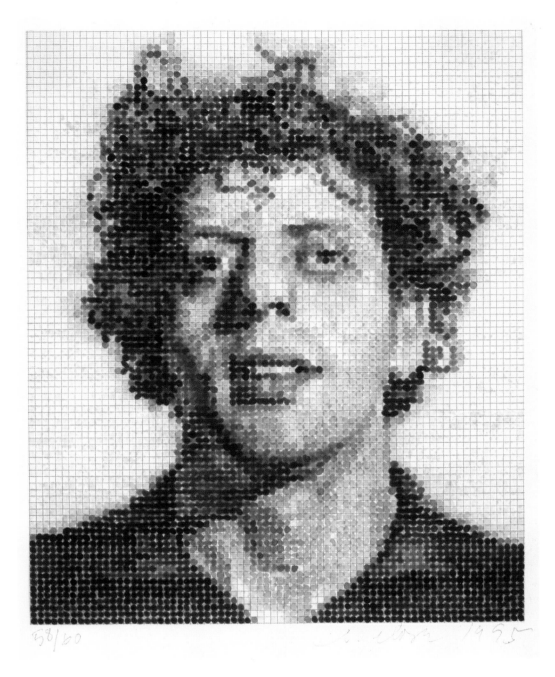

Alex Katz

Born 1927

Born to Russian parents in Brooklyn, New York, Katz grew up in the diverse neighbourhood of St Albans in Queens. Best known as a painter, he trained at the Cooper Union School of Art, Manhattan (1946–49) and the Skowhegan School of Painting and Sculpture in Maine (1949–50). He had his first solo exhibition at the Roko Gallery, New York, in 1954 but made his breakthrough in the late 1950s when he began to focus on portraiture, depicting friends, acquaintances and, most frequently, his wife, Ada. Influenced by film, television and billboard advertisements, Katz became a key figure in the new realism of the 1960s when he developed the distinctive style of flat areas and unmodulated colour of his large-scale portrait paintings. With their faces typically closely cropped and rendered with little modelling, his sitters have often appeared vacant and detached. Although he had experimented with drypoint and relief printing in the early 1950s, it was not until 1965 that printmaking became an important part of his practice. He has since produced many prints including lithographs, etchings, screenprints and woodcuts, and has collaborated with numerous printers and publishers, notably Brooke Alexander, New York, Crown Point Press, San Francisco, and Marlborough Graphics, New York. His work has been shown in many solo and group exhibitions. In 2010 the Albertina Museum, Vienna, staged a retrospective of his prints, of which it holds a complete archive. Katz continues to live in New York and spends his summers in Lincolnville, Maine. **CD**

Advertisement for the Chrysler Cordoba featuring actor Ricardo Montalban, 1975

Alex Katz

117 *Self-portrait* **1978**

Aquatint in shades of silver and grey
Signed and numbered '22/32' in pencil.
910 x 755 (35⅞ x 29¾) sheet
Schröder, Markhof and Bauer 111;
Maravell 110
British Museum, London 2014,7053.1
Purchased with funds given by the
Vollard Group

In this print Katz presents himself as a suave American idol, sporting up-to-the-minute wide lapels and a beguiling toothy smile. The image derives from a large-scale oil painting (Virginia Museum of Fine Arts, Richmond) and also relates to a drawing (National Gallery of Art, Washington, DC), both made in 1977. Seeking to portray himself in the guise of a 'superficial, narcissistic man, smiling in your face', Katz took inspiration from a series of advertisements for Chrysler cars featuring the Mexican-born Hollywood actor Ricardo Montalban (see left).[1] The silver and grey tones of the aquatint, perhaps a sly nod to the silver screen, contrast sharply with the painted version in which the artist depicted himself with a deep tan against a vibrant yellow background. Katz began to experiment with aquatint in the early 1970s and was able to achieve large flat areas and subtle changes of tone with the help of Prawat Laucheron, a New York-based printer with whom he first worked in 1975. Printed by Laucheron, this aquatint was co-published by Brooke Alexander and Marlborough Graphics, both of New York. **CD**

1 John W. Coffey, *Making Faces: Self-Portraits by Alex Katz*, Raleigh, NC: North Carolina Museum of Art, 1990, p. 10.

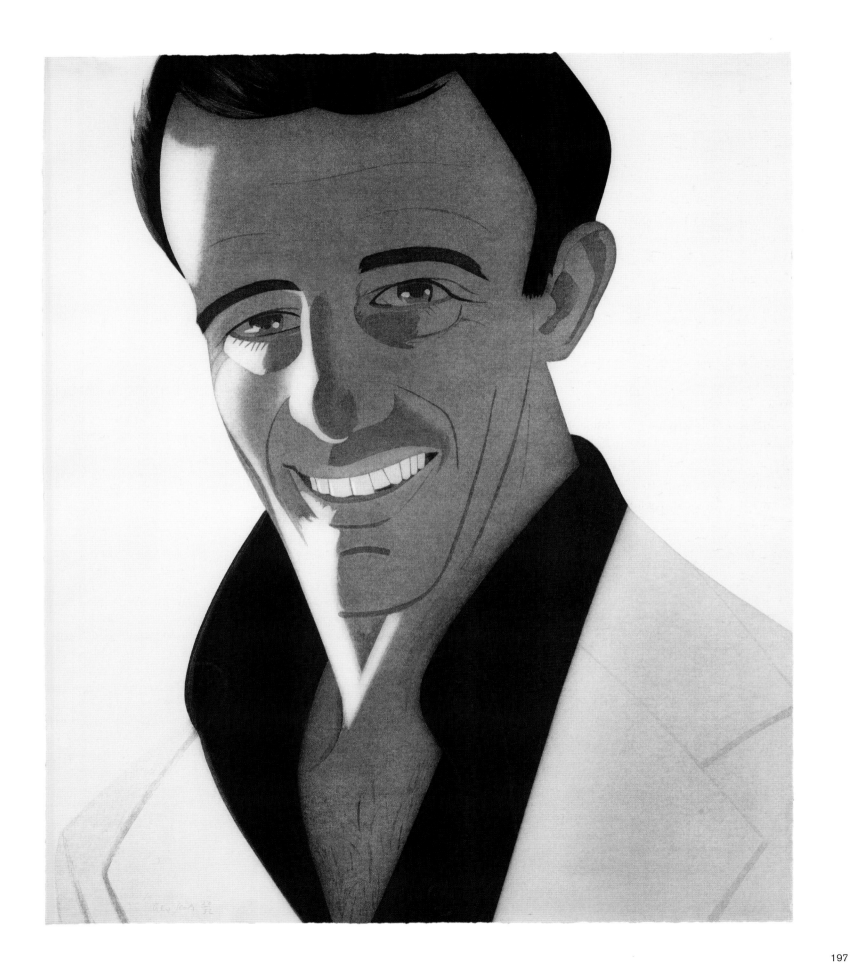

Richard Estes

Born 1932

Born in Kewanee, Illinois, Estes grew up in Evanston, Illinois, and studied at the School of the Art Institute of Chicago (1952–56). In 1959 he moved to New York where he worked as a commercial artist doing paste-ups and lay-outs for a magazine publisher and an advertising agency. From 1966 he committed to painting full-time after a decade working at night. Disciplined and meticulous, Estes began to depict the warping reflections of Manhattan shop-front windows and sleek office buildings in a highly realist style based upon photographs he had taken. In 1968 he was given his first solo exhibition by Allan Stone Gallery, New York, which launched him as a leading photorealist painter. Although based on information from photographs, his paintings and screenprints of urban landscapes were built up by a process of accumulative layers. A lucidity and order was imposed on his chosen subject matter in which the illusionistic space was subtly altered from the experienced reality. From the detailed façades of the late 1960s Estes developed perspectival urban street views in the mid-1970s and by the 1980s these had opened up into all-embracing panoramas. Although he has widened his scope to include views of particular European cities such as Venice and Paris and most recently the frozen wastes of Antarctica, it is for the urban landscape of New York that Estes is best known. In 2014–15 a retrospective of his paintings covering fifty years of his career was held at the Portland Museum of Art in Maine and at the Smithsonian American Art Museum, Washington, DC. SC

Richard Estes

118 *Grant's* from *Urban Landscapes*
1972
Colour screenprint
Signed and numbered '36/75' in pencil, blindstamp of Domberger, Stuttgart.
356 x 515 (14 x 20¼) image, 500 x 700 (19⅝ x 27½) sheet
British Museum, London 2012,7007.1
Purchased with the Presentation Fund in honour of Antony Griffiths

In 1972, four years after his breakthrough exhibition of photorealist paintings at the Allan Stone Gallery, Estes produced his first portfolio of eight colour screenprints entitled *Urban Landscapes*. With the exception of one, all are New York subjects and all focus on the shifting reflections on the façades of ordinary diners, restaurants, hardware stores and on the gleaming plate-glass windows of anonymous corporate offices. These American urban landscapes are devoid of hurrying figures and congested traffic yet the façades with their signage are replete with an implied presence of people eating, shopping and working. In this world of clean, hard edges, rectilinear gridding and fractured reflections playing on different visual planes there is no urban detritus to distract the viewer from Estes' reconstructed reality.

The prints were commissioned by the New York print publisher Parasol Press and produced in Stuttgart, Germany, at the screenprint workshop of Domberger, renowned for the technical precision of its hand-cut stencils and subtle colour printing. None of the prints is based on a corresponding painting. Instead Estes worked from detailed maquettes in gouache from one or more of his photographs. These were sent to Domberger who cut stencils on top of a black-and-white photograph of the maquette, with the workshop breaking down the image into fifteen to twenty colours. Several colours could be printed at the same time by distributing inks over different parts of the screen. While the laborious cutting of the stencils was left to the highly skilled technicians, Estes closely supervised the proofing and build-up of colour layers, with transparent inks being applied to modify or tone down a hue.

An intermittent printmaker, Estes made two further portfolios of *Urban Landscapes*, each containing eight screenprints produced at Domberger and published by Parasol Press in 1979 and 1981. Estes explained the appeal of the technique: 'It seemed to me that silkscreen was very clean – sharp layers and opaque inks. I could work in layers, which is more or less the way I paint. It seemed closer to the way I work, starting out very broad, with masses of color, and adding on top of it. There're limitations. The cut film gives a hard, sharp line, but even that seems appropriate to the way I work.'[1] SC

1 John Arthur, 'Richard Estes: The Urban Landscape in Print' (interview), *Print Collector's Newsletter*, 10:1 (March–April 1979), pp. 12–15 (p. 15).

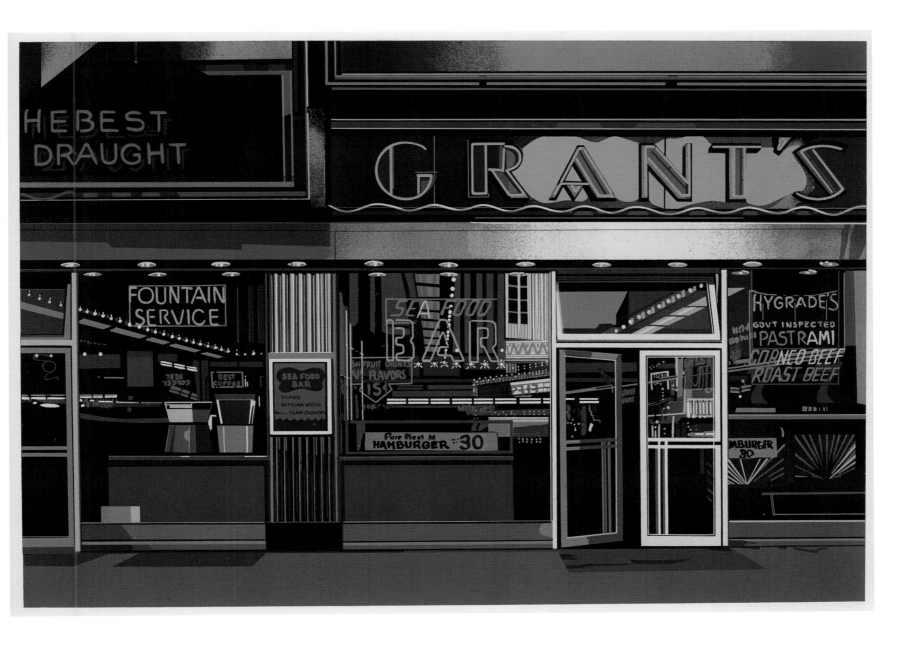

Richard Estes

119 *Oriental Cuisine* **from** *Urban*
Landscapes **1972**

Colour screenprint

Signed and numbered '28/75' in pencil,

blindstamp of Domberger, Stuttgart.

341 x 514 (12⅜ x 20¼) image, 500 x 700

(19⅝ x 20¼) sheet

British Museum, London 2010,7050.1

Purchased with funds given by the British

Museum Friends

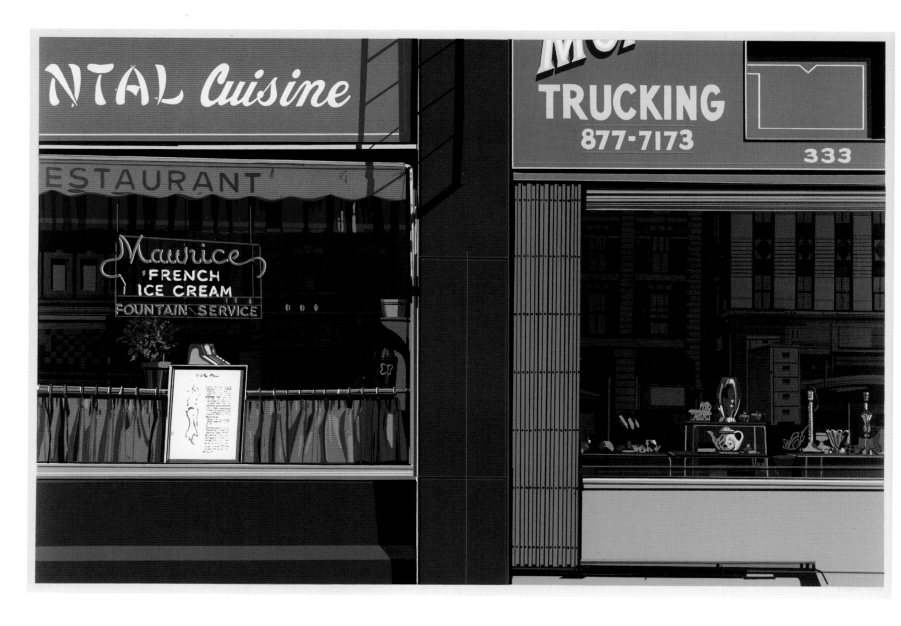

Richard Estes

120 *Danbury Tile* **from** *Urban Landscapes* **1972**

Colour screenprint

Signed and numbered '60/75' in pencil, blindstamp of Domberger, Stuttgart.
380 x 509 (15 x 20) image, 500 x 700 (19⅝ x 27½) sheet
British Museum, London 2010,7050.2
Purchased with funds given by the British Museum Friends

Richard Estes

121 *560* **from** *Urban Landscapes* **1972**

Colour screenprint

Signed and numbered '36/75' in pencil, blindstamp of Domberger, Stuttgart.
390 x 590 (15⅜ x 23¼) image,
500 x 700 (19⅝ x 27½) sheet
British Museum, London 2012,7007.2
Purchased with the Presentation Fund in honour of Antony Griffiths

Craig McPherson

Born 1948

A painter and printmaker known best for his images of New York, McPherson was born in Wichita, Kansas. After obtaining a BFA from the University of Kansas in 1970, he spent several years working as a curator and lecturer for the National Endowment for the Arts, an independent federal agency based in Washington, DC. From 1973 to 1974 he was director of the Michigan Artrain, a travelling art museum that toured small towns across the state. He moved to New York in 1975 to develop his career as an artist and spent the following years concentrating on paintings and prints of New York landscapes, primarily nocturnes. His first solo exhibition was held at the A.M. Sachs Gallery, 57th Street, New York, in 1983. Two years later he began work on a seven-year project to create a large mural cycle for the American Express Center in lower Manhattan, which included images of the waterways and bridges of Manhattan at twilight (painted between 1985 and 1986) and major harbours of the world (1987–92). In 1998 the Fitzwilliam Museum, Cambridge, staged his first museum retrospective, concentrating on his achievements as a printmaker. His work is held in numerous museum collections including the Metropolitan Museum of Art, New York, the National Gallery of Art, Washington, DC, and, in the UK, the Fitzwilliam Museum, Cambridge, and the British Museum. **CD**

Craig McPherson
122 *Yankee Stadium at Night* **1983**
Mezzotint
Signed, titled and numbered '53/75' in pencil. 604 x 900 (23¾ x 35½) plate, 742 x 1052 (29¼ x 41⅜) sheet
Hartley F4
British Museum, London 1984,1006.24

Large in scale and intensively worked, this mezzotint was a breakthrough for McPherson, gaining him recognition as a leading American printmaker. It is a view at night from his studio in Washington Heights, Manhattan, and derives from the left-hand section of a panoramic drawing made in 1979. It depicts the Yankee baseball stadium in the Bronx with the Art Deco-style Bronx County Courthouse to the left and East Manhattan to the right. The bright lights of the stadium create a vivid and eerie spectacle against the night sky. McPherson made his first editioned mezzotints in 1978. The technique, which required him to work from dark to light, was particularly suitable for his night scenes. It took him twelve months to work the plate all over with a hand rocker before he was able to burnish away those areas that he wanted to print as light. The inking of the plate was equally considered: a blacker, stiffer ink was used for the night sky and the darkened city, and a slightly oilier ink was used for the area along the horizon. Laboriously worked, this print went through three states before the fourth and final state was published by the artist in an edition of 75. The finished print was first exhibited at the Mary Ryan Gallery, New York, in 1983. McPherson made three other mezzotints using the same source drawing, each focusing on a different section of the view: *The Rear Window* (1984), *Chop Shop* (1985) and *Girders* (1986). **CD**

Yvonne Jacquette

Born 1934

Calling herself a 'portraitist of American cities',[1] Jacquette is best known for her aerial views of New York and other urban landscapes. Born in Pittsburgh, Pennsylvania, she grew up in Stamford, Connecticut, and trained at the Rhode Island School of Design in Providence (1952–55). After obtaining her BFA, she moved to New York where she became part of a social circle that included Alex Katz, Willem de Kooning and the filmmaker and photographer Rudy Burckhardt (1914–1999), whom she married in 1964. Her interest in aerial views was triggered by a flight to San Diego in 1969, after which she began to make pastel sketches and take photographs of cities from aeroplanes or high vantage points such as skyscrapers, from which she produced large-scale paintings. Jacquette made her first prints at the invitation of the publisher Brooke Alexander in 1973 and printmaking has been an important part of her practice ever since. In the late 1970s she began to focus on night scenes, beginning with the painting *East River View at Night II* (1978).[2] She has exhibited widely since the mid-1960s and had her first major museum exhibition in 1983 at the Saint Louis Art Museum, Missouri. She continues to live and work in New York, spending her summers in Searsmont, Maine. **CD**

1 Andrea Henderson Fahnestock and Vincent Katz, *Picturing New York: The Art of Yvonne Jacquette and Rudy Burckhardt*, New York: Bunker Hill Publishing for the Museum of the City of New York, 2008, p. 15.

2 Reproduced in ibid., p. 36, plate 2.

Yvonne Jacquette

123 *Tip of Manhattan* **1987**

Woodcut in black and blue on Okawara paper

Signed (twice), dated and numbered 'A.P. 3' (artist's proof outside ed. 30) (twice) in white pencil, publisher's copyright blindstamp. 762 x 1422 (30 x 56) sheet

Faberman 30

British Museum, London 2012,7048.1

Purchased with funds given by the Joseph F. McCrindle Foundation to the American Friends of the British Museum

One of Jacquette's first woodcuts, this vertiginous view of Manhattan looking south depicts the city's buildings, roads and rivers through its artificial lights. Unlike the static urban landscapes of Richard Estes, the scene is alive with nocturnal activity. Elongated lights from the traffic on the roads and along the Hudson River to the right provide a sense of movement, inviting us to imagine the city's population streaming home after a day at work. The composition derives from Jacquette's painted diptych *Lower Tip of Manhattan*, 1981–82 (private collection). The image was transferred using a slide of the underpainting, which the artist projected onto paper to make a drawn template. Two blocks were cut: one for the dark ink and one for the royal blue around the windows, which captures the particular tone of the evening light. Having never made a woodcut before, Jacquette had expected to cut the blocks herself but arrived at Experimental Workshop, San Francisco, to find that this had already been done by the printers. She has continued to make woodcuts throughout her career and has since hand-cut all her own blocks. *Tip of Manhattan* was published by Experimental Workshop and distributed by Brooke Alexander, New York. **CD**

Vija Celmins

Born 1938

Latvian-born Celmins arrived in the United States with her family as refugees in 1948 after fleeing to Germany from the advancing Russian army in the final stages of the Second World War. She grew up in the American Midwest in Indianapolis where she attended the John Herron Art Institute (BFA, 1962). In 1961 she received a Yale summer-school fellowship where her young contemporaries included Chuck Close and Brice Marden. From 1962 to 1980 she lived on the West Coast, establishing her studio close to the beach at Venice, California, and completing her MFA in 1965 at the University of California, Los Angeles. Like Close, she gave up her early abstract expressionist idiom and painted with an ominous intensity ordinary household objects (heater, electric frying-pan, hot plate) before making meticulous grisaille paintings and graphite drawings based on clippings of Second World War imagery from newspapers and magazines that she collected. From the late 1960s the focus of her monochromatic imagery has been restricted to ocean surfaces, desert floors, starry night skies and, more recently, the microcosm of the spider web. Celmins' work is based on photographs, either her own (the ocean, desert) or from scientific images (galaxies, spider webs), but she is careful to emphasize that she 'redescribe[s] an existing image, not copy or reproduce'.[1] Working and reworking the surface of the canvas, paper or print matrix repeatedly, Celmins is concerned with process, declaring that 'the image is just a sort of armature on which I hang my marks and make my art'.[2] A touring retrospective of her paintings, drawings, prints and sculpture, including her painstakingly painted cast replicas of stones picked up in the New Mexico desert, was organized by the Institute of Contemporary Art, Philadelphia, in 1992–94. The first retrospective of her prints was given by the Metropolitan Museum of Art, New York, in 2002. A drawings retrospective was held at the Centre Pompidou, Paris, and the Hammer Museum, Los Angeles, in 2006–7. Since 1980 she has lived and worked in New York City. **SC**

1 'A Delicate Balance: An Interview with Vija Celmins', in Samantha Rippner, *The Prints of Vija Celmins*, New York: Metropolitan Museum of Art; New Haven and London: Yale University Press, 2002, p. 23.

2 'Interview with Chuck Close (extracts), 1991', in Lane Relyea, Robert Gober and Briony Fer, *Vija Celmins*, London: Phaidon, 2004, p. 129.

Vija Celmins

124 *Ocean Surface Woodcut 1992*
1992
Woodcut
Signed, dated and numbered '4/50'
in pencil. 225 x 305 (8⅝ x 12) image,
495 x 394 (19½ x 15½) sheet
Rippner fig. 33
British Museum, London 2004,0602.22
Bequeathed by Alexander Walker

The hypnotic, rhythmic heave of the ocean surface extending over a limitless expanse is conveyed by small, finely cut marks distributed across the woodblock. Celmins has said that she seeks to hold together in her work 'stillness and movement, flatness and depth…in a delicate balance. I like to hide things behind looks, so that the work first looks like a photograph but when you get up close you see it's something handmade and carved from wood: a kind of surprise.'[1] This woodcut, on which she spent a year 'with my face inches away from [the] block, cutting this way and that', is based on a photograph she had taken at Venice Beach, California, around 1969 and brought with her to New York.[2] Her first single-sheet print from woodblock, it was made in 1992 with the printer Leslie Miller of the Grenfell Press, New York, with whom she had first collaborated in a group book project on a bestiary two years before. **SC**

1 'A Delicate Balance: An Interview with Vija Celmins', in Rippner, op. cit., pp. 41–42.

2 'Interview: Robert Gober in conversation with Vija Celmins', in Relyea, Gober and Fer, op. cit., p. 33.

A/p 4/20 V. Celmins 1997

Vija Celmins

125 *Night Sky Woodcut 1997* **1997**

Woodcut on Kozo-Gampi paper mounted
on Fabriano Tiepolo paper
Signed, dated and numbered 'A/P 4/20'
(artist's proof outside ed. 30) in pencil on
backing sheet. 220 x 245 (8⅝ x 9⅝)
image, 224 x 249 (8¾ x 9¾)
Kozo-Gampi paper, 447 x 317
(17⅝ x 12½) Fabriano Tiepolo paper
Rippner fig. 32
British Museum, London 2004,0602.21
Bequeathed by Alexander Walker

The points of light in the star-scattered
night sky were made by cutting the
surface of the cherry woodblock with
nails and needles. Celmins' infinitesimal
marks express the infinity of space. At the
same time, we are asked to experience
the object as a surface of marks – a spatial
abstraction. The grain of the woodblock
can just be discerned; its incorporation
suggesting a whirling night sky alive
with movement. The warm glow of the
Japanese paper, an idea suggested by
the printer Leslie Miller of the Grenfell
Press, New York, gives the image an
additional depth. Celmins began to make
paintings of the night sky in the early
1990s; this woodcut is close to the oil
on canvas *Night Sky #6* of 1993 (Walker
Art Center, Minneapolis). She has also
returned to the night sky in mezzotint and
aquatint as well as in a series of charcoal
drawings in the 1990s. **sc**

8 The figure reasserted

In the late 1960s Philip Guston, one of the chief proponents of abstract expressionism, provoked considerable contention by returning to figuration. In an abrupt departure from his gestural style, he began to create cartoonish images of hooded figures, dismembered limbs, hobnail boots and other representational forms. A decade earlier Richard Diebenkorn had also gone against the grain, abandoning abstraction in favour of the human figure, still lifes and recognizable landscapes. Before changing tack yet again in the mid-1960s, Diebenkorn was at the centre of a resurgence of figurative painting in the San Francisco Bay Area, where he participated in regular life-drawing sessions. Philip Pearlstein also worked from life, producing nude figure paintings from the early 1960s, having previously worked in a gestural style.

The rejection of abstraction in favour of a more representational approach led to the rise of figurative expressionism among a new generation of American artists in the 1970s and 1980s. In printmaking, this can be seen in the work of Susan Rothenberg, Richard Bosman, Robert Longo and Eric Fischl, all of whom created psychologically charged images of the human figure. Rothenberg's first figurative works were of horses but she turned to the human form in the late 1970s, making paintings and prints that blurred the line between figuration and abstraction. Her interest in depicting figures in motion was shared by Robert Longo whose *Men in the Cities* series (begun in 1979) captures 'yuppie'-style figures from the corporate world in dynamic, contorted positions. Bosman and Fischl developed their figurative styles at the end of the 1970s, which although markedly different, both contain a strong narrative element. Influenced by comic books and pulp-fiction novels, Bosman's images often convey a sense of allegory, while Fischl's unsettling scenes are peopled with enigmatic characters whose interactions possess a filmic quality.

Richard Diebenkorn
For biography see page 104
126 *Seated Woman* 1968
Lithograph
Signed with initials and dated on the
stone, signed with initials, dated and
numbered '1/20' in pencil, blindstamp
of Tamarind Lithography Workshop, Los
Angeles. 505 x 640 (19⅞ x 25¼) sheet
British Museum, London 2013,7002.1
Purchased with funds given by the
James A. and Laura M. Duncan
Charitable Gift Fund

This lithograph was made after
Diebenkorn had begun the abstract
paintings that would define his mature
style, but it addresses a subject he
depicted repeatedly in the late 1950s and
early 1960s: a seated woman, her limbs
casually crossed though not languid,
turned away from the viewer. The figure's
position is similar to that of the artist's
wife, Phyllis, in the drypoint that opened
his first print publication, *41 Etchings
Drypoints* (1963), as well as to other
plates, all drawn swiftly from life in 1964.
In the lithograph the scale is larger and
the influence of Henri Matisse's lean,
descriptive line to flatten the space is
stronger. But Diebenkorn's sitter has a
contained integrity that sets her apart
from Matisse's women, so often cast
as proxies for desire, or mystery, or the
artist's emotional state. The figure here
is both an independent being and an
occasion for observing structural beauty.
The composition of pronounced
diagonals braced by rhythmically
repeated horizontals can be seen in his
later abstractions just as clearly, but
without the folding director's chair. **ST**

1/20
RDG8

RDG8

Philip Pearlstein

Born 1924

Born in Pittsburgh, Pennsylvania, the son of a poultry-seller, Pearlstein had two of his paintings reproduced in *Life* magazine (16 June 1941) after winning a national high-school competition. In 1946, when Pearlstein returned to the Carnegie Institute of Technology, Pittsburgh, on the G. I. Bill after serving in the Second World War, his classmate Andy Warhol asked him what it was like to be famous, to which he replied: 'It only lasted five minutes.'[1] Pearlstein and Warhol became close friends at Carnegie Tech and after graduating they left together for New York in 1949 where they initially shared an apartment. During the 1950s Pearlstein worked in a gestural style, often inspired by landscape, while completing an MA dissertation (1955) on the French modernist Francis Picabia at the Institute of Fine Arts, New York University, and supporting himself by working as a graphic designer for plumbing-supply catalogues. In gradual retreat from abstract expressionism, Pearlstein began to paint from the nude model from the early 1960s. His faith in figurative realism was declared in his groundbreaking article 'Figure Paintings Today are not Made in Heaven' published in *ARTnews*, in which he challenged the modernist dictates of the flatness of the picture plane and what he termed the 'roving point-of-view' climaxing with abstract expressionism.[2] His nude figure paintings were given a first solo exhibition in 1963 at the Allan Frumkin Gallery, New York; Frumkin regularly showed his work in the 1960s and 1970s. In 1978 a retrospective of Pearlstein's prints was organized by the Springfield Art Museum, Springfield, Missouri, which toured to ten museums across the United States. **SC**

1 Philip Pearlstein, 'In Philip Pearlstein's Autobiography, Warhol is a Major Character', *ARTnews* (www.artnews.com/2014/04/25/philip-pearlstein-autobiography-features-warhol-as-a-major-character) [accessed 12 March 2016].

2 Philip Pearlstein, 'Figure Paintings Today are not Made in Heaven', *ARTnews*, 61 (Summer 1962), pp. 39, 51–52 (p. 39).

Philip Pearlstein
127 *Nude on Mexican Blanket* 1972
Colour aquatint and etching
Signed, titled and numbered '61/73'
in pencil. 466 x 602 (18⅜ x 23¾) plate,
563 x 757 (22⅛ x 29¾) sheet
Field 56
British Museum, London 1997,1102.14
Presented by Mike Godbee

Pearlstein began to make prints in 1968 after he had already established a reputation as a realist painter. The presence of the model is paramount. As in his paintings, Pearlstein works on the etching plate in front of the model in the studio rather than within a print workshop. His nudes are always depersonalized. Although he may work with the same model over several years, Pearlstein is not interested in the figure's personality but in the volume and weight of the human form expressed by the pose. The model's foreshortening in this etching, with the leg crossed over the thigh, presses against the picture plane, yet this is offset by the pronounced diagonal of the figure into recessed space. The model is at rest yet the eye moves along the stitch-like lines following the contours of her body. Subtle layers of aquatint are applied as shapes of tone. They define the hollows and form of the body as well as convey the sense of flesh and the play of shadows from the stark studio lighting. Pearlstein often contrasts the nakedness of his models against the textures and patterns of ethnic and tribal cloths upon which they recline. This etching was produced in collaboration with his printer and former model Virginia Piersol, who prepared the plates for biting in the artist's studio. Pearlstein's first etchings, like this one, were self-published. **SC**

Nude on Mexican Blanket 61/75 Philip Pearlstein

Susan Rothenberg

Born 1945

Born and brought up in Buffalo, New York, Rothenberg studied sculpture as an undergraduate, receiving her BFA from Cornell University, Ithaca, in 1967. In 1969 she moved to New York City where she worked for a short time as an assistant to the artist Nancy Graves (1939–1995). After initially experimenting with minimalist painting and sculpture, she began around 1973 to produce the paintings of horses for which she is best known. Her new style of emotionally subjective figuration, which retained an element of abstraction, led to her inclusion in the Whitney Museum of American Art's 'New Image Painting' exhibition in 1978 and brought her wider recognition. Rothenberg made her first professional prints in 1977 at Derrière L'Etoile Studios, New York: two lithographs depicting horses in profile. She has since produced a large body of prints using a variety of techniques: etching, woodcut, lithography and mezzotint. Although not derived from specific paintings, her prints echo the subject matter found in her painted work, notably horses in the late 1970s and the human figure in the 1980s. An intuitive and experimental printmaker, Rothenberg has worked with numerous print workshops and publishers including ULAE on Long Island, Gemini, Los Angeles, and Brooke Alexander, New York City. Since 1990 she has lived and worked on a ranch near Galisteo, New Mexico, which she shares with her husband, Bruce Nauman. **CD**

Susan Rothenberg
128 *Boneman* **1986**
Mezzotint printed on wood veneer paper
Signed, dated and numbered '3/42'
in pencil, blindstamp of Gemini G.E.L.,
Los Angeles. 606 x 510 (23⅞ x 20)
plate, 760 x 510 (29⅞ x 20) sheet
Maxwell 31
British Museum, London 2014,7002.1
Purchased with funds given by the
Joseph F. McCrindle Foundation

Depicting a seated figure engaged in
what appears to be rigorous, almost
frenetic drumming, this print reflects
Rothenberg's long-standing interest in
portraying figures in motion. Initially
focused on horses, she moved her
attention to the human form in the late
1970s, after which her subjects included
dancers and gymnasts. In this print,
Rothenberg evokes a quickening
movement through the blurred arms of
the drummer and the expanding triangle
of sound and kinetic energy. The subject
is mysterious; neither the figure nor the
act is given any context. We do not know
if this is a private moment, a performance,
a ritual, or even an apparition.

Rothenberg's use of the mezzotint
technique and her choice of paper add
to the sense of mystery and mounting
tension that this print conveys. Working
from dark to light on the pre-rocked plate
allowed her to draw the figure out from
the shadows through a process of erasure.
The darkness of the ground is heightened
by the light brown of the wood veneer
paper, areas of which are left blank at
the bottom and top right corner of the
sheet, suggesting an enclosed space.
Furthermore, the paper's vertical lines
create friction where they cross the
diagonal lines emanating from the
drummer, making the cloud of energy
appear to be almost incendiary.
Boneman was printed and published
by Gemini, Los Angeles. **CD**

Robert Longo

Born 1953

Born in Brooklyn, New York, Robert Longo is a painter, draughtsman, sculptor, filmmaker, musician and performance artist. Showing early artistic promise, he received a grant in 1972 to study at the Accademia di Belle Arti in Florence, Italy. In 1975 he obtained his BFA from Buffalo State University, where he studied sculpture. As a student, he and his friends established an avant-garde art gallery in Buffalo, which became Hallwalls Contemporary Art Center where he had his first solo exhibition in 1976. After graduating, Longo moved to New York City where he became part of the underground art scene and staged his first performance works in the late 1970s. He became well known in the 1980s for his *Men in the Cities* drawings of life-size figures writhing or dancing in contorted positions, which he began in 1979. Often examining the power dynamics at play in American society, much of Longo's work is influenced by imagery from film, television and printed media. He has had numerous solo exhibitions including retrospectives at the Menil Collection, Houston (1988) and the Los Angeles County Museum of Art (1989). In 1997 his work was exhibited at the Venice Biennale and his drawings were included in the Whitney Biennial exhibition in 2004. Longo has also directed a number of films including the dystopian action thriller *Johnny Mnemonic* (1998). **CD**

Robert Longo
129 *Cindy* **1984**
Lithograph
Signed, dated and numbered '25/38' in pencil. 1520 x 512 (60 x 20) image approx. (irregular), 1727 x 991 (68 x 39) sheet
British Museum, London 2013,7048.1
Purchased with funds given by Hamish Parker

130 *Eric* **1984**
Lithograph
Signed, dated and numbered '25/38' in pencil. 1475 x 585 (58 x 23) image approx. (irregular), 1727 x 991 (68 x 39) sheet
British Museum, London 2013,7048.2
Purchased with funds given by Hamish Parker

This imposing pair of large-scale lithographs is based on life-sized charcoal and graphite drawings from Longo's *Men in the Cities* series, which he made between 1979 and 1981. Depicting full-length men and women in distorted, twisted poses, the drawings were inspired by a scene in Rainer Werner Fassbinder's film *The American Soldier* (1970), in which a smartly dressed gangster contorts his body in agony after being shot. Longo asked friends to pose for him and photographed them on the roof of his New York studio, which was situated near the financial district of Manhattan. He threw tennis balls at them, pushed them and occasionally swung them in a sling to elicit the physical reactions that he required. In both the drawings and the prints, the figures are presented against a stark white background with no context or explanation for their movements. They could be dancing ecstatically or writhing in pain. Dressed smartly in suits and ties, they reflect the 'yuppie' look of corporate America. In 2000, work from the series featured prominently in the apartment of the fictional investment banker Patrick Bateman in the film *American Psycho*.

Cindy and *Eric* are two of five large-scale prints that Longo made between 1982 and 1984 after his *Men in the Cities* drawings. They were each printed by Maurice Sánchez at Derrière L'Etoile Studios and published by Brooke Alexander, both of New York. The model for Cindy was the artist Cindy Sherman, a fellow student of Longo's in Buffalo and a former girlfriend with whom he moved to New York. *Eric* depicts the dancer Eric Barsness. The source drawings for both were made in 1981 and are in the collection of the artist and the Vanmoerkerke Collection in Belgium respectively. **CD**

Richard Bosman

Born 1944

The son of a Dutch sea captain and an Australian mother, Richard Bosman was born in Madras, India, and spent time in Suez and Singapore as a child. Between the ages of 7 and 21 he spent most of his life in Australia where he attended school in Perth. After studying at the Byam Shaw School of Painting and Drawing in London (1964–69), he moved to America where he undertook further training at the New York Studio School (1969–71) and the Skowhegan School of Painting and Sculpture in Maine (1970). Initially influenced by abstract expressionism, Bosman began to develop his distinctive figurative style in the late 1970s and has become known for his dramatic, sometimes violent scenes inspired by the imagery of comic books, pulp novels and B-movies. He began to make prints in 1978 and worked with the print publisher Brooke Alexander, in whose New York gallery he had his first solo exhibition in 1980. Although he has predominantly produced woodcuts, he has used a variety of printing techniques including screenprinting, etching, lithography and monotyping. Bosman's work has been exhibited widely and is represented in numerous museum collections including the Museum of Modern Art, New York. He is currently based in Esopus, New York, where he continues to work. **CD**

Richard Bosman
131 *South Seas Kiss* **1981**
Colour woodcut
Signed and inscribed 'AP 5/10' (artist's proof outside ed. 31) in pencil, blindstamp of the printer (Chip Elwell). 380 x 595 (15 x 23⅜) image, 415 x 625 (16⅜ x 24⅝) sheet
Stevens 18
British Museum, London 2013,7039.1
Purchased with funds given by the Joseph F. McCrindle Foundation and Leslie and Johanna Garfield

A sea captain kisses a naked island girl amid luxuriant flowering growth under a romantic full moon. His waiting ship rides a phosphorescent sea. The scene owes much to the comic-book narratives and pulp fiction that Bosman consumed. In another woodcut, made the same year, titled *Mutiny*, a similar-looking sea captain is shot in the head at close range by a hidden assailant. Printed in New York by Chip Elwell and Ted Warner using twenty-one colours, *South Seas Kiss* was published by Brooke Alexander. A black-and-white version, depicting only the lovers' heads, was produced at the same time. **CD**

Richard Bosman

132 *Man Overboard* **1981**

Colour woodcut

Signed and inscribed 'X Working Proof'

(outside ed. 36) in pencil. 605 x 380

(23⅞ x 15) image, 645 x 410

(25⅜ x 16⅛) sheet

Wye 1996, 41

British Museum, London 2013,7039.2

Presented by the artist

Man Overboard, the first woodcut that
Bosman made, was inspired both by an
incident in the artist's childhood and the
cover of a book that he had seen (but not
read), which depicted a man falling from
an ocean liner. During one of several long
voyages that Bosman had taken as a child,
a priest committed suicide by throwing
himself overboard, leaving a note in his
shoes on the deck. Bosman appropriated
the image from the novel, re-clothing his
figure in a suit and tie and removing the
shoes. As with many of Bosman's works,
the image carries an element of mystery:
did the figure jump or was he pushed?
Is this an actual event or an allegory?
Falling figures occur repeatedly in
Bosman's work, as does the sea, which
played such a crucial role in his early life.
Printed in eight colours by Elwell and
Warner using four blocks carved by the
artist, *Man Overboard* was published by
Brooke Alexander. **CD**

Eric Fischl

Born 1948

A painter, sculptor and printmaker who first came to attention in the early 1980s, Eric Fischl was born in New York and grew up in the suburbs of Long Island. In 1967 he moved with his parents to Phoenix, Arizona, and attended Phoenix College before obtaining a BFA from the California Institute for the Arts in 1972. He lived briefly in Chicago before moving to Nova Scotia, where he taught painting at the Nova Scotia College of Art and Design in Halifax and where he had his first solo exhibition at the Dalhousie Art Gallery. Fischl returned to New York City in 1978, exhibiting at the Edward Thorp Gallery the following year, and is now based in Sag Harbor on Long Island, New York. Associated with the return to figuration in the late 1970s and early 1980s, Fischl is best known for his paintings and prints depicting enigmatic scenes with unsettling narratives. He began to make prints in 1982, encouraged by the master printer Patricia Branstead, and has since worked with numerous workshops and publishers including Peter Kneubühler in Zurich and Derrière L'Etoile Studios and the Grenfell Press in New York. CD

Eric Fischl

133 *Year of the Drowned Dog* **1983**

Portfolio of six colour etchings with aquatint, drypoint, soft-ground and scraping

Each sheet: signed and numbered '6/35' in pencil in the image

Sheet a (boy with dog): 545 x 425 (21½ x 16¾)

Sheet b (woman with child watching): 455 x 285 (17⅞ x 11¼)

Sheet c (three men standing): 580 x 290 (22⅞ x 11⅜)

Sheet d (deserted beach): 570 x 875 (22½ x 34½)

Sheet e (man walking): 320 x 245 (12⅝ x 9⅝)

Sheet f (man dressing): 584 x 495 (23 x 19½)

Fine 1989, 45

British Museum, London 2014,7079.1.a-f

Purchased with funds given by Hamish Parker

Composite image showing the prints for *Year of the Drowned Dog*, 1983, assembled as per the publisher's diagram

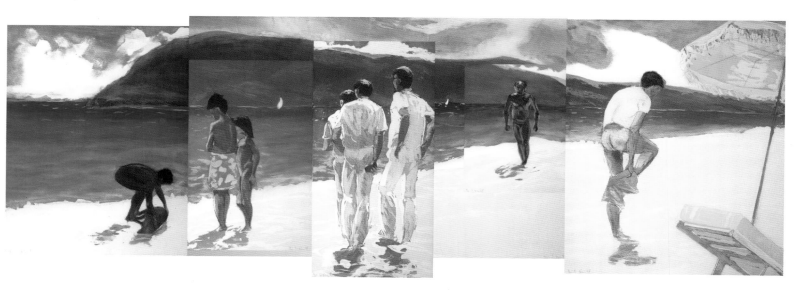

Comprising six etchings of differing sizes
that can be arranged to form a composite
image (see below), this portfolio was
both a critical and commercial success,
making Fischl's name as a printmaker.
The setting is a Caribbean beach peopled
with a mysterious cast of characters
including a boy bending over a lifeless
dog, a woman and child watching, and
three men in smart white uniforms.
The individual prints must be overlapped
to align the sea and the sky. Although
the artist did not specify an order, the
publisher included a diagram in the
portfolio to show how they can be
assembled. The relationship between
the figures is unclear. The uniformed men
are perhaps sailors, military personnel or
law-enforcement officers – for now, they
seem mere onlookers. By contrast, a man
advancing along the beach appears
almost aggressive in his purposeful stride
while another man with his back to the
scene is quietly changing into his trunks.
The ambiguity is intentional: although
Fischl has said that he included the dog
to suggest an incident, he has also stated
that the scene may not represent a single
moment in time, but possibly a protracted
period, hence the use of the word 'Year'
in the title.[1] Working closely with the
master printer Peter Kneubühler, Fischl
achieved the impression of dazzling
sunlight by leaving areas of unmarked
paper around the figures.[2] Published by
Peter Blum Edition, New York, the prints
are presented in a grey linen-board
portfolio designed by Jörg Oberli in Basel
and are each housed in a moveable
plastic pocket. **CD**

1 Constance W. Glenn and Jane K. Bledsoe, eds,
 *Eric Fischl: Scenes Before the Eye. The Evolution
 of Year of the Drowned Dog and Floating Islands*,
 Long Beach, CA: University Art Museum, California
 State University, Long Beach, 1986, p. 12.
2 Kenneth Baker, 'Eric Fischl: "Year of the
 Drowned Dog"', *Print Collector's Newsletter*,
 15:3 (July–August 1984), pp. 81–84 (p. 82).

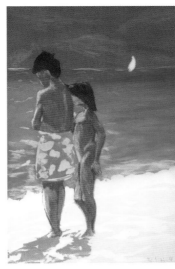
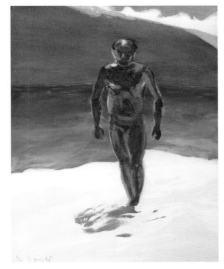
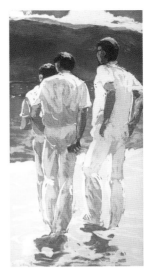

Philip Guston

For biography see page 142

134 *Sea* 1980

Lithograph on grey handmade paper
Signed, dated, titled and numbered '6/50'
in pencil, blindstamp of Gemini G.E.L., Los
Angeles. 775 x 1012 (30½ x 39⅞) sheet
Semff 26

British Museum, London 2004,0602.72
Bequeathed by Alexander Walker

Though Guston was a highly successful
abstract expressionist painter for much
of his career, it was his late strange,
cartoonish figurative work that most
profoundly influenced the direction of
American art, opening up new avenues
of figuration for subsequent generations.
In the 1970s Guston's gestural structures
unexpectedly morphed into icons of
enigmatic dereliction: dangling light bulbs,
empty chairs, segmented body parts. His
daughter observed, 'the image maker in
him that feared and longed to create
golems probably never did feel entirely
comfortable with abstraction.'[1] Though
he suffered a near-fatal heart attack in
March 1979 and was unable to paint,
in a burst of creativity later that year he
created twenty-five lithographs over the
course of a few weeks. Most are drawn
with a heavy, scrappy hand – *Sea* is
unusual in its delicacy – capturing the
objects of his psychological obsession.

Sea's pile of bulbous heads with
protuberant eyes floating on water like
a panoptic Portuguese man-of-war and
Room's tangle of bent limbs and hobnail
boots were motifs Guston returned to
again and again. But Guston declined
any precise symbolic reading of these
images, describing them simply as 'a
world of tangible things, images, subjects,
stories like the way art always was'.[2] **ST**

1 Musa Mayer, 'My Father, Philip Guston', *The New York Times Magazine*, 7 August 1988: www.nytimes.com/1988/08/07/magazine/my-father-philip-guston.html?pagewanted=all

2 Philip Guston, 'Philip Guston Talking', Lecture, University of Minnesota, 1978. Excerpted in Nicholas Serota, ed., *Philip Guston: Paintings 1969–1980*, London: Whitechapel Art Gallery, 1982, p. 50.

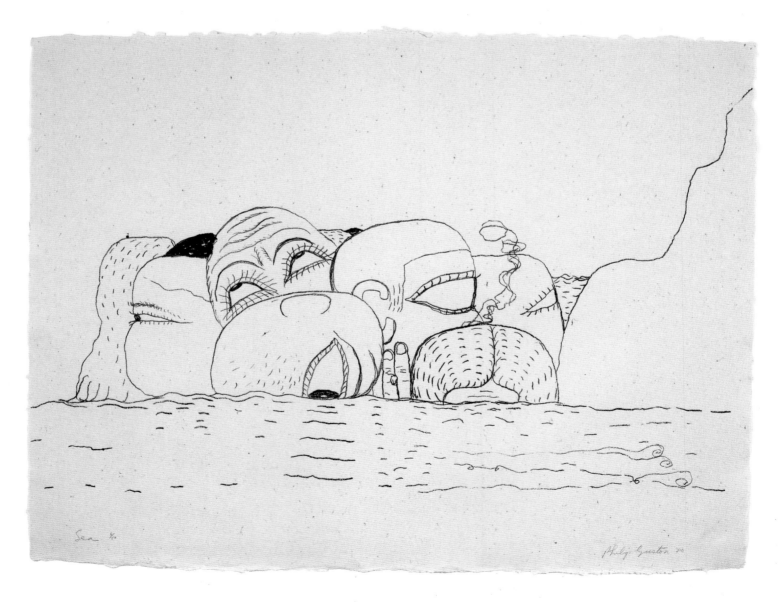

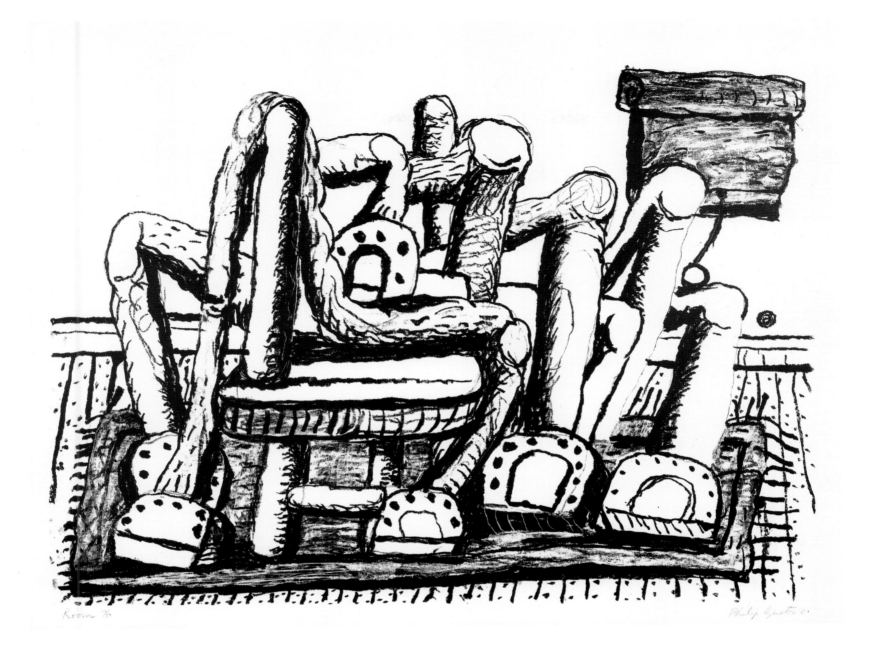

Philip Guston

135 *Room* **1980**

Lithograph

Signed, titled and numbered '10/50'

in pencil, blindstamp of Gemini G.E.L., Los

Angeles. 830 x 1079 (32⅝ x 42½) sheet

Semff 22

British Museum, London 2004,0602.74

Bequeathed by Alexander Walker

Carroll Dunham

Born 1949

Born in New Haven, Connecticut, Carroll Dunham went to boarding school at Phillips Academy Andover, Massachusetts, before returning to Connecticut to take his degree at Trinity College, Hartford, in 1972. After graduating he moved to New York City where he made his name with colourful abstract paintings on wood. His work is often cited as key to the resurgence of painting in the 1980s. Dunham first embarked on printmaking in 1984 after Bill Goldston, director of Universal Limited Art Editions, West Islip, sent him a lithographic stone in an attempt to coax him into printmaking. In that year he produced three lithographs at ULAE and began to experiment with intaglio printmaking at the 2RC workshop in Rome three years later. Between 1988 and 1995 he worked on an ambitious series of four large-scale etchings at ULAE, each featuring a central T-shaped form (*Untitled, Wave, Point of Origin* and *Another Dimension*), after which he focused on painting for around five years. Dunham's style became more representational in the mid-1990s when the bizarre, misshapen figures, which have populated his work ever since, began to appear. Sharing affinities with the work of Philip Guston, Dunham's cartoon-like figures lend an element of wry humour to his often disturbing, violent or sexually charged scenes. In addition to ULAE, Dunham has worked with numerous workshops and publishers including the Grenfell Press, Two Palms Press, Pace Editions and Burnet Editions, all of New York. He continues to live and work in New York City. CD

Carroll Dunham
136 *Atmospherics (Hills, Trees, House, Storm, Coast, Pond, Town, Lost)*
2001–2002
Portfolio of eight intaglio prints (drypoint, sugar-lift, aquatint and spit-bite) printed on yellow paper
Each sheet signed, dated and inscribed 'P.P. 2/3' (printer's proof outside ed. 21) in pencil, blindstamp of Burnet Editions, New York. 152 x 203 (6 x 8) each plate, 340 x 384 (13⅜ x 15⅛) each sheet
Kemmerer A77.1–8
British Museum, London 2014,7031.1.1-5

The eight prints in this series form a narrative featuring a penis-nosed protagonist with prominent teeth and no eyes wearing a collared shirt and a stovepipe hat. The individual titles of the prints document the journey that this figure embarks upon, in which he encounters trees, a house, a storm and a pond while travelling past hills, the coast and a town before finally finding himself lost. The scratchy marks and messy splashes on the final print evoke the figure's apparent anxiety. Dunham's abstract works often feature forms

resembling disembodied genitals and many of his figures have a phallic appendage. The penis-nosed figure in this series appears in a number of earlier prints including *Stove Pipe Hat* (wood-engraving, 2000), *Gunslinger* (lithograph with screenprint, 2001) and a series of photo-engravings, which was given the revealing title *Mr. Nobody* (2001). Speaking about this character, Dunham has said, 'I realized, at a certain point, that this thing had almost chosen me. I didn't sit down and strategize my way to an image of a sightless humanoid with genitals growing out of its head in a funny hat. It just evolved from things connecting, triggering'.[1] Printed by Gregory Burnet at Burnet Editions, New York, on a beautiful Queen Anne Bible Yellow Ruscombe paper, *Atmospherics* was published as a boxed portfolio by Michael Steinberg Editions, New York, in an edition of 21. The British Museum's portfolio is one of three printer's proof sets. **CD**

1 Alexi Worth, 'True Discomfort: Carroll Dunham in Conversation', in *Carroll Dunham*, London: White Cube, 2006, p. 18, quoted in Allison N. Kemmerer, Elizabeth C. DeRose and Carroll Dunham, *Carroll Dunham Prints: Catalogue Raisonné, 1984–2006*, New Haven: Yale University Press in association with Addison Gallery of American Art, Phillips Academy, Andover, Massachusetts, 2008, p. 191.

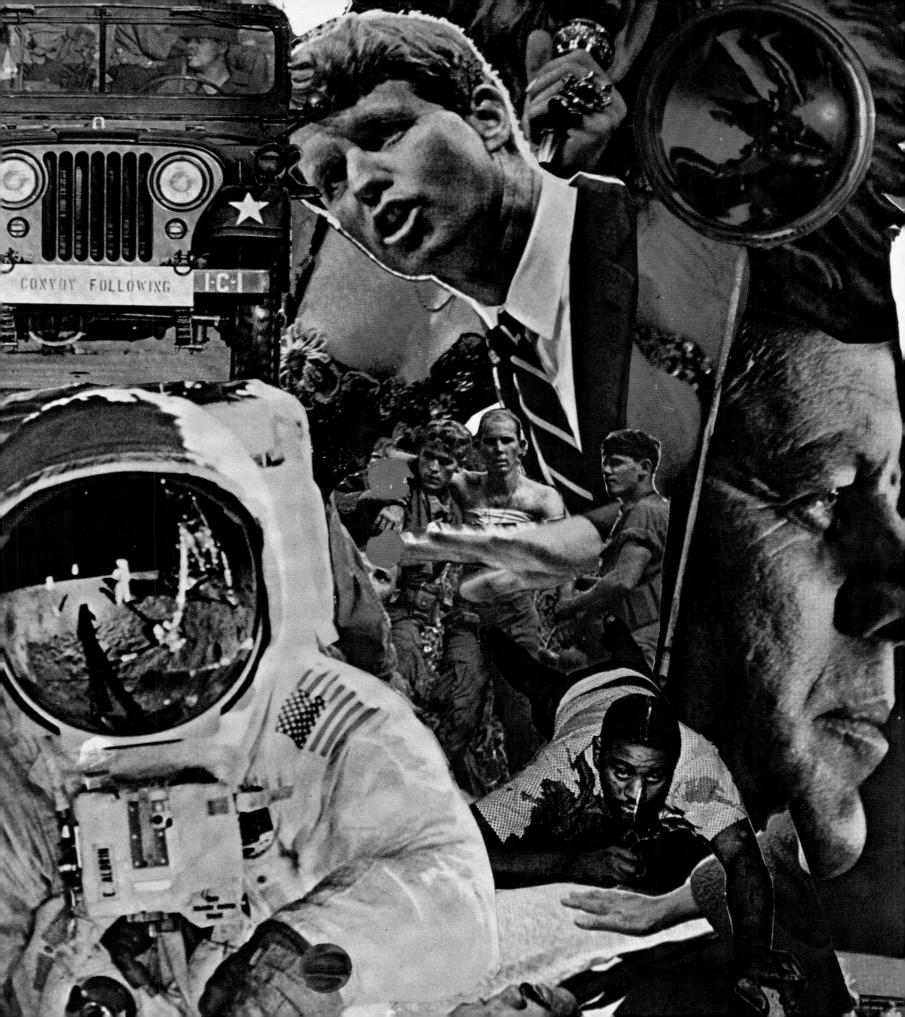

9 Politics and dissent

The 1960s began with the election of a dynamic, young president who spoke of a New Frontier and promised to put men on the moon by the end of the decade. Three years later, on 22 November 1963, President John F. Kennedy was assassinated in Dallas, Texas, with his wife by his side. In the period since, the United States has experienced war, the AIDS crisis, terrorist attacks and economic downturn, issues that many artists have responded to directly. Robert Rauschenberg summed up the political anxieties of the 1960s in his screenprint *Signs* (1970, cat. 137 and detail opposite), a montage of news photographs that includes a portrait of Kennedy juxtaposed with scenes from Dallas on the day of his death. Andy Warhol reacted to JFK's assassination by focusing on Jackie Kennedy, the grieving widow. His political commentary was generally implied rather than overt but in 1972 he made his sympathies clear with his colour screenprint *Vote McGovern* (cat. 139), made in support of Richard Nixon's Democratic rival.

Printmaking has long been used as a medium for social and political comment and the theme of war has frequently been addressed. In the 1960s and 1970s America's military intervention in Vietnam and Cambodia prompted artists including Öyvind Fahlström, Bruce Nauman and Richard Artschwager to make prints on the subject. More recently, Donald Sultan has used etching to consider the consequences of conflicts in the Balkans and the Middle East, and Jenny Holzer has explored the effect on civil liberties of the so-called 'War on Terror'. For activist groups such as the feminist artist collective the Guerrilla Girls and ACT UP (AIDS Coalition to Unleash Power), screenprinting and offset lithography have provided quick and effective ways to reach wide audiences and disseminate political messages.

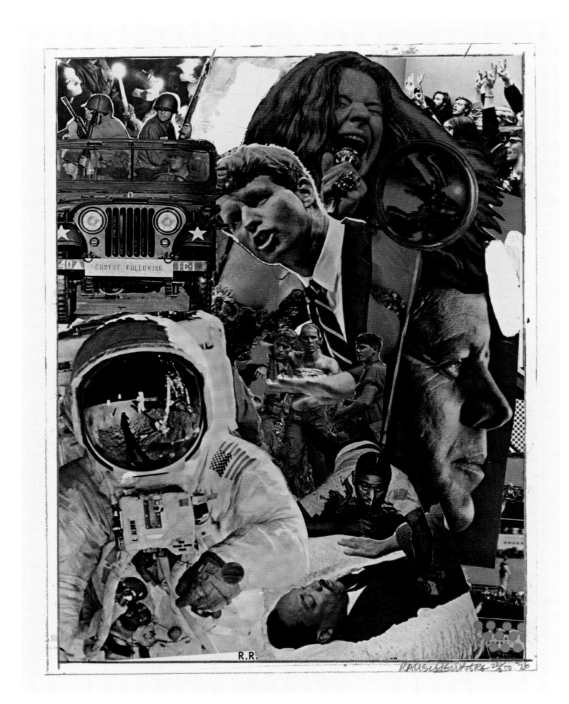

Robert Rauschenberg

For biography see page 70

137 *Signs* 1970

Colour screenprint
Signed, dated and numbered '221/250'
in pencil. 894 x 679 (35¼ x 26¾) image,
1092 x 864 (43 x 34) sheet
Foster 1970, 155
Museum of Modern Art, New York. Gift
of Leo and Jean-Christophe Castelli in
memory of Toiny Castelli, 1988

Signs was Rauschenberg's fraught elegy
to the 1960s. Originally designed as a
cover for *Newsweek*, though never used,
this screenprint was published in a large
edition of 250 by Castelli Graphics, New
York. It is unusual in Rauschenberg's work
for its reliance on instantly recognizable
news photographs. Tragedy piles on
tragedy: John F. Kennedy, Robert F.
Kennedy, Martin Luther King Jr.,
American soldiers carrying their wounded,
a black man in a pool of blood on a
Detroit street.[1] Yet the largest image is
of Buzz Aldrin, and in his visor we see the
reflection of Neil Armstrong and the lunar
module on the surface of the moon – the
mind-boggling outcome of the launch
Rauschenberg had witnessed the
previous year from Cape Kennedy (see
the *Stoned Moon* series, cats 26–31).
At the top, students light candles and
make the peace sign while Janis Joplin
– still alive when the print was made –
wails into a microphone. It is a work,
Rauschenberg wrote, 'conceived to remind
us of love, terror, violence of the last ten
years. Danger lies in forgetting.'[2] **ST**

1 Photographer Dennis Brack sued over the use of
 this photograph, taken during the 1967 Detroit riots,
 which Rauschenberg had clipped from *Newsweek*.
2 Robert Rauschenberg, exhibition announcement,
 New York: Castelli Graphics and Automation House,
 1970; reprinted in Foster 1970, under cat. no. 155.

Andy Warhol

For biography see page 36

**138 *Jackie II* from *11 Pop Artists,
vol. II* 1965, published 1966**

Colour screenprint

Verso: signed with a rubber stamp and
numbered '183' in pencil. 607 x 759
(23⅞ x 29⅞) sheet

Feldman and Schellmann II.14

British Museum, London 2015,7028.1
Purchased with funds given by the
Vollard Group

The assassination of President John F.
Kennedy on 22 November 1963 shocked
America and the world, and the event
replayed continuously on television and in
the press. Warhol shortly afterwards began
his series of screenprinted, multiple-
imaged paintings of the president's
glamorous widow, Jacqueline Kennedy,
in 1963–64 using media pictures by Fred
Ward from *Life* magazine (6 December
1963). In 1966 he contributed three
screenprints of Jackie to three group
portfolios entitled *11 Pop Artists* utilizing
the same source material. The three
Jackie screenprints were produced by
the New York commercial printers
Knickerbocker Machine and Foundry, Inc.
Warhol here presents the veiled widow
isolated in her bereavement in front of
the world's press. The coarse dots of the
news photo are enlarged by photo-
screenprinting to the point that Jackie's
image appears to break up. The repetition
of Jackie against a flat metallic surface of
dolorous purple reinforces the subject's
tragic dimension. **SC**

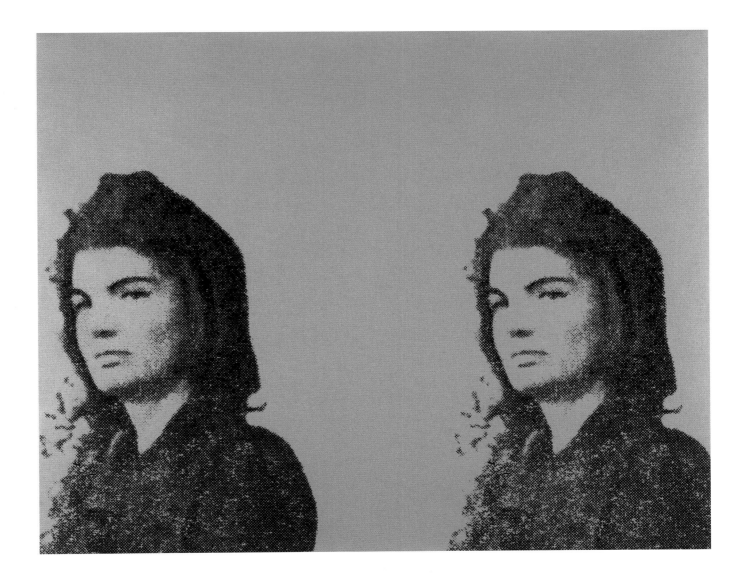

Andy Warhol

139 *Vote McGovern* 1972

Colour screenprint
Signed in felt-tip pen, blindstamp of
Gemini G.E.L., Los Angeles; verso: signed
and numbered '33/250' in ballpoint pen,
copyright stamp '© copyright 1972 Andy
Warhol', 1067 x 1067 (42 x 42) sheet
Feldman and Schellmann II.84
British Museum, London 2016,7038.1
Purchased with funds given by the
Vollard Group

For the presidential elections in 1972
Warhol was persuaded to make this
print as a fundraiser in support of the
Democratic candidate Senator George
McGovern. It was his first print for a
political campaign; he later produced
others in support of the Democratic
presidential candidates Jimmy Carter
in 1976 and Edward Kennedy in 1980.
Warhol pictured Richard Nixon,

McGovern's Republican opponent, with
a livid green face, yellow lips and demonic
orange eyes, beneath which a graffiti-like
hand has scrawled 'Vote McGovern'.
Warhol lifted the source image from an
official publicity photograph of President
and Mrs Richard M. Nixon on the front
cover of *Newsweek* (27 January 1969),
transferring the green colour of Mrs
Nixon's conservative outfit to her
husband's face. Ben Shahn's 1964
political screenprint poster *Vote Johnson*
depicting the president's Republican
opponent Barry Goldwater in a
cartoon-like drawing also seems to
have been the model for Warhol's more
savagely confrontational image. Produced
in an edition of 250, it was the only print
that Warhol made with Ken Tyler at the
Gemini print workshop in Los Angeles.
Whereas the earlier screenprints had
favoured a flat uninflected background
surface, Warhol in this print and the *Mao*

(cat. 140) portraits of the same year
employed screens carrying freely drawn
gestural passages that became a
signature of his later prints. The inclusion
of visible tape marks used to adhere the
photo-stencil became another feature of
his screenprints from the 1970s. Warhol
later complained that his *Vote McGovern*
print had so enraged the Nixon
administration that he was thereafter
placed under continuous scrutiny by the
Internal Revenue Service for tax audits,
prompting him to begin his now-famous
diaries as a daily log of expenditure.[1] **sc**

1 *The Andy Warhol Diaries*, ed. Pat Hackett, 1989;
London: Penguin Books, 2010, see the entry under
3 November 1983, p. 748: 'it was [Brooke
Hayward] and Jean Stein that got me in all this IRS
trouble because they're the ones that asked me to
do a McGovern poster, and I wanted to do something
clever, so I got that bright idea to do a green face
of Nixon with 'Vote McGovern' under it. And that's
when the IRS got so interested in me.'

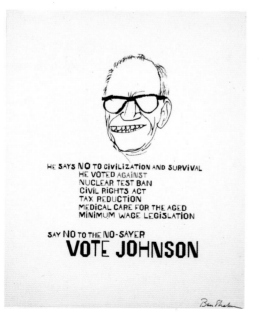

Ben Shahn, *Vote
Johnson*, 1964,
screenprint, 714 x 559
(28½ x 22)

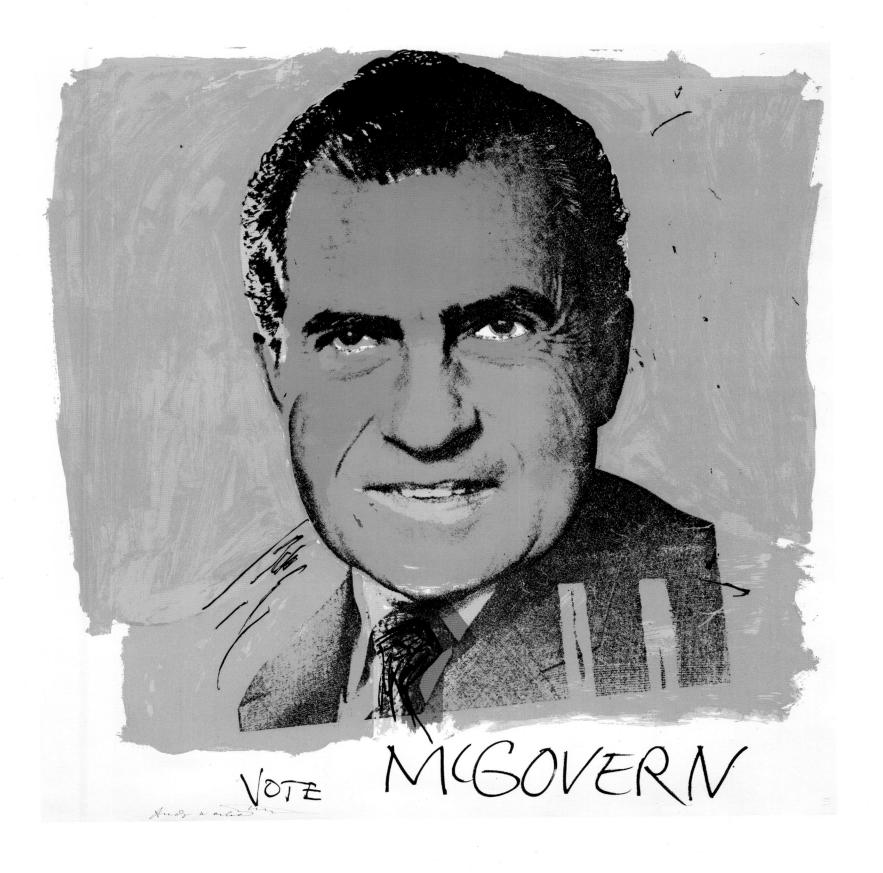

VOTE McGOVERN

Andy Warhol
140 *Mao* **1972**

From the portfolio of 10 colour
screenprints
Verso: signed in ballpoint pen and
numbered from the edition of 250 with a
rubber stamp. 914 x 914 (36 x 36) sheet
Feldman and Schellmann II.91
Private collection, UK (promised gift
to the British Museum)

President Nixon's first visit to the People's
Republic of China in February 1972 to
meet Chairman Mao Zedong marked a
milestone in restoring diplomatic relations
between the two superpowers after an
estrangement of twenty-five years.
Warhol's tribute to Mao as a political
leader was announced in a set of ten
screenprints produced at Styria Studio,
New York, in an edition of 250 for the
print publishers Castelli Graphics and
Multiples in the year of Nixon's visit.
In the same year, a parallel series of Mao
screenprinted paintings also appeared;
from now on Warhol's production of prints
would run in tandem with his paintings
and not after several years, as had been
the case in the 1960s. The source image
of Warhol's Mao was the photographic
portrait that appeared on the front cover
of *Quotations from Chairman Mao
Tse-Tung*, the 'Little Red Book', published
in the popular Bantam paperback edition
of 1972. The introduction of squiggly
screened lines on the Mao canvases and
prints signalled a departure from Warhol's
impersonal machine-like look of the
1960s for a 'style' incorporating freely
drawn marks that would largely
characterize his subsequent work. **SC**

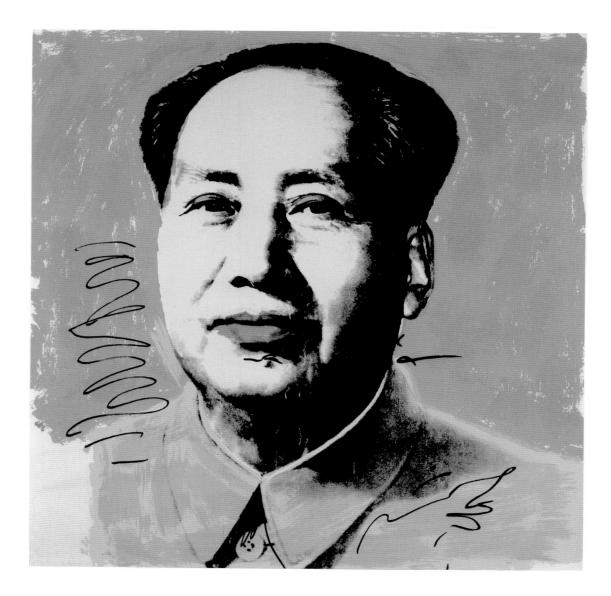

Jim Dine

For biography see page 78

141 *Drag: Johnson and Mao* **1967**

Photo-etching with stencil colour

Signed, dated, titled and numbered
'28/53' in pencil. 868 x 1217
(34⅛ x 47⅞) sheet

Mikro 44; Sidey 367

British Museum, London 1979,0623.6

President Lyndon Johnson and Chairman
Mao, then the respective leaders of the
American and Chinese superpowers,

are sent up here as a pair of drag queens.
In 1967, when this print was made,
President Johnson was embroiled in
the Vietnam War and Chairman Mao had
imposed the Cultural Revolution in China.
In classic pop art style, Dine appropriated
newspaper photographs of the two world
leaders and had them enlarged and
separately photo-etched. Colour was
applied through stencils to suggest heavy
make-up. This print was published by
Editions Alecto in London, where Dine
was living from 1967 to 1971. **sc**

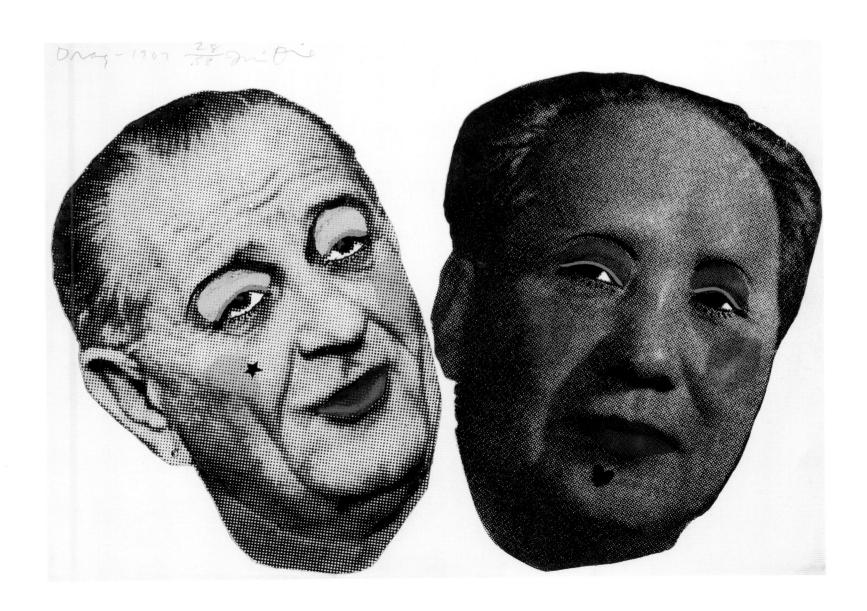

Richard Artschwager

1923–2013

The son of a Prussian-born botanist father and a Russian artist mother, Richard Artschwager was born in Washington, DC, but moved with his family to Las Cruces, New Mexico, at the age of 11. In 1941 he enrolled to study biology, chemistry and mathematics at Cornell University, Ithaca, New York, but was drafted at the end of his second year. He saw combat in France and was lightly wounded in the Battle of the Bulge, after which he spent time in the counter-intelligence corps in Vienna. He returned to Cornell in 1947 and was awarded his degree the following year, moving to New York City after graduation. Having lost his enthusiasm for a career in science, he worked initially as an itinerant photographer of babies and in 1949 spent a year studying at the New York studio school of French artist Amédée Ozenfant (1886–1966). In 1953 he opened his own business making and designing furniture but turned to art professionally after a fire destroyed his workshop in 1958. Many of Artschwager's early works were sculptures inspired by the forms and materials of domestic furniture. In the 1960s he began to make grisaille paintings in acrylic on Celotex, an inexpensive building material with a textured surface, using photographs from newspapers and magazines as a source for his images. Reflecting his interest in space and architecture, his paintings often depict the interior or exterior of buildings. Artschwager began to make prints in 1969 at the invitation of the publisher Brooke Alexander. Although he experimented with different techniques, he had developed a preference for etching by the late 1970s. He died a few days after the closing of his major retrospective at the Whitney Museum of American Art, New York. In 2015 a retrospective of his prints and multiples was held at the Frances Lehman Loeb Art Center, Vassar College, in Poughkeepsie, New York. **CD**

Richard Artschwager
142 *Sailors* 1972
Screenprint and photo-screenprint
Signed, dated and numbered '141/180' in pencil, blindstamp of Styria Studio, New York. 375 x 335 (14¾ x 13⅛) image, 625 x 450 (24⅝ x 17¾) sheet
Weitman 2015, 2
British Museum, London 2013,7003.1
Purchased with the Presentation Fund in honour of Antony Griffiths

This print is derived from *Sailors* (1966), Artschwager's four-panel painting in acrylic on Celotex.[1] The white cruciform of the print replaces the polished metal frames that divide the four panels of the painting. The image is based on a black-and-white patriotic news photograph of a group of young Second World War sailors. Looking smart in their crisp uniforms and squinting into the sun, they appear carefree and oblivious of the experiences that await them. The window-like quartering of the image allows us only a partial view of this brief moment of apparent fresh-faced innocence and optimism. A sense of melancholy and loss is reinforced by Artschwager's characteristic recreation of the grainy quality of the photograph. Artschwager began to use found imagery in his work in 1961, devising a method of enlarging and transferring an image onto canvas using a grid, anticipating the practice of photorealists such as Chuck Close. The majority of his early prints were based on pre-existing paintings. This screenprint was published in an untitled portfolio for the Cologne Art Fair by the Verein progressiver deutscher Kunsthändler (Association of Progressive German Art Dealers), Cologne. It was printed by Styria Studio, New York. **CD**

1 Reproduced in Gross, fig. 39 (p. 39) and R. Armstrong, *Artschwager, Richard*, New York: Whitney Museum of American Art, 1988, cat. 38 (p. 81).

Richard Artschwager

143 *Building Riddled with Listening Devices (Beta)* **1990**

Soft-ground etching, aquatint, burnishing and drypoint
Signed, dated and numbered '7/60' in pencil. 525 x 610 (20⅝ x 24) plate, 840 x 895 (33 x 35¼) sheet
Gross 103; Weitman 2015, 13
British Museum, London 2015,7015.1
Purchased with funds given by Margaret Conklin and David Sabel

Something sinister is afoot. Dressed in an overcoat and carrying a briefcase, the shadowy figure in the foreground of this image appears to be on a covert mission. The building behind him, we are told in the title, is riddled with listening devices, as indicated by the waves and signals swirling across the print. The scene is based on a newspaper photograph of the American Embassy in Moscow.[1]

After decades of negotiation, work was begun on the new eight-storey building in 1979. In the mid-1980s, however, it was discovered that the Soviet construction workers had incorporated highly sophisticated surveillance systems into the building's structure. This hugely expensive and embarrassing episode became public knowledge in 1987 and the building remained unused until 2000. Made during the dying days of the Soviet Union, this etching was printed by Patricia Branstead at Aeropress, New York. It was published by Multiples, Inc., New York, in a series of three with *Building Riddled with Listening Devices (Alpha)*, of which this print is a reversal, and *Horizon*, an image of the interior of an art gallery. **CD**

1 'Richard Artschwager, *Building Riddled with Listening Devices (Alpha)*, *Building Riddled with Listening Devices (Beta)* and *Horizon*, Prints and Photographs Published', *Print Collector's Newsletter*, 21:1 (March–April 1990), pp. 24–25 (p. 25).

7/10 Wichowski 1990

Öyvind Fahlström

1928–1976

A painter, draughtsman, printmaker, playwright, poet and documentary maker, Öyvind Fahlström was born in São Paulo, Brazil, to a Norwegian father and Swedish mother. In July 1939 he was sent to Sweden to spend the summer with his maternal grandfather but became stranded there due to the outbreak of the Second World War. Between 1949 and 1952 he pursued classical studies and art history at the University of Stockholm, having elected to become a Swedish citizen on leaving school. In the 1950s he divided his time between Stockholm, Paris and Rome, writing plays and concrete poems and creating avant-garde art works including *Opera* (1952, Museo Nacional Centro de Arte Reina Sofía, Madrid), a felt-tip drawing the size of a room. In 1961 he moved to New York, funded by a grant from the Swedish-American Foundation, where he stayed for the rest of his life, spending summers in Sweden, France and Italy. In the 1960s he continued to write plays and staged a number of Happenings. As a visual artist, his work was included in the New Realists exhibition at the Sidney Janis Gallery, New York, in 1962 and he represented Sweden at the Venice Biennale in 1966. Fahlström's works often have a performative element to them, requiring the viewer to engage with the information and imagery he presents in an interactive way. His left-wing worldview is clearly expressed through his art, which repeatedly examines both domestic and international politics. Most of his prints relate to pre-existing paintings. He hoped that printmaking would allow him to reach a wider audience and initially sought to produce prints for the price of a book or record by publishing very large unsigned editions, but found this financially unsustainable. Interest in Fahlström's work was re-ignited by his posthumous inclusion in 'Documenta 10' in 1997 and a travelling exhibition organized by the Museu d'Art Contemporani de Barcelona in 2000. An exhibition of his complete prints and multiples was held at the BAWAG Foundation, Vienna, in 2001–2. CD

Öyvind Fahlström

144 *Sketch for World Map* **1973**

Screenprint
Signed and numbered '65/150' in pencil,
blindstamps of Styria Studio, New York,
and Avery, Kenner and Weiner.
515 x 1045 (20¼ x 41⅛) image,
560 x 1060 (22 x 41¾) sheet
Avery-Fahlström 12
British Museum, London 2012,7065.1
Purchased with the Presentation Fund
in honour of Antony Griffiths

The information presented in this print is
intended to highlight the damage inflicted
on the world by the political, social and
economic interests of the United States
and other dominant powers. Using words
and comic-book-inspired imagery to relay
statistics, excerpts from political statements
and wry commentary, Fahlström tackles
many subjects including the war in Vietnam,
the use of cheap labour to meet the
demand of American consumers, racial
inequality, human-rights abuses and the
crippling effect of debt on developing
nations. Like a picture puzzle, the 'map'
is made up of interlocking sections
representing individual countries. It is
not geographically accurate; the more

information Fahlström includes about a
country, the bigger it becomes and the
more insistent of our attention. South
Vietnam, for example, occupies almost
the entire right edge of the print, while
the USSR, above it to the left, remains
relatively small.

This print is derived from a
preparatory drawing for Fahlström's
brightly coloured painting *World Map*
(1972, acrylic and Indian ink on vinyl,
private collection). The left-hand section
of the drawing had previously been used
for *Sketch for World Map Part I (Americas,
Pacific)*, an offset lithograph on newsprint,

which Fahlström self-published in a huge
edition of around 7,300 in 1972. This
screenprint was printed the following year
at Styria Studio, New York, and published
in a much smaller edition of 150 by Avery,
Kenner and Weiner, Inc., New York. It was
made to benefit the Youth International
Party, a counter-cultural group whose
members were active in the anti-war
movement. It is one of a number of
politically themed 'maps' that Fahlström
made, some of which have moveable
magnetized parts including *Section of
World Map – A Puzzle*, a screenprint on
vinyl on a metal panel (1973). **CD**

Bruce Nauman

For biography see page 122

145 *Raw-War* **1971**
Colour lithograph
Signed, dated and numbered '49/100' in
pencil, blindstamp of Cirrus Editions, Los
Angeles. 567 x 717 (22⅜ x 28¼) sheet
Cordes 7
Tate: Purchased 1992

The first of Nauman's word-images, this
lithograph printed in red and black at
Cirrus Editions, Los Angeles, was produced
shortly after his neon palindrome *Raw
War*. Made in 1970, at the height of the
Vietnam War, the neon angrily flashed
'Raw' (in red) and 'War' (in orange) in
alternate strobes. Nauman exploited 'raw'
and 'war' as a palindrome in which the
terms are intrinsically linked and
impossible to separate. In visual terms
the raw blood-red evoked the carnage
of war while in aural terms the roar of
war bellowed its horror. By these visual/
verbal/aural stratagems Nauman tells us
to 'pay attention' (see cat. 68). While
acknowledging the political emotions
expressed in the print and the neon,
Nauman has evaded any interpretation
that they are specific responses to the
Vietnam War. **SC**

Donald Sultan

For biography see page 102

146 *Refugees* **from** *The Brutal Unsentimental Landscape* **2004**

Colour etching and aquatint
Signed, dated 'Oct 2004', titled and numbered 'AP 4/20' (artist's proof outside ed. 50) in pencil. 352 x 480 (13⅞ x 18⅞) plate, 575 x 685 (22⅝ x 27) sheet
British Museum, London 2010,7076.1.1
Purchased with funds given by the James A. and Laura M. Duncan Charitable Gift Fund

Sultan's political concerns about war, displacement and the politics of oil are reflected in this print from a suite of five etchings. Although not intended as a depiction of a specific scene but rather a timeless image of 'refugees wandering in the wasteland',[1] the etching inevitably brings to mind the US-led invasion of Iraq in 2003. The other prints in the 2004 series are titled *Oil Field*, *Dead Soldiers*, *Industrial Park* and *The Shelling of Dubrovnik 1999*. Sultan has noted that 'Horrific images, over time, anesthetize us.'[2] In an age of continuous news coverage when images of harrowing scenes are constantly replayed, these prints encourage the viewer to question one's own responses to such imagery and to recognize the brutal and unsentimental truths contained within. The suite was printed by Maurice Payne in New York and published by Arte y Naturaleza, Madrid. **CD**

1 Donald Sultan in an email to Stephen Coppel, 30 January 2014.
2 Ibid.

Guerrilla Girls

Active from 1985

Formed with the aim of challenging gender inequality in the art world, the Guerrilla Girls is an evolving collective of anonymous women artists. The group was founded in 1985 by seven women in response to the exhibition 'International Survey of Recent Painting and Sculpture' held at the Museum of Modern Art, New York, in 1984, which included work by 156 male artists but only thirteen women. Following comments by the exhibition's curator, Kynaston McShine, that any artist whose work was not featured in the show should rethink 'his' career, the Guerrilla Girls staged a protest in front of the museum and embarked on a poster campaign.[1] Signing themselves the 'conscience of the art world' and appropriating the language of advertising and mass media, they pasted their self-printed posters up around Manhattan, initially targeting museums, commercial galleries, curators, dealers, critics and other artists. The Guerrilla Girls have expanded their output to include magazine spreads, billboard advertisements, stickers and other multiples, and artwork intended for gallery display. Members of the group have also participated in public debates and discussions and have organized workshops at schools and museums. Although the subject of gender inequality remains a central concern, the group has addressed other social and political issues such as racism, abortion rights, war, homelessness and censorship. Members maintain their anonymity by wearing gorilla masks when appearing in public and assign themselves names of important women from history, mostly those of female artists such as Frida Kahlo and Käthe Kollwitz. Calling themselves 'feminist masked avengers',[2] the Guerrilla Girls continue to produce art in response to contemporary concerns. In 2015 Matadero Madrid hosted a retrospective of the collective's work to mark their thirtieth anniversary. **CD**

1 Guerrilla Girls, *Confessions of the Guerrilla Girls*, with an essay by Whitney Chadwick, London: Pandora, 1995, p. 13.

2 www.guerrillagirls.com [accessed 26 May 2016].

Guerrilla Girls
147 *Guerrilla Girls' Code Of Ethics For Art Museums* from *Guerrilla Girls Talk Back* 1990
Screenprint
Portfolio numbered '12/50'. 435 x 560
(17⅛ x 22) sheet
Tate: Purchased 2003

The Guerrilla Girls first created their poster *Code of Ethics for Art Museums* in 1989. Intended to expose and to condemn unfair and unethical practices in public art institutions in the United States, the code takes the form of Ten Commandments for trustees and curators. With characteristic wit and irony, these are presented in the form of two stone tablets in biblical language. Specific issues addressed include nepotism: 'Thou shalt not give more than 3 retrospectives to any Artist whose Dealer is the brother of the Chief Curator', and the lack of diversity among living artists exhibited in museums: 'Thou shalt provide lavish funerals for Women and Artists of Color who thou planeth to exhibit only after their Death.' According to the group, in the years since it was designed, copies of the poster 'have been spotted hanging in museum offices all over the country'.[1] This screenprinted version was published in the portfolio *Guerrilla Girls Talk Back: The First Five Years, 1985–90*, which included thirty of the group's poster designs, originally produced as offset lithographs (cats 157 and 158). The portfolio of screenprints was printed and published by the collective in an edition of 50 in 1990. **CD**

1 Guerrilla Girls, op. cit., p. 63.

GUERRILLA GIRLS' CODE OF ETHICS FOR ART MUSEUMS.

I. Thou shalt not be a Museum Trustee and also the Chief Stockholder of a Major Auction House.

II. A Curator shalt not exhibit an Artist, or the Artists of a Dealer, with whom he/she has had a sexual relationship, unless such liaison is explicitly stated on a wall label 8" from the exhibited work.

III. Thou shalt not give more than 3 retrospectives to an Artist whose Dealer is the brother of the Chief Curator.

IV. Thou shalt not limit thy Board of Trustees to Corporate Officers, Wealthy Entrepreneurs and Social Hangers-on. At least .001% must be Artists representing the racial and gender percentages of the U.S. population.

V. Thou shalt not permit Corporations to launder their public images in Museums until they cleaneth up their Toxic Waste Dumps and Oil Slicks.

VI. Thou shalt provide lavish funerals for Women and Artists of Color who thou planeth to exhibit only after their death

VII. If thou art an Art Collector sitting on the Acquisitions or Exhibitions Committee, thou shalt useth thy influence to enhance the value of thine own collection not more than once a year.

VIII. Thy Corporate Benefactors who earneth their income from products for Women and People of Color shalt earmark their Museum donations for exhibits and acquisitions of art by those groups.

IX. Thou shalt keepeth Curatorial Salaries so low that Curators must be Independently Wealthy, or willing to engage in Insider Trading.

X. Thou shalt admit to the Public that words such as genius, masterpiece, seminal, potent, tough, gritty and powerful are used solely to prop up the Myth and inflate the Market Value of White Male Artists.

532 LaGUARDIA PL #237, NY 10012 **GUERRILLA GIRLS** CONSCIENCE OF THE ART WORLD

Jenny Holzer

Born 1950

Known best for her text-based works, Jenny Holzer is a politically engaged conceptual artist who has addressed issues relating to power, violence, feminism, human rights and war. She was born in Gallipolis, Ohio, in a hospital founded by her grandparents. After training at Ohio University, Athens (1972), and Rhode Island School of Art and Design (1977), she moved to New York to enrol on the Whitney Museum's Independent Study Program. During her postgraduate studies she was exposed to conceptual art and became interested in using language in her work. In the late 1970s she began to produce street posters printed with 'truisms' – single-line aphorisms, clichés and motivational slogans – that she flyposted around Manhattan. She has since produced her *Truisms* in many other formats including LED light installations, bronze plaques, carved stone benches and multiples such as baseball caps and coffee cups. In 1990 she became the first woman to represent the United States at the Venice Biennale, winning the Leone d'Oro award for her exhibition. Much of Holzer's recent work has addressed the so-called 'War on Terror' and the general sense of anxiety and paranoia in post-9/11 America. **CD**

Jenny Holzer

148 *Inflammatory Essays I* **1982**

Suite of 10 offset lithographs
Signed in ink (final sheet), unnumbered.
432 x 432 (17 x 17) each sheet
Wye 1996, 1
British Museum, London 2013,7093.1.1-10
Purchased with funds given by the
James A. and Laura M. Duncan
Charitable Gift Fund

Holzer's *Inflammatory Essays* were produced between 1979 and 1982. Like her *Truisms*, which they followed, they were originally posted anonymously in public spaces around New York. In total the series comprises twenty-four essays although this portfolio was published as a selection of ten. Printed in a uniform font on squares of paper measuring around 432 x 432 mm, the texts are each exactly 100 words and twenty lines long. The differing colours of the sheets serve to isolate the individual voices and themes within the series. Written by the artist, the essays are deliberately provocative, reflecting a range of contentious views on politics, religion, society and human nature. The aggressive and confrontational nature of the writing is heightened by the use of capital letters. Approximately 100 sets of the essays were printed by the Millner Brothers, New York, and published by the artist. Within the gallery space, the essays are usually displayed in a block, often featuring multiple sets arranged by colour. Shown in this way, the series reflects Holzer's interest in structure and order, and the influence of minimalist artists including Sol LeWitt and Donald Judd becomes clear. **CD**

> YOU GET AMAZING SENSATIONS FROM
> GUNS. YOU GET RESULTS FROM GUNS.
> MAN IS AN AGGRESSIVE ANIMAL;
> YOU HAVE TO HAVE A GOOD OFFENSE
> AND A GOOD DEFENSE. TOO MANY
> CITIZENS THINK THEY ARE HELPLESS.
> THEY LEAVE EVERYTHING TO THE
> AUTHORITIES AND THIS CAUSES
> CORRUPTION. RESPONSIBILITY
> SHOULD GO BACK WHERE IT BELONGS.
> IT IS YOUR LIFE SO TAKE CONTROL
> AND FEEL VITAL. THERE MAY BE
> SOME ACCIDENTS ALONG THE PATH
> TO SELF-EXPRESSION AND SELF-
> DETERMINATION. SOME HARMLESS
> PEOPLE WILL BE HURT. HOWEVER,
> G-U-N SPELLS PRIDE TO THE
> STRONG, SAFETY TO THE WEAK
> AND HOPE TO THE HOPELESS.
> GUNS MAKE WRONG RIGHT FAST.

SHRIEK WHEN THE PAIN HITS DURING INTERROGATION. REACH INTO THE DARK AGES TO FIND A SOUND THAT IS LIQUID HORROR, A SOUND OF THE BRINK WHERE MAN STOPS AND THE BEAST AND NAMELESS CRUEL FORCES BEGIN. SCREAM WHEN YOUR LIFE IS THREATENED. FORM A NOISE SO TRUE THAT YOUR TORMENTOR RECOGNIZES IT AS A VOICE THAT LIVES IN HIS OWN THROAT. THE TRUE SOUND TELLS HIM THAT HE CUTS HIS FLESH WHEN HE CUTS YOURS, THAT HE CANNOT THRIVE AFTER HE TORTURES YOU. SCREAM THAT HE DESTROYS ALL KINDNESS IN YOU AND BLACKENS EVERY VISION YOU COULD HAVE SHOWN HIM.

BECAUSE THERE IS NO GOD SOMEONE MUST TAKE RESPONSIBILITY FOR MEN. A CHARISMATIC LEADER IS IMPERATIVE. HE CAN SUBORDINATE THE SMALL WILLS TO THE GREAT ONE. HIS STRENGTH AND HIS VISION REDEEM MEN. HIS PERFECTION MAKES THEM GRATEFUL. LIFE ITSELF IS NOT SACRED, THERE IS NO DIGNITY IN THE FLESH. UNDIRECTED MEN ARE CONTENT WITH RANDOM, SQUALID, POINTLESS LIVES. THE LEADER GIVES DIRECTION AND PURPOSE. THE LEADER FORCES GREAT ACCOMPLISHMENTS, MANDATES PEACE AND REPELS OUTSIDE AGGRESSORS. HE IS THE ARCHITECT OF DESTINY. HE DEMANDS ABSOLUTE LOYALTY. HE MERITS UNQUESTIONING DEVOTION. HE ASKS THE SUPREME SACRIFICE. HE IS THE ONLY HOPE.

CHANGE IS THE BASIS OF ALL HISTORY, THE PROOF OF VIGOR. THE OLD IS SOILED AND DISGUSTING BY NATURE. STALE FOOD IS REPELLENT, MONOGAMOUS LOVE BREEDS CONTEMPT, SENILITY CRIPPLES THE GOVERNMENT THAT IS TOO POWERFUL TOO LONG. UPHEAVAL IS DESIRABLE BECAUSE FRESH, UNTAINTED GROUPS SEIZE OPPORTUNITY. VIOLENT OVERTHROW IS APPROPRIATE WHEN THE SITUATION IS INTOLERABLE. SLOW MODIFICATION CAN BE EFFECTIVE; MEN CHANGE BEFORE THEY NOTICE AND RESIST. THE DECADENT AND THE POWERFUL CHAMPION CONTINUITY. "NOTHING ESSENTIAL CHANGES." THAT IS A MYTH. IT WILL BE REFUTED. THE NECESSARY BIRTH CONVULSIONS WILL BE TRIGGERED. ACTION WILL BRING THE EVIDENCE TO YOUR DOORSTEP.

FEAR IS THE MOST ELEGANT WEAPON, YOUR HANDS ARE NEVER MESSY. THREATENING BODILY HARM IS CRUDE. WORK INSTEAD ON MINDS AND BELIEFS, PLAY INSECURITIES LIKE A PIANO. BE CREATIVE IN APPROACH. FORCE ANXIETY TO EXCRUCIATING LEVELS OR GENTLY UNDERMINE THE PUBLIC CONFIDENCE. PANIC DRIVES HUMAN HERDS OVER CLIFFS; AN ALTERNATIVE IS TERROR-INDUCED IMMOBILIZATION. FEAR FEEDS ON FEAR. PUT THIS EFFICIENT PROCESS IN MOTION. MANIPULATION IS NOT LIMITED TO PEOPLE. ECONOMIC, SOCIAL AND DEMOCRATIC INSTITUTIONS CAN BE SHAKEN. IT WILL BE DEMONSTRATED THAT NOTHING IS SAFE, SACRED OR SANE. THERE IS NO RESPITE FROM HORROR. ABSOLUTES ARE QUICKSILVER. RESULTS ARE SPECTACULAR.

FREEDOM IS IT! YOU'RE SO SCARED, YOU WANT TO LOCK UP EVERYBODY. ARE THEY MAD DOGS? ARE THEY OUT TO KILL? MAYBE YES. IS LAW, IS ORDER THE SOLUTION? DEFINITELY NO. WHAT CAUSED THIS SITUATION? LACK OF FREEDOM. WHAT HAPPENS NOW? LET PEOPLE FULFILL THEIR NEEDS. IS FREEDOM CONSTRUCTIVE OR IS IT DESTRUCTIVE? THE ANSWER IS OBVIOUS. FREE PEOPLE ARE GOOD, PRODUCTIVE PEOPLE. IS LIBERATION DANGEROUS? ONLY WHEN OVERDUE. PEOPLE AREN'T BORN RABID OR BERSERK. WHEN YOU PUNISH AND SHAME YOU CAUSE WHAT YOU DREAD. WHAT TO DO? LET IT EXPLODE. RUN WITH IT. DON'T CONTROL OR MANIPULATE. MAKE AMENDS.

SENTIMENTALITY DELAYS THE REMOVAL OF THE POLITICALLY BACKWARD AND THE ORGANICALLY UNSOUND. RIGOROUS SELECTION IS MANDATORY IN SOCIAL AND GENETIC ENGINEERING. INCORRECT MERCIFUL IMPULSES POSTPONE THE CLEANSING THAT PRECEDES REFORM. SHORT-TERM NICETIES MUST YIELD TO LONG-RANGE NECESSITY. MORALS WILL BE REVISED TO MEET THE REQUIREMENTS OF TODAY. MEANINGLESS PLATITUDES WILL BE PULLED FROM TONGUES AND MINDS. WORDS LIKE "PURGE" AND "EUTHANASIA" DESERVE NEW CONNOTATIONS. THEY SHOULD BE RECOGNIZED AS THE RATIONAL PUBLIC POLICIES THEY ARE. THE GREATEST DANGER IS NOT EXCESSIVE ZEAL BUT UNDUE HESITATION. WE WILL LEARN TO IMITATE NATURE. HER KILLS NOURISH STRONG LIFE. SQUEAMISHNESS IS THE CRIME.

THE MOST EXQUISITE PLEASURE IS DOMINATION. NOTHING CAN COMPARE WITH THE FEELING. THE MENTAL SENSATIONS ARE EVEN BETTER THAN THE PHYSICAL ONES. KNOWING YOU HAVE POWER HAS TO BE THE BIGGEST HIGH, THE GREATEST COMFORT. IT IS COMPLETE SECURITY, PROTECTION FROM HURT. WHEN YOU DOMINATE SOMEBODY YOU'RE DOING HIM A FAVOR. HE PRAYS SOMEONE WILL CONTROL HIM, TAKE HIS MIND OFF HIS TROUBLES. YOU'RE HELPING HIM WHILE HELPING YOURSELF. EVEN WHEN YOU GET MEAN HE LIKES IT. SOMETIMES HE'S ANGRY AND FIGHTS BACK BUT YOU CAN HANDLE IT. HE ALWAYS REMEMBERS WHAT HE NEEDS. YOU ALWAYS GET WHAT YOU WANT.

DESTROY SUPERABUNDANCE. STARVE THE FLESH, SHAVE THE HAIR, EXPOSE THE BONE, CLARIFY THE MIND, DEFINE THE WILL, RESTRAIN THE SENSES, LEAVE THE FAMILY, FLEE THE CHURCH, KILL THE VERMIN, VOMIT THE HEART, FORGET THE DEAD. LIMIT TIME, FORGO AMUSEMENT, DENY NATURE, REJECT ACQUAINTANCES, DISCARD OBJECTS, FORGET TRUTHS, DISSECT MYTH, STOP MOTION, BLOCK IMPULSE, CHOKE SOBS, SWALLOW CHATTER. SCORN JOY, SCORN TOUCH, SCORN TRAGEDY, SCORN LIBERTY, SCORN CONSTANCY, SCORN HOPE, SCORN EXALTATION, SCORN REPRODUCTION, SCORN VARIETY, SCORN EMBELLISHMENT, SCORN RELEASE, SCORN REST, SCORN SWEETNESS, SCORN LIGHT. IT'S A QUESTION OF FORM AS MUCH AS FUNCTION. IT IS A MATTER OF REVULSION.

DON'T TALK DOWN TO ME. DON'T BE POLITE TO ME. DON'T TRY TO MAKE ME FEEL NICE. DON'T RELAX. I'LL CUT THE SMILE OFF YOUR FACE. YOU THINK I DON'T KNOW WHAT'S GOING ON. YOU THINK I'M AFRAID TO REACT. THE JOKE'S ON YOU. I'M BIDING MY TIME, LOOKING FOR THE SPOT. YOU THINK NO ONE CAN REACH YOU, NO ONE CAN HAVE WHAT YOU HAVE. I'VE BEEN PLANNING WHILE YOU'RE PLAYING. I'VE BEEN SAVING WHILE YOU'RE SPENDING. THE GAME IS ALMOST OVER SO IT'S TIME YOU ACKNOWLEDGE ME. DO YOU WANT TO FALL NOT EVER KNOWING WHO TOOK YOU?

b7C PER OPM

VI (2)

b7C PER OPM

ONLY Orwell's book,
REFERS TO Homage to Catalonia, is in my opinion, one of the few politically clear pic-
ORWELL IN tures of the complex situation during that first year of the war.
BOOK DESCRIBES

b7C PER OPM

VI

b7C PER OPM

THERE IS NO MENTION OF OR
REFERENCE TO GEORGE ORWELL OR ANY AKA!
ON THIS PAGE.

b7C PER OPM

X (2)

b7C PER OPM

THERE IS NO MENTION OF OR REFERENCE
TO GEORGE ORWELL ON THIS PAGE.
OR ANY AKA's

b7C PER OPM

II

b7C PER OPM

THERE IS NO MENTION OF OR REFERENCE
TO GEORGE ORWELL ON THIS
PAGE. OR ANY AKA's

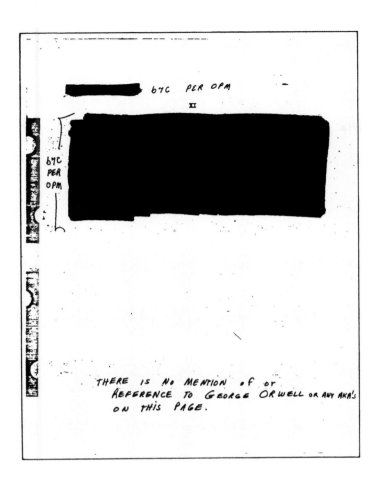

Jenny Holzer
149 *AKA 1-5* 2006
Series of five photo-etchings
Signed and numbered '1/40' in pencil
(final sheet). 487 x 373 (19⅛ x 14⅝)
each plate, 755 x 563 (29¾ x 22⅛)
each sheet
British Museum, London 2015,7016.1-5
Purchased with funds given by Scott and
Cindy Burns

Printed and published by Brand X
Editions, New York, this series reproduces
five pages from a document that was
included in an FBI file on the writer
George Orwell (1903–1950), world
renowned for his books *Animal Farm*
(1945) and *Nineteen Eighty-Four* (1949).
Provided in response to a Freedom of
Information (FOI) request, the text has
been almost entirely redacted. Only a
single reference to Orwell's 1938 book
Homage to Catalonia remains visible
but this information is redundant as no
context is given. To comply with the FOI
legislation, the pages are annotated with
the sentence 'There is no mention of or
reference to George Orwell or any AKAs
[Also Known As] on this page' along with
the official code that permits the redactions.
The dense black blocks that dominate
each page in place of the text evoke the
monochrome minimalism of artists such
as Richard Serra and Donald Judd, and
displayed together, the prints appear
almost abstract. Holzer began to use
declassified government documents in
her work in around 2004, reproducing
them primarily in the form of paintings
and LED light installations. Many of
the documents she has used relate to
controversial activities undertaken by the
United States security services, especially
those that threaten human or civil rights
including undercover surveillance and the
interrogation of detainees. **CD**

Keith Sonnier

Born 1941

Best known as a sculptor, Keith Sonnier was born in Mamou, Louisiana, to French-American parents. He trained at the University of Southwestern Louisiana, Lafayette (1959–63) and Rutgers University, New Jersey (1965–66), after which he moved to New York. Labelled a 'post-minimalist' along with artists such as Richard Serra and Bruce Nauman, he came to attention in the late 1960s with his sculptures made from unusual materials including latex, cheesecloth and found objects. In the mid-1960s he began to make light works using first incandescent and then coloured neon lights, reflecting a long-standing interest inspired by the lights of Louisiana's paddy fields. Often described as three-dimensional drawings, his gestural neon pieces have become central to his work. Since the 1980s Sonnier has become well known for several large-scale neon installations made for public spaces such as the New International Airport, Munich (1989–92). He has also made work using film, video, television transmissions and live satellite feeds, reflecting his interest in electronic communication and moving images. As a printmaker, Sonnier has made works with Gemini, Los Angeles, and Graphicstudio, Tampa, Florida. In 1974 he was awarded first prize at the 9th International Biennial Exhibition of Prints at the National Museum of Modern Art, Tokyo. He currently lives and works in New York City and Bridgehampton, New York. **CD**

Keith Sonnier

150 *Control Scene* **1975**

Screenprint, vat-dyed and wax-coated, on thin coral-pink Japanese Okawara paper
Signed with initials, dated, inscribed 'C-S V' and numbered '20/25' in white pencil on image, blindstamp of Gemini G.E.L., Los Angeles. 889 x 1200 (35 x 47¼) sheet
British Museum, London 2012,7070.1
Purchased with funds given by the Joseph F. McCrindle Foundation to the American Friends of the British Museum

Although not an overtly political image, the title of this screenprint hints at a wariness of nascent computer technology and recognition of its potential to control and manipulate. Viewed with hindsight, the print seems to presage the era of mass surveillance via personal computer. The imagery is taken from Sonnier's video work *Animation II*, which he made at a Computer Image centre in Denver, Colorado, in 1974. Each a composite of five separate stills, the images vary across the edition of 25, which was printed and published by Gemini, Los Angeles. The colour of the paper also varies as each sheet was vat-dyed either red, coral-pink, yellow, green or blue after the image was printed in black from a photo-stencil. A wax coating was then applied to the surface of the paper giving it a computer-like sheen. The title comes from a still in the video in which the headings 'ANIMATION CONTROL' and 'SCENE 0001' are displayed side by side (see left). **CD**

Keith Sonnier, still from *Animation II*, 1974
Video, 25:56 min
ZKM Centre for Art and Media Karlsruhe

Roy Lichtenstein

For biography see page 46

151 *I Love Liberty* 1982

Colour screenprint

Signed, dated and numbered 'AP 16/73'
(artist's proof outside ed. 250) in pencil.

823 x 536 (32⅜ x 21⅛) image,
975 x 688 (38⅜ x 27) sheet

Corlett 192

Private collection, UK (promised gift
to the British Museum)

Throughout his career Lichtenstein made
prints and posters as fundraisers to benefit
political and social causes. The appeal
of his work made Lichtenstein a popular
choice for charity events. This print was
produced in connection with 'I Love
Liberty', a national celebration of American
ideals on the 250th anniversary of the birth
of the first president of the United States,
George Washington. An extravaganza
with performances by various celebrities,
actors and comedians, including Robin
Williams personifying the American flag,
it was organized by the liberal pressure
group People for the American Way as
a counterfoil to the Moral Majority and
other conservative forces. Screened on
national television on 21 March 1982,
'I Love Liberty' upheld the rights of
minorities and oppressed groups,
including gays, women, African Americans,
Hispanics and Native Americans, as
inclusive of American values. Lichtenstein's
Statue of Liberty is depicted in a style
of strong outlines and bold diagonals
derived from American art deco. **SC**

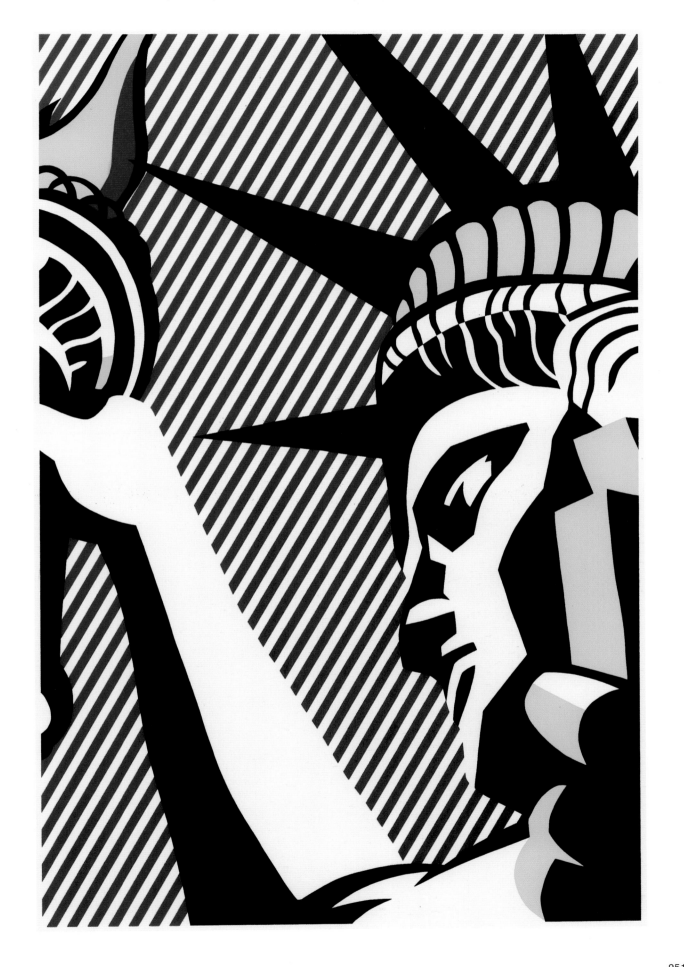

Keith Haring

1958–1990

Born and brought up in Pennsylvania, Keith Haring began to draw at an early age. He was influenced by his father, an amateur cartoonist, and popular imagery such as Walt Disney cartoons and Dr Seuss illustrations. Initially intending to become a commercial artist, he enrolled on a course at the Ivy School of Professional Art in Pittsburgh in 1976 but left after only two semesters and began to concentrate on more creative projects. He had his first solo exhibition at the Pittsburgh Center for the Arts in 1978 and moved to New York shortly afterwards to study at the School of Visual Arts. In New York he became part of the thriving alternative art scene based in the city's East Village. He experimented with performance, installation and video art but came to prominence with his public drawings and murals that typically featured the cartoon-like figures for which he is best known. He began to make prints in 1982, publishing his first works with the Barbara Gladstone Gallery in New York. During the course of his short career, he made over sixty editioned prints and more than eighty posters. A social activist, his work often carried defiant political messages. In 1985 he designed an anti-apartheid 'Free South Africa' poster and he made work dealing with drug and alcohol abuse and nuclear disarmament. Openly gay, he was greatly affected by the HIV/AIDS epidemic and much of his work from the mid-1980s addressed this issue. He died from an AIDS-related illness in 1990 after receiving a positive diagnosis two years before. **CD**

Keith Haring
152 *Ignorance=Fear* 1989
Offset colour lithograph on glazed poster paper
Signed and dated on the matrix.
610 x 1090 (24 x 42⅞) sheet
Gundel 79
Victoria and Albert Museum.
Given by Robert Farber

This print was made for the AIDS Coalition to Unleash Power (ACT UP), a direct-action group founded in New York City in March 1987. Fuelled by anger at the perceived slow response of the Reagan administration to the escalating crisis, the group protested about the prohibitively high cost of medicine, the lack of an effective awareness-raising campaign and the stigmatization of those with the disease. From the outset, ACT UP produced visual material in the form of posters, leaflets, fine-art prints and multiples to spread its messages and raise money. Many bore the slogan 'Silence=Death' and the symbolic pink triangle, first used in Nazi concentration camps to identify homosexual men but since claimed as an emblem of gay pride. In this poster Haring's characteristic figures refuse to look, listen and speak and consequently each is marked with a cross, a warning of the dangers of ignoring AIDS. **CD**

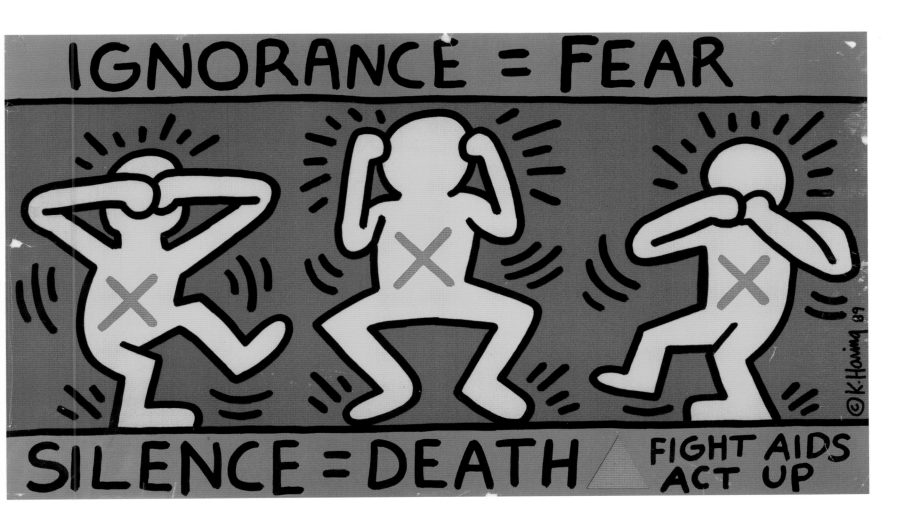

David Wojnarowicz

1954–1992

A member of the avant-garde art scene in New York's East Village in the 1980s, David Wojnarowicz worked as a painter, writer, filmmaker, photographer and performance artist. He was born in Red Bank, New Jersey, but moved to New York City with his mother and attended the High School of Music and Art in Manhattan. A victim of childhood abuse, his early life was traumatic and he spent his later teenage years on the streets. These experiences informed much of his later work, as did his homosexuality, which also contributed to his feelings of social marginalization. Largely self-taught, he came to prominence in the early 1980s with images stencilled onto the sides of buildings, and in 1985 his work was included in the Whitney Biennial. Deeply affected by the HIV/AIDS epidemic in New York, to which he lost many friends, much of his work from the mid-1980s addressed the subject, especially after he received a positive diagnosis himself in 1987. As a printmaker, Wojnarowicz made a relatively small body of work. Some of his early prints were published by Normal Editions Workshop in Illinois, after the University Galleries at Illinois State University held an exhibition of his work in 1990. He died in Manhattan from an AIDS-related illness. **CD**

David Wojnarowicz
153 *Untitled (for ACT UP)* 1990
Colour screenprint (diptych)
Signed, dated and numbered '62/100' in pencil. 590 x 700 (23¼ x 27½) each sheet
British Museum, London 2015,7094.1.1-2
Purchased with funds given by Hamish Parker

This screenprinted diptych was made to raise money for the campaign group ACT UP, with which Wojnarowicz was actively involved. It was printed by fellow ACT UP members Richard Deagle and Joe Wollin and published by the group. Written by the artist in 1987 after the AIDS-related death of his close friend the photographer Peter Hujar, the text on the upper sheet encapsulates Wojnarowicz's anger and frustration at the prejudiced attitudes directed at victims of the illness. The text is superimposed on an underwater image from a Red Cross lifesaving manual, which serves to highlight the urgent need for action. On the lower sheet stock-market information from the *Wall Street Journal* is printed over a map of America in the form of a shooting target. The reference to big-business commerce alludes to one of ACT UP's central concerns: the prohibitively high cost of AIDS medication and the lack of government intervention in this area. The implication is that, in America, profits come before people. **CD**

"If I had a dollar to spend for healthcare I'd rather spend it on a healthy or innocent person with some defect or illness not of their own responsibility; not some person with AIDS..." says the texas healthcare official and I can't even remember what he looks like I reached in through the t.v. screen and ripped his face in half I was told I have ARC recently and this was after watching seven friends die in the last two years slow vicious unnecessary deaths because fags and dykes and drug addicts are expendable in this country "If you want to stop AIDS shoot the queers..." says the ex-governor of texas and I'm carrying this rage like a blood filled egg and there's a thin line between the inside and the outside a thin line between thought and action and that line is simply made up of blood and muscle and bone I'm waking up more and more from daydreams of tipping amazonian blowdarts in 'infected blood' and spitting them at the exposed necklines of certain politicians or nazi-preachers or government healthcare officials or the rabid strangers parading against AIDS clinics in the nightly news suburbs there's a thin line a very thin line and as each T cell disappears from my body it's replaced by ten pounds of pressure ten pounds of rage and I focus that rage into non-violent resistance but that focus is starting to slip my hands are beginning to move independent of thought the egg is starting to crack america seems to understand murder as a self defense against those who would murder us and it's been murder on a daily basis for eight long years in this killing machine called america and I say there's certain politicians that better increase their security forces there's walking swastikas in the forms of religious leaders and healthcare officials that had better get bigger dogs and higher fences and more complex security alarms for their homes and queer bashers better start doing their work from inside howitzer tanks because the thin line between the outside and the inside is beginning to erode and at the moment I'm a sixteen foot tall five hundred and seventy two pound man inside this six foot frame and all I can feel is the pressure all I can feel is the pressure and the need for release.

General Idea

Active 1969–1994

A collective based in Toronto, Canada, General Idea's members were A. A. Bronson (a.k.a. Michael Tims, b.1946), Felix Partz (a.k.a. Ron Gabe, 1945–1994) and Jorge Zontal (a.k.a. Jorge Saia, 1944–1994). Founded in 1969, the group produced over 200 prints and multiples including postcards, wallpaper, balloons and badges. Between 1972 and 1989 they published the magazine *FILE* (an anagram of *Life* magazine). In 1974 they opened Art Metropole in Toronto, a not-for-profit gallery and shop where they exhibited, distributed and archived artists' editions including books, videos and multiples. In addition, they collaborated on numerous performance pieces and installations. They moved to New York in 1986 and were among the first visual artists to make work relating to the AIDS crisis, focusing on this issue from 1987 to 1994. Both Partz and Zontal died from AIDS-related causes in 1994. CD

Robert Indiana, *LOVE*, 1967
Screenprint, 863 x 863 (34 x 34)
Museum of Modern Art, New York
415.1990

General Idea

154 *AIDS wallpaper* 1989

Colour screenprint

2160 x 685 (85 x 27) sheet

Fischer 8910; Wye 1996, 120

Victoria and Albert Museum.

Given by General Idea

General Idea's AIDS wallpaper was produced as part of a project that began with a painting to benefit the American Foundation for AIDS Research (amfAR) in New York in 1987. Appropriating the format of Robert Indiana's ubiquitous *LOVE* image (see opposite), the group created an AIDS logo, which they reproduced in a variety of formats including posters, sculptures, videos, paintings, postage stamps, magazine covers and lottery tickets. In 1989 they placed 4,500 posters of the image across the New York subway system and the logo was shown on the Spectacolor board in the city's Times Square. The intention was for the image to spread like a virus, appearing in urban spaces across the world, something that Indiana's *LOVE* had inadvertently achieved.

A colour screenprint of the AIDS logo was published by Koury Wingate Gallery, New York, in an edition of 80 in 1987. The wallpaper was printed by the artists two years later in an unlimited edition for various gallery installations. With its repetitive design, it was a particularly effective means of disseminating the image. **CD**

Eric Avery

Born 1948

Born in Milwaukee, Wisconsin, and brought up in Pecos, Texas, Avery studied art at the University of Arizona, Tucson. Encouraged by his printmaking professor to enter medical school to avoid the war in Vietnam, he enrolled in the University of Texas Medical Branch at Galveston in 1970 with the assistance of his physician father. He obtained his MD in 1974 and, following a year's medical internship, moved to New York to take up a residency in adult psychiatry at New York State Psychiatric Institute. Seeking to demonstrate the relationship between medicine and visual art, he continued to make prints throughout his training. In 1978 he left medicine to concentrate on art, making prints at the Lower East Side Printshop and playing in a New York City street band. He resumed his medical practice in 1979 when, moved by media stories about the plight of Thai and Cambodian refugees, he travelled first to northern Indonesia to work with Vietnamese refugees and then to a large refugee camp in Somalia, where he became a medical director. He made woodcuts during this time as a way of dealing with the traumatic nature of the work. On his return to South Texas, he became a human-rights activist with Amnesty International USA and began to build a career as a professional printmaker, finding representation through the Mary Ryan Gallery, New York. In the mid-1980s, when his friends began to die from AIDS in Houston, he started making prints addressing the HIV/AIDS crisis. The epidemic convinced him to return to medicine once more and from 1992 to 2012 he was the AIDS psychiatrist at the University of Texas Medical Branch at Galveston where he was given time to make art as a member of the Institute for the Medical Humanities. Avery has worked as an artist full time since retiring from his medical practice in 2013. His prints are included in numerous museum collections including the Philadelphia Museum of Art, the Smithsonian American Art Museum, Washington, DC, and the Fogg Museum, Harvard University. **CD**

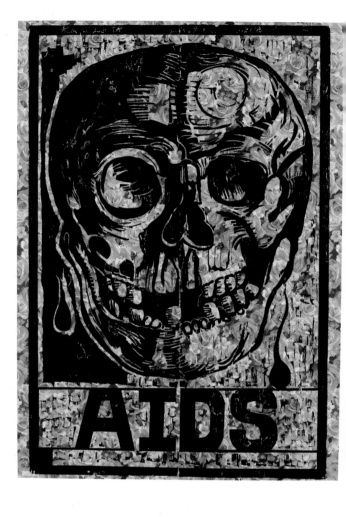

Eric Avery

155 *1984 AIDS* **2010**

Woodcut on Mexican wrapping paper
Signed and numbered '3/10' in pencil.
874 x 563 (34⅜ x 22⅛) image,
890 x 609 (35 x 24) sheet
British Museum, London 2016,7010.1
Purchased with funds given by Margaret Conklin and David Sabel

Avery made the preparatory drawing for this woodcut in 1984 when the death toll from AIDS was rising at an alarming rate. As a gay man, he was living in fear of a positive diagnosis. It is based on a 17th-century French woodcut that Avery had seen at the Philadelphia Museum of Art, which is of a type that was commonly pasted onto the doors of plague victims.[1] He turned the uncut block to the wall, as it was a reminder of a frightening time, and felt unable to make the print until 1990. In that year he printed four versions in preparation for his final exhibition with Bill Graham, his Houston dealer, who died of AIDS in 1992. This impression is from a later edition that was printed in Avery's Galveston studio with the assistance of Nobue Urushihara Urvil, a Japanese medical humanities PhD student. The orange-pink floral wrapping paper on which it is printed brings to mind associations of the rose with disease, death and mourning. For the artist, who has for many years been based on the Texas-Mexico border, it also has associations with the Mexican Day of the Dead. **CD**

1 Philadelphia Museum of Art (ARS MEDICA Collection), accession no. 1982-118-1.

Eric Avery
156 *Blood Test* **1985–86,**
printed 1988
Moulded paper woodcut
Signed, dated '1/9/88' [American style],
titled and numbered '5/6' in pencil on the
verso, initialled by Susan Mackin Dolan.
1150 x 455 (45¼ x 17⅞) approx. (irregular)
British Museum, London 2016,7017.1
Purchased with funds given by Margaret
Conklin and David Sabel

Working in his studio in San Ygnacio,
Texas, Avery drew this image of his arm
and cut the block while waiting for the
result of his first HIV test. He had been
counselled to expect a positive result and
was full of fear. Although proofed on plain
paper, he printed the final version on paper
pulp made from cotton, abaca and linters,
which was moulded during the printing
process. The block was made from a
rough piece of Texan pecan into which
Avery cut deeply to create the snaking
mass of bulging veins. A knot in the wood
produced the swollen weal of paper at
the base of the biceps, an imperfection
that Avery wanted to retain. *Blood Test*
was first printed in an edition of six in
1985–86. Ten more impressions were
printed between 1988 and 1990 in
preparation for an exhibition at the Blue
Star Art Space in San Antonio, Texas, with
the assistance of Susan Mackin Dolan,
a friend of the artist and teacher of
papermaking. For Avery, printing the image
multiple times symbolized the growing
numbers of people infected with HIV.
He printed some impressions using a
brown-coloured paper pulp to reflect
the prevalence of the virus in people
of colour. **CD**

10 Feminism, gender and the body

In the 1960s and 1970s women increasingly challenged the traditional male power structures in American society. Widely known as 'second wave feminism', this movement gained momentum through the publication of feminist books such as Betty Friedan's *The Feminine Mystique* (1963) and the formation of campaigning groups such as the National Organization for Women (1966). Aiming to achieve a more equal society, feminists formed 'consciousness-raising groups' to plan direct action and discuss shared experiences and concerns. Women artists' groups began to emerge in the early 1970s to address gender inequalities in the art world. Non-profit co-operative galleries such as A.I.R. (Artists in Residence), founded in New York in 1972, provided exhibition space for women as an alternative to the male-dominated commercial art scene. The underrepresentation of women artists in museums and galleries was a key issue for the Art Workers Coalition, founded in 1969, and remains a central concern for the Guerrilla Girls, the anonymous collective whose 1989 poster *Do Women Have To Be Naked To Get Into The Met. Museum?* (cat. 158) sums up their frustrations.

As the feminist movement developed, women artists began to address broad feminist themes, including female sexuality, reproductive rights, the domestic role of women and the objectification of the female body. Through her 'Big Daddy' paintings and prints, begun in 1967, May Stevens questioned America's patriarchal power structures, while Ida Applebroog examined the balance of power in the home and the domestic role of women through her artist's books in the late 1970s. Applebroog has also addressed the objectification of the female body, a subject that Louise Bourgeois and Dotty Attie have explored. More recently, Kiki Smith has considered the representation of women in art, religion, literature and popular culture, while her unconventional depictions of the body have reflected her fascination with anatomy and challenged traditional notions of femininity.

Guerrilla Girls

For biography see page 242

157 *The Advantages of Being a Woman Artist* **1988 (first published)**

Offset lithograph

444 x 571 (17½ x 22½) sheet

Victoria and Albert Museum. Given by Margaret Timmers

This poster was produced in response to the sexism that members of the Guerrilla Girls repeatedly experienced within the art world. Ironic in tone, the thirteen points listed actually reveal *dis*advantages to being a woman artist, although they are presented as positives. The 'advantages' include: 'Working without the pressure of success' and 'Not having to undergo the embarrassment of being called a genius'. According to a member of the group, it was hoped that the poster would 'encourage female artists to look on the sunny side' and to identify with the Guerrilla Girls and their aims.[1] It clearly struck a chord both in the United States and internationally: one woman artist sent the group $1,000 to run the image as an advertisement in *Artforum* magazine, and the poster has been translated into numerous languages. **CD**

1 Guerrilla Girls, *Confessions of the Guerrilla Girls*, with an essay by Whitney Chadwick, London: Pandora, 1995, p. 53.

THE ADVANTAGES OF BEING A WOMAN ARTIST:

Working without the pressure of success
Not having to be in shows with men
Having an escape from the art world in your 4 free-lance jobs
Knowing your career might pick up after you're eighty
Being reassured that whatever kind of art you make it will be labeled feminine
Not being stuck in a tenured teaching position
Seeing your ideas live on in the work of others
Having the opportunity to choose between career and motherhood
Not having to choke on those big cigars or paint in Italian suits
Having more time to work when your mate dumps you for someone younger
Being included in revised versions of art history
Not having to undergo the embarrassment of being called a genius
Getting your picture in the art magazines wearing a gorilla suit

A PUBLIC SERVICE MESSAGE FROM **GUERRILLA GIRLS** CONSCIENCE OF THE ART WORLD

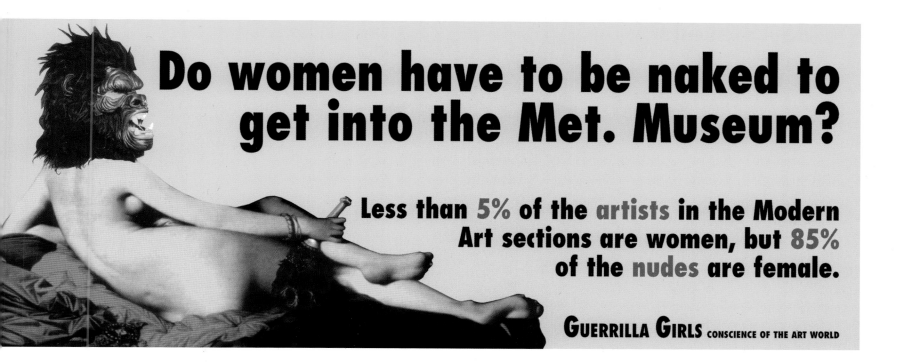

Guerrilla Girls

158 *Do Women Have To Be Naked To Get Into The Met. Museum?* **1989**
Colour offset lithograph
281 x 711 (11 x 28) sheet
Victoria and Albert Museum. Given by Margaret Timmers

One of the Guerrilla Girls' best-known works, this design was produced for a billboard commissioned by the Public Art Fund in New York. When it was rejected on the grounds that it 'wasn't clear enough', the group ran it as an advertisement on New York City buses until the bus company cancelled the lease because the protruding fan in the figure's hand was seen as too suggestive.[1] Targeting the city's august Metropolitan Museum of Art ('the Met'), the poster highlighted the vast underrepresentation of women artists in the museum's modern collections (5 per cent) and the very high proportion of women among the nudes on display (85 per cent). The statistics were based on what the group termed a 'weenie count' conducted on a guerrilla raid at the museum one Sunday morning. The figures have since been periodically updated as the design has been reprinted in different iterations.

The image is based on Jean-Auguste-Dominique Ingres' painting *La Grande Odalisque* (see right). In the Guerrilla Girls' version, the unidentified 'harem woman' is further anonymized by the addition of a gorilla mask, although as a symbol of the group itself, the mask serves to empower the formerly passive figure. The Guerrilla Girls may have been inspired to use this image by an exhibition of works by Ingres from the Met's own collection (including a grisaille version of the Louvre painting, without the offending fan),[2] which ran at the museum from December 1988 to March 1989. **CD**

1 Guerrilla Girls, op. cit., p. 61.
2 Museum accession number 38.65.

Jean-Auguste-Dominique Ingres, *La Grande Odalisque*, 1814, oil on canvas 910 x 1620 (35⅞ x 63¾) Musée du Louvre, Paris

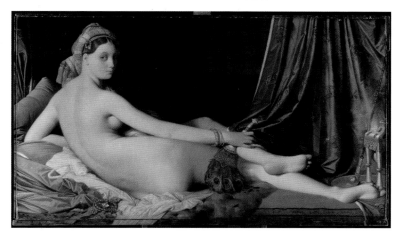

May Stevens

Born 1924

A painter, printmaker and activist, Stevens was born to a working-class family in a suburb of Boston and grew up in Quincy, Massachusetts. She had a difficult relationship with her father, which deteriorated after the early death of her younger brother and her mother's subsequent breakdown. In 1947, after graduating from Massachusetts College of Art, Stevens moved to New York where she studied at the Art Students League. She had her first solo exhibition at the city's Roland de Aenlle Gallery in 1961. Stevens and her husband, Rudolf Baranik, a Lithuanian artist, were politically and socially engaged, becoming involved in the civil rights movement in the early 1960s and later protesting against the war in Vietnam. Between 1961 and 1966 Stevens taught at the School of Visual Arts, New York, where her classes included 'Women and the Arts' and 'Art and Politics'. In the 1970s she became very involved in the feminist movement and was part of a group of female artists who founded the feminist magazine *Heresies* in 1976. In 1999 she was the first living female artist to have a retrospective at the Museum of Fine Arts, Boston. **CD**

May Stevens
159 *Reversal* **1970**
Gouache and ink
Signed and dated '1970' in red ink; verso: titled with the earlier date '1968' in pencil.
1076 x 762 (42⅜ x 30)
British Museum, London 2013,7063.1
Purchased with funds given by Hamish Parker

Stevens' flat, cartoon-like imagery has led some to call her work 'political Pop'.[1] This drawing depicts 'Big Daddy', a character that featured in a series of paintings, drawings and prints made between 1967 and 1976. Almost all of the Big Daddy images have a cobalt blue background, which serves to highlight the character's pallid, naked body. In 1973 this drawing was included in an exhibition of her Big Daddy project at the Herbert F. Johnson Museum of Art, Cornell University.[2] **CD**

1 Patricia Hills, *May Stevens*, San Francisco: Pomegranate, 2005, p. 33.
2 *May Stevens*, Herbert F. Johnson Museum of Art, Cornell University, 28 November– 21 December 1973, Ithaca, NY: Cornell University, 1973, no. 4 (dated 1970).

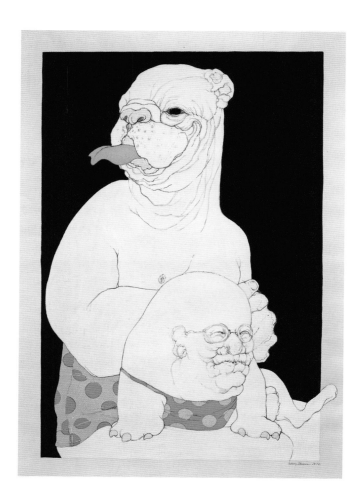

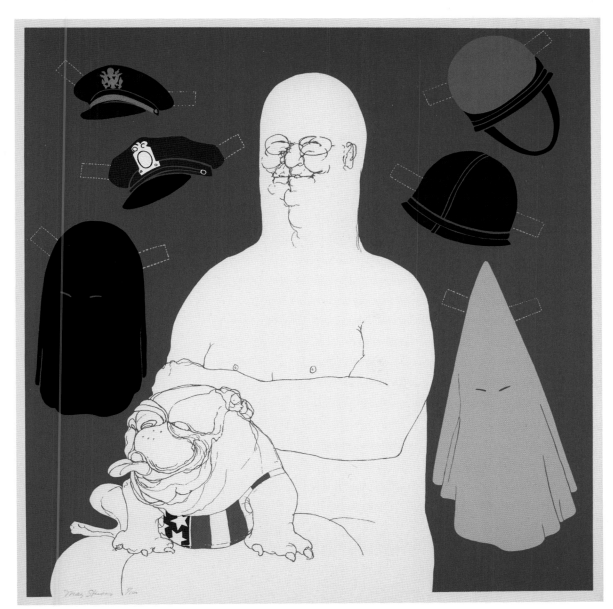

May Stevens
160 *Big Daddy with Hats* 1971
Colour screenprint
Signed and numbered '5/100' in pencil.
560 x 538 (22 x 21¼) image,
590 x 570 (23¼ x 22½) sheet
British Museum, London 2012,7048.4
Purchased with funds given by the
Joseph F. McCrindle Foundation to the
American Friends of the British Museum

The Big Daddy figure is derived from
a photograph that Stevens took of her
father, whom she resented for his bigoted
attitudes and lack of compassion towards
the mental breakdown of her mother.
Developed at a time when the artist was
actively involved in the anti-war movement,
Big Daddy became the incarnation of
male, small-minded, middle America.
Usually depicted naked and seated, as
if enthroned, the smug, authoritarian
character is both ridiculous and pathetic.
The often-present bulldog, clothed here
in a patriotic flag, is derived from an image
of an army mascot. In this print Big Daddy
is shown surrounded by hats symbolizing
figures of male authority and power: the
policeman, the riot cop, the executioner,
the soldier and the Ku Klux Klansman.
Their dotted tabs, like those on a paper
doll, suggest that Big Daddy could occupy
any of these guises. The print relates
closely to the painting *Big Daddy Paper
Doll* (1970), now in the Brooklyn Museum.
 In the drawing *Reversal* (see
opposite), Big Daddy and his bulldog
have swapped places, suggesting that
their bodies are almost interchangeable.
Here they are almost literally tied
together by the spotted garment in which
they are both wrapped. The similarity
between their inane expressions and
the fleshy folds of their skin makes the
imagery more absurd, undermining the
authority that Big Daddy represents. **CD**

Lee Lozano

1930–1999

Lozano established herself as a leading woman artist in the male-dominated avant-garde art world of New York in the 1960s before she deliberately withdrew from it in the early 1970s with her conceptual *Dropout Piece*. Born Lenore Knaster in Newark, New Jersey, the only child of a secular Jewish middle-class family, she studied natural science and philosophy at the University of Chicago (BA 1951), married the Mexican-American architect Adrian Lozano and completed her BFA at the School of the Art Institute of Chicago (1960), the year she also divorced her husband and moved to New York City. In the early 1960s she produced a series of aggressively erotic paintings and drawings featuring the penis as an active agent in a cartoonish style that blended the idioms of abstract expressionism and pop art. By 1964 her sexual imagery had morphed into tools – drills, screwdrivers, bolts and nuts – executed in heavily worked graphite in a metallic hard-edged style. Her first solo show was held in 1966 at the Bianchini Gallery, New York. From 1967 her work shifted towards minimalism and culminated in the *Wave Series*, a cycle of eleven mathematically based paintings, shown at the Whitney Museum of American Art in 1970.

Thereafter she switched to *Language Pieces*, her conceptual text-based instructional works. Her *General Strike Piece* (12 June 1969), published in the conceptual art magazine *0 to 9* (no. 6, July 1969, p. 57), the staple-bound, mimeographed journal edited by Vito Acconci and Bernadette Mayer, signalled her intention to withdraw from the art world.[1] She simultaneously withdrew from the political activities of the Art Workers Coalition, the pressure forum instigated by Lucy Lippard and others agitating on behalf of women and marginalized groups in the art world. For her *Dialogue Piece* she invited individuals, including the artists Brice Marden, Richard Serra, Keith Sonnier and many others, to her studio loft usually one-to-one at an agreed time with the single aim of promoting a conversation. Underlying her piece was the conceptual imperative that art was a tool for personal communication as opposed to a product that had some commercial value. Her stance took a more extreme turn in 1971 when she initiated *Boycott Piece*: for a month she chose not to interact with women so that afterwards 'communication will be better than ever'[2] but then decided to perpetuate the boycott for the rest of her life. Lozano disappeared from view after her *Dropout Piece*, declaring it 'the *hardest* work I have ever done'.[3] She moved to Dallas, Texas, to live with her parents, dying there in 1999. At her request, she was buried in an unmarked grave. **SC**

1 Lozano's *General Strike Piece* is discussed in Gwen Allen, *Artists' Magazines: An Alternative Space for Art*, Cambridge, MA, and London: MIT Press, 2011, p. 84.

2 Lozano, cited in Lucy Lippard, 'Cerebellion and Cosmic Storms', in Iris Müller-Westermann, ed., *Lee Lozano*, exh. cat., Stockholm: Moderna Museet, and Ostfildern, Germany: Hatje Cantz Verlag, 2010, p. 198 (illus. p. 195).

3 Lozano, cited in Todd Alden, 'The Cave Paintings Exist Because The Caves Were Toilets: Reactivating the Work of Lee Lozano', in Adam Szymczyk, ed., *Lee Lozano: Win First Dont Last, Win Last Dont Care*, exh. cat., Basel: Kunsthalle, 2006, p. 18.

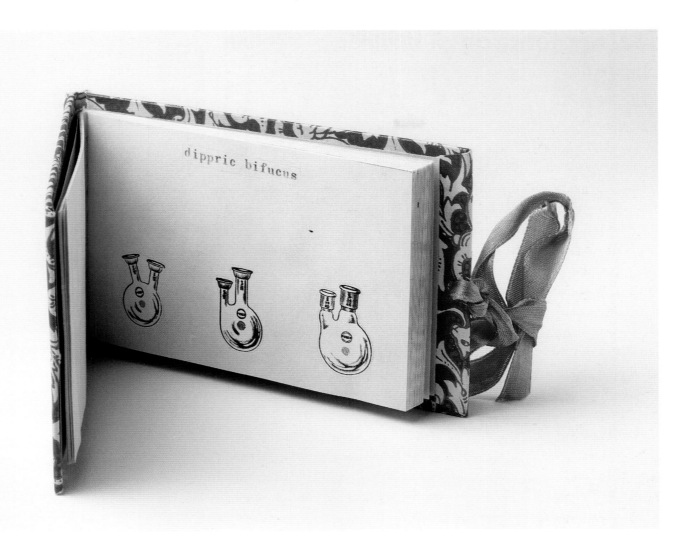

Lee Lozano

161 *Thesis* **1968**

Artist's book from the portfolio *S.M.S.*
(Shit Must Stop) No. 2 April 1968
75 x 120 (3 x 4¾) closed book
British Museum, London 2015,7052.2.7
Purchased with funds given by the
Vollard Group

An astonishing variety of phallic scientific
instruments made from Pyrex laboratory
glass is assembled as hard evidence by
Lozano to support her thesis that 'All Men
Are Hardly Created Equal'. The textbook
illustrations are variously labelled with
dog-Latin tags: 'pueri clumsi', 'dippric
bifucus', 'recti semi erectus', 'globuli cum
titillatis regularis', etc. Lozano presents
her findings in the form of a thesis
submitted for an academic degree, with
notes, a conclusion and an erratum at
the end. The title-page reads: 'THESIS/

prepared by O.S./candidate for/
MASTER'S DEGREE/in/BIOLOGY,
THE HUMANITIES and/THE SOCIAL
SCIENCE'. The author reached the
following conclusion from her exhaustive
research: 'the proof of this thesis is in the
viewing of its evidence, which i collected
and tested with great care and no little
pleasure. although i am somewhat
indisposed at the conclusion of my
research, i hope to start work on my
doctorate degree as soon as my wounds
heal.' In contrast to the dry pseudo-scientific
presentation of its contents, the 46-page
thesis is prettily bound in patterned paper
of ornamental baroque dragons and
swirling leaves, tied with a lilac satin ribbon.

Lozano's mock-feminist critique of a
phallocentric universe plays on her
scientific background, her delight in
pungent puns and on her text-based
investigations that characterized her work

in the late 1960s. The small artist's book
was included in the second portfolio of
S.M.S. (the acronym for *Shit Must Stop*),
a project established in New York by the
American artist, gallerist, art journal editor
and writer William Copley in 1968. Under
the imprint of The Letter Edged in Black
Press, Copley styling himself as 'President
and Provocateur' and Dimitri Petrov,
his associate, as 'Vice-President and
Henchman', published six portfolios of
S.M.S. from a studio loft on the upper
West Side. In all, a collection of seventy-
three original multiples by various artists,
ranging from famous pop artists such as
Roy Lichtenstein and Claes Oldenburg,
international luminaries including Marcel
Duchamp, Man Ray and Richard
Hamilton, to lesser-known figures of the
contemporary avant-garde, was issued
in February, April, June, August, October
and December of that year. Irrespective

of their reputation, each contributor, who
also included poets, musicians and art
dealers, was paid a flat fee of $100.
Posted in cardboard mailboxes as a means
of circumventing the gallery system by
bringing art directly to subscribers at the
affordable price of $125, the contents of
each portfolio took a bewildering variety
of unexpected forms. Lozano's *Thesis*
was among eleven objects in the second
portfolio that also included a seven-
minute recording of word-play by Marcel
Duchamp, a stack of 'dollar bills' marked
'Legal Tender' by Bruce Conner, and a
debossed print of a fur-covered hand-
held mirror by Meret Oppenheim.
According to the prospectus announcing
the first issue of *S.M.S.*, the intended
edition of each portfolio was 2,500. **sc**

Ida Applebroog

Born 1929

Applebroog emerged in the late 1970s as a distinctive voice addressing the issue of power within everyday relationships – male over female, parents over children, doctors over patients – presented in the form of simplified, cartoon-like narratives that were often unsettling in their deliberate ambiguity. Born Applebaum in the Bronx, New York, into an Orthodox Jewish family, she studied graphic design at the New York Institute of Applied Arts and Sciences (1948–50) before moving with her academic husband Gideon Horowitz to Chicago where she raised a family. After returning as a mature student to the School of the Art Institute of Chicago (1965–68), Applebroog suffered a period of depression requiring hospitalization following the family's move to San Diego, California, in 1969. Her crisis precipitated a change of name to Applebroog. In 1974 she moved to New York where she reconnected to the art world by mailing her artist's books to people she hardly knew, if at all – artists, critics, curators and gallerists. Exploring issues of power relationships, sexuality and gender, often within a domestic space, her books and her related multi-panel vellum drawings in ink and Rhoplex – a glue-like medium – found early support from the New York gallerist Ronald Feldman, who also published her prints in the early 1980s. In 1987 she participated in 'Documenta 8' at Kassel and again in 'Documenta 13' in 2012. In 1998 the Corcoran Gallery of Art, Washington, DC, gave a ten-year survey exhibition of her paintings. *Monalisa*, an installation of scanned drawings of her vagina originally produced within the privacy of her bathroom in 1969, was shown at Hauser and Wirth, New York, in 2010. SC

Ida Applebroog

162 *Sure I'm Sure, Now Then* and *Look At Me* from *Dyspepsia Works, A Performance* 1979

Artist's books
Sure I'm Sure, signed and dated 'Sept 15, 1979' in pencil on 1st page (no inscriptions on the other two); signed and numbered '40/46' in pencil on colophon sheet of boxed set. 195 x 160 (7⅝ x 6¼) each book
British Museum, London 2013,7094.2.11, 14, 16
Purchased with the Champion & Partners Acquisition Prize in honour of Richard Hamilton

Applebroog called each of her artist's books 'A Performance'. Within their modest comic-strip format, an enigmatic scene is played out in each book as a single repeated image that is interrupted with a terse, usually disquieting, caption. Viewed through the stage-set of a rear window with partially pulled-down shades, the outline figures appear vulnerable, anxious and exposed, often with an implied sexual connotation. Applebroog has described her imagery as 'like entering a film montage; there's no middle, there's no end. You just come into a piece mid situation.'[1] Ambiguous power relations underscore the scenarios. *Sure I'm Sure*, for instance, depicts a couple in a bedroom, the man assertively taking off his jacket while his companion lies with her arms folded protectively across her chest; 'I threw it away' and 'Sure I'm sure' is the only dialogue between them, leaving it open to the viewer to interpret. As Applebroog has put it: 'the meaning shifts with everyone who comes to the work – whether they're male, female, old, young, middle aged, from different backgrounds – everything is very personal. You come to my work with your baggage, with your life experience.'[2]

Printed by commercial offset lithography, the 24-page paperback

SURE I'M SURE

A PERFORMANCE

IDA APPLEBROOG

I THREW IT AWAY

books were self-published. Applebroog mailed them to various unsolicited individuals as a means of circulating her work outside the gallery system and announcing herself as an artist. The books provoked varying reactions – delight, indifference, outright rejection. In all, three sets were published: *Galileo Works*, 1977 (comprising ten books), *Dyspepsia Works*, 1979 (eleven books) and *Blue Books*, 1981 (seven books). Applebroog later recalled: 'when I first started putting out these images…some people were uncomfortable: I was hitting too close to some of their experiences, feelings. The drawings were about situations that people don't talk about. They were very private, personal thoughts, and in art, one just didn't do that. Think of the work that was out there in the 70s: minimalism, performance, very cool conceptualism.'[3] The British Museum owns a complete set of the twenty-eight books from the original printings that the artist later collected together in an edition of 46 as a boxed set; the grey archive box in which they are housed reproduces a mailed envelope marked 'Return to Sender' with a note from an angry recipient: 'Dont Send any more of these! [*sic*]'. **SC**

1 Patricia Spears Jones, 'Ida Applebroog' (interview), *BOMB*, 68 (Summer 1999), p. 35.
2 Ibid.
3 Ibid., p. 36.

Ida Applebroog

163 *American Medical Association I*
1985

Linocut on two sheets of oriental paper
Left sheet: inscribed 'I' and numbered
'6/20' in pencil, right sheet: signed, dated,
inscribed 'I' and numbered '6/20' in
pencil, printer's blindstamp. 748 x 538
(29½ x 21¼) each sheet
British Museum, London 2013,7094.1.a-b
Purchased with the Champion & Partners
Acquisition Prize in honour of Richard
Hamilton

While disavowing the labels of being a
feminist artist or a political person,
Applebroog is concerned with the politics
of gender and the power of authority.
The title of this two-part linocut questions
the presumed authority of the powerful
American Medical Association in
addressing the ordinary patient as an
impersonal medical case. Three seated
professional men in suits appear to be
discussing the case of a naked woman
projected on a screen before them, her
body exposed as an object with just a
mask covering her eyes as a male
concession to protecting her identity. On
the right panel a medical figure in a white
coat inserts a sexually suggestive small
finger in his mouth. A second version of
this print was printed in blood red ink. **SC**

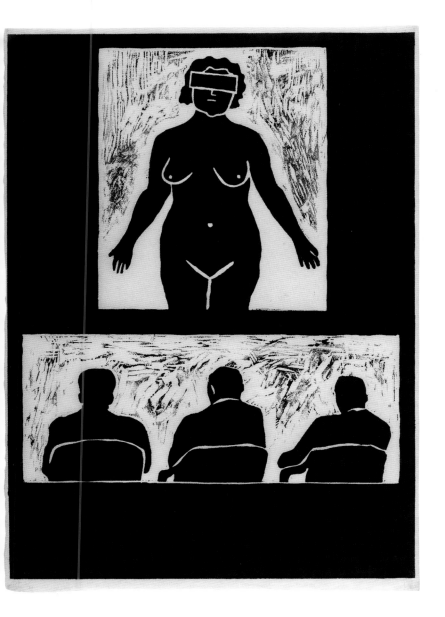

Dotty Attie

Born 1938

A painter and printmaker based in New York City, Attie came to attention as a feminist artist in the early 1970s. She was born in Pennsauken, New Jersey, and obtained her BFA from the Philadelphia College of Art in 1959. She went on to study at the Brooklyn Museum Art School in the following year and the Art Students League, New York, in 1967. In 1972 Attie co-founded A.I.R. (Artists in Residence) Gallery, an artist-run, non-profit exhibition space for women artists. She had her first solo exhibition at the gallery in its foundation year, which was then located in the SoHo area of New York. She has continued to exhibit widely, most recently at the P.P.O.W. Gallery, New York (in 2013), and her work is held in numerous museum collections, including the Whitney Museum of American Art, the Elizabeth A. Sackler Center for Feminist Art at the Brooklyn Museum and the National Museum of Women in the Arts, Washington, DC. Attie's work often has a narrative quality and frequently includes references to existing images such as Old Master paintings and early photographs. Among the recurring themes in her work are the eroticized representation of women in art, the portrayal of children and the mother-child relationship. CD

Dotty Attie
164 *Mother's Kisses* **1982**
Lithograph
Signed, titled and numbered 'A.P. 12' (artist's proof outside ed. 25) in pencil, blindstamp of Solo Press, New York.
910 x 675 (35⅞ x 26⅝) sheet
British Museum, London 2013,7003.2
Purchased with funds given by Elizabeth H. Llewellyn

Bronzino, *An Allegory with Venus and Cupid*, c.1545, oil on wood, 1461 x 1162 (57½ x 45¾) National Gallery, London NG651

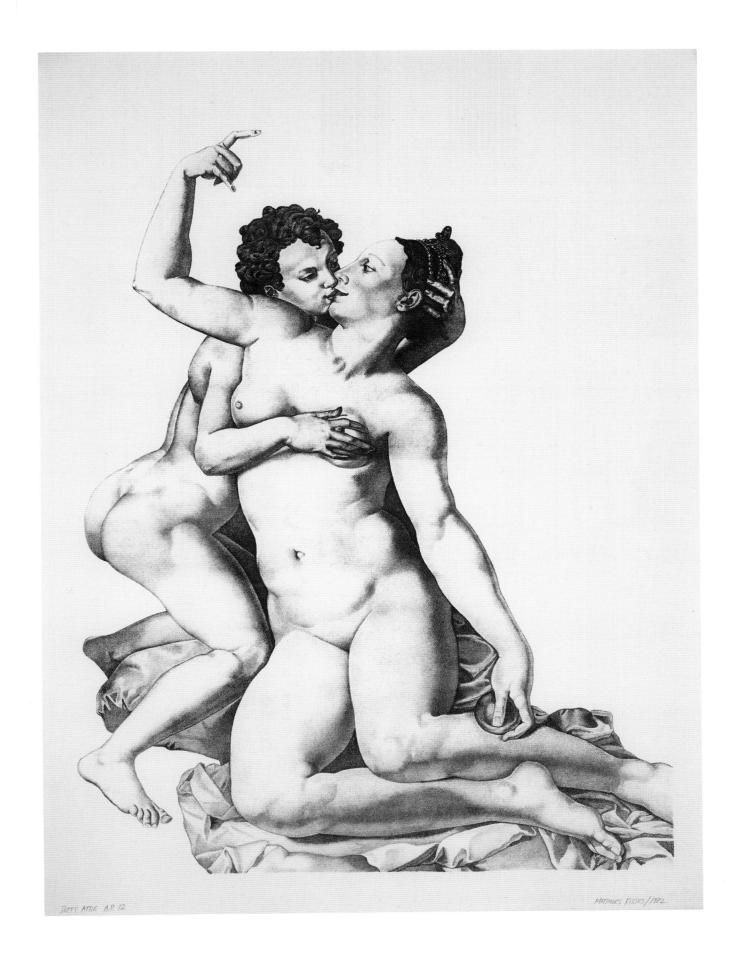

Dotty Attie A.P. 12

Mothers Kisses/1982

273

Dotty Attie

165 *Mother's Kisses* 1982
Boxed portfolio of lithographs with hand colouring
152 x 152 (6 x 6) each
British Museum, London 2013,7003.3.1-26
Purchased with funds given by Elizabeth H. Llewellyn

Conceived as a single work, *Mother's Kisses* comprises a large-scale lithograph and a boxed portfolio containing twenty-six smaller prints. The larger work (cat. 164) reproduces the central figures from Bronzino's painting of *c.*1545, *An Allegory with Venus and Cupid* (National Gallery, London) (see p. 272). Venus, the Roman goddess of love, is presented as an idealized female figure, naked and frozen like a marble statue. She is being kissed on the lips by Cupid, her infant son. The portfolio contains sixteen separate fragments of this larger composition, hand-coloured in delicately subtle shades reminiscent of Victorian illustration. They are interspersed with text written by the artist that presents an unsettling narrative of an implied incestuous relationship. It begins: 'Mother and he had always been very close' and ends: 'Although he anticipated the satisfactions of maturity with pleasure, nothing, he knew, would ever be as sweet as mother's kisses'. *Mother's Kisses* was printed and published by Judith Solodkin of Solo Press, New York. The portfolio is one of two Solo Press Impressions printed outside the edition of 25. **CD**

Louise Bourgeois

1911–2010

A painter, sculptor and printmaker, Louise Bourgeois was born in Paris on Christmas Day, 1911. Her parents ran a business repairing and selling tapestries and she occasionally helped by drawing missing sections of the damaged textiles. She had a difficult relationship with her father and was profoundly affected by the death of her mother in 1932. In that year Bourgeois began to study mathematics at the Sorbonne before turning to art in 1935. She trained at the École des Beaux-Arts (from 1935) and also at the Académie Julian and the Académie de la Grand Chaumière. In 1938 she married the American art historian Robert Goldwater and moved with him to New York City where she studied painting and lithography at the Art Students League. She spent the 1940s painting, drawing and printmaking, often producing her own prints at home. From 1946 to 1949 she worked at Stanley William Hayter's celebrated Atelier 17 where she printed her important suite of engravings *He Disappeared into Complete Silence* (1947). After Hayter returned to Paris in 1950, Bourgeois focused on sculpture, and it was with this medium that she initially made her name. She returned to printmaking following the death of her husband in 1973 and taught printmaking and sculpture at a number of institutions, most notably the School of Visual Arts, New York (1974–77). Her second period of printmaking began in earnest in the 1980s when her heightened fame, fuelled by a retrospective at the Museum of Modern Art, New York (MoMA), in 1982, led to requests from print workshops and publishers to collaborate. In 1990 she presented her entire printed *oeuvre* to MoMA and the museum staged her first print retrospective in 1994. Bourgeois used her art to both express and process her emotions. The themes that run through her work in all media remained relatively constant throughout her career and include the body, sexuality, loneliness, anxiety, pain, jealousy and motherhood. Often dealing with issues specific to women, much of her art has feminist overtones and her work has been an important source of inspiration for many female artists including May Stevens and Kiki Smith. **CD**

Louise Bourgeois
166 *Ste Sebastienne* **1992**
Alternative title: *The Arrows of Stress*
Drypoint
Signed and numbered 'P.P. 4/5' (printer's proof outside ed. 50) in pencil. 989 x 784 (38⅞ x 30⅞) plate, 1205 x 943 (47½ x 37⅛) sheet
Wye and Smith 110.1 State VI/VI; MoMA 504.2/VII, version 2/2, state VII/VII
Private collection, UK (promised gift to the British Museum)

Like many of Bourgeois' prints, *Ste Sebastienne* 'large' (as this drypoint is sometimes known) is one of a number of states and variants that derive from a single source drawing.[1] In this case, the drawing dates from 1987.[2] Although the basic outline is retained, in the original image the figure has a head, a smiling face and long hair flowing outwards behind her. Bourgeois described the drawing as 'a self-portrait of a person who is very happy and running and then suddenly realizes that she has antagonized certain people. She gets shot at.'[3] A female version of the martyred St Sebastian, the apparently pregnant figure is under attack, a victim of unjust aggression who is defenceless without arms. In this print she is made more vulnerable through the loss of her head and the addition of contour lines that

emphasize her flesh and muscles. The arrows appear to target weak points including her bulging stomach, drawing attention to perceived imperfections. The initially carefree figure in the drawing has been reduced to an anonymous body.

Bourgeois began the process of making the *Ste Sebastienne* prints in 1990, working first with the printer Christian Guérin of Gravure, New York, and then Harlan & Weaver, New York, who printed the published versions. She continued to work on the first plate into 1991 but did not use it for any published prints until *Stamp of Memories I* (cat. 167) was produced in 1993. Using photocopies to reconfigure and enlarge the composition, she created the second plate in 1992 and produced six unpublished states before Peter Blum Edition, New York, published this, the seventh state, in an edition of 50. **CD**

1 Deborah Wye and Carol Smith, *The Prints of Louise Bourgeois*, exh. cat., New York: MoMA, 1994, nos 110.1-2, pp. 175–81; Museum of Modern Art, New York, *Louise Bourgeois: The Complete Prints and Books*, online catalogue, 504.1-2, www.moma.org/explore/collection/lb/index [accessed 22 May 2016].
2 *Louise Bourgeois Drawings*, New York: Robert Miller Gallery; Paris: Galerie Lelong, 1988, no. 180.
3 Louise Bourgeois and Lawrence Rinder, *Louise Bourgeois Drawings and Observations*, exh. cat., Berkeley: University Art Museum and Pacific Film Archive, University of California, Berkeley, 1995, p. 147.

Louise Bourgeois

167 *Stamp of Memories I* 1993

Drypoint and metal stamp additions
Signed and numbered 'P.P. 2/5' (printer's
proof outside ed. 30) in pencil.
429 x 251 (16⅞ x 9⅞) plate, 640 x 435
(25¼ x 17⅛) sheet
Wye and Smith 110.1, state XIII/XIV;
MoMA 504.1/XII, version 1/2, state XII/XII
Private collection, UK (promised gift
to the British Museum)

After *Ste Sebastienne* 'large' was published
in 1992 (cat. 166), Bourgeois returned to
working on the smaller plate resulting in
the publication of *Stamp of Memories I*
and *II*, also by Peter Blum Edition. For the
former, which was published in an edition
of 30, she used her father's metal sealing
stamp, covering the figure's body with his
elaborately interwoven initials. She used
her own sealing stamp for the second
print, which was published in an edition
of fifteen the following year. Bourgeois
addressed her difficult relationship with
her father in a number of her works. As
a child she was deeply affected by the
discovery of his affair with her young
English tutor, Sadie Gordon Richmond,
who lived with the family, and Bourgeois
later claimed her father was repeatedly
cruel to her, especially when she was
grieving for her mother. As she was named
after her father Louis, both stamps read
'LB' but the styles are markedly different.
Speaking about these prints, she noted,
'My stamp is the opposite of my father's…
it is immediately readable' and declared,
'I don't need his brand, I have my own.'[1]

In contrast to *Ste Sebastienne* 'large',
the figure's head has been retained in
both prints, together with a second
face in the form of a cat. The original
drawing's long flowing hair, often an
autobiographical marker in Bourgeois'
work, has been swept up to create a
nest-like structure, which holds three
eggs. The eggs represent the artist's
three sons: Michel, Jean-Louis and Alain.
By her own admission, the responsibility
of motherhood caused Bourgeois a great
deal of anxiety.[2] The cat's face derives
directly from the source drawing and
represents the changes to the figure's
mood and actions when she realizes she
is under attack. 'She is transformed,'
explained Bourgeois, 'from a nice, sweet
creature into a mean, feline person.'[3] **CD**

1 Wye and Smith, op. cit., pp. 179–80.
2 Ibid., p. 20.
3 Bourgeois and Rinder, op. cit., p. 147.

Louise Bourgeois

168 *Stamp of Memories II* 1993

Drypoint and metal stamp additions
Signed and numbered 'P.P. 2/5' (printer's
proof outside ed. 15) in pencil.
426 x 253 (16¾ x 10) plate, 640 x 435
(25¼ x 17⅛) sheet
Wye and Smith 110.1, state XIV/XIV;
MoMA 504.1/XII, version 1/2, state XII/XII
Private collection, UK (promised gift
to the British Museum)

Louise Bourgeois

169 *The Laws of Nature* 2003

Illustrated book with five drypoints
and an essay by Paulo Herkenhoff
Each plate signed, dated and numbered
'16/25' in pencil; numbered '16/25' in
pencil on the colophon. 220 x 238
(8⅝ x 9⅜) each page
MoMA 350a–354a
Private collection, UK (promised gift
to the British Museum)

This droll series of prints depicts a man
and woman in a sequence of comically
gymnastic sexual positions. Both are
naked except for the woman's necklace
and high heels, and their smiling faces
and her long, free-flowing hair indicate
playful abandon. According to the artist,
the couple's frolics are an adult version of
'faire des galipettes', the French children's
game of turning somersaults.[1] The book
includes an essay by the curator and
critic Paulo Herkenhoff, then director of
the Museu Nacional de Belas Artes in
Rio de Janeiro, with whom the artist had
a longstanding friendship and
professional relationship.

Bourgeois developed an interest in
illustrated books as a child and began to
build her own collection as a young adult.
Beginning with *He Disappeared into
Complete Silence* (1947), she produced
numerous books throughout her career,
some of which were printed on paper and
others on fabric. This paper edition of *The
Laws of Nature* was printed and published
by Harlan & Weaver, New York, in an edition
of 25. In 2006 it was printed on fabric
and published in an edition of ten. **CD**

1 Museum of Modern Art, New York, *Louise
 Bourgeois: The Complete Prints and Books*, online
 catalogue, www.moma.org/explore/collection/lb/
 index [accessed 22 May 2016].

Kiki Smith

Born 1954

The daughter of American sculptor Tony Smith and the actress and opera singer Jane Lawrence, Chiara 'Kiki' Smith was born in Nuremberg, Germany, but brought up in South Orange, New Jersey. After finishing high school she spent a short time living in a commune in San Francisco before returning east in 1974 to study film at Hartford Art School, Connecticut. Abandoning her studies after eighteen months, she moved to New York City in 1976 where she joined Collaborative Projects, Inc. (Colab), a cooperative artists' group that operated outside the commercial gallery system. Her earliest works include monotypes, which she made on friends' etching presses, and screenprinted multiples, which she sold through Colab's store. She began to gain recognition in the early 1980s and had her first solo exhibition in 1983 at The Kitchen, an alternative art space in New York. From her earliest years as an artist she has made work about the human body. In 1983 she trained as an emergency medical technician, gaining specialist knowledge that would inform her work. She has repeatedly addressed universal themes including sexuality, birth, disease, mortality, nature and the cosmos. More recently, her work has reflected an interest in fairy tales and moralizing stories with female protagonists. Coming of age at the height of second-wave feminism, Smith has attributed her very existence as an artist to the movement, and her feminist worldview has always been central to her work.[1] She is best known as a sculptor although printmaking is an important part of her practice and in 2003 the Museum of Modern Art, New York, held a major exhibition of her printed work. **CD**

1 Jo Anna Isaak, 'Working in the Rag-and-Bone Shop of the Heart', in Jon Bird, ed., *Otherworlds: The Art of Nancy Spero and Kiki Smith*, London: Reaktion Books, 2003, pp. 49–73 (p. 60).

Kiki Smith

170 *Black Flag* **1989, printed 1990**
Etching and aquatint on handmade Nepalese paper
Signed and numbered '15/16' in pencil.
516 x 751 (20⅜ x 29½) plate, 535 x 843 (21 x 33¼) sheet
Weitman 2003, 19
Victoria and Albert Museum

Black Flag was Smith's first published etching, made at San Antonio Art Institute in Texas. It depicts a human ovum surrounded by a cluster of cells that appear sinister but are actually protective and necessary to make ovulation possible. The meaning of the image is ambiguous, however, especially as the title suggests a warning. Smith began to produce work relating to reproduction in the mid-1980s as the issue of abortion became more prominent in American political discourse. At the time, as women fought to retain control of their bodies, many of Smith's friends and acquaintances were losing control of theirs as a result of AIDS. Smith's own sister Beatrice died of the disease in 1988, and viewed in this context, *Black Flag* can be seen as an image about the fragility of life. In this print Smith presents the female body from its most vulnerable point. The delicacy of its internal structure is highlighted by the painterly application of the aquatint and the fibrous quality of the paper. The ovum is suspended in anticipation, waiting for nature to take its course. **CD**

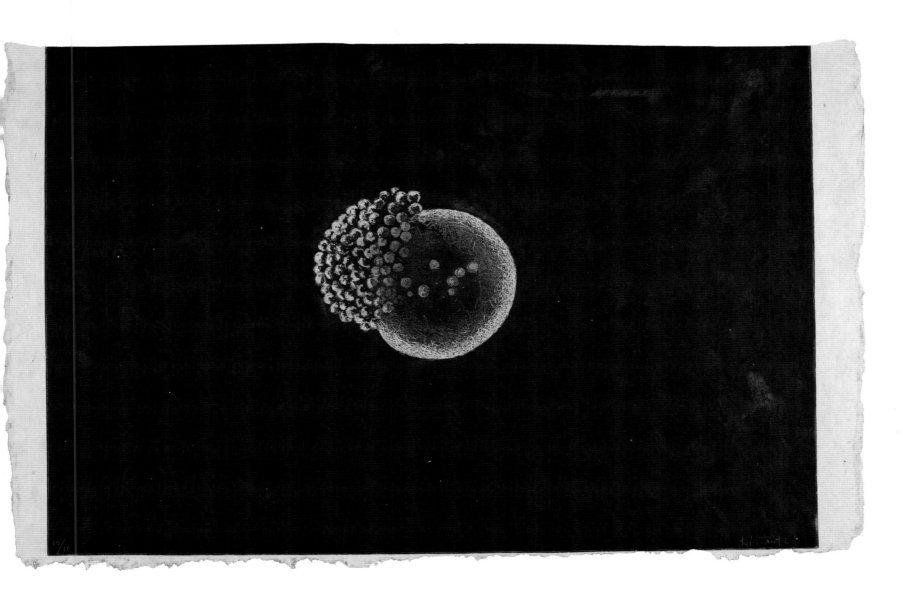

Kiki Smith

171 *Untitled (Hair)* **1990**

Lithograph in 2 shades of brown on
custom-made Mitsumashi paper
Signed, dated and numbered '19/54' in
pencil, blindstamp of ULAE, West Islip,
New York, and the printer. 908 x 912
(35¾ x 35⅞) sheet
Weitman 2003, 43
Private collection, UK (promised gift
to the British Museum)

Marking the start of an enduring
relationship with ULAE, this lithograph
was made at a time when Smith was
focusing less on the internal organs of
the body and more on the external. Her
interest in hair derived in part from its
cultural and religious significance in the
West, particularly its associations with
wild and immoral women. Reflecting
her dual practice as a sculptor and
two-dimensional image-maker, it depicts
her own 'unfolded' head. Her face can be
seen in profile at the top two corners and
at the bottom right, which, once noticed,
gives the image an almost kaleidoscopic
effect. Using dental plaster, she made
moulds of her face and neck, which were
cast in vulcanized rubber to be inked
and transferred to the lithographic plate.
To create the dense mass of entangled
hair, she used photocopy transfers of her
own long hair as well as a wig and corn
silks. When viewed up close, the image
is almost abstract, its tangle of lines
resembling the all-over gestural marks
of the abstract expressionists. The lighter
marks around the edges appear ghostly,
like fleeting memories or traces of a
head on a pillow. **CD**

17/54

Kiki Smith 1990

Kiki Smith

172 *Virgin with Dove, Wolf Girl,*
Virgin Mary, Emily D, Dorothy **and**
Melancholia **from** *Blue Prints* **1999**
Etching, aquatint and drypoint
Signed, dated and numbered '16/20'
in pencil.
Virgin with Dove: 276 x 224 (10⅞ x 8⅞)
plate, 508 x 406 (20 x 16) sheet
Weitman 2003, 118–121
Wolf Girl: 276 x 200 (10⅞ x 7⅞) plate,
508 x 406 (20 x 16) sheet
Virgin Mary: 276 x 203 (10⅞ x 8) plate,
508 x 406 (20 x 16) sheet

Emily D: 202 x 141 (8 x 5½) plate,
508 x 406 (20 x 16) sheet
Dorothy: 162 x 98 (6⅜ x 3⅞) plate,
381 x 305 (15 x 12) sheet
Melancholia: 149 x 119 (5⅞ x 4⅝) plate,
381 x 305 (15 x 12) sheet
Private collection, UK (promised gift
to the British Museum)

This group is from a suite of fifteen
etchings that depict female figures drawn
from a variety of sources. They were
printed at Harlan & Weaver, New York,
and published by Thirteen Moons, the

artist's own imprint. The series reflects
many of Smith's diverse influences
including Roman Catholicism, Northern
Renaissance Art, Victorian visual culture,
early photography and fairy tales. Printed
entirely in blue, the series has a despondent
tone that is alluded to by the title's double
meaning and the inclusion of the figure
of *Melencolia*, based on Dürer's engraving
of 1514. This mood is intensified by
references to tragic figures such as Judy
Garland in the guise of Dorothy, seen at
the point she first encounters the Wicked
Witch of the West in the 1939 film of the

Wizard of Oz. A conflation of various
characters, *Emily D* takes its name from
the melancholic 19th-century poet Emily
Dickinson. The hirsute figure represented
in *Wolf Girl* relates to Smith's sculpture
Daughter, also made in 1999, in which
the same figure is presented as the
freakish offspring of Little Red Riding
Hood and the wolf. In making these
prints, Smith became more familiar with
the aquatint process, which allowed her
to create many of the textures and
effects seen across the series. **CD**

Kiki Smith

173 *Born* **2002**

Colour lithograph
Signed, dated and numbered '23/38'
in pencil, blindstamp of ULAE, West Islip,
New York. 1730 x 1415 (68⅛ x 55¾)
image, 1730 x 1425 (68⅛ x 56⅛) sheet
Weitman 2003, 128
British Museum, London 2012,7046.1
Purchased with funds given by Hamish
Parker

Smith began to make work relating to the
story of Little Red Riding Hood in 1999
at a time when she was interested in
childhood and stories featuring young
female protagonists. In its earliest
published form, which appeared in
17th-century France, the story was an
adult satire in which the girl ends up
sharing a bed with the wolf. Adapted for
children by the Brothers Grimm in the
19th century, it became a cautionary tale
about the dangers of straying from the
path. This print is one of many works in a
variety of media that Smith has made on
the theme, some of which are conflated
with references to St Genevieve, the
patron saint of Paris, who is often depicted
with wolves. In some versions of the story
the girl and her grandmother are eaten by
the wolf but saved by a hunter who cuts
them out of its stomach. The bloodied
mouth of the wolf in this print suggests
this scenario. As the title implies, their
rescue marks a new beginning, a rebirth.
Printed and published by ULAE, West
Islip, New York, this lithograph relates
closely to Smith's bronze sculpture
Rapture (2001), in which a life-sized
naked woman steps out of a recumbent
wolf. The faces of both the woman and
the girl in the print are based on images
of the artist. **CD**

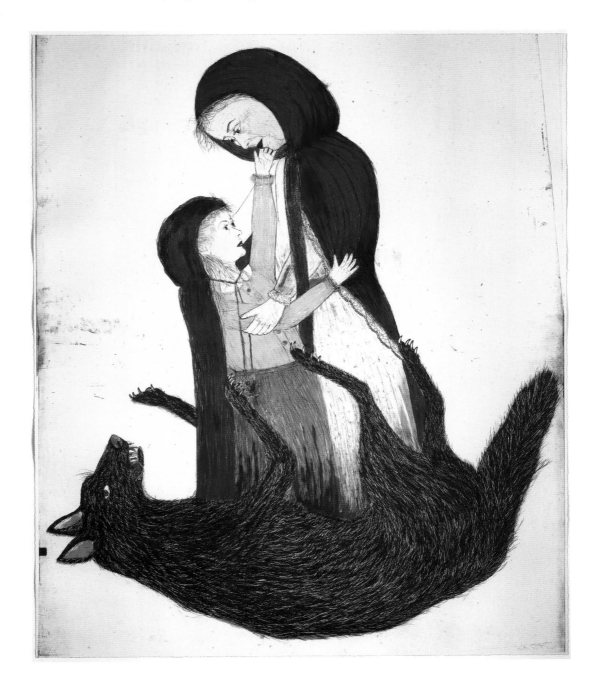

Kiki Smith

174 *Ginzer* **2000**

Etching, aquatint and drypoint
Signed, dated and numbered '3/24'
in pencil. 457 x 610 (18 x 24) plate,
572 x 787 (22½ x 31) sheet
Weitman 2003, 102
Private collection, UK (promised gift
to the British Museum)

Ginzer is an image of the artist's dead cat.
The close bond that she had enjoyed with
the animal is evident in her self-portrait
drawing *Pietà* (1999, Whitney Museum
of American Art), in which she cradles its
dead body. To make the etching, she took
the body into the studio of Harlan &
Weaver, New York, and traced its outline
on to a copper plate. She built the image
up slowly, adding layers of aquatint and
carefully erasing some of the etched

areas to achieve the almost tactile
depiction of the fur. The resultant print is
one of a group of five etchings of animals
and birds that she made at Harlan &
Weaver during this time. The technique
enabled her to capture the crisp, delicate
lines of the fur and feathers of the
creatures, which also included an
embalmed monkey (*Immortal*, 1998),
a bird skeleton (*Bird Skeleton*, 2000; cat.
175), a fawn (*Fawn*, 2001) and a falcon
(*Falcon*, 2001). A memorial to a lost friend,
the etching *Ginzer* seems to capture the
animal in a moment between life and
death. With its open eyes, visible teeth
and lustrous fur, its lifeless state is not
explicitly apparent. Evidence of the
animal's former vitality is presented in
Bird Skeleton, alongside which Smith
intended *Ginzer* to be displayed. **CD**

Kiki Smith

175 *Bird Skeleton* **2000**

Etching, aquatint and drypoint
Signed, dated and numbered '3/24' in
pencil. 152 x 152 (6 x 6) plate, 301 x 301
(11⅞ x 11⅞) sheet
Weitman 2003, 103
Private collection, UK (promised gift
to the British Museum)

Kiki Smith

176 *Two* 2002

Etching with plate tone
Signed, dated and numbered '11/18'
in pencil. 960 x 754 (37¾ x 29⅝) plate,
1146 x 892 (45⅛ x 35⅛) sheet
Weitman 2003, 105
British Museum, London 2003,1130.1
Purchased with funds given by the
American Friends of the British Museum

This double portrait of an anonymous
figure seems to depict two moments of
great intimacy, but it is unclear whether
the man is resting, dying or perhaps even
dead. In the lower image his eyes are
slightly open but above, they are closed
and his face has a peaceful quality that is
reminiscent of a death mask. References
to mortality became more prevalent in
Smith's work after the death of her father
in 1980 and she has since made numerous
death masks, casting both her father and
her sister. It is a process that she has
likened to photography as it records a
specific moment, unlike sculpture, which
is used to present a more generalized
representation.[1] For this etching, Smith
used photographs of her friend the
Russian artist Dmitry Gaev, which were
taken in her backyard. She used a tracing
to transfer the upper image onto the
copper plate but drew the lower, more
vital image, freehand. She then used
sandpaper to create the highlights in the
faces. Produced at Harlan & Weaver, *Two*
followed on from Smith's group of animal
and bird etchings that include *Ginzer*
and *Bird Skeleton* (cats 174 and 175).
Continuing a process in which she had
been preoccupied with depicting fur and
feathers, and confronting the sometimes
blurred lines between life and death, *Two*
provided a further challenge of using
etching to represent human flesh. **CD**

1 Chuck Close, 'Kiki Smith', *BOMB*, 49 (Fall 1994)
 http://bombmagazine.org/article/1805/kiki-smith
 [accessed 27 March 2016].

11 Race and identity
Unresolved histories

In February 1960 four African American college students asked to be served at an all-white lunch counter at a Woolworth's store in Greensboro, North Carolina. When they were refused, they began a peaceful sit-in using tactics advocated by the civil rights leader Martin Luther King Jr. It was a turning point in the movement, gaining attention and inspiring action elsewhere. In May 1963, a similar sit-in sparked riots in Birmingham, Alabama, when the police reacted violently. A few weeks later, photographs documenting the event were published in *Life* magazine, providing the source material for Andy Warhol's *Birmingham Race Riot* (1964, screenprint, cat. 177). The images shocked many Americans, opening their eyes to their country's inherent racism.

In the 1960s few artists of colour were able to penetrate America's mainstream art world. The frustrations this caused led to the formation of Spiral in New York in 1963, an alliance of African American artists that included the painter and printmaker Emma Amos. Having moved to New York from Atlanta, Georgia, Amos has often explored the history of black people in the Southern states and her own personal history as the descendant of slaves. The legacy of slavery is a subject that has preoccupied the African American artist Kara Walker, whose often shocking and violent imagery has confronted the brutal realities of the slavery era and its implications for black Americans today. It is a subject that has also been addressed by Willie Cole, whose monumental woodcut *Stowage* (1997, cat. 183) traces the trajectory of black Americans from slave to domestic servant. Glenn Ligon has also looked to the past, drawing on literature, popular culture and political speeches to create text-based works on the subject of race and identity. As divisions persist in American society, the work of these artists continues to challenge ongoing inequalities and make visible the deep scars of history.

Andy Warhol

For biography see page 36

**177 Birmingham Race Riot from X + X
(Ten Works by Ten Painters) 1964**

Screenprint

Blindstamp of Ives-Sillman, New Haven,
Connecticut. 510 x 610 (20 x 24) sheet

Feldman and Schellmann II.3

The University of Warwick Art Collection

The riots that began in Birmingham,
Alabama, in early May 1963 were a key
event in the civil rights movement. They
began as protests against segregation
at lunch counters but escalated partly
due to the heavy-handed response of the
police who used dogs and high-pressure
water hoses. Many of the protesters
were arrested, including Martin Luther
King Jr. This print uses a photograph first
published in *Life* magazine on 17 May
1963, taken by the press photographer
Charles Moore two weeks earlier. It was
the first time that Warhol appropriated a
current news photograph in his printmaking.
He instructed the screenprinter to heighten
the contrast between black and white in
order to reinforce the message about
race relations. Warhol also used the
photograph and others by Moore for ten
silkscreen paintings made for his *Death
in America* exhibition at the Sonnabend
Gallery, Paris, in 1964, where some of
his images of the electric chair were
also shown. The print was published in
the same year, in the portfolio *X + X (Ten
Works by Ten Painters)*, by the Wadsworth
Atheneum Museum of Art in an edition
of 500. It was commissioned by the
curator Sam Wagstaff and printed by
Sirocco Screenprints in North Haven,
Connecticut, under the supervision of
Ives-Sillman. **CD**

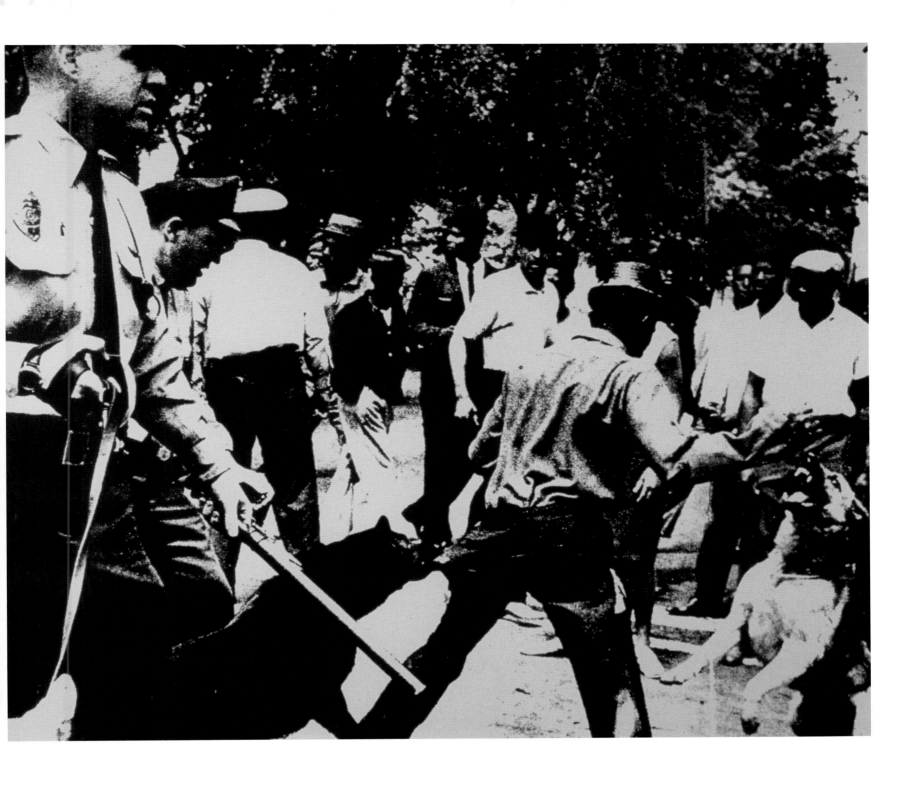

Emma Amos

Born 1938

A painter, printmaker and weaver, Emma Amos grew up in Atlanta, Georgia, where, as an African American, she attended segregated schools. As part of a fine-art programme at Antioch University in Ohio, she spent a year at the Central School of Art, London, in 1958, where she studied painting and printmaking. She returned to London the following year to complete a postgraduate diploma in etching. In 1960 she moved to New York where she began to make prints professionally and work with textiles. Finding the New York art world difficult to penetrate, Amos became the only female member of Spiral, a short-lived collective of black artists that grew out of the civil-rights movement in the mid-1960s. Faced with both race and gender bias throughout her career, Amos has said, 'For me, a black woman artist, to walk into the studio is a political act.'[1] **CD**

1 Quoted in Lisa E. Farrington, 'Emma Amos: Art as Legacy', *Woman's Art Journal*, 28:1 (Spring–Summer 2007), pp. 3–11 (p. 3).

Emma Amos

178 *Mississippi Wagon 1937* **1992**
Colour monotype and photo laser transfer
Signed, dated, titled and numbered '4/4'
in pencil. 405 x 515 (15⅞ x 20¼) sheet
British Museum, London 2015,7001.2
Presented by the artist and the Ryan
Lee Gallery

The photograph reproduced at the centre of this print was taken by George Shivery, a black photographer and family friend of the Amos family in Atlanta. Amos inherited Shivery's photographs, most of which depict scenes from the Southern states in the 1930s and 1940s, and incorporated some into her work in the 1990s. Taken at a time of great poverty in Mississippi, the image reflects Amos's interest in the history of black people in America. By setting it against the Confederate battle flag, Amos infuses it with political meaning. A highly divisive emblem, the flag represents for many the Confederacy's fight to preserve legally sanctioned slavery during the Civil War. For the artist, as the great-granddaughter of slaves, the flag has personal resonances. Against the blood-like red ink, the photograph, taken a year before Amos was born, recalls the artist's own ancestry, her own American bloodline. **CD**

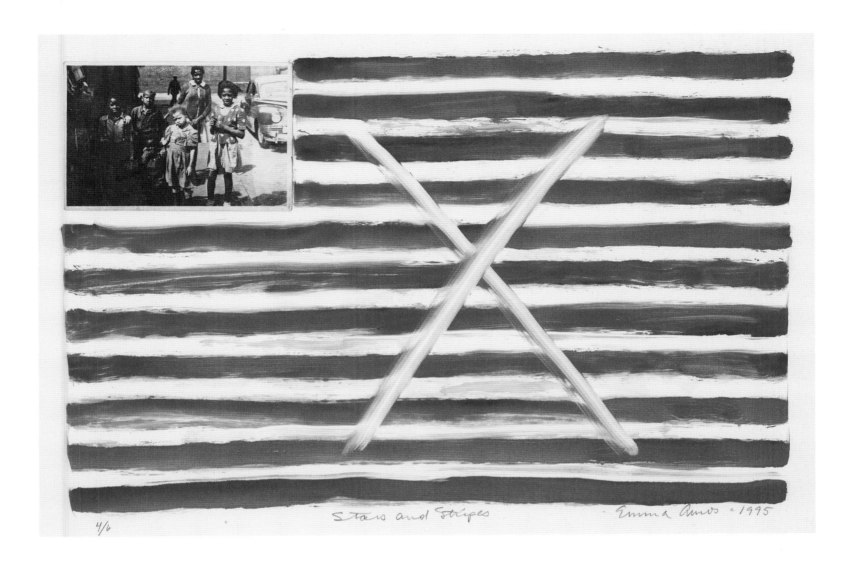

4/6 Stars and Stripes Emma Amos · 1995

Emma Amos

179 *Stars and Stripes* **1995**

Colour monotype and photo laser transfer
Signed, dated, titled and numbered
'4/6' in pencil. 370 x 570 (14½ x 22½)
image, 562 x 757 (22⅛ x 29¾) sheet
British Museum, London 2015,7001.1
Purchased with funds given by the
James A. and Laura M. Duncan
Charitable Gift Fund

Despite the title, the stars are missing
from Amos's American flag. In their place
is a George Shivery photograph of
mid-20th-century African American
children staring cheerlessly out at the
viewer. An effective visual substitution
for the stars, the blue-tinted photograph
allows the iconography of the flag to
remain briefly intact before the viewer
notices their absence. Amos invites the
viewer to look again at this ubiquitous
symbol of the American Dream and to
consider the alternative history that the
photograph represents. The cross in the
centre is ominous, perhaps an allusion to
the Confederacy's saltire. Related to an
oil painting on paper that Amos made in
1992, this print has a painterly quality that
has been achieved through the thick
application of ink in sweeping, imprecise
lines. The result is an informal rendering
of a formal symbol; an untidy, uncertain
and unsettling interpretation of this
emblem of national pride. **CD**

Kara Walker

Born 1969

Born in Stockton, California, Walker spent her adolescence in Georgia where her father, artist Larry Walker, taught painting at the state university. In part because of her California accent, Walker found it difficult to fit in with other African American children and felt alienated by her European American peers because of her race. Stone Mountain, the city in which her family lived, was associated with the Ku Klux Klan as it was the site of the group's modern founding in 1915 and annual KKK rallies were held there in the early 1980s. Although as a student she was initially resistant to making work about race, Walker began to explore the subject as a postgraduate at the Rhode Island School of Design. By the time she came to prominence in the mid-1990s, themes relating to the history of black people in America had become central to her work. Now based in New York, Walker is best known for the large-scale wall installations of silhouetted figures that often depict scenes of violence and abuse endured by black slaves. Her appropriation of the 'polite' cut-paper silhouette format developed in the 18th century serves to heighten the shocking nature of the imagery. **CD**

Kara Walker
180 *Confederate Prisoners Being Conducted from Jonesborough to Atlanta* from *Harper's Pictorial History of the Civil War (Annotated)* 2005
Offset lithograph with screenprint
Signed, dated and numbered '8/35' in pencil. 655 x 845 (25¾ x 33¼) image, 995 x 1350 (39⅛ x 53⅛) sheet
British Museum, London 2014,7005.1
Purchased with funds given by the Joseph F. McCrindle Foundation to the American Friends of the British Museum

Taken from *Harper's Pictorial History of the Civil War* (ed. Alfred H. Guernsey and Henry M. Alden, 1866), the image in the background of this print depicts Confederate prisoners being marched to Atlanta after the battle of Jonesborough, Georgia, in 1864. The battle was a decisive event that caused the Confederacy to lose control of Atlanta and facilitated the end of the war. Using the characteristic silhouette style for which she is best known, Walker has overlaid the image with the screenprinted head of a black slave, the freedom of whom would have been dependent on the outcome of the conflict. The print is from a series of fifteen, each of which depicts an enlarged plate from the book reproduced using offset lithography and overlaid with a silhouetted figure or scene. Through her 'annotations', Walker inserts the previously under-represented history of African Americans into Harper's visual narrative. The series was co-published in New York by the LeRoy Neiman Center for Print Studies at Columbia University and Sikkema Jenkins & Co. **CD**

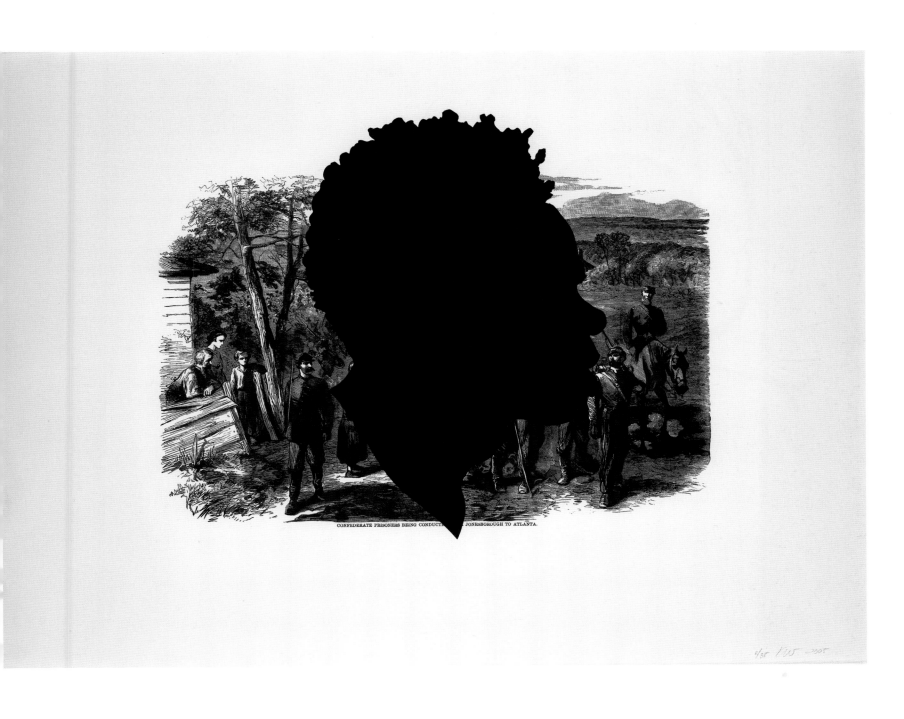

CONFEDERATE PRISONERS BEING CONDUCTI... ...JONESBOROUGH TO ATLANTA.

Kara Walker
181 _Restraint_ 2009
Etching with sugar aquatint
Signed, dated and numbered 'P.P. 2/3'
(printer's proof outside ed. 35) in pencil,
blindstamp of Burnet Editions, New York.
610 x 483 (24 x 19) plate, 785 x 606
(30⅞ x 23⅞) sheet
British Museum, London 2014,7001.1
Purchased with funds given by the
Joseph F. McCrindle Foundation to the
American Friends of the British Museum

Much of Walker's work explores the
experience of black slaves in the
Southern states of pre-Civil War America.
The figure depicted in this print wears
a bridle of a type that female slaves in
particular were forced to wear as
punishment, preventing them from
speaking, lying down or running away.
The brutal nature of the subject is at odds
with the calm beauty of the silhouette,
which ironically recalls a style of profile
portraiture that was popular in Europe
and America during the slavery era.
The print was produced for the Hammer
Museum, Los Angeles, which held a
major exhibition of Walker's work in
2008, and was printed in New York
by Burnet Editions. **CD**

Kara Walker

182 *no world* from *An Unpeopled Land in Uncharted Waters* **2010**

Aquatint with spit-bite and drypoint
Signed, dated and numbered 'P.P. III/III'
(printer's proof outside ed. 25) in pencil.
606 x 905 (23⅞ x 35⅝) plate,
768 x 1007 (30¼ x 39⅝) sheet
British Museum, London 2016,7007.1
Purchased with funds given by Margaret
Conklin and David Sabel

A pun on the phrase 'New World', the title of this print suggests a different experience from that of European settlers for whom the journey to America promised opportunity and freedom. As otherworldly hands emerge from a choppy ocean carrying a slave ship to shore, the silhouetted figures of a plantation owner and slave can be seen on land, a glimpse of a life to come. A figure of a black woman beneath the water brings to mind the many slaves who did not survive the horrific and perilous voyage. Presenting the scene from the perspective of the water, Walker invites the viewer to identify with these drowning souls. Printed by Burnet Editions and published by Sikkema Jenkins & Co., New York, the layers of aquatint used to evoke the vast depths of the Atlantic display a great mastery of the technique. **CD**

Willie Cole

Born 1955

Best known as a sculptor, Cole creates his assemblages from ordinary, everyday objects of America's consumer culture – hairdryers, high-heeled shoes, ironing boards and steam irons – that he invests with an African American significance. Brought up in deprived parts of Newark, New Jersey, he was encouraged by his working-class parents to take drawing classes at the Newark Museum, where he first encountered African art. After his BFA (1976) at the School of Visual Arts, New York, and further study at the Art Students League, he lived and worked in an old industrial loft in the neglected Ironbound district of Newark where he found many of his discarded materials. Since the late 1980s the steam iron has become a powerful motif in his work. Heated irons were stamped onto paper, canvas and other surfaces to create scorched imprints that suggested the appearance of African tribal masks, ritual scarification and branding. Associated with generations of domestic servitude of African American women, the steam iron also had a personal connection for Cole, whose mother and grandmother worked as domestics and often asked him to fix their irons. In 1998 the Museum of Modern Art, New York, gave him an exhibition of his 'scorches' and the woodcut *Stowage* (cat. 183). A national touring survey of his work in different media began in his home state of New Jersey at Montclair Art Museum in 2006. An exhibition comprising mostly his prints, initiated by the James Gallery, City University of New York, to tour university museums, was held at the Rowan University Art Gallery, Glassboro, New Jersey, in 2012. SC

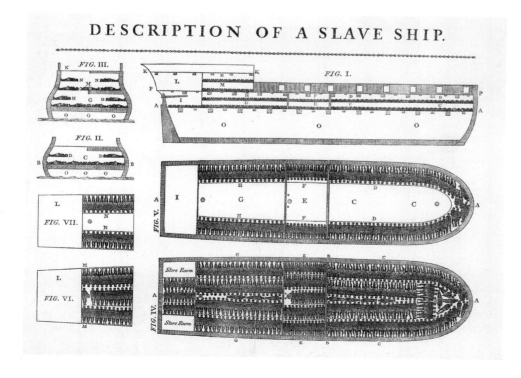

Anonymous, *Description of a slave ship*, 1789, woodcut, 328 x 444 (12⅞ x 17½). British Museum, London 2000,0521.31 Purchased with funds given by Dame Gillian Beer

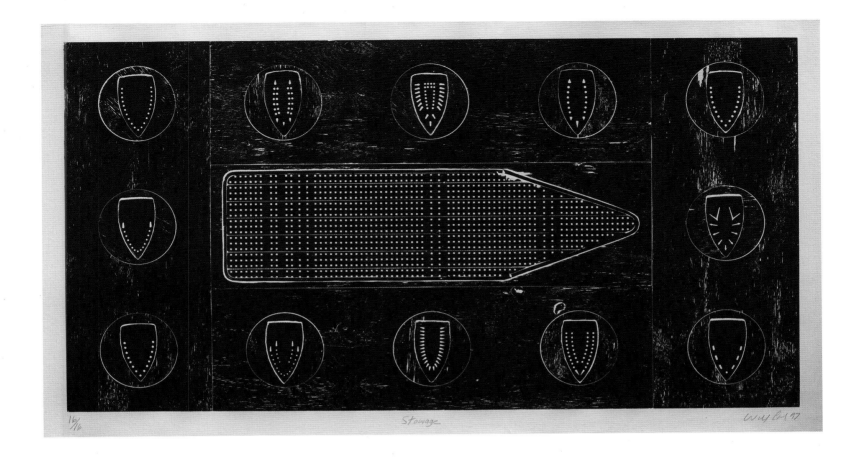

Willie Cole

183 *Stowage* 1997
Woodcut on Japanese paper
Signed, dated, titled and numbered
'16/16' in pencil. 1262 x 2412 (49⅝ x 95)
image, 1424 x 2640 (56 x 103⅞) sheet
British Museum, London 2016, 7038.2
Purchased with funds given by the
Vollard Group

Measuring almost 1.5 x 2.7 metres, this
monumental woodcut is the largest and
most ambitious print Cole has produced
to date. Made in 1997, it was also the
artist's second print edition. Its starting
point was a famous small woodcut of a
Liverpool slave ship, *Brookes* (see
opposite), that was widely distributed
by the abolitionists from the late 1780s
in their campaign against the slave trade
in England and the United States. The
woodcut diagram showed in plan and
cross-section the layout of the slave ship
and the disposition of its human cargo
from West Africa in the most appalling
conditions of overcrowding and neglect.
Cole had first encountered the image in
a school book when he was growing up.
In his woodcut the shape of the slave
ship is represented by a metal ironing
board embedded in an area cut out of the
central plank of the printing woodblock.

The perforated surface of the ironing
board becomes a grid of tightly packed
rows denoting the position of the slaves
in the hold. The metal soles of twelve
steam irons are inserted in the porthole
circles cut into the four planks of wood
that border the central image. The
downwards-pointing irons, each with a
different set of openings for the steam,
are transformed into masks symbolizing
the various West African tribes
transported across the Atlantic on board
such a ship. The diverse markings on the
faces of the irons can be likened to the
distinctive scarification of different tribal
communities while the steam irons

themselves connote the branding of
slaves as merchandise. Printed in black
ink, this woodcut was produced by Cole
in New York City with the printer Maurice
Sánchez at Derrière L'Etoile Studios and
published by Alexander and Bonin
Publishing, Inc. in a small edition of
sixteen. A major statement addressing
African American slave heritage and
identity, *Stowage* is held by twelve public
museums in the United States. The
British Museum holds the only example
outside the United States. **SC**

Glenn Ligon

Born 1960

Based in New York, Glenn Ligon grew up in a housing project in the Bronx where he lived with his mother and brother. A studious child with a love of reading, he won a scholarship to a prestigious private school in Manhattan at the age of 7. He studied art at Wesleyan University in Connecticut, after which he spent several years making gestural paintings influenced by the abstract expressionists. Finding that the style did not allow him to express himself satisfactorily, he developed a more conceptual approach while enrolled on the Whitney Museum's Independent Study Program from 1984. Much of his work is concerned with his own identity as an African American and the history of black people in the United States. Known first as a painter and draughtsman, Ligon began to create work in other media in the early 1990s and has been making prints since 1992. **CD**

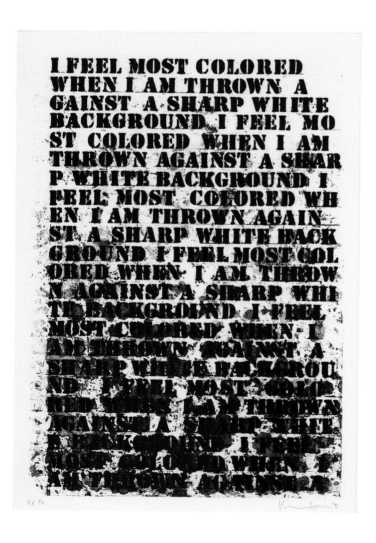

Glenn Ligon

184 Two plates of four from *Untitled (Four Etchings)* 1992

Both soft-ground etching, aquatint, spit-bite and sugar-lift aquatint
Both signed, dated and numbered 'P.P. 3/3' (printer's proof outside ed. 45) in pencil. 600 x 404 (23⅝ x 15⅞) plate, 635 x 432 (25 x 17) each sheet
British Museum, London 2012,7019.2, 4
Presented by Judith Pillsbury to the American Friends of the British Museum in honour of Antony Griffiths

Ligon started to incorporate text into his work in the mid-1980s, firstly by writing in pencil over painted sheets of paper and later using stencils to reproduce blocks of text. Often taken from literary works by black authors or political speeches, many of the texts he has used directly address the issue of race. These etchings are from a series of four, two of which are printed in black on white paper and two in black on black. The first shown here (on white paper) repeats a sentence from Zora Neale Hurston's essay 'How it Feels to Be Colored Me', which was first published in 1928. About the author's dawning awareness of her race after leaving a black community for boarding school, the account has parallels with Ligon's own childhood experiences. The second (on black paper) reproduces text from Ralph Ellison's novel *Invisible Man* (1952), about a black man living in New York. Because of the black background, the densely printed black text is barely visible, like the titular protagonist of the book. Closely related to earlier drawings and paintings, these etchings were Ligon's first limited-edition prints and the inaugural project for the print workshop Burnet Editions, New York. They were published by Max Protetch, New York, with whom Ligon has worked extensively. **CD**

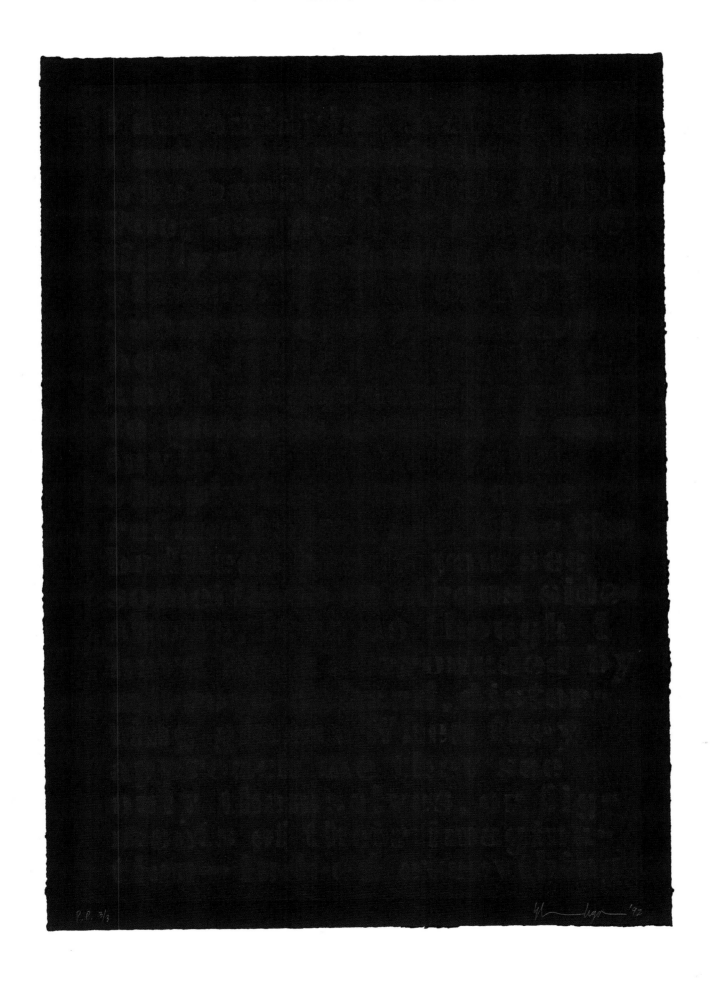

P.P. 3/3

Glenn Ligon

185 *Warm Broad Glow (reversed)* 2007
Photogravure aquatint
Signed, dated "08" and numbered '31/35'
in pencil, blindstamp of Burnet Editions,
New York. 406 x 673 (16 x 26½) plate,
622 x 902 (24½ x 35½) sheet
British Museum, London 2014,7001.2
Purchased with funds given by the
Joseph F. McCrindle Foundation to the
American Friends of the British Museum

This etching relates to Ligon's first neon
work, which he made in 2005 (cat. 186).
The phrase is taken from Gertrude Stein's
novella *Melanctha*, first published in
1909. Then thought to be a progressive
book, Stein's phrase 'the warm broad
glow of negro sunshine' to describe a
black person's laughter reflected the
widespread racial stereotyping of the
time. The letters in the neon piece are
'blacked out' with paint so that the light
from the tubes can only be seen as a
glow on the wall behind. For the print
Ligon has used a photographic negative
of the neon so that this is reversed and
the phrase becomes starkly visible against
what is now a wry black 'glow'. It was
printed and published by Burnet Editions,
New York, in an edition of 35. **CD**

Glenn Ligon

186 *Warm Broad Glow* 2005
Neon and black paint. Number 7
from an edition of 7.
102 x 1219 (4 x 48) approx.
Thomas Dane, London

Inspired by the use of light in the work of
African American artist David Hammons,
Warm Broad Glow is the first of a number
of neon pieces that Ligon has made. The
influence of Bruce Nauman is evident,
particularly in the interplay between the
neon work and the related print (cat. 185).
Ligon commissioned this piece from a
high-end neon-sign shop that was
serendipitously situated beneath his
Brooklyn studio. The old-fashioned
typewritten style of the lettering makes
reference to the outdated text from
which the words are taken. **CD**

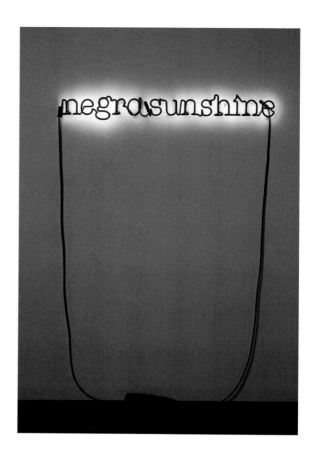

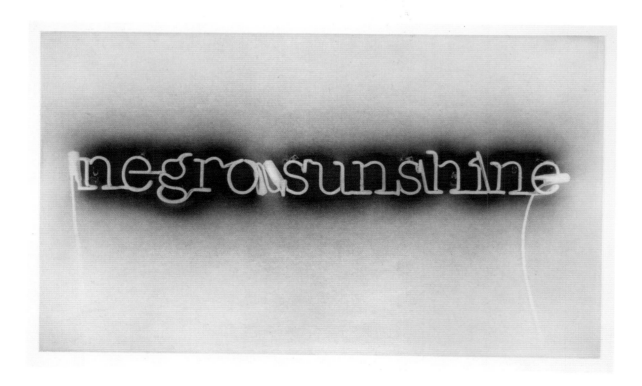

Glenn Ligon

187 *Untitled (Condition Report for*
Black Rage) 2015

Screenprint and digital print
Signed, dated and numbered '8/30' in
pencil. 238 x 198 (9⅜ x 7¾) image
(irregular), 280 x 216 (11⅜ x 8½) sheet
British Museum, London 2015,7068.1
Purchased with funds given by the
Vollard Group

First published in 1968, the book *Black*
Rage was written by two black psychiatrists
who argued that the anger experienced
by African Americans as the result of
racism could lead to abnormal behaviour.
Ligon first appropriated the cover for his
exhibition 'Good Mirrors Are Not Cheap',
held at the Whitney Museum's Philip
Morris branch in Manhattan in 1992.
There, the image of the enraged black
man was reproduced on large-scale
banners that were hung in the public
atrium alongside texts reflecting on race.
In this print, the book cover is reproduced
in full and annotated in the form of a
museum conservator's condition report.
Physical flaws and signs of decay are
highlighted, drawing attention to the
passing of time since the book was
written, yet despite the close scrutiny
under which the object has apparently
been placed, its wider message appears
to go unnoticed or ignored. The print was
made to commemorate the publication
of Ligon's book *A People on the Cover*
(Ridinghouse, 2015), in which he traces
the representation of black people in the
United States through the images on
the front of books. It was published by
Karsten Schubert, London. **CD**

Enrique Chagoya

Born 1953

Chagoya's preoccupation with borders – cultural, ethnic, class or gender as well as political and geographic – derives from his dual background as a Mexican American. Born in Mexico City, where his mother ran a sewing business from home and his father worked for the Mexican Central Bank, his identification with indigenous Mexican culture came from the nurse who partly brought him up. After studying political economics at the National Autonomous University of Mexico, he became politically active in support of the rural labouring poor. In 1977 he crossed the border into the United States with his then American wife and began working as a freelance illustrator in Berkeley, California. In 1984 he graduated in printmaking at the San Francisco Art Institute and completed his MA and MFA (1987) at the University of California, Berkeley. Since 1995 he has taught painting and printmaking at Stanford University where he is professor in the department of art. He has worked with many printer-publishers in the United States, including Shark's Ink in Colorado and ULAE on Long Island. His printed codices, inspired by the few surviving codices of the pre-Spanish conquest Aztecs and Meso-Americans, serve as vehicles for his 'reverse anthropology' where Meso-American culture is conceived as the 21st-century norm. Provocative in his aim, Chagoya uses satire in his prints and his codices to raise consciousness of issues concerning immigration, race and ethnicity. *The Misadventures of the Romantic Cannibals*, his 2003 lithographic codex produced with the printer Bud Shark, made news headlines in 2010 when it was on view at the Loveland Museum/Gallery, Colorado, and was physically attacked with a crowbar by an enraged religious fanatic. SC

Enrique Chagoya
188 *Return to Goya, no. 9* **2010**
Etching and aquatint with letterpress on paper
Signed, dated and numbered '50/50' in pencil, captioned with Goya's title on matrix outside image but within the plate: 'No te escaparás' (You will not escape), blindstamp of ULAE, Bay Shore, New York.
220 x 150 (8⅝ x 5⅞) plate, 370 x 280 (14½ x 11) sheet
Kirk Hanley 2013, 10
British Museum, London 2012,7077.1
Presented by the International Print Center New York

During his career Chagoya has frequently returned to Goya, whose etchings he first encountered in 1983 as a student in a class given by Robert Flynn Johnson, curator of the Achenbach Foundation for Graphic Arts in San Francisco. Taking the artistic hero implanted within his name as his cue, he has since then made some forty etchings faithfully reproduced after Goya, often inserting different political personalities of the day, from Ronald Reagan to Barack Obama. Whereas his first Goya etching of 1983, *Contra el bien general (Against the common good)*, substituted Goya's head of a fiend with that of Reagan, in this etching Obama's benignly smiling face takes the place of an attractive young woman – an indication of Chagoya's political allegiance. Goya's title 'No te escaparás' (You will not escape) from plate 72 of his *Los Caprichos (The Caprices)* implies, however, that the engulfing forces of reaction, personified by the pursuing demons, threaten to frustrate the promise of political and social change under the first black President of the United States. The red letterpress stamp below the image, replicating an institutional stamp or a collector's mark, depicts a fleeing Ku Klux Klansman as a plucked chicken clutching a cross with flames rising behind. In 1999, in his etching *Que viene el Coco (Here comes the Bogeyman)*, Chagoya had depicted David Duke, then Louisiana's state representative and former Ku Klux Klan Grand Wizard, as the real threat in place of Goya's bogeyman. *Return to Goya, no. 9* was produced as a benefit edition for the International Print Center New York, a not-for-profit organization founded in 2000. SC

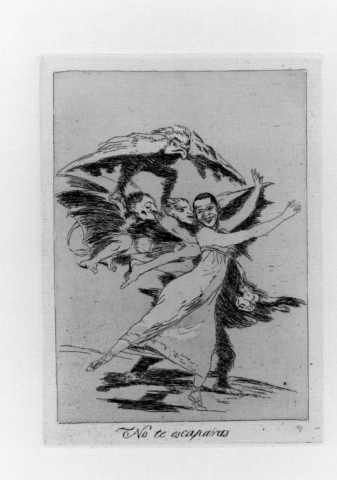

No te escaparás

50/50

Eidblagaya '10

12　Signs of the times

If the American Dream depends on prosperity, the first decade of the twenty-first century has witnessed its partial eclipse. Economic slowdown and its social repercussions have made the traditional markers of success, including home ownership and stable employment, unobtainable for many. The effects of the 2008 financial collapse have been far-reaching and have added to a general feeling of anxiety and insecurity in a nation still reeling from the devastating terrorist attacks on 11 September 2001 in New York, Washington, DC, and Pennsylvania. Reflecting on a changing nation, Ed Ruscha, Mel Bochner and Julie Mehretu have all made prints exploring the signs of the times.

Inspired by the everyday ephemera of the economic downturn, the jubilant colours of Bochner's *Going Out of Business* (2012, cat. 189) belie the depressing reality of its message, while Ruscha's *Rusty Signs* speak of a disenfranchised and redundant blue-collar workforce forced to advertise 'Cash For Tools' (2014, cat. 193). Since Ruscha made his first prints in the 1960s, America has changed profoundly and much of his recent work has reflected these changes. His 21st-century prints depict empty billboards, blank roadsigns and even a crumbling Hollywood sign. The colour has drained from Ruscha's America and this is nowhere more clear than in *Ghost Station* (2011, cat. 194), an inkless iteration of his famous *Standard Station* image. Mehretu's commentary on contemporary America is more oblique, but the pulsating lines of her *Algorithms/Apparitions/Translations* (2013, cat. 195) evoke a nation in flux, a nation responding to the diverse forces of a changing world, shifting, adapting and finding new ways to thrive.

Mel Bochner

Born 1940

The son of a sign-painter, Mel Bochner was born in Pittsburgh and trained at the city's Carnegie Institute of Technology (1958–62). He moved to New York in 1964, initially working as a security guard at the Jewish Museum and then as a studio assistant for artists Jack Tworkov, Robert Motherwell and Ruth Vollmer. Bochner's early works were small, monochrome painted panels followed by assemblage paintings that incorporated found objects and photographs. His style began to change, however, after 1966 when he was exposed to minimalism through the Jewish Museum's 'Primary Structures' exhibition, which featured the work of Donald Judd and Sol LeWitt. Bochner wrote an essay about the exhibition for *Arts Magazine* and began to make works based on numerical systems, language and geometry around this time. In 1970 he first exhibited his breakthrough work, *Language Is Not Transparent* (paint and chalk on a wall), in the 'Language IV' exhibition at the Dwan Gallery, New York, by which time language and text had become central to his work. Having gained recognition as a leading conceptual artist in the late 1960s, he made his first prints in 1973–74, which included the aquatint *Triangle and Square* (1973) and a portfolio of etchings titled *Q.E.D.* (1974), both published by Parasol Press, New York. Since around 2002 Bochner has been making paintings and prints of semantically related words and phrases. The compositions are often sparked by a phrase he has overheard or happened upon, which he builds on using *Roget's Thesaurus*. CD

Mel Bochner
189 *Going Out of Business* 2012

Monoprint with collage, engraving and embossing on hand-dyed handmade paper
Signed and dated in pencil. 762 x 565 (30 x 22¼) sheet
British Museum, London 2013,7010.1
Purchased with funds given by the Joseph F. McCrindle Foundation to the American Friends of the British Museum

Made shortly after the global financial meltdown in 2008, this print uses phrases that reiterate those commonly found on shop fronts in America and elsewhere in the following years: 'EVERYTHING MUST GO!', 'NO GOOD OFFER REFUSED!' The jaunty lettering and eye-catching bright colours are at odds with the negativity of the words. This unique work was made and published by Two Palms Press, New York, where Bochner began to experiment with monoprints in the 1990s. Uninterested in using conventional methods, he collaborated with the workshop's founder, David Lasry, to develop a process of creating heavily embossed prints through extreme vertical pressure exerted by a hydraulic press. Using a laser-cut Plexiglas plate, his most recent examples are printed in oil paint on specially made paper, which is often dyed in colour bands. He made this print in three different sizes: small, medium and large – this is the medium version. In the same year he made a painting of *Going Out of Business* in oil on velvet (private collection, New York). CD

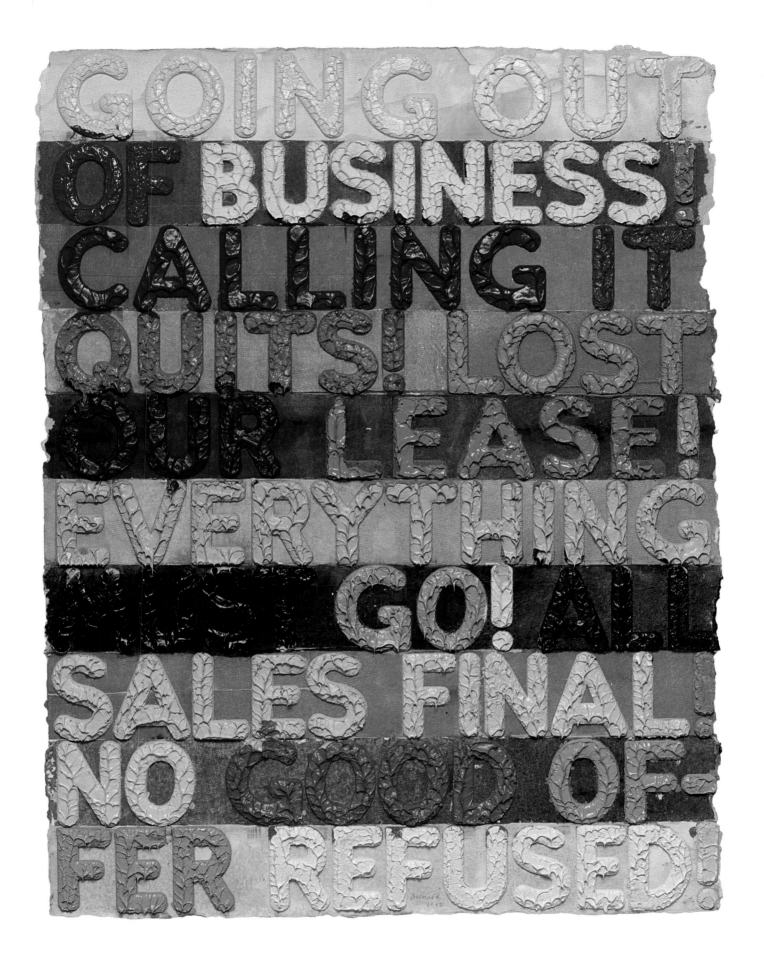

Mel Bochner

190 *It Doesn't Get Any Better Than This*
2013

Etching with aquatint
Signed, dated and numbered '15/20' in
pencil. 565 x 770 (22¼ x 30⅜) sheet
British Museum, London 2014,7056.3
Purchased with funds given by the
Vollard Group

Made around the same time as *Going
Out of Business* (cat. 189), the phrases in
these prints (cats 190 and 191) are
equally negative in tone. The melancholic
blue and the absence of an exclamation
mark leave us in no doubt that the words
'IT DOESN'T GET ANY BETTER THAN
THIS' are laden with irony. Reflecting
Bochner's enduring preoccupation with
language, these two works are from a
group of seven etchings with aquatint
that were printed and published by Two
Palms Press, New York, in 2012–13.
Each a single phrase, the prints appear
to mock the widespread usage of clichés
and oft-repeated colloquialisms. The
compositions echo Bochner's important
early installation work *Language Is Not
Transparent* (1970), in which the title
phrase is written in white chalk on black
paint that drips down a wall. **CD**

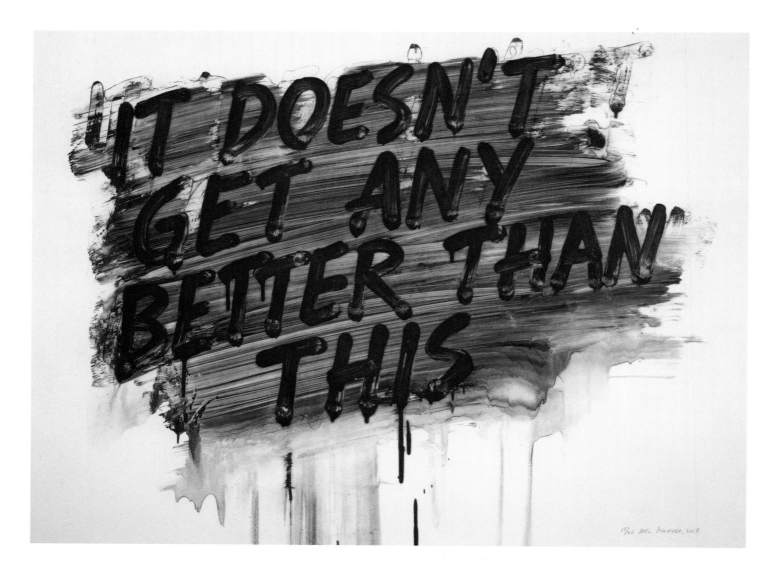

Mel Bochner
191 *I've Had It Up To Here* **2012**
Etching with aquatint
Signed, dated and numbered '15/20' in
pencil. 565 x 770 (22¼ x 30⅜) sheet
British Museum, London 2014,7056.1
Purchased with funds given by the
Vollard Group

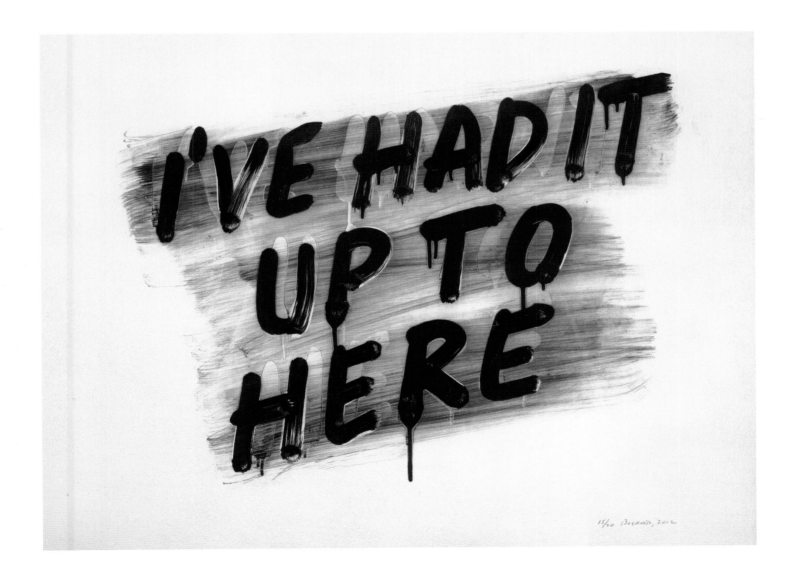

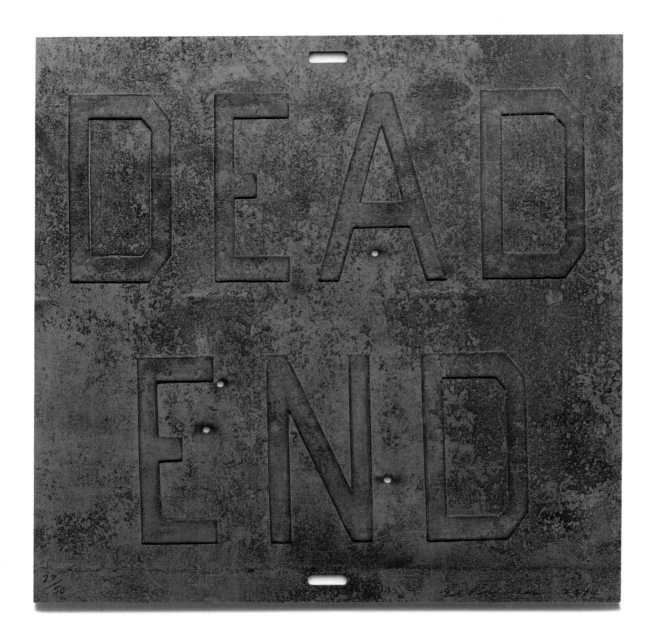

Opposite: Ed Ruscha
193 *Cash For Tools 2* from *Rusty Signs*
2014
Mixografía® print on handmade paper
Signed, dated and numbered '27/50' in
pencil. 610 x 608 (24 x 23⅞) sheet
British Museum, London 2016,7004.1
Purchased with funds given by
Gifford Combs

Ed Ruscha

For biography see page 108
192 *Dead End 2* from *Rusty Signs* **2014**
Mixografía® print on handmade paper
Signed, dated and numbered '27/50' in
pencil. 610 x 608 (24 x 23⅞) sheet
British Museum, London 2016,7004.2
Purchased with funds given by
Gifford Combs

'Neglected and forgotten signs from
neglected and forgotten landscapes'
of America is how Ruscha described
these three-dimensional prints made at
the Mixografía Workshop in Los Angeles
in 2014.[1] The proprietary process by
which they were made takes its name
from the workshop where it was
developed. Ruscha drew the letters of
each sign as well as the bullet holes and
various piercings and then superimposed
them on weathered and corroded metal
plates before the printing plates were
made. The relief effect was obtained by
placing the wet handmade paper on the
inked printing plate and passing it through
the press under great pressure. By this
process the specially made paper became
strong and dense and the shape of the
plate and every detail on its surface was
picked up.[2] Each sign was inked in
a slightly different way to suggest
weathering at different rates and under
different conditions. The bullet holes,
clipped corners, dents and the holes of
old fastenings were faithfully reproduced
life size. The squared-off letter form is
one that Ruscha often favours. 'A kind of
typography that I call Boy Scout Utility
Modern', he once named it, '…the kind
of thing a carpenter might apply to
making a letter form…I like them to look
homemade.'[3] *Rusty Signs*, a suite of six
works, two of which are shown here,
expresses Ruscha's deepening
preoccupation with the decay of the
American Dream, first addressed at the
2005 Venice Biennale with his *Course
of Empire* paintings. **SC**

1 Cited by Sarah Kirk Hanley in *Art in Print*, 4:6
 (March–April 2015), p. 25.
2 Email from Shaye Remba, Director of Mixografía
 Workshop, to Stephen Coppel, 10 August 2016,
 describes the process of making these prints upon
 which this account is based.
3 Ruscha, quoted in Suzanne Muchnic, 'Getting a Read
 on Ed Ruscha', *Los Angeles Times,* 9 December
 1990, Calendar, p. 3; in Ed Ruscha, *Leave Any
 Information at the Signal: Writings, Interviews, Bits,
 Pages*, ed. Alexandra Schwartz, Cambridge, MA,
 and London: MIT Press, 2002, p. 311.

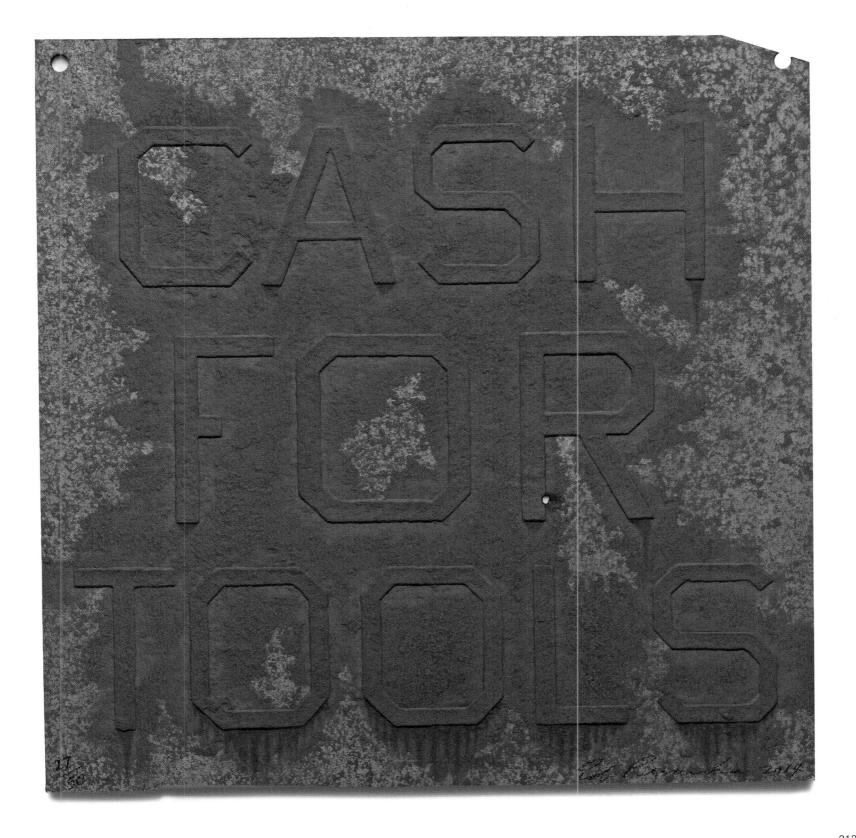

Ed Ruscha

194 *Ghost Station* **2011**

Mixografía® inkless print on white
handmade paper
Signed, dated and numbered '53/85'
in pencil. 528 x 1004 (20¾w x 39½)
plate, 688 x 1156 (27 x 45½) sheet
British Museum, London 2016,7050.1
Purchased with funds given by Laura M.
and James A. Duncan

Revisiting his emblematic *Standard
Station* (cat. 56), Ruscha meditates on
the passage of time since the 1960s.
Made at the Mixografía Workshop in Los
Angeles, this print is an inkless white relief.
The dynamism and optimism of America
in the 1960s, when gas ruled as the
unquestioned king of fuel, is replaced by
its present-day ghostly shadow. Ruscha
appears to be suggesting an eclipse
prompted by the fuel crisis, the closure
of gasoline stations and the search for
alternative sources of energy. **sc**

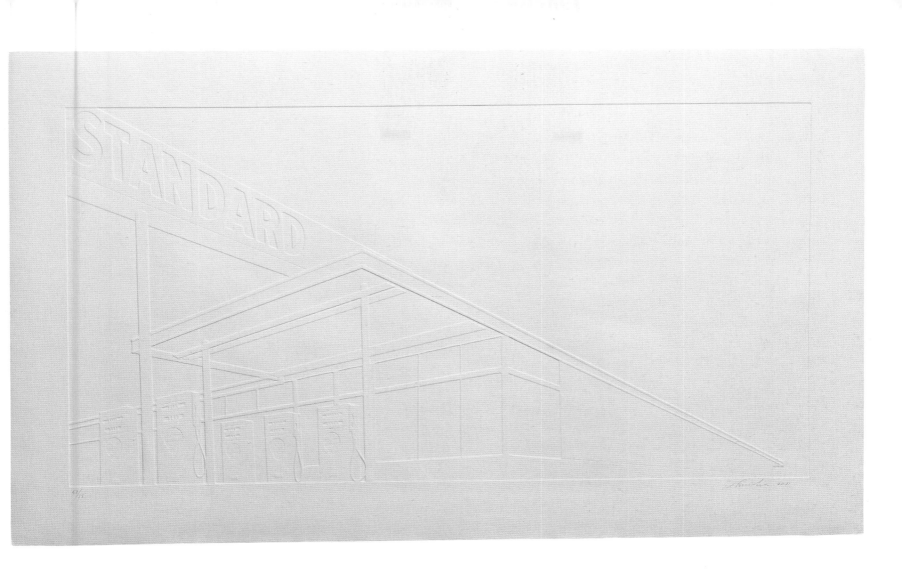

Julie Mehretu

Born 1970

Julie Mehretu was born in Addis Ababa, Ethiopia, but moved as a child with her family to East Lansing, Michigan, in 1977. She studied at Université Cheikh Anta Diop, Dakar, Senegal (1990–91), and graduated with a BA from Kalamazoo College, Michigan (1992), before obtaining an MFA from Rhode Island School of Design, Providence, in 1997. After establishing a studio in New York, Mehretu became known for her large-scale gestural paintings composed of dense layers of acrylic paint overlaid by complex arrangements of expressive marks. Inspired by maps, weather systems, urban landscapes and architectural imagery, her works reflect her interest in history, the growth of cities and global power structures. Although she experimented with printmaking as a student, it was not until 2000 that she made her first edition when she contributed to a benefit portfolio by the New York alternative space Exit Art. She has since made prints with Derrière L'Etoile and Burnet Editions in New York and Crown Point Press in San Francisco. Mehretu uses a similar visual language across her prints, drawings and paintings, which have been collectively described as 'fantastic topographies'.[1] Her work often has a political dimension and war is a recurring theme. In 2002 she made the lithograph *Rogue Ascension*, which dealt with the chaotic aftermath of the 9/11 terrorist attacks on New York, and in 2005 she made a series of prints about the devastation wreaked on New Orleans by Hurricane Katrina. In 2009 the Deutsche Guggenheim, Berlin, staged a major exhibition of Mehretu's work and in July–August 2016 she had her first exhibition in Ethiopia, at the Modern Art Museum: Gebre Kristos Desta Center in Addis Ababa. She currently lives and works in New York. **CD**

1 Siri Engberg, 'Beneath the Surface: Julie Mehretu and Printmaking', in S. Engberg, *Excavations: The Prints of Julie Mehretu*, Minneapolis: Highpoint Editions, 2009, pp. 6–11 (p. 6).

Julie Mehretu
195 *Algorithms/Apparitions/ Translations* 2013
A portfolio of five etchings
Each signed, dated and numbered 'I/IV' (outside ed. 35) in pencil, blindstamp of Burnet Editions, New York. 580 x 755 (22⅞ x 29¾) each plate, 794 x 946 (31¼ x 37¼) each sheet
Presented by Catherine Gatto Harding in memory of Jack Harding on loan from the American Friends of the British Museum

In each of these prints the mass of lines and abstract marks appears to be moving, pulsating and swaying as competing forces pull it forwards and back. Like live satellite pictures relaying information about the weather, the images evoke a sense of flux and turbulence as different shapes and colours appear, then disappear. In the third print scratchy orange and green lines attempt to penetrate the central dark mass. Using different combinations of etching, aquatint, spit-bite, soft-ground, drypoint and engraving, this portfolio was printed by Gregory Burnet and published by Burnet Editions, New York. Speaking about her work in 2003, Mehretu said that she aims to create 'a picture that appears one way from a distance – almost like looking at a cosmology, city, or universe from afar' but then 'shatters into numerous other pictures, stories and events' as you approach it.[1] **CD**

1 'Looking Back: E-mail Interview Between Julie Mehretu and Olukemi Ilesanmi, April 2003', in Julie Mehretu, Douglas Fogle and Olukemi Ilesanmi, *Julie Mehretu: Drawing into Painting*, Minneapolis: Walker Art Center, 2003, pp. 11–16 (p. 11).

1/VI Mehretu 2013

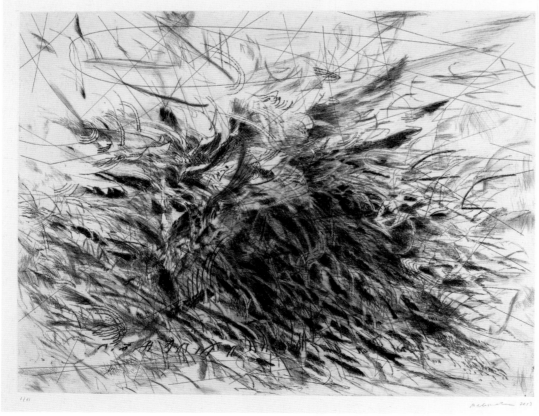

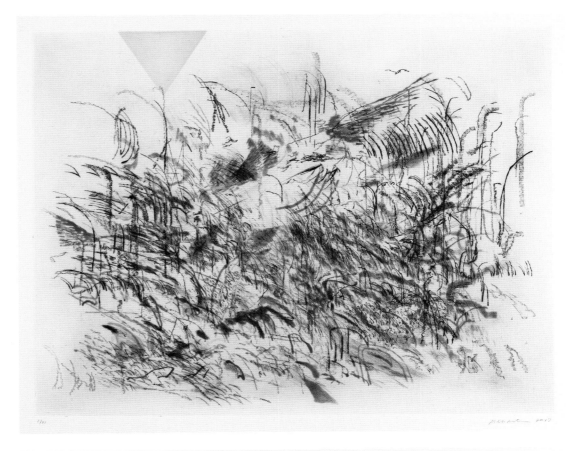

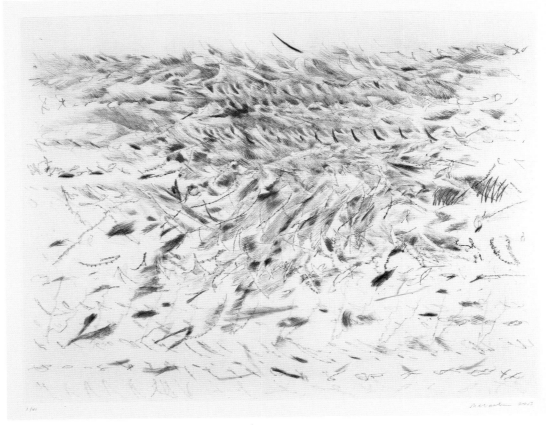

Select bibliography

The literature on American art from the 1960s is vast. The following select bibliography focuses on American printmaking from 1960 to the present day and on specific works covered in this catalogue.

General

Allen, G., *Artists' Magazines: An Alternative Space for Art*, Cambridge, MA, and London: MIT Press, 2011

Armstrong, E., *First Impressions*, Minneapolis: Walker Art Center, 1989

Armstrong, E. et al., *Tyler Graphics: The Extended Image*, New York: Abbeville Press and Minneapolis: Walker Art Center, 1987

Armstrong, E. and M. Goldwater, *Images and Impressions: Painters Who Print*, Minneapolis: Walker Art Center, 1984

Battcock, G., *Minimal Art: A Critical Anthology,* New York: E. P. Dutton, 1968

Berry, I. and J. Shear (eds), *Twice Drawn: Modern and Contemporary Drawings in Context*, Munich, London and New York: Prestel, 2011 **[abr. Berry and Shear]**

Blum, P. and B. Walker, *Scenes and Sequences, Peter Blum Edition, New York: A Selection from 1980 to 2006*, Aarau: Aargauer Kunsthaus, 2007

Breuer, K., R. E. Fine and S. A. Nash, *Thirty-Five Years at Crown Point Press: Making Prints, Doing Art*, Berkeley, Los Angeles and London: University of California Press, 1997

Brodie, J. and A. Greenhalgh, *Yes, No, Maybe: Artists Working at Crown Point Press*, Washington, DC: National Gallery of Art, 2013

Brodie, J., A. Johnston and M. J. Lewis, *Three Centuries of American Prints From the National Gallery of Art*, New York: Thames & Hudson in association with the National Gallery of Art, Washington, 2016

Carey, F. and A. Griffiths, *American Prints 1879–1979*, London: British Museum, 1980

Castleman, R., *Printed Art: A View of Two Decades*, New York: Museum of Modern Art, 1980

Castleman, R., *American Impressions: Prints Since Pollock*, New York: Alfred A. Knopf, 1985

Cherix, C. with K. Conaty and S. Suzuki, *Print/Out: 20 Years in Print*, New York: Museum of Modern Art, 2012

Coppel, S. with the assistance of J. Kierkuc-Bielinski, *The American Scene: Prints from Hopper to Pollock*, London: British Museum, 2008

Devon, M. (ed.), *Tamarind: Forty Years*, Albuquerque, NM: University of New Mexico Press, 2000

Field, R. S. and R. E. Fine, *A Graphic Muse: Prints by Contemporary American Women*, New York: Hudson Hills Press in association with the Mount Holyoke College Art Museum, 1987

Fine, R. E., *Gemini G.E.L.: Art and Collaboration*, Washington, DC: National Gallery of Art and New York: Abbeville Press, 1984 **[abr. Fine 1984]**

Fine, R. E. (ed.), *The 1980s: Prints from the Collection of Joshua P. Smith*, catalogue by C. M. Ritchie with assistance from T. Coolsen, Washington, DC: National Gallery of Art, 1989 **[abr. Fine 1989]**

Fine, R. E. and M. L. Corlett, *Graphicstudio: Contemporary Art from the Collaborative Workshop at the University of South Florida*, Washington, DC: National Gallery of Art, 1991

Gilmour, P., *Ken Tyler, Master Printer, and the American Print Renaissance*, Canberra: Australian National Gallery, 1986

Gott, T., *Don't Leave Me This Way: Art in the Age of Aids,* Canberra: National Gallery of Australia, distributed by Thames & Hudson, 1994

Kinsman, J., *Workshop: The Kenneth Tyler Collection*, Canberra: National Gallery of Australia, 2015

Lippard, L., *Six Years: The Dematerialization of the Art Object from 1966 to 1972* (first published 1973), Berkeley: University of California Press, 1997

Marano, L., *Parasol and Simca: Two Presses/Two Processes,* Lewisburg, PA: Bucknell University, 1984

Peabody, R., A. Perchuk, G. Phillips and R. Singh (eds), *Pacific Standard Time: Los Angeles Art 1945–1980*, London: Tate Publishing in association with the Getty Research Institute and the J. Paul Getty Museum, Los Angeles, 2011

Sidey, T., *Editions Alecto: Original Graphics, Multiple Originals, 1960–1981*, Aldershot; Burlington, VT: Lund Humphries, 2003 **[abr. Sidey]**

Sparks, E., *Universal Limited Art Editions: A History and Catalogue: the First Twenty-five Years*, Chicago: Art Institute of Chicago and New York: Harry N. Abrams, 1989 **[abr. Sparks]**

Stein, D., *Rags to Riches: 25 Years of Paper Art from Dieu Donné Papermill*, with essays by S. Gosin, T. V. Hansen and D. Stein, New York: Dieu Donné Papermill, 2001

Tallman, S., *The Contemporary Print: From Pre-Pop to Postmodern*, London: Thames & Hudson, 1996

Tyler, K. E., *Tyler Graphics: Catalogue Raisonné, 1974–1985*, foreword by E. Armstrong and essay by P. Gilmour, Minneapolis: Walker Art Center and New York: Abbeville Press, 1987 **[abr. Tyler Graphics]**

Weitman, W., *Pop Impressions Europe/ USA: Prints and Multiples from the Museum of Modern Art*, New York: Museum of Modern Art, 1999

Wye, D., *Thinking Print: Books to Billboards, 1980–95,* New York: Museum of Modern Art, 1996 **[abr. Wye 1996]**

Wye, D., *Artists and Prints: Masterworks from the Museum of Modern Art*, New York: Museum of Modern Art, 2004

ARTISTS

Anni Albers

Danilowitz, B. and N. Fox Weber, *The Prints of Anni Albers: A Catalogue Raisonné, 1963–1984*, Bethany, CT: Josef and Anni Albers Foundation and Mexico City: Editorial RM, 2009 **[abr. Danilowitz 2009]**

Fox Weber, N. and P. Tabatabai Asbaghi, *Anni Albers*, New York: Solomon R. Guggenheim Foundation, 1999

www.albersfoundation.org

Josef Albers

Danilowitz, B., *The Prints of Josef Albers: A Catalogue Raisonné 1915–1976*, New York: Hudson Hills Press in association with the Josef and Anni Albers Foundation, 2001 **[abr. Danilowitz 2001]**

Horowitz, F. A. and B. Danilowitz, *Josef Albers: To Open Eyes: The Bauhaus, Black Mountain College and Yale*, London and New York: Phaidon Press, 2006

www.albersfoundation.org

Emma Amos

Farrington, L. E., 'Emma Amos: Art as Legacy', *Woman's Art Journal*, 28:1 (Spring–Summer 2007), 3–11

Hotton, J., 'Emma Amos: Woman of Substance', *Black American Literature Forum*, 19:1, Contemporary Black Visual Artists Issue (Spring 1985), 24–25

www.emmaamos.com

Ida Applebroog

Cohen, R. H., 'Ida Applebroog: Her Books', *Print Collector's Newsletter*, 15:2 (May–June 1984), 49–51

Spears Jones, P., 'Ida Applebroog', *BOMB*, 68 (Summer 1999), 32–39

www.idaapplebroog.com

Richard Artschwager

Armstrong, R., *Artschwager, Richard*, New York: Whitney Museum of American Art, 1988

Gross, J. R., *Richard Artschwager!*, New York: Whitney Museum of American Art, distributed by Yale University Press, New Haven and London, 2012 **[abr. Gross]**

'Richard Artschwager, *Building Riddled with Listening Devices (Alpha), Building Riddled with Listening Devices (Beta)* and *Horizon*, Prints and Photographs Published', *Print Collector's Newsletter*, 21:1 (March–April 1990), 24–25

Weitman, W., *Punctuating Space: The Prints and Multiples of Richard Artschwager*, Poughkeepsie, NY: Frances Lehman Loeb Art Center, Vassar College, 2015 **[abr. Weitman 2015]**

Dotty Attie

'Dotty Attie, *Mother's Kisses*, Prints and Photographs Published', *Print Collector's Newsletter*, 13:2 (May–June 1982), 56

Eric Avery

Bjelajac, D., *Eric Avery: Healing Before Art*, Corpus Christi, TX: Weil Gallery, Corpus Christi State University, 1987

Walker, B., 'An Interview with Eric Avery' in L. Tyler and B. Walker (eds), *Hot off the Press: Prints and Politics*, Albuquerque: University of New Mexico Press for Tamarind Institute, 1994, pp. 71–85
www.docart.com

Jennifer Bartlett
Field, R. S. and S. Scott, *Jennifer Bartlett: A Print Retrospective*, Orlando, FL: Orlando Museum of Art, 1993 **[abr. Field and Scott]**

Robert Bechtle
Brown, K., 'Robert Bechtle', *Overview, Crown Point Press Newsletter* (May 2011), 1–3

Mel Bochner
Bochner, M. and B. Schwabsky, *Monoprints. Mel Bochner: Words, Words, Words…*, New York: Two Palms, 2012
Borchardt-Hume, A. and D. Globus (eds), *Mel Bochner: If the Colour Changes*, London: Whitechapel Art Gallery and Ridinghouse, 2012
Field, R. S. (ed.), *Mel Bochner: Thought Made Visible 1966–1973*, New Haven: Yale University Art Gallery, 1995
Kleeblatt, N. L. and M. Bochner, *Mel Bochner: Strong Language*, New York: The Jewish Museum and New Haven and London: Yale University Press, 2014
Schwabsky, B., 'Reverse Continuity: The Prints of Mel Bochner', *Print Collector's Newsletter*, 25:3 (July–August 1994), 85–88
www.melbochner.net

Richard Bosman
'Richard Bosman, *Man Overboard*, Prints and Photographs Published', *Print Collector's Newsletter*, 12:2 (May–June 1981), 47
'Richard Bosman, *South Seas Kiss*, Prints and Photographs Published', *Print Collector's Newsletter*, 12:5 (Nov–Dec 1981), 149
Stevens, A., *Prints by Richard Bosman*, Madison: Elvehjem Museum of Art, University of Wisconsin, 1989 **[abr. Stevens]**
www.rbosman.com

Louise Bourgeois
Bourgeois, L. and L. Rinder, *Louise Bourgeois Drawings and Observations*, Berkeley: University Art Museum and Pacific Film Archive, University of California, Berkeley, 1995
Liebmann, L., 'Louise Bourgeois, At Last', *Print Collector's Newsletter*, 24:1 (March–April 1993), 7–8
Museum of Modern Art, New York, *Louise Bourgeois: The Complete Prints and Books*, online catalogue, www.moma.org/explore/collection/lb/index [accessed 22 May 2016] **[abr. MoMA]**
Wye, D. and C. Smith, *The Prints of Louise Bourgeois*, New York: Museum of Modern Art, 1994 **[abr. Wye and Smith]**

Vija Celmins
Ratcliff, C., 'Vija Celmins: An Art of Reclamation', *Print Collector's Newsletter*, 14:6 (January–February 1984), 193–96
Relyea, L., R. Gober and B. Fer, *Vija Celmins*, London: Phaidon, 2004
Rippner, S., *The Prints of Vija Celmins*, New York: Metropolitan Museum of Art and New Haven and London: Yale University Press, 2002 **[abr. Rippner]**

Enrique Chagoya
Hickson, P., R. Storr and D. Perez, *Enrique Chagoya: Borderlandia*, Des Moines: Des Moines Art Center, 2007
Kirk Hanley, S., 'Visual Culture of the Nacirema: Enrique Chagoya's Printed Codices', *Art in Print*, 1:6 (March–April 2012), 3–15
Kirk Hanley, S., 'The Recurrence of Caprice: Chagoya's Goyas', *Art in Print*, 3:2 (July–August 2013), 11–19 **[abr. Kirk Hanley]**
www.enriquechagoya.com

Chuck Close
Pernotto, J., *Chuck Close: Editions, A Catalog Raisonné and Exhibition*, Youngstown, OH: Butler Institute of American Art, 1989 **[abr. Pernotto]**
Shapiro, M., 'Changing Variables: Chuck Close & His Prints', *Print Collector's Newsletter*, 9:3 (July–August 1978), 69–73
Storr, R., K. Varnedoe and D. Wye, *Chuck Close*, New York: Museum of Modern Art, 1998

Sultan, T. (ed.), *Chuck Close Prints: Process and Collaboration*, with essay by R. Shiff, Princeton, NJ: Princeton University Press in association with Blaffer Gallery, the Art Museum of the University of Houston, 2003 **[abr. Sultan]**
www.chuckclose.com

Willie Cole
Sims, P., *Anxious Objects: Willie Cole's Favorite Brands*, Montclair, NJ: Montclair Art Museum and Rutgers University Press, 2006
Sims, P., *Willie Cole: Deep Impressions*, Glassboro, NJ: Rowan University Art Gallery, 2012
Weitman, W., 'New Concepts in Printmaking 2: Willie Cole', *MoMA*, 1:3 (June 1998), 32–34
www.williecole.com

Willem de Kooning
Graham, L., *The Prints of Willem de Kooning: A Catalogue Raisonné, 1957–1971*, Paris: Baudoin Lebon éditeur, 1991 **[abr. Graham]**
www.dekooning.org

Richard Diebenkorn
Nordland, G., *Richard Diebenkorn: Graphics, 1981–1988*, Billings, MT: Yellowstone Art Center, 1989
Stevens, M., *Richard Diebenkorn: Etchings and Drypoints, 1949–1980*, Houston: Houston Fine Art Press, 1981

Jim Dine
Ackley, C. and P. Murphy, *Jim Dine Printmaker: Leaving My Tracks*, Boston: Museum of Fine Arts, 2012
Carpenter, E., *Jim Dine Prints, 1985–2000: A Catalogue Raisonné*, with an essay by J. Ruzicka, Minneapolis: Minneapolis Institute of Arts, 2002
Jim Dine: Complete Graphics, Berlin: Galerie Mikro, 1970 **[abr. Mikro]**
Dine, J., *A Printmaker's Document*, Göttingen: Steidl, 2013
Krens, T., *Jim Dine Prints: 1970–1977*, Williamstown, MA, and New York: Williams College Museum of Art and Harper & Row, 1977 **[abr. Krens]**

Carroll Dunham
Brintzenhofe, K. S., 'Carroll Dunham: In Progress to 'Red Shift'', *Print Collector's Newsletter*, 19:6 (January–February 1989), 217–20

Kemmerer, A. N., E. C. DeRose and C. Dunham, *Carroll Dunham Prints: Catalogue Raisonné, 1984–2006*, New Haven: Yale University Press in association with Addison Gallery of American Art, Phillips Academy, Andover, MA, 2008 **[abr. Kemmerer]**
Tallman, S., 'Hot Pink Souls Ice: The Printed Work of Carroll Dunham', *Art on Paper*, 5:4 (March–April 2001), 44–53
www.carrolldunham.net

Richard Estes
Arthur, J., 'Richard Estes: The Urban Landscape in Print', *Print Collector's Newsletter*, 10:1 (March–April 1979), 12–15
Arthur, J., *Richard Estes: Paintings and Prints*, San Francisco: Pomegranate Artbooks, 1993

Öyvind Fahlström
Avery-Fahlström, S., *Öyvind Fahlström: The Complete Graphics, Multiples and Sound Works*, with an essay by M. Kelley and foreword by C. Kintisch, Vienna: BAWAG Foundation, 2001 **[abr. Avery-Fahlström]**
Coulson, A., 'Mapping History', *Art on Paper*, 9:5 (May–June 2005), 58–61
Kuspit, D. B., 'Öyvind Fahlstrom's Political Puzzles', *Art in America*, 4 (April 1982), 106–11
www.fahlstrom.com

Eric Fischl
Baker, K., 'Eric Fischl: "Year of the Drowned Dog"', *Print Collector's Newsletter*, 15:3 (July–August 1984), 81–84
'Eric Fischl, *Year of the Drowned Dog*, Prints and Photographs Published', *Print Collector's Newsletter*, 14:5 (November–December 1983), 174
Glenn, C. W. and J. K. Bledsoe (eds), *Eric Fischl: Scenes Before the Eye. The Evolution of Year of the Drowned Dog and Floating Islands*, Long Beach, CA: University Art Museum, California State University, Long Beach, 1986
www.ericfischl.com

Sam Francis
Lembark, C., *The Prints of Sam Francis: A Catalogue Raisonné, 1960–1990*, with introduction by R. E. Fine, 2 vols, New York: Hudson Hills Press, 1992 **[abr. Lembark]**
www.samfrancis.com

Helen Frankenthaler

Fine, R. E., *Helen Frankenthaler: Prints*, Washington, DC: National Gallery of Art, 1993

Frankenthaler, H., 'The Romance of Learning a New Medium for an Artist', *Print Collector's Newsletter*, 8:3 (July–August 1977), 66–67

Frankenthaler, H., N. Hawkins, V. Patterson, S. Earle and T. Krens, *Helen Frankenthaler Prints: 1961–1979*, New York and London: Harper & Row, 1980

Goldman, J., *Frankenthaler: The Woodcuts*, New York and Naples, FL: George Braziller, Inc. and Naples Museum of Art, 2002

Harrison, P., *Frankenthaler: A Catalogue Raisonné, Prints, 1961–1994*, with introduction by S. Boorsch, New York: Harry N. Abrams, 1996 **[abr. Harrison]**

General Idea

Bordowitz, G., *General Idea: Imagevirus*, London: Afterall, 2010

Fischer, B., *General Idea Editions, 1967–1995*, Toronto: Blackwood Gallery, University of Toronto, 2003 **[abr. Fischer]**

General Idea, *General Idea: Multiples. Catalogue Raisonné, Multiples and Prints, 1967–1993*, Toronto: S. L. Simpson Gallery, 1993

Guerrilla Girls

Guerrilla Girls and Whitney Chadwick, *Confessions of the Guerrilla Girls*, New York: Harper Perennial, 1995

www.guerrillagirls.com

Philip Guston

Semff, M. (ed.), *Philip Guston: Prints: Catalogue Raisonné*, Munich: Sieveking Verlag, 2015 **[abr. Semff]**

Serota, N. (ed.), *Philip Guston Paintings 1969–80*, London: Whitechapel Art Gallery, 1982

Keith Haring

Gundel, M., *Keith Haring: Short Messages: Posters*, with a catalogue raisonné of posters by Claus von der Osten, Munich, Berlin, London and New York: Prestel, 2002 **[abr. Gundel]**

Littmann, K. (ed.), *Keith Haring: Editions on Paper, 1982–1990: The Complete Printed Works*, paperback edn, Stuttgart: Hatje Cantz, 1997

David Hockney

Brighton, A., *David Hockney Prints, 1954–77*, London: Midland Group and the Scottish Arts Council in association with Petersburg Press, 1979 **[abr. Brighton]**

Jenny Holzer

Jenny Holzer: War Paintings, with essay by J. Craze, Cologne: Walther König, 2015

Hughes, G., 'Power's Script: Or, Jenny Holzer's Art after "Art after Philosophy"', *Oxford Art Journal*, 29:3 (2006), 419, 421–40

Joselit, D., J. Simon and R. Salecl, *Jenny Holzer*, London: Phaidon, 1998

Yvonne Jacquette

Faberman, H., *Aerial Muse: The Art of Yvonne Jacquette*, New York: Hudson Hills Press, 2002 **[abr. Faberman]**

Henderson Fahnestock, A. and V. Katz, *Picturing New York: The Art of Yvonne Jacquette and Rudy Burckhardt*, New York: Bunker Hill Publishing for the Museum of the City of New York, 2008

Karney, J., D. Piech and M. Ryan, *Yvonne Jacquette: The Complete Woodcuts, 1987–2009*, New York: Mary Ryan Gallery, 2009

Ratcliff, C., 'Yvonne Jacquette: American Visionary', *Print Collector's Newsletter*, 12:3 (July–August 1981), 65–68

Jasper Johns

Field, R. S., *Jasper Johns: Prints 1960–1970*, Philadelphia: Philadelphia Museum of Art, 1970 **[abr. Field 1970]**

Field, R. S., *Jasper Johns: Prints 1970–1977*, Middletown, CT: Wesleyan University Press, 1978

Field, R. S., *The Prints of Jasper Johns, 1960–1993: A Catalogue Raisonné*, West Islip, NY: Universal Limited Art Editions, 1994 **[abr. ULAE 1994]**

Geelhaar, C. *Jasper Johns Working Proofs*, London: Petersburg Press, 1980

Kozloff, M., *Jasper Johns*, New York: Harry N. Abrams, 1967

Steinberg, L., 'Jasper Johns: The First Seven Years of his Art' in L. Steinberg, *Other Criteria: Confrontations with Twentieth-Century Art*, New York and Oxford: Oxford University Press, 1972, pp. 17–54

Varnedoe, K. and C. Hollevoet (eds), *Jasper Johns: Writings, Sketchbook Notes, Interviews*, New York: Museum of Modern Art, 1996

Donald Judd

Judd, D., *Complete Writings 1959–1975*, Halifax: Press of the Nova Scotia College of Art and Design and New York: New York University Press, 1975

Schellmann, J. and M. J. Jitta, *Donald Judd, Prints and Works in Editions: A Catalogue Raisonné*, 2nd revised edn, Munich and New York: Edition Schellmann, 1996 **[abr. Schellmann and Jitta]**

www.juddfoundation.org

Alex Katz

Coffey, J. W., *Making Faces: Self-Portraits by Alex Katz*, Raleigh, NC: North Carolina Museum of Art, 1990

Maravell, N. P., *Alex Katz: The Complete Prints*, New York and London: Alpine Fine Arts, 1983

Schröder, K. A., M. Mautner Markhof and G. Bauer (eds), *Alex Katz Prints: Catalogue Raisonné, 1947–2011*, Vienna: Albertina and Hatje Cantz, 2011 **[abr. Schröder, Markhof and Bauer]**

Walker, B., *Alex Katz: A Print Retrospective*, New York: The Brooklyn Museum in association with Burton Skira, Inc., 1987

www.alexkatz.com

Ellsworth Kelly

Axsom, R., *The Prints of Ellsworth Kelly: A Catalogue Raisonné*, Portland, OR: Jordan Schnitzer Family Foundation, 2012 **[abr. Axsom 2012]**

Sol LeWitt

Legg, A. (ed.), *Sol LeWitt*, with essays by L. Lippard, B. Rose and R. Rosenblum, New York: Museum of Modern Art, 1978

Lewison, J., *Sol LeWitt: Prints 1970–86*, London: Tate Gallery, 1986 **[abr. Lewison 1986]**

LeWitt, S., 'Paragraphs on Conceptual Art', *Artforum*, 5:10 (Summer 1967), 79–84

Maffei, G. and E. De Donno, *Sol LeWitt: Artist's Books*, with texts by D. Bozzini, C. Metelli and M. Bonomo, Foligno: Edizioni Viaindustriae, 2009

www.sollewittprints.org (organized by the Barbara Krakow Gallery, Boston, MA) **[abr. Krakow]**

Roy Lichtenstein

Coplans, J. (ed.), *Roy Lichtenstein*, London: Allen Lane, Documentary Monographs in Modern Art, 1974

Corlett, M. L., *The Prints of Roy Lichtenstein: A Catalogue Raisonné 1948–1997*, with introduction by R. E. Fine, 2nd revised edn, New York: Hudson Hills Press in association with the National Gallery of Art, Washington, DC, 2002 **[abr. Corlett]**

Cowart, J., *Roy Lichtenstein 1970–1980*, London: Petersburg Press in association with the Saint Louis Art Museum, 1982

Rondeau, J. and S. Wagstaff, *Roy Lichtenstein: A Retrospective*, London: Tate in association with the Art Institute of Chicago, 2012

www.lichtensteinfoundation.org

Glenn Ligon

Ligon, G., *A People on the Cover*, London: Ridinghouse, 2015

Rothkopf, S., *Glenn Ligon: AMERICA*, New York: Whitney Museum of American Art, distributed by Yale University Press, New Haven and London, 2011

Robert Longo

Longo, R. and C. Sherman, *Robert Longo – Men in the Cities – Photographs, 1976–1982*, Munich: Schirmer/Mosel, 2009

Ratcliff, C., 'Robert Longo: The City of Sheer Image', *Print Collector's Newsletter*, 14:3 (July–August 1983), 95–98

'Robert Longo, *Cindy, Eric*, Prints and Photographs Published', *Print Collector's Newsletter*, 16:1 (March–April 1985), 19

www.robertlongo.com

Lee Lozano

Müller-Westermann, I. (ed.), *Lee Lozano*, with essays by J. Applin, B. Meyer-Krahmer, L. Lippard and I. Müller-Westermann, Stockholm: Moderna Museet and Ostfildern: Hatje Cantz, 2010

Szymczyk, A. (ed.), *Lee Lozano: Win First Dont Last, Win Last Dont Care*, Basel: Kunsthalle Basel, 2006

Craig McPherson
Hartley, C., *Darkness Into Light: Craig McPherson and the Art of Mezzotint*, Cambridge: Fitzwilliam Museum, 1998 [abr. Hartley]
www.craigmcpherson.net

Brice Marden
Lewison, J., *Brice Marden: Prints, 1961–1991: A Catalogue Raisonné*, London: Tate Gallery, 1992 [abr. Lewison 1992]

Julie Mehretu
Brown, K., 'The Artist as Urban Geographer: Mark Bradford and Julie Mehretu', *American Art*, 24:3 (Autumn 2010), 100–13
Engberg, S., *Excavations: The Prints of Julie Mehretu*, Minneapolis: Highpoint Editions, 2009
Mehretu, J., D. Fogle and O. Ilesanmi, *Julie Mehretu: Drawing into Painting*, Minneapolis: Walker Art Center, 2003
Young, J., B. Dillon and A. Balfour, *Julie Mehretu: Grey Area*, Berlin: Deutsche Guggenheim, 2009

Robert Motherwell
Belknap, D. C. and S. Terenzio, *The Prints of Robert Motherwell: A Catalogue Raisonné*, 1984; New York: Hudson Hills in association with the American Federation of Arts; revised edn, 1991 [abr. Belknap]
Motherwell, R. and S. Terenzio, *The Collected Writings of Robert Motherwell*, New York: Oxford University Press, 1992

Bruce Nauman
Cordes, C., *Bruce Nauman: Prints 1970–89: A Catalogue Raisonné*, with essay by J. Yau, New York: Castelli Graphics, Lorence Monk Gallery and Chicago: Donald Young Gallery, 1989 [abr. Cordes]

Claes Oldenburg
Axsom, R. H. and D. Platzker, *Printed Stuff: Prints, Posters and Ephemera by Claes Oldenburg: A Catalogue Raisonné 1958–1996*, New York: Hudson Hills Press in association with Madison Art Center, Wisconsin, 1997 [abr. Platzker]

Celant, G., C. Oldenburg and C. van Bruggen, *A Bottle of Notes and Some Voyages: Claes Oldenburg Coosje van Bruggen*, Sunderland: Northern Centre for Contemporary Art and Leeds: Henry Moore Centre for the Study of Sculpture, Leeds City Art Gallery, 1988
Oldenburg, C., *Store Days. Documents from the Store (1961) and Ray Gun Theater (1962)*, New York: Something Else Press, 1967
www.oldenburgvanbruggen.com

Philip Pearlstein
Adrian, D., 'The Prints of Philip Pearlstein', *Print Collector's Newsletter*, 4:3 (July–August 1973), 49–52
Field, R. S., *The Lithographs and Etchings of Philip Pearlstein*, Springfield, MO: Springfield Art Museum, 1978 [abr. Field]

Mel Ramos
www.melramos.com

Robert Rauschenberg
Foster, E. A., *Robert Rauschenberg: Prints 1948–1970*, Minneapolis: Minneapolis Institute of Arts, 1970 [abr. Foster 1970]
Mattison, R. S., *Robert Rauschenberg: Breaking Boundaries*, New Haven and London: Yale University Press, 2003
Rauschenberg, R., 'Notes on Stoned Moon', *Studio International*, 178:917 (December 1969), 246–47
Rauschenberg, R., *Rauschenberg: Cardbirds*, Los Angeles: Gemini G.E.L., 1971
Tomkins, C., *Off the Wall: Robert Rauschenberg and the Art World of Our Time*, New York: Penguin Books, 1980
Young, J. E., 'Pages and Fuses: An extended view of Robert Rauschenberg', *Print Collector's Newsletter*, 5:2 (May–June 1974), 25–30
www.rauschenbergfoundation.org

Edda Renouf
Edda Renouf: Etchings and Aquatints, 1974–1994, with introduction by A. Dagbert, Toulouse: Editions Sollertis and New York: Parasol Press, 1994 [abr. Sollertis/ Parasol Press]

Renouf, E., J. Westmacott and B. Konau, *Edda Renouf: Revealed Structures*, Washington, DC: National Museum of Women in the Arts and Gainsville, GA: Brenau University Galleries, 2004
Studinger, E., R. Denizot, R. E. Fine and G. Reising, *Edda Renouf: Werke 1972–1997/Oeuvres/Works*, Karlsruhe: Staatliche Kunsthalle and Ostfildern: Hatje Cantz, 1997
www.eddarenouf.com

James Rosenquist
Geldzahler, H., 'James Rosenquist's F-111', *Metropolitan Museum of Art Bulletin*, 26:7 (March 1968), 277–81
Glenn, C. W., *Time Dust, James Rosenquist: Complete Graphics, 1962–1992*, New York: Rizzoli, 1993 [abr. Glenn]
Rosenquist, J., *Painting Below Zero: Notes on a Life in Art*, New York: Alfred A. Knopf, 2009

Susan Rothenberg
Ackley, C. S., '"I Don't Really Think of Myself as a Printmaker": Susan Rothenberg', *Print Collector's Newsletter*, 15:4 (September–October 1984), 128–29
Robertson Maxwell, R., *Susan Rothenberg: The Prints*, with contributions by J. Lewison, W. Weitman and K. Brintzenhofe, Philadelphia: Peter Maxwell, 1987 [abr. Maxwell]

Ed Ruscha
Benezra, N. and K. Brougher, *Ed Ruscha*, with a contribution by P. Rosenzweig, Washington, DC: Hirshhorn Museum and Sculpture Garden and Oxford: Museum of Modern Art, 2000
Bogle, A., *Graphic Works by Edward Ruscha*, Auckland: Auckland City Art Gallery, 1978
Breuer, K. with K. Brougher and D. J. Waldie, *Ed Ruscha and the Great American West*, San Francisco: Fine Arts Museums of San Francisco and University of California Press, 2016
Engberg, S. and C. Phillpot, *Edward Ruscha: Editions, 1959–1999: Catalogue Raisonné*, 2 vols, Minneapolis: Walker Art Center, 1999 [abr. Engberg]

Ruscha, E., *Leave Any Information at the Signal: Writings, Interviews, Bits, Pages*, ed. by A. Schwartz, Cambridge, MA, and London: MIT Press, 2002
Turvey, L., *Edward Ruscha. Catalogue Raisonné of the Works on Paper, Volume One: 1956–1976*, New York: Gagosian Gallery, distributed by Yale University Press, 2014 [abr. Turvey]
www.edruscha.com

Fred Sandback
Prokopoff, S., 'An Interview: Fred Sandback and Stephen Prokopoff' in *The Art of Fred Sandback: A Survey*, Champaign-Urbana, IL: Krannert Art Museum, University of Illinois, 1985, n.p., www.fredsandbackarchive.org/ [accessed 13 July 2016]
Field, R. S., 'Fred Sandback: Drawings and Prints' in *Fred Sandback: Sculpture*, New Haven: Yale University Art Gallery and Houston: Contemporary Arts Museum, 1991
Jahn, F., *Fred Sandback: Die gesamte Grafik*, Munich: Galerie Fred Jahn in association with Städtisches Museum Leverkusen, Schloss Morsbroich, 1987 [abr. Jahn]
Sandback, F., 'Lines of Inquiry: Interview by Joan Simon', *Art in America*, 85:5 (May 1997), 86–93, 143
www.fredsandbackarchive.org

Richard Serra
Berswordt-Wallrabe, S. von and S. Breidenbach, *Richard Serra Prints: Catalogue Raisonné 1972–1999*, Düsseldorf: Richter, 1999 [abr. Berswordt-Wallrabe and Breidenbach]
Rosenthal, Mark, 'Interview' in *Richard Serra: Drawings and Etchings from Iceland*, New York: Matthew Marks Gallery, 1992, n.p.

Kiki Smith
Bird, J. (ed.), *Otherworlds: The Art of Nancy Spero and Kiki Smith*, London: Reaktion Books, 2003
Weitman, W., *Kiki Smith: Prints, Books and Things*, New York: Museum of Modern Art, 2003 [abr. Weitman 2003]

Weitman, W., 'Emerging Images: The Creative Process in Prints', IPCNY10, EBrochure www.ipcny.org/sandbox/wp-content/uploads/2014/06/EIbrochure.pdf [accessed 16 May 2016]

Keith Sonnier

'Keith Sonnier, *Control Scene*, Prints and Portfolios Published', *Print Collector's Newsletter*, 6:4 (September–October, 1975), 108

www.keithsonnier.net

Frank Stella

Auping, M., *Frank Stella: A Retrospective*, with essays by J. Kantor and A. D. Weinberg and an interview by L. Owens, New Haven and London: Yale University Press in association with Whitney Museum of American Art, New York, and the Modern Art Museum of Fort Worth, 2015

Axsom, R. H. with L. Kolb, *Frank Stella Prints: A Catalogue Raisonné*, New York: Jordan Schnitzer Family Foundation in association with the Madison Museum of Contemporary Art, 2016 **[abr. Axsom 2016]**

Rubin, W., *Frank Stella 1970–1987*, New York: Museum of Modern Art, 1987

May Stevens

Alloway, L., *May Stevens*, Ithaca, NY: Herbert F. Johnson Museum of Art, Cornell University, 1973

Hills, P., *May Stevens*, San Francisco: Pomegranate, 2005

Donald Sultan

Henry, G., 'Donald Sultan: His Prints', *Print Collector's Newsletter*, 16:6 (January–February 1986), 193–96

Meyers, M., *Sean Scully/Donald Sultan: Abstraction/Representation: Paintings, Drawings and Prints from the Anderson Collection*, Stanford, CA: Stanford University Art Gallery, 1990

Walker, B., *Donald Sultan: A Print Retrospective*, New York: American Federation of Arts in association with Rizzoli, 1992 **[abr. Walker]**

www.donaldsultanstudio.com

Al Taylor

Loock, U. and A. Taylor, *Al Taylor*, Bern: Kunsthalle Bern, 1992

Semff, M., D. Taylor and M. Thompson, *Al Taylor, Prints: Catalogue Raisonné*, Ostfildern: Hatje Cantz, 2013 **[abr. Semff]**

Wayne Thiebaud

Denker, E., *The Icing on the Cake: Selected Prints by Wayne Thiebaud*, Washington, DC: Corcoran Gallery of Art, 2001

Lewallen, C., 'Interview with Wayne Thiebaud, August 1989', *View, Crown Point Press,* 6:6 (Winter 1990), 1–23

Sullivan Maynes, E., *Wayne Thiebaud: By Hand, Works on Paper from 1965–2015*, with interview by D. Cartwright, San Diego: Robert and Karen Hoehn Family Galleries, Founders Hall, University of San Diego, 2015

Wayne Thiebaud Graphics 1964–1971 (catalogue of travelling exhibition at Whitney Museum of American Art, New York, and elsewhere), New York: Parasol Press, 1971 **[abr. Whitney 1971]**

Wilmerding, J., *Wayne Thiebaud*, with essay by P. Karmel, New York: Acquavella and Rizzoli, 2012

Cy Twombly

Bastian, H., *Cy Twombly: Das Graphische Werk 1953–1984*, Munich and New York: Edition Schellmann, 1984 **[abr. Bastian]**

www.cytwombly.info

Kara Walker

Dubois Shaw, G., *Seeing the Unspeakable: The Art of Kara Walker*, Durham, NC, and London: Duke University Press, 2004

Andy Warhol

Castleman, R., *The Prints of Andy Warhol*, New York: The International Council of the Museum of Modern Art and Jouy-en-Josas: Cartier Foundation for Contemporary Art, 1990

Feldman, F. and J. Schellmann, *Andy Warhol Prints: A Catalogue Raisonné 1962–1987*, 3rd edn revised and expanded by F. Feldman and C. Defendi, Munich and New York: Edition Schellmann at Schirmer/Mosel Verlag in association with Ronald Feldman Fine Arts, Andy Warhol Foundation for the Visual Arts, 1997 **[abr. Feldman and Schellmann]**

Frei, G. and N. Printz (eds.), *The Andy Warhol Catalogue Raisonné: Paintings and Sculptures, Volume 2A 1964–1969*, London and New York: Phaidon, 2004

Goldsmith, K. (ed.), *I'll Be Your Mirror: The Selected Andy Warhol Interviews*, with introduction by R. Wolf, New York: Carroll & Graf, 2004

McShine, K. (ed.), *Andy Warhol: A Retrospective*, with essays by K. McShine, R. Rosenblum, B. H. D. Buchloh and M. Livingstone, New York: Museum of Modern Art, 1989

Warhol, A., *America*, 1985; London: Penguin Books, 2011

The Andy Warhol Diaries, ed. P. Hackett, 1989; London: Penguin Books, 2010

Warhol, A. and P. Hackett, *POPism: The Warhol Sixties*, 1980; London: Penguin Books, 2007

www.warholfoundation.org

Tom Wesselmann

Livingstone, M., *Tom Wesselmann: Still Life, Nude, Landscape: The Late Prints*, London: Alan Cristea Gallery, 2013

Stealingworth, S. (T. Wesselmann), *Tom Wesselmann*, New York: Abbeville Press, 1980

Wesselmann, T., *Tom Wesselmann: Graphics 1964–1977. A Retrospective of Work in Edition Form*, with an introduction by T. J. Fairbrother, Boston: Institute of Contemporary Arts, 1978

Wilmerding, J., *Tom Wesselmann: His Voice and Vision*, New York: Rizzoli, 2008

www.tomwesselmannestate.org

David Wojnarowicz

Carr, C., *Fire in the Belly: The Life and Times of David Wojnarowicz*, New York: Bloomsbury USA, 2014

Scholder, A. (ed.), *Fever: The Art of David Wojnarowicz*, New York: Rizzoli, 1998

Glossary

The main printmaking techniques and terms referred to in this publication are described below. Fuller explanations are given in Antony Griffiths, *Prints and Printmaking: An Introduction to the History and Techniques* (1980), 2nd edn, London: British Museum Press, 1996 (reprinted with revisions 2010); and Paul Goldman, *Looking at Prints, Drawings and Watercolours: A Guide to Technical Terms* (1988), 2nd edn, London: British Museum Press, 2006.

Aquatint

A variety of *etching* used to create tone, originally to imitate the effect of a watercolour wash. Within a dust-box, fine resin particles are shaken and allowed to fall as a thin layer on to a metal plate; this is then heated until the resin melts and fuses to the surface, forming a porous ground. During immersion in an acid bath, the acid bites into the minute channels around each resin particle. These hold sufficient ink to print as an even tone. Highlights can be obtained by 'stopping out' with an acid-resistant varnish (see under *etching*), or by burnishing down.

Drypoint

The line is drawn directly into a metal plate with a sharp point held like a pencil, which throws up a metal burr along the incision. Ink is retained in the burr, producing a rich, feathery line when printed. Because the burr wears down easily under pressure from the press, only a few impressions showing the full richness of the drypoint line can be pulled. The plate is sometimes steel-faced to protect the burr from wearing and so allow a larger number of impressions to be printed.

Engraving

Lines are cut cleanly and directly into the bare metal plate using a V-shaped tool called a *burin*. The lines hold the ink, and the plate is printed in intaglio (*q.v.*).

Etching

A needle is used to draw freely through a hard, waxy acid-resistant ground covering the metal plate. The exposed metal is then 'bitten' by acid, creating the lines. This is done by immersing the plate in an acid bath; the longer the acid bites, the deeper the lines become and hence the darker they print. The plate can be bitten to different depths by 'stopping out' the lighter lines with a varnish before returning the plate to the bath. The ground is then cleaned off before printing in intaglio (*q.v.*).

Intaglio printmaking

The traditional hand-drawn techniques of *etching*, *aquatint*, *drypoint*, *engraving* and *mezzotint* are all intaglio processes. The methods of printing are the same, although the appearance given by each technique is different. The basic principle is that the line is incised into the metal plate, which is usually copper or zinc. Ink is rubbed with a dabber into the recessed lines and the surface of the plate wiped clean. Printing is achieved by placing a sheet of dampened paper over the inked plate, which is then passed through the press under heavy pressure. Characteristic of intaglio printmaking is the plate mark impressed into the paper.

Linocut

The same process as for *woodcut*, except that linoleum is used instead of wood.

Lithography

The technique of printing from stone or specially prepared zinc plates that relies on the antipathy of grease and water. An image is drawn on the printing surface with a greasy medium, such as crayon or a lithographic ink containing grease, known as *tusche*. The printing surface is then dampened so that when greasy ink is applied it will adhere only to the drawn image and will be repelled by water covering the rest of the stone or plate. The ink is transferred to a sheet of paper by passing paper and printing surface together through a flat-bed scraper press.

Mezzotint

An intaglio process that works from dark to light by scraping down a metal plate initially roughened with a serrated rocker tool to give the metal a 'tooth' that can hold ink. The entire plate prints black at the start. Areas are scraped and burnished so that they hold less ink, creating lighter parts of the design.

Monotype

A flat surface, such as a piece of glass or an unworked metal plate, is painted with ink by the artist and printed. Only one strong impression can be printed; a second, weaker impression can sometimes be taken from the residual ink.

Open-bite

An intaglio process in which unprotected areas of the plate are brushed with acid to produce a subtle light tone. The character of the biting can also be affected by applying the acid with a brush dipped in human saliva (known as *spit-bite*) to control the flow of acid.

Photogravure

A general term for an intaglio printing process in which a line image is transferred to the metal surface of the plate by photographic means prior to etching it with acid; also called *photo-etching*. The term 'photogravure' is also applied to the photographic intaglio process used to produce a continuous tone image. The metal plate is coated with a light-sensitive gelatine and the photographic image exposed to light. Areas exposed to light harden, while the unexposed areas remain soft. The plate is then etched in the usual way. The tone on the plate is given by a layer of aquatint applied beforehand.

Proof

An impression outside the edition, usually pulled during the process of working on the plate and sometimes called a *trial proof*. An *artist's proof* is one from a small number of impressions reserved for the artist outside the edition. A *printer's proof* is sometimes also pulled outside the edition and retained by the printer.

Screenprint (also called silkscreen)

A mesh is attached tautly to a frame to form a screen, and a stencil, made of cut paper or film, or a photographically developed film of gelatine, is fixed to the mesh, masking it in some places and leaving it open elsewhere for the passage of ink. To make a print, a sheet of paper is placed underneath the frame, and ink is forced through the screen with a rubber blade known as a *squeegee*. Most screenprints use multiple screens to build up colour.

Soft-ground etching

A drawing is made on a sheet of paper laid on to a plate covered with a crumbly, soft ground. The ground clings to the underside of the paper when the sheet is lifted, exposing the plate wherever contact has taken place. The plate is then etched in the usual way.

States

While the artist is developing the image on the plate, proofs are taken in order to help the artist decide what further work is needed. These proofs in the development of the print are known as *states*.

Sugar-lift aquatint

A type of aquatint that allows the artist to produce the design in positive brushstrokes. After the plate has been prepared with resin, the image is brushed on to the plate using a special fluid containing sugar. When almost dry the plate is covered with an acid-resistant 'stopping-out' varnish and immersed in a bath of warm water. As the sugar swells in the water it causes the varnish to lift, revealing the artist's original resin-covered drawing. The plate is now ready to be 'bitten' by acid in the usual way, while the 'stopping-out' varnish protects the non-drawn areas of the plate.

Woodcut

A block, usually of plank wood revealing the grain, is cut with chisels and gouges so that the areas to be inked stand in relief. Ink is then rolled on to the surface of the block, which is printed on to a sheet of paper, either in a press under vertical pressure or by hand-rubbing the back of the paper.

Wood-engraving

A version of *woodcut*, in which a very hard wood, like box-wood, cut across the grain, is used. The close grain of the end-block permits the cutting of very fine lines; these are achieved with a *graver* tool that is similar to the engraver's *burin*. This enables work of greater detail to be created than in a woodcut. It is then printed from the surface of the block like a woodcut.

Picture credits

Piecing together the American Dream
Fig. 1 © 2016 The Andy Warhol Foundation for the Visual Arts, Inc./ Artists Rights Society (ARS), New York and DACS, London
Figs 2, 3 © Jasper Johns/VAGA, New York/DACS, London 2016. © 2016. Digital Image, The Museum of Modern Art, New York/Scala, Florence
Figs 4, 5 Reproduced by permission of the artist
Fig. 6 © Fred Wilson, courtesy Pace Gallery
Fig. 7 Photograph by Gregory Burnet

Irresistible: the rise of the American print workshop
Fig. 1 © ADAGP, Paris and DACS, London 2016
Fig. 2 © Universal Limited Art Editions
Fig. 3 © Jasper Johns/VAGA, New York/DACS, London 2016. Image © Jasper Johns/Universal Limited Art Editions/ Licenced by VAGA, New York, NY
Fig. 4 Tamarind Lithography Workshop records, 1954–1984/Archives of American Art, Smithsonian Institution
Fig. 5 © Patrick Dullanty. Image courtesy Crown Point Press
Fig. 6 © Marvin Bolotsky. Courtesy Sragow Gallery, NYC
Fig. 7 © The Josef and Anni Albers Foundation/VG Bild-Kunst, Bonn and DACS, London 2016. Image courtesy of National Gallery of Art, Washington

Fig. 8 Courtesy the artist; Craig Krull Gallery, Los Angeles and The Getty Research Institute, Los Angeles. Malcolm Lubliner
Fig. 9 Photograph by Peter Balwan. National Gallery of Australia, Canberra. Gift of Kenneth Tyler, 2002
Fig. 10 © Kathan Brown. Image courtesy Crown Point Press
Fig. 11 Photograph by Gianfranco Gorgoni. National Gallery of Australia, Canberra. Gift of Kenneth Tyler, 2002
Fig. 12 Photograph by Lindsay Green. National Gallery of Australia, Canberra. Gift of Kenneth Tyler, 2002
Fig. 13 Photograph by Gregory Burnet

Section 1
1 © 2016 The Andy Warhol Foundation for the Visual Arts, Inc./Artists Rights Society (ARS), New York and DACS, London. Image © Tate, London 2016
2 © 2016 The Andy Warhol Foundation for the Visual Arts, Inc./Artists Rights Society (ARS), New York and DACS, London
3 © 2016 The Andy Warhol Foundation for the Visual Arts, Inc./Artists Rights Society (ARS), New York and DACS, London. Image courtesy of Sotheby's
4 (and frontispiece) © James Rosenquist/DACS, London/VAGA, New York 2016
5 © 1976 Claes Oldenburg
6 © 1970 Claes Oldenburg. Image © Tate, London 2016
7 © 1980 Claes Oldenburg and Coosje van Bruggen. Image © Tate, London 2016
8 © Estate of Roy Lichtenstein/DACS 2016
9, 10 (and detail page 34) © Estate of Roy Lichtenstein/DACS 2016 © 2016. Digital image, The Museum of Modern Art, New York/Scala, Florence
11, 12 © Estate of Tom Wesselmann/ DACS, London/VAGA, NY 2016
13 © Mel Ramos. DACS, London/VAGA, New York 2016

Section 2
14, 15, 18, 19, 24 © Jasper Johns/ VAGA, New York/DACS, London 2016

16, 17, 21, 22, 23 © Jasper Johns/ VAGA, New York/DACS, London 2016. Image Tom Powel imaging
20 © Jasper Johns/VAGA, New York/ DACS, London 2016. Image Victoria and Albert Museum, London
25, 26, 27, 28, 30 © Robert Rauschenberg Foundation/DACS, London/VAGA, New York
29, 31 © Robert Rauschenberg Foundation/DACS, London/VAGA, New York. Image courtesy of National Gallery of Art, Washington
32, 33 (and detail page 56), 34, 35, 36, 37, 38, 39, 40, 41 Reproduced by permission of the artist

Section 3
42, 50 © Jasper Johns/VAGA, New York/DACS, London 2016. Image courtesy of National Gallery of Art, Washington
43 © Jasper Johns/VAGA, New York/ DACS, London 2016
44 © Robert Rauschenberg Foundation and ULAE/Licenced by VAGA, New York NY
45 (and detail page 88) © Robert Rauschenberg Foundation and ULAE/Licenced by VAGA, New York NY. Image courtesy of Sotheby's
46, 48, 51, 52 © Robert Rauschenberg Foundation/DACS, London/VAGA, New York. Image courtesy of National Gallery of Art, Washington
47 © Robert Rauschenberg Foundation/DACS, London/VAGA, New York
49 Copyright 1969 Claes Oldenburg. © 2016. Digital Image, The Museum of Modern Art, New York/Scala, Florence
53 Reproduced by permission of the artist and Mary Ryan Gallery, New York
54 © The Richard Diebenkorn Foundation

Section 4
55, 57, 59, 60, 61, 62, 63, 64, 65 (and detail page 106), 67 © Ed Ruscha, courtesy of the artist
56 © Ed Ruscha, courtesy of the artist. © 2016. Digital Image, The Museum of Modern Art, New York/Scala, Florence
58, 66 © Ed Ruscha, courtesy of the artist. Image courtesy of National Gallery of Art, Washington

68 © Bruce Nauman/Artists Rights Society (ARS), New York and DACS, London 2016. Image courtesy Mary Ryan Gallery, New York
69 © Bruce Nauman/Artists Rights Society (ARS), New York and DACS, London 2016. Image courtesy Gagosian. Photo Zarko Vijatovic
70, 71, 72 © Bruce Nauman/Artists Rights Society (ARS), New York and DACS, London 2016
73, 74, 75, 76, 77, 78. © Wayne Thiebaud/DACS, London/VAGA, New York 2016
79, 80, 81 Reproduced by permission of the artist
82 © David Hockney/Tyler Graphics Ltd. Image © Tate, London 2016
83 © David Hockney/Gemini G.E.L. Image © Victoria and Albert Museum, London

Section 5
84 © Estate of Roy Lichtenstein/DACS 2016
85, 86 © The Willem de Kooning Foundation/Artists Rights Society (ARS), New York and DACS, London 2016
87 © Cy Twombly Foundation
88 Reproduced by permission of the artist
89, 90 (and detail page 140) © Dedalus Foundation, Inc./VAGA, NY/DACS, London 2016
91 © Helen Frankenthaler Foundation, Inc./ARS, NY and DACS, London 2016. © 2016. Digital Image, The Museum of Modern Art, New York/ Scala, Florence
92 © Sam Francis Foundation, California/DACS 2016
93 © Sam Francis Foundation, California/DACS 2016. Image courtesy of National Gallery of Art, Washington
94, 95 © The Josef and Anni Albers Foundation/DACS London
96, 97 © Ellsworth Kelly, courtesy Matthew Marks Gallery
98 © Frank Stella. ARS, NY and DACS, London 2016
99 © Frank Stella. ARS, NY and DACS, London 2016. © 2016. Digital Image, The Museum of Modern Art, New York/Scala, Florence

Index